How to Think about
The Great Ideas

Books by Mortimer Adler

Dialectic (1927) • *Music Appreciation* (1929) • *The Nature of Judicial Proof* (with Jerome Michael, 1931) • *Crime, Law, and Social Science* (with Jerome Michael, 1933) • *Diagrammatics* (with Maude Phelps Hutchins, 1935) • *Art and Prudence* (1937) • *What Man Has Made of Man* (1937) • *Saint Thomas and the Gentiles* (1938) • *How to Read a Book* (1940) • *The Philosophy and Science of Man* (1940) • *Problems for Thomists: The Problem of Species* (1940) • *Scholasticism and Politics* (as editor, 1940) • *A Dialectic of Morals* (1941) • *How to Think about War and Peace* (1944) • *A Syntopicon: An Index to The Great Ideas* (as editor, 2 volumes, 1952) • *Research on Freedom* (2 volumes, 1954) • *The Idea of Freedom* (volume 1, 1958) • *The Revolution in Education* (with Milton Mayer, 1958) • *The Capitalist Manifesto* (with Louis O. Kelso, 1958) • *The New Capitalists* (with Louis O. Kelso, 1961) • *Great Ideas from the Great Books* (1961) • *The Idea of Freedom* (volume 2, 1961) • *The Great Ideas Today* (as editor, with Robert Hutchins, 1961) • *Gateway to the Great Books* (as editor, 10 volumes, with Robert Hutchins, 1963) (*The Conditions of Philosophy* (1965) • *The Difference of Man and the Difference It Makes* (1967) • *The Annals of America* (as editor, 21 volumes, 1968) • *The Time of Our Lives* (1970) • *The Common Sense of Politics* (1971) • *Propaedia* (as editor, 30 volumes, 1974) • *The American Testament* (with William Gorman, 1975) • *Some Questions about Language* (1976) • *Philosopher at Large* (1977) • *Reforming Education* (1977) • *Great Treasury of Western Thought* (as editor, with Charles Van Doren, 1977) • *Aristotle for Everybody* (1978) • *How to Think about God* (1980) • *Six Great Ideas* (1981) • *The Angels and Us* (1982) (*The Paideia Proposal* (1982) • *How to Speak/How to Listen* (1983) • *Paideia Problems and Possibilities* (1983) • *A Vision of the Future* (1984) • *The Paideia Program* (with members of the Paideia Group, 1984) • *Ten Philosophical Mistakes* (1985) • *A Guidebook to Learning* (1986) • *We Hold These Truths* (1987) • *Intellect: Mind over Matter* (1990) • *Truth in Religion* (1990) • *Haves Without Have-Nots* (1991) • *Desires, Right, and Wrong* (1991) • *A Second Look in the Rearview Mirror* (1992) • *The Great Ideas* (1992) • *The Four Dimen-sions of Philosophy* (1993) • *Art, the Arts, and the Great Ideas* (1994) • *Adler's Philosophical Dictionary* (1995) • *How to Think about The Great Ideas* (2000)

How to Think about The Great Ideas

From the Great Books of
Western Civilization

MORTIMER J. ADLER

Edited by
Max Weismann

OPEN COURT
Chicago and La Salle

To order books from Open Court, call toll-free 1-800-815-2280.

Open Court Publishing Company is a division of Carus Publishing Company.

Copyright © 2000 by Carus Publishing Company

First printing 2000
Second printing 2000
Third printing 2001
Fourth printing 2001

Printed and bound in the United States of America

Library of Congress Cataloging-in-Publication Data

Adler, Mortimer Jerome, 1902-
 How to think about the great ideas : from the great books
of Western civilization / Mortimer J. Adler ; edited by Max
Weismann.
 p. cm.
 Includes index.
 ISBN 0-8126-9412-0 (pbk : alk. paper)
 1. Great books of the Western world I. Weismann, Max.
II. Title.

ACI .A67 2000
081—dc21 99-045251

To all the members of
the Center for the Study of The Great Ideas

Contents

Preface

This book can be read either as an introduction to philosophy or as a thought-provoking treatment of selected philosophical issues by a living master of philosophical education.

No contemporary philosopher has been so extraordinarily successful at encouraging philosophical thought and spreading philosophical knowledge as Mortimer Adler. The 52 chapters of this book are the edited transcripts of Professor Adler's classic TV series, *The Great Ideas.*

Mortimer Adler's name will always be associated with The Great Ideas and The Great Books. It was Adler who first understood that there are a limited number of Great Ideas which form the core of the thought of Western Civilization and the keys to the Great Books.

Heading a large research staff at the Institute for Philosophical Research, Dr. Adler spent eight years constructing a reference work entitled *Syntopicon: An Index to The Great Ideas,* a systematic and comprehensive inventory of the fundamental ideas to be found in the Great Books of the Western world. At first, Adler's team listed some seven hundred possible candidates for inclusion among the Great Ideas, but on closer examination over a two-year period most of these turned out to be fragments or portions of more inclusive ideas. These were gradually eliminated, leaving 102 irreducible and indispensable Great Ideas. Over subsequent years, Dr. Adler has found no reason to eliminate any of the 102, and the Great Idea of Equality has been added, making 103.

For his path-breaking TV series on *The Great Ideas,* Dr. Adler selected 22 Great Ideas which would be most suitable for popular discussion, some of these requiring more than one TV show.

Here are the 103 Great Ideas, with the 22 selected for Adler's TV series listed in bold type:

Angel, Animal, Aristocracy, **Art**, Astronomy and Cosmology, **Beauty**, Being, Cause, Chance, **Change**, Citizen, Constitution, Courage, Custom and Convention, Definition, **Democracy**, Desire, Dialectic, Duty, Education (**Learning**), Element, **Emotion**, Equality, Eternity, **Evolution**, Experience, Family, Fate, Form, **God**, **Good and Evil**, **Government**, Habit, **Happiness**, History, Honor, Hypothesis, Idea, Immortality, Induction, Infinity, Judgment, **Justice**, Knowledge, Labor (**Work**), Language, **Law**, Liberty (**Freedom**), Life and Death, Logic, **Love**, **Man**, Mathematics, Matter, Mechanics, Medicine, Memory and Imagination, Metaphysics, Mind, Monarchy, Nature, Necessity and Contingency, Oligarchy, One and Many, **Opinion**, Opposition, Philosophy, Physics, Pleasure and Pain, Poetry, Principle, **Progress**, Prophecy, Prudence, **Punishment**, Quality, Quantity, Reasoning, Relation, Religion, Revolution, Rhetoric, Same and Other, Science, Sense, Sign and Symbol, Sin, Slavery, Soul, Space, State, Temperance, Theology, Time, **Truth**, Tyranny and Despotism, Universal and Particular, Virtue and Vice, **War and Peace**, Wealth, Will, Wisdom, World.

All the Great Ideas are recognizably the same as they were in the ancient world; none of them is a "modern discovery." The ancient Greeks had a name for all 103 of them.

These ideas have been objects of speculation and enquiry since the beginning of human thought. They are the common stock of the human mind. The vast literature which exists on each Great Idea reflects not only the continuity of human thought about them, but also the wide diversity of opinions to which such thought inevitably gives rise. By learning about The Great Ideas, we discover all the fundamental disagreements—and agreements—of humankind.

Although The Great Ideas are the same as they were a millennium ago, this doesn't mean that there has been nothing new in the world of ideas. On the contrary, most of the Great Ideas have kept on changing and growing in substance and scope. In every epoch, intellectual geniuses, though they have not discovered new Great Ideas, have exposed new facets of the Great Ideas.

Some Great Ideas (like Prophecy or Angel) had a livelier history in antiquity or the Middle Ages than more recently. Others (like Progress or Evolution) have seen an enormous expansion of attention and refinement in modern times. But even these "modern" ideas were clearly identified in antiquity. "The ancients stole all our ideas from us," as Mark Twain wryly observed.

Even more important than the living presence of a Great Idea is its future. Each Great Idea is still imperfectly understood; each is still unfinished business. Mortimer Adler has tried to understand the history of thinking about one after another of the Great Ideas, reading all the major writings on each subject, charting the whole range of different conceptions and theories which outstanding thinkers have advanced with respect to it, and assessing its present significance.

Every one of The Great Ideas is a unique adventure. Each has an interior structure and life of its own. You can see this in the different strategies which Dr. Adler employs to tackle the different ideas in *How to Think about The Great Ideas*. Some of the Great Ideas involve as many as 40 or 50 different main subdivisions; others require only 10 or 15. Some have a relatively simpler internal structure whereas others have a complex and intricate structure.

Mortimer Adler has taught us that we are all philosophers. We all think—well or sloppily, enthusiastically or inattentively. The slightest sense perception—a falling leaf, a twinkling star, a smiling child—awakens our minds as well as arousing our feelings, and forces us to ask: Why? What? Whence? Whither?

Not to engage in this pursuit of ideas is to live like ants instead of humans. The ant can live without ideas because the whole course of its life is fixed. But human beings have the freedom—and therefore the necessity—to choose, and always to choose in terms of ideas.

We have all become used to the notion that we live in a world with no more unexplored frontiers. We speak of pioneering as a thing of the past. We are encouraged to think that future breakthroughs will come from Ph.D.'s in white coats, wielding astronomically expensive equipment.

This is a colossal mistake, especially in the field of philosophy, the true realm of ideas. In the world of ideas, there is always pioneering to be done, and any one of us can do it, using the equipment with which we have been endowed, our minds. The Great Ideas belong to everyone.

All the royalties from sales of this book will go to the Center for the Study of the Great Ideas, a not-for-profit 501(c)(3) organization. Anyone interested in the work of the Center, membership benefits, or purchasing videos of the original TV shows on which this book is based, can contact the Center at 845 North Michigan Avenue, Suite 950W, Chicago, Illinois 60611. Telephone: 312-440-9200. Fax: 312-440-0477. Email: mjadler@xsite.net. Homepage: TheGreatIdeas.org.

Acknowledgments

Special mention must be made in gratitude to Mr. and Mrs. Richard S. Wolfe whose generosity underwrote the cost of producing the audio masters and transcriptions without which this book would not have been possible.

I would also wish to express my appreciation to the following members of the Center for the Study of the Great Ideas, whose unstinting support contributed the necessary funding to restore and reproduce these classic TV programs: Mary Ann Allison, Steven O. Buchanan, Roland G. Caldwell, Julian S. Chestnut, DVM, DO, The Dooley Group, Inc., Gary B. Dunn, Charleen L. Dwyer, Roland F. Frerking, Brian D. Hansen, Dr. and Mrs. Alfred B. Hathcock, Nina R. Houghton, Richard M. Hunt, Douglas Iliff, M.D., James E. and Veta V. Iliff, Michael Martinez, Dr. Maura S. McAuliffe, Todd W. McCune, M.D., George and Martha Mitchell, Mike Murphy, The Paideia Group, Inc. Patricia Weiss, Bob Peters, Mr. and Mrs. Richard G. Powell, Ben and Esther Rosenbloom Foundation, Norman Ross, Adele Smith Simmons, Helen Simmons, Richard N. Stichler, Stiegman Farms, Shelly and Pete Thigpen, Mr. and Mrs. Richard S. Wolfe, Andrew A. Zvara

Finally, I record my deep appreciation to Mr. Wayne Moquin, who graciously devoted his time and expertise to index this book, and to David Ramsay Steele of Open Court, for his immeasurable help in the final preparation of the manuscript.

About the Author

Born in Manhattan in 1902, Mortimer Jerome Adler at first wanted to become a journalist, and dropped out of school at the age of 15 to work as a copy boy for the New York *Sun*. He worked there full-time for two years, doing a number of editorial tasks including writing editorials.

Adler attended Columbia University where he refused to take part in physical education. As a result, Columbia would not give him a bachelor's degree, though he had fulfilled all the other requirements. He continued at Columbia as teacher and graduate student, gaining his Ph.D. in experimental psychology in 1928. Adler was the only Ph.D. in the country without a master's degree, a bachelor's degree, or a high-school diploma.

In 1929, the 27-year-old Mortimer Adler was hired as professor of philosophy at the University of Chicago, by the "boy president" of the university, Robert Maynard Hutchins, who had been appointed president at the age of 30 (he had become Dean of Yale Law School at 28). Together at Chicago, Adler and Hutchins became the center of swirling, often bitter, controversy.

Adler and Hutchins attracted national attention as leaders in the development of of a controversial new approach to liberal education centered on the Great Books. Although courses based on outstanding works of the past were already well-known, Adler first popularized the phrases "Great Books" and "Great Ideas" and provided focus to this organization of liberal education by emphasizing that there were a limited, objectively identifiable number of Great Ideas and Great Books. With Hutchins, Adler initiated the Great Books Foundation and the Basic Program of Liberal Education for Adults.

The turmoil at Chicago exploded in 1931, with an open revolt of infuriated faculty, culminating in a mass meeting in the University's Rockefeller Chapel, at which the faculty threatened mass resignation if their demands were not met. President Hutchins had to succumb to a number of demands including the removal of Mortimer Adler from the philosophy department.

Adler was given a position in the Law School as associate professor of philosophy of law, and so he remained, as he put it later, "at large." The unfriendly disputation continued for years however, and became focussed on Hutchins's and Adler's opposition to instrumentalism in science, as well as their radical proposals for liberal education. These issues came to be portrayed as the Aristotelianism and even medievalism of Hutchins and Adler, as against the pragmatism and instrumentalism of the "Chicago School" reflecting the influence of such "progressive" figures as Dewey and Mead.

Although Adler and Hutchins were ultimately frustrated at Chicago, their ideas were implemented at St. John's College in Annapolis, Maryland, and then by other St. John's Colleges and by Thomas Aquinas College. The Great Books approach was depicted by opponents as the imposition of medieval Thomism, yet the Great Books themselves included far more works by "heretics" and "forbidden" authors than by Catholics, and for that reason the Great Books program made little headway in specifically Catholic institutions.

Having published *Art and Prudence*, a work which included a chapter applying the ideas of Aristotle's *Poetics* to movies ("Cinematics"), Adler became a consultant to the movie industry, in its struggles to defend itself against the threat of censorship.

His *How to Read a Book* became an international bestseller, and successfully vanquished the then still prevalent idea that it was wrong to "deface" even one's own books. Adler's systematic, efficient method for marking up a book and quickly identifying its key elements has become standard practice among college students the world over.

Adler now describes the years 1938–43 as his "Thomistic period," the time when he came closest to the philosophy of Thomas Aquinas, although Adler's enemies had pegged him as a medievalist much earlier. From 1938, he attempted to communicate with the orthodox Thomists of the American Catholic

Philosophical Association, but the reaction of many Thomists was even more hostile to Adler than that of mainstream philosophers: he was attacked as a revisionist for attempting to improve upon the arguments of Aristotle and Aquinas, especially for contending that Aquinas's arguments for the existence of God were not conclusive.

After 1943, Adler largely gave up trying to influence Thomists, and, being out of sympathy with the direction of mainstream American philosophy, increasingly addressed himself to the intelligent layperson. However, with the passage of the years, more American Thomists have come to appreciate and agree with many of Adler's arguments. Adler continues to maintain that mainstream philosophy today has missed certain vital insights of the Thomist or neo-Aristotelian approach.

Adler and Hutchins split over the issue of American involvement in World War II, with Hutchins taking the isolationist side; this disagreement, however, became irrelevant after Pearl Harbor.

During and after the war, there was an active movement for world government; Adler became one of its leading spokesmen. He encountered some hostility after a statement falsely attributed to him—"We must do everything we can to abolish the United States"—was widely publicized by the John Birch Society. Later, much to Adler's immense disappointment, the movement for world government evaporated. Almost alone, he has continued to publicly promote the idea.

The Great Books movement became a popular cause, attracting the devotion of many thousands of adults across the country and drawing the attention of the media and of such notables as President Truman. Among a number of such hugely successful events, a 1948 presentation by Adler and Hutchins on Plato's account of the trial of Socrates, held at Chicago's Orchestra Hall, drew a capacity crowd of 3,000, with 1,500 people turned away.

In 1943, the University of Chicago was given control of the content of the *Encyclopædia Brittannica*, with an editorial board headed by Hutchins and later by Adler. Since editions of the great classics were then rare, *Encyclopædia Britannica* also commissioned the 54-volume set of the Great Books, edited by Adler.

Adler had the idea of an index to the Great Books which would delineate the discussion of all the Great Ideas. Thus began the project for the *Syntopicon*: identifying the truly Great Ideas and finding all references to these in the Great Books. Adler had at his disposal

a staff of over 30, and estimated compilation of the index would take two years and $60,000. In fact it took seven years and a million dollars, making an outlay of 2.5 million dollars for the whole set.

Adler's staff grew to 25 indexers and over 50 clerical workers. These were the days before computers, and all the work was done on index cards, with typed-out copies of all the cards prepared to date having to be continually updated for consultation by indexers. Each indexer represented a great author, so that, for instance, the indexer representing Marx would wrangle with the indexer representing Plato over the inclusion of particular topics.

The set of Great Books sold tens of thousands of copies each year, reaching its height of 49,000 sets per year in the early 1960s. But it's doubtful whether it ever recouped the outlay.

Adler's work on the *Syntopicon* led to the foundation of the Institute for Philosophical Research, which began work under his direction in San Francisco in 1952. The Institute aimed to achieve a dialectical summation of Western thought in the sphere of each one of its Great Ideas, though it was eventually realized that this might take centuries. The first tangible achievement was Adler's book *The Idea of Freedom.*

In 1963, the Institute moved to Chicago. Adler continued as its director, additionally taking up a *Britannica* lectureship at the University of Chicago and becoming editorial director of the new edition of the *Encylcopædia*. At this time, Mortimer Adler's first marriage of 33 years ended in divorce. At the age of 60, Adler married 26-year-old Caroline Pring. They have two sons.

The 15th edition of *Britannica*, launched in 1974, followed Adler's organizational plan and was a radical departure from all earlier editions. Known as "Britannica 3" because of its three-part structure (Propaedia, Macropaedia, and Micropaedia), the new work preserved the alphabetical ordering principle for consultation, while simultaneously depicting the orderly structure of all human knowledge.

In 1982, responding to the perceived crisis in American public education, Adler, together with a number of other leading educators, and after intensive study and debate, launched the Paideia movement, calling for the abolition of multitrack schooling systems, and arguing for a single elementary and secondary school curriculum for all students. He proposed to eliminate electives and other forms of specialization or vocational learning in the

early stages of education, arguing that these should come only after a full course of basic education which should be common to everyone.

Both Adler's critics and his many admirers generally assumed that he was a religious person, probably a Roman Catholic, but for Adler, philosophical theology was the honest pursuit of a genuine intellectual puzzle, and although he early developed what he considers a sound argument for the existence of God, he had never made the "leap of faith" required to become a believer in the active and committed sense. When his book *How to Think about God* appeared in 1980, many readers were astounded to find that not only was it explicitly addressed to "pagans"—it was also avowedly written by one.

In 1984, following a mysterious and depressing illness, Adler made the "leap of faith," and was baptised into the Episcopalian Church.

Author's Introduction

It cannot be too often repeated that philosophy is everybody's business. To be a human being is to be endowed with the proclivity to philosophize. To some degree we all engage in philosophical thought in the course of our daily lives. Acknowledging this is not enough. It is also necessary to understand why this is so and what philosophy's business is. The answer, in a word, is ideas. In two words, it is Great Ideas—the ideas basic and indispensable to understanding ourselves, our society, and the world in which we live.

These ideas constitute the vocabulary of everyone's thought. Unlike the concepts of the special sciences, the words that name the Great Ideas are all words of ordinary, everyday speech. They are not technical terms. They do not belong to the private jargon of a specialized branch of knowledge. Everyone uses them in ordinary conversation. But everyone does not understand them as well as they can be understood, nor has everyone pondered sufficiently the questions raised by each of the Great Ideas. To think one's way through to some resolution of the conflicting answers to these questions is to philosophize.

This book aims to do no more than to provide some guidance in this process. We have limited the consideration of these ideas to an outline that will try to achieve three results for you.

First, it should give you a surer grasp of the various meanings of the word you use when you talk about the idea.

Second, the delineation of each idea should make you more aware than you normally are of questions or issues that you cannot avoid confronting if you are willing to think a little further about the idea—basic ones, ones that human beings have been arguing about over the centuries.

Third, in the consideration of each idea, we are led to the consideration of other ideas. How does our understanding of truth affect our understanding of goodness and beauty? How does our understanding of what is good and bad carry us not only to an understanding of what is right and wrong, but also to an understanding of justice, and how does that affect our understanding of liberty and equality as well?

If we have succeeded in these aims, we will have helped you engage in the business of philosophy, which is everybody's business not only because nobody can do much thinking, if any at all, without using The Great Ideas, but also because no special, technical competence of the kind that is imperative for the particular sciences and other special disciplines is required for thinking about the Great Ideas. *Everybody does it*, wittingly or unwittingly.

I believe that this book will be helpful to all those who would wish to do it just a little better.

Mortimer J. Adler, (with Max Weismann) Co-Founder
 and Chairman
Center for the Study of The Great Ideas

1 How to Think about Truth

Today we are going to consider The Great Idea of Truth. As beauty is connected in our minds with art, as goodness is connected in our minds with the character of men and their actions, so *truth* is connected with the pursuit of knowledge, with all of the attempts that men make to *know* in science, in philosophy, in religion. All earnest and serious efforts at inquiry comprise the pursuit of truth.

I'm sure you've heard people say, "I would like to know the truth about that." I wonder if you've stopped to think how redundant that expression is, "to know the truth." Because the very meaning of the phrase "to know" is to have in one's mind the truth about the object one is trying to know. It is perfectly obvious—is it not?—that "false knowledge" is impossible. It wouldn't be knowledge if it were false. And "true knowledge" is redundant. To know is to have the truth. And those who doubt man's ability to know anything are skeptical, therefore of his ability to possess the truth about anything.

Now, *skepticism* is just one of the attitudes that men take toward the problem of the pursuit of truth. There are others. Let me summarize for you quickly some basic oppositions in the attitudes that men take toward truth. First is this attitude that I have just mentioned, skepticism. The skeptic thinks that there is nothing true or false, or that everything is equally true and false and that we are unable to know what is true or what is false, that we simply don't have knowledge or possess the truth.

The opposite position here is taken by those who think that men can inquire and can succeed in inquiry and can come to have some grasp of the truth about things. For example, let me

1

read you what Freud says against the skeptic. He speaks of the skeptic or skeptics as nihilists who say that there is no such thing as truth or that it is only the product of our own needs or desires. They make it absolutely immaterial what views we accept. All of them are equally true or false. And no one has the right to accuse anyone else of error. And Freud comments on this: "If it were really a matter of indifference what we believe, then we might just as well build our bridges of cardboard as of stone, or inject a tenth of a gram of morphine into a patient instead of a hundredth, or take teargas as a narcotic instead of ether; but the intellectual anarchists themselves"—here Freud is calling the skeptic an intellectual anarchist—"but the intellectual anarchists themselves would strongly repudiate any such practical applications of their theory."

Another attitude toward the truth is *relativism*. And according to this view, some things that are true for you are false for me, and what may be true for me is false for you, and what was once true in some other period of history or in some other culture is no longer true. Against this position of the relativity of truth to individuals or cultures, there is the opposite view that truth is objective, not subjective and relative, that it is absolute and immutable, always and everywhere the same for all men.

Then there is the *pragmatic* attitude toward truth which says that truth consists in those ideas or those thoughts of ours which bear practical fruit in action, that truth consists in the things which *work*. Truth is what works in the way of our thinking. And as against this emphasis on action and practical results as the measure of truth; there are those who say that such practical verification in action or experience is not needed at all for man's having a grasp of the truth.

Now the problems raised by these basic oppositions that I've just summarized for you are in one way easy and in one way hard. There are two distinct questions here that are often confused. One is the question, "What is truth?" a question that calls for the definition of truth. And the other question is a question—listen to the difference—not "What is truth?" but "What is true in a particular case?" or "What is true?" It is a question that calls upon us to say whether this statement is true or that statement is false, and to state the criteria or the standards by which we judge that a given statement is either true or false.

TRUTH DEFINED

The easy question or at least the easier question of the two is the question, "What is truth?" This is the question supposedly that Pontius Pilate asked, and wouldn't wait for an answer. But if he had wished to, he could have waited because he wouldn't have had to wait too long. And the hard question, the much harder question, is the other question, namely, "What is true?" This other question asks how we can *judge* that something is true or false.

I want to deal with the easier question first, the question of defining "truth," the question, "What is the truth, or what is truth itself?" Then we'll go from that to the harder question, the question about how we know whether a statement is true or false. And then if there is some time left, I'd like to deal quickly at the end with the problem of the relativity and mutability of truth.

You all have a pretty clear notion of what truth is. Let me show you that you do by reminding you of the distinction between truth telling and lying. Everyone of us has told a lie. Everyone of us knows how to lie. And everyone of us knows the difference between lying and telling the truth. We know that if we say something is the case when it is not, or that it is not the case when it is, we are lying. That substitution of *is* for *is not* or *is not* for *is,* is telling a lie. That is why Josiah Royce defined a liar as "a man who willfully misplaces his ontological predicates." And you can see then that lying is a lack of correspondence between what one thinks and what one says.

When one takes an oath in a courtroom and tells the whole truth and nothing but the truth, what one is taking an oath to do is to put into speech faithfully what one thinks, to let there be no discrepancy between speech and thought. Now this doesn't imply at all, that when a person speaks truthfully it follows necessarily that what he thinks is true in fact. For a person who speaks "truthfully" may be in error; he may suppose he knows something that in fact he does not know. But I want you to consider this question: can a person lie deliberately without at least thinking that he knows something to be true, that he has some grasp of the truth? Could he tell a lie if he didn't think that he had a grasp of the truth? This is a good question for the skeptic to consider.

Now there is another mode of truth other than this business of telling the truth as opposed to telling a lie which exists in the

communication of men, that men are talking to one another. And when individuals talk to one another and speech words pass between them, it is possible for those words to be used by them in such a way that they have the same ideas in mind. Or sometimes, when communication fails, it is possible for them to use the same words and to have quite different ideas in mind.

We say that truth lies between, there is a truth of understanding or a truth in communication when using words brings their minds in correspondence to one another. When there is a correspondence through the language they use of what one person thinks with what another person thinks, then there is truth in communication. Notice here again that there is a correspondence between one mind and another as in the first case there is a correspondence between what a person thinks and what a person says. And only if there is such a correspondence, can you speak of there being truth in their communication.

Now these two considerations of truth telling and truth in the communication between persons bring us to the difficult question, prepare us in a way for defining what truth is in statements about the world, when we make statements that something is or is not the case.

And perhaps I ought to recapitulate what I have just said so that I can bring you up to this problem with the advantage of understanding the simple points we have already seen together. Remember now in telling the truth, in order to tell the truth, we must achieve a correspondence between our words, our speech, and our thought. We speak truthfully when our speech corresponds or conforms to what we think. And there is truth in communication between persons when, in using words, their two minds correspond with one another. The ideas in one person's mind correspond to the ideas in the other. What remains then, what is the third and difficult case? It is the case in which there is a correspondence between the mind itself and reality, the world in which we live. And when there is this kind of correspondence between the mind and reality, then the mind has truth in it about the world that it is trying to know or understand.

THE EASY PROBLEM OF TRUTH

This definition of truth as *correspondence between the mind and reality* is, I think, one that is generally agreed upon in European thought. I would like to read you a number of quotations from great authors in the ancient world, the Medieval world, and the modern world, to show you how they all are saying the same thing in defining truth as this kind of correspondence between the mind and reality.

Let me begin with Plato, in some sense the forerunner of all the rest of European thought. Plato says, "A false proposition," that is, a false statement, "is one which asserts the nonexistence of things which are or the existence of things which are not." And Aristotle amplifies that just a little. Listen carefully now to this next statement. Aristotle says, "To say of what is that it is or of what is not that it is not, is to speak the truth or to think truly; just as it is false to say of what is that it is not or of what is not that it is." See again, that goes back to that remark of Josiah Royce's that a liar is a man who misplaces his ontological predicates. And Aquinas, with this background of Plato and Aristotle, in one single sentence says that truth in the human mind consists in the mind's conformity to reality to that which is.

Later, in modern times, we have John Locke saying, "Though our words signify nothing but our ideas, yet being designed by them to signify things, the truth they contain will be only verbal when they stand for ideas in the mind that do not agree with the reality of things."

And then in the twentieth century an American philosopher by the name of William James was very much concerned with the theory of truth. In fact, he wrote a book called *The Meaning of Truth* and he is associated in all of our minds with having spent a good part of his life worrying about the whole problem of truth. James—and he by the way is a leading pragmatist who developed the pragmatic theory of truth—referring to the pragmatist view that an idea's working successfully is a sign of its truth, warns his critics that this is a not a new definition of the nature of truth. Notice that the idea's working is a sign of its truth; it's not a new definition of the nature of truth, but only a new interpretation of what it means to say that the truth of our ideas consists in their agreement with reality as their falsity means their disagreement

with reality. "Pragmatists and intellectuals," James goes on to say, "both accept this definition as a matter of course." But he also points out that the theory of truth begins rather than ends with the simple definition of truth as agreement with reality; many problems remain.

The rather remarkable fact here is the extent of the agreement across the centuries among philosophers of quite different persuasions concerning the nature of truth. It is a really remarkable agreement. "How then," you may ask, "is there any problem of truth left for us to consider?" If they do agree about this, what is the problem of truth that disturbs them and concerns them so much? What do philosophers quarrel about in regard to truth, not about what truth is, but about what is true? The problem they are concerned with is how we tell whether something in question is true or false. And that is the difficult problem.

Let's assume for a moment that what truth is is the correspondence of one thing with another. The truth in the mind is the correspondence of the mind with reality, or the truth of our speech is a correspondence of what we say with what we think. If this is the case, then in the simple problem of telling the truth everyone except the pathological liar is able to know quite directly whether his own words faithfully express what he thinks. That correspondence between my speech and my thoughts is something that I myself can directly inspect. I have no problem of seeing whether or not my speech corresponds with my thought.

And in the case of communication between two human beings, which of course is a little more difficult, nevertheless it is still possible for the two human beings, by talking to one another patiently and painstakingly, to discover whether or not they are getting a correspondence between what they think. They ask one another questions, they test each other's use of words. And by this careful, patient, methodical effort they can detect whether or not in their efforts to communicate there is a correspondence between their minds and so whether they have truth in their communication.

Let me show you these two cases in a guide. In the simple case of truth-telling where speech corresponds with thought, where what I say corresponds with what I think, there is no difficulty about detecting the correspondence at once, because it is all within my own mind. I understand what I say, I understand what I think, and I can see the correspondence between them, can I not?

Or when I lie, I know quite well that what I say does not correspond with what I think.

And here is a slightly more difficult case of two persons, *a* and *b*, mind *a* and mind *b*. Speech connects them. They are in communication. And by speech they can tell whether their thought is the same, whether there is a communication in thought, whether they have communicated thought from one another, they have thought in common, the ideas of one man correspond with ideas or thoughts of the other. There again, it is possible because they can speak to one another and try each other out, to test the presence or absence of the correspondence of their minds.

THE DIFFICULT PROBLEM OF TRUTH

Now then, let's take the really difficult case. That difficult case is the case in which you ask, How do I test the correspondence between my own mind and reality, the world, to find out whether what I think is true? Let me show you why this is such a difficult case. Here we have the mind and here we have reality; and the mind is trying to know reality. In the mind is thought. Reality consists of existences. And those existences are things to be apprehended or known. But the thought, "Is that reality in my mind?" that thought is the reality that is apprehended. I don't have in my mind two things, my thought and the object of my thought. Whatever is in my mind is in my mind, and I can't know any "grasp of reality." I have no way of getting hold of reality except by knowing it. But then I can't test whether I know it or not by comparing what I know with what I am trying to know. Don't you see that in this case you can't make the comparison? There is no way of making a direct test between the two things that are supposed to correspond.

Let me put it to you another way. I express my thoughts in statements or propositions. Reality consists of the facts about which I am trying to make the propositions. And the propositions are true if they correspond with the facts. And the facts are the things to be known. The facts not as known, but to be known. The propositions are the facts as I think I know them. It isn't as if I had in one hand the propositions and in the other hand the facts and could look at them and say, "Oh, I see. My propositions

correspond to the facts," because I have no grasp of the facts except in my own propositions about them. Hence I have no way of making a direct comparison between my propositions and the facts they are trying to state. So there is no direct or even indirect way of telling whether what I think, what I say, my propositions and judgments, correspond with the way things are.

And there is not even an indirect way of doing this because I can't ask "reality" questions the way I can ask another person questions and find out whether what I think agrees with what he thinks. I can't ask reality questions. Or, I can ask the questions, but I can't get any answers. Reality won't speak back to me. And so there is no way of getting by communication the direct or indirect test of whether what I think, what is in my mind, corresponds with reality and the way things are. That is the problem of truth. It's not the problem of knowing what truth is, but the problem of telling whether what I think is true is really true, if truth consists in the correspondence of my mind with reality.

CONSISTENCY IS NEEDED FOR TRUTH

There is the beginning of a solution to this problem. Staying within my own mind, let's suppose I make two statements. Let me call one of them proposition p and the other proposition q. Those are two separate statements. Anything you want to say. Suppose these two statements are contradictory. Suppose they are like the statements "a is b and a is not b," or "two plus two equal four and two plus two does not equal four." Now we know, don't we, that both can't be true? In fact, one must be true and one must be false. And this test of contradiction or noncontradiction, or consistency, is the beginning of a sign within our own minds, just staying within our own minds and having nothing but the things we think ourselves, our own thoughts; we know that if we contradict ourselves or if we think contradictory things, we are missing the truth somewhere. And this is an interesting point, because for consistency or coherence or the absence of contradiction to be a sign of truth and falsity, or a difficulty about truth and falsity, it self-presupposes that there can be a correspondence between the mind and reality. For if reality were full of contradictions, then the presence of contradictions in the mind would not be a test or a sign of truth or falsity. Only if reality

is non-contradictory, if there are in the world of existence no contradictions, are we committed to thinking that when we find a contradiction in our own minds, we have at least come into contact with one thing which is true and one which is false.

Most philosophers are not satisfied with this sign of truth. I say most, there are some exceptions; some philosophers think this is quite sufficient. For example, Descartes takes the view that when our own ideas are quite clear and distinct, when they are so clear and distinct that they are free from all contradiction, then we know we have the truth, then we are sure, we are certain of our possession of the truth. And Spinoza says, for example, "What can be clearer or more certain than a true idea as the standard of truth? Just as light reveals both itself and the darkness, so truth is the standard of itself and of the thoughts."

But this is not sufficient, I think. And I would like to show you why it is not. Suppose these two propositions are contradictory. What we know then is that one must be true and one must be false. But which? Either one could be true, either one could be false; we don't know which is true or false from knowing that their being contradictory makes one of them true and one false. How do we solve that problem? We could solve that problem only if in our mind there are some propositions or principles which are given as true, which we are certain about as true; so that these can be used as the measure or standard of the truth in other propositions. If, for example, we were absolutely sure that propositions p is true, then we would know that if q contradicts it, q is false. But we have to know first that p is true. And we can't know that simply from the fact that p contradicts q. To solve this problem fully we must have some assurance about certain propositions as true and use them to measure truth and falsity in others.

Aristotle makes this point, I think, very clearly when he says, "The human mind uses two kinds of principles. There are the unquestionable truths of the understanding which are axioms or self-evident truths and there are the truths of perception, truths which we know, which we possess, when we perceive matters of fact, such as, "Here is a piece of paper in my hand," or "Here is a book, I see a book, I observe a book." That is a matter of fact I can't have any doubt about, just as the self-evident truth that the whole is greater than the part is a truth of my understanding about which I can have no doubt.

Now all that moderns have added to this is an elaborate, care-fully, worked-out logic of the methods of empirical verification. But all the truth can be tested by finding whether or not anything else agrees with the facts we know by observation or agrees with the principles which are self-evident to our understanding. With these two at either extreme, we can tell whether anything else we think is true by seeing that it doesn't contradict this or this. I think if you will reflect about what I have said, you will see that it begins to solve the problem of how we tell whether a given statement is true or false in terms of the way that statement accords or dis-agrees with self-evident truths or truths of immediate perception of matters of fact.

THE IMMUTABILITY OF TRUTH

I think the time is almost up, but I would like to spend a moment more on that very interesting problem about the mutability of truth. Is truth eternal or does it change? There's no question that people change their minds, that the human race in the course of centuries passes from knowledge to error or from error to knowl-edge in the opinions that it holds. But this is a change in the human mind and not a change in the truth or in what is true. For example, the opinion that the earth was flat, if it ever was false, is always false. And the opposite opinion, that the earth in which we live is round, if it ever was true, is always true. The fact that people have changed their minds about whether the earth is flat or round doesn't make the truth of the matter itself change at all.

But you may say to me, Suppose that the earth tomorrow or next year were to change itself and suddenly become flat or oblong or something else, wouldn't the proposition that the earth is round become false? No, because if I were careful and exact enough, I would say that from the beginning until this year, the earth has been round. So that if next year the earth changed its shape, my proposition still would be true, because it would always remain true that up to this year the earth had been round. Hence I think it is fair to say that truth itself is immutable, even if we as humans in our thinking do not possess the truth immutably.

2 How to Think about Opinion

Today we begin our discussion of Opinion. And like other Great Ideas that we will discuss, this idea is best considered in relation to its opposite. Just as we will look at work in relation to leisure or love in relation to desire, so we'll consider opinion in relation to knowledge.

Lloyd Luckman: Dr. Adler, I can certainly see that knowledge is a Great Idea and perhaps then the consideration of opinion in connection with knowledge would be of great importance, but I must confess that I'm rather surprised you've picked "opinion" itself as a Great Idea. Could you develop this just a little bit? Is there some way you could help me see this quickly, briefly before you go on?

Mortimer Adler: Well, perhaps, Lloyd, the easiest and the briefest way of doing just that is to report the history of the discussion of opinion in Western thought, the development of that idea in the Western tradition itself.

Is Everything a Matter of Opinion?

Let me do that for you under two headings, first, the *theoretical* signficance of opinion and then its *practical* significance.

Let me begin with the theoretical significance. The great problem of the distinction between certainty and probability is connected with this distinction between knowledge and opinion. When human beings tried to assess the goodness or worth of opinions, what made one opinion better than another, they developed the theory of probability. And by the way, this theory had its first

applications in games of chance, in gambling where men were betting on their opinions.

Then I think we ought to remember that opinion is the great weapon of the skeptic. The skeptic is the man who claims that we do not *know* anything, or not very much, that we only have opinions. In fact, the first principle of skepticism is to say that *everything is a matter of opinion*. The skeptic often goes to the extreme of saying that one opinion is as good as another, that there is no way of making one opinion appear preferable to another, that opinions are all relative, subjective, each a matter of taste.

And then, opinion is connected with the great theoretical problem of the agreement and disagreement among human beings, their conflict and diversity on almost every fundamental question. And anyone who faces this phenomenon of human disagreement must be interested in considering the nature of opinion and the causes why people hold the opinions that they do.

Lloyd Luckman: Well, you said that was a theoretical problem, but it's a practical problem too, isn't it? In fact, I think it's one of the great practical problems which face our society today; I'd call it the problem of conformity versus dissent. It seems to me that I remember a remark by President Eisenhower in which he indicated that we must not confuse loyal dissent with disloyal subversion, because the dissenting opinions of the loyal citizens in a democracy are its very lifeblood.

Mortimer Adler: That is precisely the case, and I think it shows us why opinion is an idea of the greatest importance to all of us today.

Now let me go on to say a little more about the practical significance of this idea, opinion. I think all of us recognize without any question the importance of freedom of discussion and sustained public debate of public issues in order that we can reach the soundest public opinion on matters that concern us all. In our day the word *controversial* has become a term of rebuke, a derogatory term. And controversy itself has almost become a disreputable thing. I hope we shall have time to see why we all have a moral obligation to be controversial or at least hospitable to controversy.

Another practical aspect of opinion is connected with the whole business of majority rule. Majority rule is one of the basic principles of democracy. And if we are going to understand what is right about democracy, we have to understand why adopting the

opinion of the majority is right. And we also have to know how to protect what is sound in the opinion of the minority.

So far I have emphasized the political significance of opinion. It isn't only that. Opinion is of the greatest importance today in business and in industry. Most great corporations, manufacturing or selling, depend very greatly upon the advice of public relations counsel or advertising men. Public relations and advertising are two agencies for forming opinion, forming opinions favorable to their clients. You know at one time the head of a large corporation wouldn't turn around without the advice of corporation counsel. And now most corporation heads won't say a word without the advice of public relations counsel.

Lloyd Luckman: Well, I must say, Dr. Adler, that you have done what I have asked you to do in emphasizing the importance of opinion. And I am satisfied now that it is an important idea not only theoretically but practically, too. In fact, you have shown that it involves so very, very much, I don't see how we are going to have time to even scratch the service of this important subject.

Mortimer Adler: We have four programs including this one, and if we can't cover all the points of interest, at least we can hit the high spots. And let me tell you how I propose to proceed in these four sessions on opinion. Today I should like to deal mainly with the characteristics of opinion as contrasted with knowledge, and then next time go a little more deeply into the difference between knowing and opining, so that we can deal with the limits, the line that divides knowledge from opinion or opinion from knowledge. And then in the succeeding session I should like to deal with the importance of opinion in the life of the individual and the life of society, and particularly with such problems as opinion in relation to human freedom and the institutions of government. And finally I would like to come back to this problem of controversy and the importance of controversy in our lives and what it means for us to maintain free discussion so that controversy can contribute to the soundness of the opinions by which we live.

Now I'd like to begin right away with the characteristics of opinion as contrasted with knowledge. I have a number of points here I want to make, but the first one or two I want to make in terms of the relation of truth to both knowledge and opinion, or to see the difference between knowledge and opinion in terms of

truth. But to do that you and I have to have the same understanding of truth. We have to at least have some agreement about what it means to say that any statement is true.

So I'd like to propose that here we follow the clear definition: *a statement is true if it says that that which is is, or if it says that that which is not is not; and a statement is false if it says that that which is not is, or that that which is is not.* I think anyone who has ever told a lie—and who hasn't?—understands what this means: putting *is* where *is not* should be put or *is not* where *is* should be put.

OPINION VERSUS KNOWLEDGE

Now in terms of this definition of truth, let me talk about knowledge and opinion. Knowledge consists in having the truth and knowing that you have it, because you know why what you think is true is true. Whereas opinion consists in not being sure that you have the truth, not being sure whether what you say is true or false. And even if what you say happens to be true, you aren't sure because you don't know why it is true. This, I think, explains a difference all of us feel in the way of the words we use when we say, "I know that," or a person says "I don't know that; I only think that," meaning I opine that, I don't know it.

In the conduct of trials before judges in our courts there is a famous rule called the opinion rule. The opinion rule says that a witness giving testimony must report what he saw or what he heard. He must not report what he thinks happened, because that would be giving an opinion, not knowledge by observation.

Now the second point here, one which everybody knows, everyone is familiar with it, but perhaps you've never thought of it in these terms before, is the simple fact that opinions can be true or false. Opinions can be right or wrong. We all recognize this, I think. But think a moment, knowledge can't be false, knowledge can't be wrong. If something is knowledge, it's impossible for it to be false knowledge or wrong knowledge.

Lloyd Luckman: Now I don't really see how anybody can disagree with that, Dr. Adler. And I gather from what you've said now that the skeptic who would hold that there is no such thing as knowledge would have to admit that if there were knowledge, it would be exactly as you've described it and defined it here. Now

this point though that you've just made, how about that? Is that knowledge or opinion?

Mortimer Adler: Well, if you were right, and I happen to think that you are, then no one can disagree with this way of distinguishing between knowledge and opinion. And if that is the case, then it is something we know and not just something we opine.

Mr. Luckman has just introduced, by the way, another criterion for distinguishing between knowledge and opinion. The criteria is whether or not something is universally agreed to or perhaps I should say whether or not something must be agreed to, because sometimes opinions are universally agreed to. But here the point is, *must* everyone agree to this? If everyone must agree, then it isn't opinion but knowledge.

Now I hope to come back to this point, Lloyd, in a moment as I now go to develop three or four other criteria for distinguishing between knowledge and opinion. In fact, I have four additional criteria I should like to present to you. The first of these is in terms of doubt and belief. Doubt and belief are relative only to opinion, never to knowledge.

Let me illustrate this by giving you two simple examples, one of knowledge and one of opinion. Two plus two equals four. I know this and I understand it. I do not doubt it and I cannot even properly say that I believe it. The word "believe" is not right here. I don't *believe* that two plus two equals four; I know it. "Belief" is too weak a word for this truth that two plus two equals four. But if I turn from that statement to this one, "Gentlemen prefer blondes," here I have something I do not know and I certainly wouldn't like to say I understand. Some people doubt it; some believe it; no one knows it; no one understands it.

Perhaps I ought to give you a better and perhaps a little less obvious example of knowledge and opinion to make this point. Here is a statement of knowledge, that there is always a state of war, either a cold or a hot war between sovereign nations. Anyone who thinks for a moment will see that this is true and that everyone understands it to be true. But here, in contrast, is another statement about war which is only an opinion. The opinion is that there will be another World War, a hot or a shooting war in the next 25 years. No one knows that. At most it is a probable prediction. Some people may believe it and some may doubt it, but it is not a statement of knowledge.

Perhaps I can give you one more example of this difference between knowledge and opinion with respect to doubting and believing. I have here some dice. And as I roll those dice I can only say it is my opinion that they will come up a certain number. I don't know it. I can make bets in terms of it, but I certainly don't know what number will turn up. Now I have in my pocket here another set of dice which are loaded. These dice are so loaded they will only come up seven or eleven. And as I shoot these dice I have no doubt, not a bit of doubt, that each time they will turn up either seven or eleven. That is something that I know, not doubt or believe.

A Right to Our Own Opinion

We say in matters of opinion that everyone has a right to their own opinion. Or I say I have a right to have an opinion on that subject, but no one ever says this about knowledge. I don't say I have a right to my own knowledge on this subject. I may say I have a right to know something, but I never would use the word *my own* in the expression "I have a right to my own knowledge."

Now this right to have an opinion on a subject or the right to have my own opinion on a subject is, I think, one of our basic civil rights. It is a right we talk about all the time these days in terms of freedom of thought and liberty of conscience. This right is a right that I think perhaps is more contested in the contemporary world than any other right we have.

Lloyd Luckman: Now, Dr. Adler, just a minute. I don't want you to leave this point too quickly because if I heard you right, you indicated that we can have freedom of thought only about matters of opinion. Now when you talk about freedom of conscience as you did, this usually applies at least in my thinking to religious beliefs. And am I to infer then from what you are saying that all religious beliefs are merely matters of opinion?

Mortimer Adler: That's a very tough question, Lloyd. And I wouldn't like to try to answer it today. Perhaps, however, I can return to that question and the other question that is involved in what you say next time when we go a little deeper into the difference between knowledge and opinion and draw the line between the scope of knowledge and the scope of opinion and see where religion falls. If I don't do it, remind me next time.

Lloyd Luckman: I shall.

Mortimer Adler: Let me go on now to my third main point or criterion of distinction or difference between knowledge and opinion. We say that matters of opinion are subject to conflict, that we are acquainted with the conflict of opinions, the diversity of opinions on many subjects. But when we are dealing with any subject about which there is knowledge, we do not speak of the conflict of knowledge. We don't say there is a conflict of knowledges on this point as we say there is a conflict of opinions on this point. Because it is the very nature of what it is that we have an opinion about to be subject to conflict and that is not true of things that we can know.

I think that conflict of opinion is as familiar to all of us as the very air we breathe. Let me give you just two examples. Anyone who can remember a national or a local election is in the presence of a basic conflict of people's opinions about candidates or issues. But let me give you another even more familiar example of the insistent attention on conflict of opinion. Our newspapers are full of it every day: public opinion polls. These opinion polls keep us aware of what the general state of public opinion is, and show us the disagreements which prevail upon many issues.

Now the significance of this conflict of opinion that we are so aware of is that on matters of opinion, reasonable men can disagree and still remain quite reasonable. This is a very important thing to remember because of what opinion is. Where there is a conflict of opinion usually it is the case that reasonable men can disagree and, though they disagree, still remain quite reasonable.

Now to my fourth point of differentiation between knowledge and opinion. And that is to call your attention to the fact that all of us are aware that it is only with respect to opinion that we talk about taking a consensus. In fact, we say a consensus of opinion. Or we speak of a majority opinion as opposed to the minority opinion. Or we speak of expert opinion as opposed to inexpert opinion. But notice we never say a consensus of knowledge. We never say the majority knowledge as opposed to the minority knowledge. We never say expert knowledge as opposed to inexpert knowledge, because there isn't any inexpert knowledge. Now this is, again, I think a fundamental aspect of opinion that sharply differentiates it from knowledge.

And I should like to tell you about a rule that Aristotle developed for all arguments involving matters and opinions where a

consensus of opinion might be taken. Let me read you the passage from Aristotle. Aristotle's rule runs as follows; he says, "In arguments dealing with matters of opinion," I quote, "we should base our reasoning on the opinions held by all. Or if not by all, at least those held by most men. Or if not by most men, at least by their wives. And in the last case, if we are basing it on the wives, then we should try to base our opinion or arguments on the opinions held by all the wives or if not by all the wives then by the most expert among them or at least by the most famous." That is a fairly prudent piece of advice.

Now in this matter of the consensus of opinion, we seldom have unanimity, though every now and then in the rare case the consensus of opinion will approach unanimity. Let me give you two illustrations of this rare phenomenon of a consensus of public opinion approaching something like unanimity. You all remember the great festivals that used to take place under the Nazi regime in Germany. Massed crowds, thousands of people, all of them facing Hitler would shout in unison, *"Sieg heil! Sieg heil! Sieg heil!"* That looks like almost unanimous consensus of opinion.

Is there anything like this that happens in our country? Well, you have all been at baseball games when Babe Ruth or someone like Babe Ruth has hit a homer and the stands to a man get up and cheer, that is a consensus of opinion almost unanimous.

Now I think what we have learned today is chiefly that all of us understand the difference between knowledge and opinion. Notice that I said all of us understand this difference so that you know what the difference is. I think what we have learned is that our grasp of the difference between knowledge and opinion is not itself an opinion. It is not like an opinion. It is something we know and understand. And I think the reason why we all recognize this is that the difference is something understood by us in terms of five or more criteria, each of which is as clear as it is familiar to us. Such criteria as that opinions are either true or false, right or wrong, and that opinion is subject to doubt or to belief, or that opinion is something where one says, I have a right to my own opinion. Or, I have a right to have an opinion on that subject, or that opinion is something about which reasonable men can disagree and still remain quite reasonable, that opinion is something always subject to the possibility of a conflict between men, a disagreement, a diversity of views on their part. Or that opinion is

something about which we take a consensus, that in the case of opinion, counting noses counts. It means something to count noses.

None of these things applies to knowledge as it does to opinion. That's how we know the distinction. But though we know the difference, and I really think we do know the difference, between knowledge and opinion, there are a lot of things about the subject that we don't know so readily.

QUESTIONS TO ANSWER ABOUT OPINION

Lloyd Luckman: Well, I'd be curious to know what some of these were.

Mortimer Adler: Well, let me see if I can state them for you in the form of questions. For example, the question that comes to my mind is the question about what sort of things can we have knowledge as opposed to the sort of objects, the sort of things about which we can only form opinions? On this point Plato had the position that only about things that are permanent or eternal, only things which are unchanging, the world of fixed being, is it possible to have knowledge; whereas about the whole world in flux the world as becoming, the most we can have is opinion, unstable opinion. Aristotle disagreed with this. Aristotle held that it was possible to have knowledge about the physical world as well as about the world of eternal ideas.

Another question that we ought to face some time is the question of the psychological difference between knowing and opining. The processes of thought might look the same in both cases. We make judgments, we infer, we reason, and yet there is a deep psychological difference between the act of knowing and the act of opining. That is another problem to investigate.

And another question is whether we can have knowledge and opinion about the same thing. Is it possible for a person to hold at one and the same time something—a state of mind which is knowledge of something and at the same time regard himself as holding only an opinion about that. Let me change that question a little bit. Is it possible for one person to know something which another person has only an opinion about? Can there be two individuals, one having knowledge and the other opinion, on the same point?

A fourth question that is worth considering, in fact, I think I'd say it is the 64-thousand-dollar question, How much knowledge do we have? To what extent are the things that we suppose we know really things we know as opposed to things that we only opine.

Socrates, you may remember, took the position that only God knows; that for the most part men have nothing better than opinion. And he went on to say that to know this is wisdom.

Lloyd Luckman: That strikes me as something of a contradiction, Dr. Adler. Wouldn't you say it was too?

Mortimer Adler: I think it sounds like a contradiction unless you respect the fact that Socrates is being quite ironical here. He didn't rest in a shallow skepticism. He intended to go on with inquiry. In fact, the very questions I've just mentioned were questions he himself pursued and that I hope we can pursue next time as we go on.

Now next time I hope we can reach a deeper understanding of the difference between knowledge and opinion. I trust this subject interests you and I hope you will be with us again next time as we continue with the discussion of the idea of Opinion.

3 The Difference between Knowledge and Opinion

Today, as we continue with the discussion of Opinion, we shall try to push further our understanding of the difference between knowing and opining. There are a number of questions we ought to consider.

First, what sort of objects are the objects of knowledge, as opposed to the objects about which we can only have opinions? Second, what is the psychological difference between knowing and opining as acts of the mind? Third, can we have knowledge and opinion about one and the same thing? And finally, a fourth question, what is the scope of knowledge? How much knowledge do we really have as opposed to the kinds of things about which we can only have opinions? What is the limit or scope of opinion in the things of our mind? And these are the questions we are going to try to answer as we proceed today.

Lloyd Luckman: There is one more, Dr. Adler, unless somehow you've included it in these four questions that you've already outlined.

Mortimer Adler: What do you have in mind?

Lloyd Luckman: It's my question about religion. You recall last time when you made the point about liberty of conscience; it caused me to ask you whether you thought that freedom of conscience gave a person a right to his own opinion in matters of religion? And if you do think so, then I also want to know whether you think that in matters of religious belief and religious faith that they are then simply matters of opinion rather than knowledge.

Mortimer Adler: Well, we will certainly have to face that question, Lloyd as we proceed today. I didn't mention it specifically in my enumeration of questions, because in a sense it is contained in

21

my fourth question, the question about how much knowledge we have. As we draw the line between the sphere of knowledge and the sphere of opinion, we shall have to place mathematics and the experimental sciences and philosophy and history either on one side or the other side of the line, and therefore we have to place religion one place or the other also.

Before we begin to look for an answer to that question and these other questions as a matter of fact, I would like to develop a little further the educational implications of a point that we discussed last time. It concerns knowledge and opinion in relation to the truth. We saw last time that knowledge is always true; you can't have false knowledge, but that opinion may be either true or false.

Now let's use the phrase "right opinion" to signify any opinion which happens as a matter of fact to be true. So we must ask the question, What's the difference between knowledge and right opinion? Since both are true, how do they differ? And I think we began to see the answer last time. When you have truth through knowledge, you not only have the truth, but you understand why it is true. But when you have the truth through having only a right opinion, you may have the truth in fact but you will not understand why it is true.

IT'S BETTER TO BE IGNORANT THAN WRONG

Now let me introduce two other terms into our discussion: *error* and *ignorance*. Everyone knows, I'm sure, that when one is in error or when one is ignorant, one does not have the truth. Then how do they differ? Well, they differ as follows: The person who is in error not only lacks the truth, but does not know that he does not know. On the contrary, he supposes that he does know; whereas the person who is ignorant lacks the truth and in addition knows that he does not know.

Knowledge is to right opinion on the side of truth as ignorance is to error on the side of lack of truth. The understood truth, which is knowledge, is to the not understood truth which is right opinion; as the understood lack of truth, which is ignorance, is to the misunderstood lack of truth which is error.

Lloyd Luckman: I wonder how many people have thought about this problem just this way before. Are you in fact saying that it's better to be in ignorance than in error?

Mortimer Adler: That's precisely what I'm suggesting, Lloyd. And I suspect that when I say this, when I say that ignorance is more like knowledge than error is, some of you may think it's a shocking mistake to suppose so. But though this may seem paradoxical, I think that I can explain to you why it is so. Any teacher will tell you that it is much easier to teach a student who is ignorant than one who is in error, because the student who is in error on a given point thinks that he knows whereas in fact he does not know. The student who is ignorant is in a much better condition to learn. It is almost necessary to take the student who is in error and first correct the error before you can teach him. I think that is the meaning of saying that error is further away from knowledge than ignorance is. The path from ignorance to knowledge is a shorter path than the path from error to knowledge, because if a person is in error, you must first get rid of the error and reduce him to ignorance before you can start teaching him.

Socrates was the first teacher to discover this principle of teaching and to apply it in practice. He opined all the time. It was the first principle in his method. His method was to go about, as he said himself, "cross-examining the pretenders to knowledge and wisdom," and by the cross-examination, showing them that they were in error, that what they supposed they knew, they did not know. That is first reducing them to ignorance so that they could be in the right state of mind to inquire and to learn.

This technique of Socrates was a very annoying technique. And that, combined with the fact that he was very fond of saying ironically that his only wisdom consisted in his knowing that he didn't know, and acknowledging his ignorance, so infuriated his fellow citizens that they put him to death.

As we go on to explore the psychological difference between knowing and opining as acts of the mind, I think we will see some further educational implications of this distinction between knowledge and opinion.

SCHOOLCHILDREN MAINLY LEARN OPINIONS

I would like to begin by recalling for you two insights, one that we find in Plato and one in Aristotle. The Greeks, particularly Plato and Aristotle, were very much concerned about this matter of the

difference between knowledge and opinion. Plato tells us that knowledge and only knowledge is teachable; right opinion is not teachable because it is not founded in reasons, it has no principles, it has no roots or grounds in things for which it can be demonstrated.

Most of the things that children learn in school are right opinion, not knowledge. All one has to do, I suppose, is to recall how one learns history or geography. These things, being right opinions, can only be learned by a kind of memorization. Compare that with the teaching or learning of geometry, which really can be taught and learned in a rational manner because such truth that is there rests in principles and in the demonstration of conclusions.

Aristotle's insight on this subject is that one man can opine about what another man knows. They can be thinking of the same things, but whereas the one man merely has an opinion, the other man can have knowledge on that very same subject.

Let me see if I can illustrate this for you by an example from geometry. I have here a diagram taken from Euclid that represents the famous Pythagorean Theorem. The theorem is that the square on the hypotenuse of a right triangle is equal to the sum of the squares on the other two sides. Now the teacher who knows the demonstration of this conclusion in geometry understands why it is true and therefore has knowledge of this proposition. But the student, who repeating the words of the Pythagorean Theorem and then being asked why is that true, says, "Because my professor told me," doesn't have knowledge of this truth but only has a right opinion of it because he is holding it on the authority of his teacher, and in that way alone.

What this tells us is that when anyone argues from authority, when anyone holds an opinion or holds a position, says something is true, on authority and authority alone, he is holding it as a matter of opinion. And whenever a teacher appeals to his authority to persuade the students to believe something, that teacher isn't teaching; he's really only indoctrinating them; he is forming right opinions in their minds.

Lloyd Luckman: As I listen to you, I wonder really how much actual imparting of knowledge does go on in our schools and colleges. Just how many subjects are there in the curriculum which are teachable, and by that I mean matters about which the students can actually obtain knowledge?

Mortimer Adler: That's a very hard question to answer, Mr. Luckman. A good one but a hard one. And we may find some answer to it when presently we draw the line that divides the realm of knowledge from the realm of opinion.

OPINIONS ARE ACCEPTED VOLUNTARILY

Before we do that, let's see if we can understand the thing that we've been leading up to, just what the psychological difference is between the act of knowing and the act of opining. Let me state it for you quickly at once. We opine when the assent of our minds is voluntary. We know when the assent we give to something is involuntary. Now that statement may not come clear at once. Let me illustrate it.

If I say to you, "Is this truth? Is it true that two plus two equals four?" you do not make up your mind. If you think about this, what you are thinking about makes up your mind for you. Let me show you that one other way. I hold up two cigarettes. I hold up two more cigarettes. Two cigarettes and two cigarettes, I bring them together, and I ask you the question, "Are there four cigarettes here?" can you give me the answer "No"? You cannot. You aren't free to. You are compelled by what you are looking at to say, "Yes, the answer is four." That shows it is knowledge.

But if I ask you to consider this other statement that we've been using as an example of opinion, the statement itself doesn't compel you to say yes or no. You can say either yes or no. The statement leaves you quite free to make up your own mind. And because it leaves you quite free, either on authority or because of your desires or your interests or your emotions or your passions, anything to make up your mind, this is psychologically an act of opinion on your part, not an act of knowledge.

A statement expresses knowledge when our assent to it is involuntary, when our assent to it is compelled or necessitated by the object we are thinking about, as in the case of two plus two equals four. But a statement expresses opinion, not knowledge, when our assent to it is voluntary, when the object leaves us quite free to make up our own minds to think this way or that way about the object, to think about the object exactly as we please.

And usually, in the case of opinions, what makes up our mind one way or the other is not the thing we are thinking about, but our emotions, our desires, our interests, or some authority upon which we are relying. Thus you can see that the nature of opinion is wishful thinking. It is an exercise of the will to believe. And when one is holding mere opinion, one finds the emotional content very high indeed. Precisely in proportion as the opinion is not well-founded in fact or evidence, one tends to support it with one's emotions and to be obstinate in holding onto it as one holds onto a prejudice. I know this in my own case when I find that I am saying, "No, no. That is not so. That isn't so." I'm sure I'm right about that with emphasis and great thought, I suspect that I am holding an opinion without much evidence to support it. And I am putting it in my emotions, making up by my emotions for the lack of evidence.

I think, Mr. Luckman, that this has a bearing on your last question about teaching. Many of the things taught in school may not be knowledge in the strict sense. But if they are not mere opinion in this sense, if they are well-founded opinion, opinions that have probabilities resting on the evidence, and moreover if the teacher appeals to the intellect of the student, weighing the evidences, weighing the probabilities, and does not merely appeal to his own authority to persuade the student, then he is teaching them in a very genuine sense, even if it is only opinion rather than knowledge. But on the other hand, if the teacher appeals to the emotions of the student and heavily relies upon his own authority to persuade them, then he isn't teaching them but indoctrinating them. Does that answer your question?

Llloyd Luckman: Well, yes, in part it does. But I would still like to know how much of what is learned in school is really knowledge in the stricter sense, that is, opposed to the very best sort of opinion, as you have been putting it, this highly probable opinion, based on evidence, and so forth.

SKEPTICS DENY THAT WE HAVE KNOWLEDGE

Mortimer Adler: Let's see if we can find the answer to that question. As a matter of fact, I want to say "the answers" to that question, because there are two answers to that question, one

given by the skeptic, the man who thinks that there is very little knowledge; the other given by the opponent of the skeptic, the man who thinks that there is considerably more knowledge.

Let me start out with the skeptical view and begin by stating the position of a man who in modern times represents the extreme of skepticism. That man is the French essayist, Montaigne. Montaigne says that we know nothing; everything is a matter of opinion. "And we mustn't be fooled," he says, "by the feelings which we sometimes have of certainty," the feeling that the thing is perfectly clear and sure for us.

The argument the skeptic uses against the persons who say, "Well, I feel certain about that," to show them that they oughtn't to be certain, is the argument coming from the illusions of the senses, perceptual illusions. You know, there are optical illusions, where two lines on a page look as if they were of very unequal lengths though they are in fact equal, or where two circles look to be of different sizes, though they are in fact the same size.

Now a more moderate skepticism is that of the Scottish philosopher David Hume. David Hume took the position that we do have some knowledge. Our knowledge consists in sciences like mathematics where we do begin with axioms or self-evident truths and are able to demonstrate conclusions. But Hume says this is all the knowledge we have. In all of history, in all of the experimental sciences we have only, according to Hume, at best, highly probable opinion.

Let me read you Hume's famous statement that summarizes this point. I have here a volume of Hume and this statement, by the way, is easy to find because it comes at the very end of Hume's great *Enquiry concerning Human Understanding.* He asks the question, "If we take in our hand any volume . . ., let us ask," he says, *"Does it contain any abstract reasoning concerning quantity or number?",* that is, Is it a work in mathematics? Or let us ask, *"Does it contain any experimental reasoning concerning matters of fact and existence?",* that is, Is it a work in experimental science? If the answer to both these questions is no, Hume says, "Commit it then to the flames: for it can contain nothing but sophistry and illusion."

Now what is Hume saying in this very famous passage? He is saying that only in mathematics do we have the certitude of knowledge, and that we have such certitude only when we are thinking about the relations between our own ideas, our own concepts.

Whereas in regard to all matters of fact or real existence, we have experimental reasoning. And this, according to Hume, is at best probable. And because it is probable, it is opinion, not knowledge, even though there is highly probable evidence in support of some opinion. For Hume everything else which is not experimental science or mathematics is worse than that. And he puts philosophy here. It is sheer opinion, not even probable opinion, but mere superstition or prejudice.

Now in our day we have gone even further toward the skeptical extreme than Hume went. Because in our day with our knowledge of non-Euclidean geometry, we tend to doubt that even mathematics is knowledge. Mathematical systems, like Euclidean and non-Euclidean geometry, seem to be based upon postulates or assumptions rather than on self-evident principles.

I have a letter in my file, if I can find it, on this subject that I would like to read to you. A man writes that "Even two plus two equals four," he says, "only if you assume certain things." And he goes on to say that mathematics is simply a man-made system of logic consistent with itself. And therefore in view of this he wants to know whether mathematics should properly be called knowledge. "And if you call mathematics knowledge," he says, "then is any body of statements, based on certain assumptions and consistently developed therefrom, knowledge?" And my answer to that question is no. If mathematics were only based on assumption and nothing else, on postulates rather than axioms, then I would say it was opinion, not knowledge.

The Answer to the Skeptic

Now what is the answer to the skeptic? I have stated the skeptic's position; let me now give the answer to the skeptic. First of all, on the matter of perceptual illusion. How do we know they are illusions? If we know they are illusions, we can only know it because we regard some sense perceptions as accurate. If we could not have some perceptions verified as clear and acceptable perceptions, we couldn't know these others were illusions.

When we have two lines on a page that look to be of different lengths, we can put down a ruler against each of them, we can measure them. This convinces us they are really the same length.

Here we are correcting an illusory perception by performing a measurement, but the measurement is itself also a perception. If this perception were not knowledge, I couldn't call the wrong perception an illusion. Hence, to even discover that there are perceptual illusions, I have to rely upon perceptions, I have to know by perceiving.

And then with regard to mathematics, the opponent of the skeptic answers by saying, I think quite rightly in this case, that mathematics is not based only on assumptions but upon axioms, self-evident truths. And that not only mathematics but metaphysics and other branches of philosophical science are knowledge in the same sense.

As for history and experimental science, even the opponent of the skeptic is likely to agree with the skeptic on this point; that these subjects are not knowledge, but highly probable opinion. In fact, we might say that experimental science is a kind of conditional knowledge, conditional upon the state of the evidence at a given time.

One final reply to the skeptic is this, that the skeptic, particularly when he is an extreme skeptic and says that everything is a matter of opinion, can't argue for his case. He can't defend his case, for he would try to prove his point, he would establish that something was knowledge and so defeat himself.

I think, Lloyd, that you now have some indication at least of the two leading answers, the two opposed answers to your question about what is taught in school, about how much of it is strictly knowledge and how much of it is only probable opinion.

IS RELIGION A MATTER OF OPINION?

Lloyd Luckman: Well, I like these answers, but I still think I'll have to think about them just a little bit more in order that I can apply them and see how they work out in practice and actually affect our teaching. But you still haven't answered my question about religion. How about it? Religion, matters of faith, are they knowledge or opinion?

Mortimer Adler: Let me see if I can answer that question in the closing moments of today's discussion.

There are two views of religious faith. One, held by William James, is that religious faith is an act of the will to believe and this act of the will to believe takes place when we are beyond the evidence or the evidence is insufficient. And so according to James, religious faith is strictly opinion. On the other hand, there is the position of Aquinas, that religious belief or faith is an act of the will. He agrees with James so far. But it is an act of the will wherein the will is itself moved by a supernatural gift of grace from God. Faith is a gift of grace and therefore, according to Aquinas, faith isn't knowledge but neither is it opinion; it is something in between knowledge and opinion.

Shall I read you what Aquinas has to say on this subject?

Lloyd Luckman: I would very much like to hear it. From which of his works are you selecting the passage?

Mortimer Adler: This comes from *The Treatise on Faith, Hope, and Charity.* And this is the very beginning of the treatise on faith. Aquinas says, "The intellect assents to a thing in two ways: first, through being moved to assent by its very object which is known either by itself as in the case of first principles or axioms or through something else already known as in the case of demonstrating conclusions." "In either case," says Aquinas, "you have knowledge, not opinion." "Secondly," Aquinas says, "the intellect assents to something not through being sufficiently moved to assent by its proper object, but through an act of choice, whereby it voluntarily turns to one side rather than the other." And if this be accompanied by doubt and by fear of the opposite, then you'll have opinion. While there will be certainty and no fear of the opposite, then there will be faith. "And this certainty of faith, Aquinas explains, "results from the fact that is supernatural." It is the gift of God, for he says, "Since man, by assenting to matters of faith, is raised above his nature, this must needs accrue to him for some supernatural principle, moving him inwardly, and this is God. Therefore faith, as regard to the assent which is the chief act of faith, is from God, moving man inwardly by grace." That is why Aquinas says that faith is neither knowledge nor opinion, but something intermediate between them, like them in both respects.

Lloyd Luckman: I'm sorry, but I don't quite see how it is like them both. In what way is it like them both?

Mortimer Adler: Well, on the one hand, Lloyd, faith is like opinion in that it is an act of the will rather than an act based upon

the thing in its own terms. That is why Saint Paul defines faith as the evidence of things unseen, not seen directly on their own terms. On the other hand, faith is like knowledge because of the certitude it has, a certitude that is even greater than the certitude of ordinary knowledge, because it rests upon the supernatural gift of grace.

Now this concludes our discussion of the difference between knowledge and opinion and of the scope of each in human life, the realm of opinion and the realm of knowledge. Next time as we go on, I hope we can deal with some of the practical problems concerning opinion, such problems as the relation of opinion to human freedom, the institutions of government, and the opposition between majority and minority opinion.

4 Opinion and Human Freedom

Today, as we continue with the discussion of the Great Idea, Opinion, we shall consider a number of practical problems involving opinion, opinion in the realm of action rather than opinion in the realm of thought.

In the realm of thought, as we have seen, men differ as to how they draw the line between knowledge and opinion. Some who are more skeptical tend to say that almost everything we think is opinion rather than knowledge; while others who are less skeptical admit that there are some subjects about which we may be able to develop sciences that have genuine knowledge.

Lloyd Luckman: Well, Dr. Adler, if you are going to deal with opinion as related to action, then I think there is another brand of skepticism which you haven't mentioned that you ought to be concerned with.

Mortimer Adler: What's that, Lloyd?

Lloyd Luckman: It's the skepticism that is so prevalent today in our own time, the skepticism, for example, about moral and political matters, about which men must hold opinions and form opinions as to whether they are right or wrong, good or bad. You know the approach and the distinction is made between matters of fact and matters of value. And the brand of skepticism that I have in mind would hold that it may be possible to have knowledge about matters of fact, but insofar as matters of value are concerned, we can have only opinion. We say that all our value judgments to these people are mere matters of opinion.

Mortimer Adler: I'm acquainted with that brand of skepticism. And it certainly is widely prevalent. In fact, it would be very hard

to graduate from our schools and colleges today without being inoculated with it.

Lloyd Luckman: Yes, and I would place the responsibility right at the door of the departments of anthropology and sociology. You might even call it sociological skepticism.

Mortimer Adler: Well, I agree with your diagnosis, and sociological skepticism is a good name for it. Sociological skepticism usually goes to the extreme of saying that on questions of value there is simply no way of showing that one man's or one society's opinion is better than another man's or another society's.

The anthropologists and sociologists talk about an ethnocentric predicament in which we all find ourselves, by which they mean that the people of one society, one tribe, or one culture simply cannot judge in any way the values, the rules, the practices, the habits, or beliefs of the people of another tribe and culture since any judgment that would be made would have to be made from the point of view of a given society; and therefore the judgment made from that point of view would necessarily be prejudiced and invalid.

Now although the sciences of anthropology and sociology are new in the curriculum of our schools and colleges, sociological skepticism itself is not new. It existed among the ancient Greeks as a result of the travels of Herodotus, one of the first historians who traveled among the peoples of the ancient world and brought back to Greece stories of all their strange habits and beliefs and customs. And as a result the influence of his telling these stories about the variety of beliefs and customs made the Greek sophists say that everywhere people differed about how they should live and how they should act. These Greeks argued that only about natural matters, matters of nature, could there be science, but not about questions of conduct or of how societies should be organized.

This sociological skepticism was quite rampant in the sixteenth century as a result of the travels of that day, the many voyages of exploration to distant lands and to strange peoples. I am thinking particularly of how it affected Montaigne to learn that there were cannibals in the world. This led the Europeans—and Montaigne is the spokesman for them—to suppose that there was no practice so unthinkable that some people might not adopt it and think it good.

So maybe, Mr. Luckman, the saying "travel broadens the mind" really means :"travel opens the mind up to sociological skepticism."

Lloyd Luckman: Well, maybe for the men of those times and even today for our explorers, but what is the answer? How are you going to respond to these sociological skeptics?

Mortimer Adler: The complete answer would take us too far from the subjects we're going to discuss today. But I think it's possible to sketch the answer briefly at least. Let me try to do that now.

Fundamental Values are Universal

The answer, in brief, to the sociological skeptic is merely to call his attention to some facts he neglects. While it is quite true that opinions about practical matters or matters of value vary from tribe to tribe and from culture to culture, it is also quite true that certain fundamental rules of human conduct, certain fundamental human values, are present everywhere and are everywhere quite the same.

Let me read you a passage from John Locke which makes this point quite well. John Locke begins by admitting that "there is scarce that principle of morality or rule of virtue which is not somewhere or other slighted or condemned by general fashion of whole societies of men, governed by practical opinions and rules of living quite opposite to others." But then he goes on to say that "Nevertheless the most general rules of right and wrong, the most general rules of virtue and vice are kept everywhere the same."

Now let me illustrate Locke's point quite concretely. In almost every human society, murder is prohibited. I would feel it not an exaggeration or daring for me to say that every human society, every tribe of men, prohibits murder. But they differ with respect to the particular acts that they regard as murder, some tribes calling certain acts excusable killings, other tribes calling those very same acts murder.

Or let me take another example. In every human society, in every human culture, courage is honored and cowardice is despised. But men certainly differ in how they think courage

should be manifested. Take, for example, the American Indian. In some tribes a young brave, an American Indian youth, would standing the ordeal of burning by sun, tied to a pole, facing the boiling sun for hours; the length of his endurance would express the degree of his courage. Now compare such physical courage with the moral courage of any man in our society today who will speak out in defense of an unpopular opinion.

Lloyd Luckman: Well, now, Dr. Adler, if I get the drift of your answer to the sociological skeptic, it appears to me that you follow him fairly generally except for this emphasis that you've placed upon fundamentals which are common to all men and therefore where we might say that we know that these are good and right values. But it seems on the other hand insofar as particulars are concerned, you are in agreement with the skeptics in holding that there aren't many of these matters of which we have knowledge, rather opinions, and highly conflicting opinions at that.

Mortimer Adler: Yes, Lloyd, that is the general tenor of my position. We have knowledge only on the most fundamental questions of action or conduct. We have knowledge only where it involves the most universal principles.

In respect to all questions below this top level we have, I think, only opinions about what it is good or bad, right or wrong to do in particular cases, for example, whether this particular law is better than that law or whether this way or that way is the way to manifest courage.

OPINION AND THE NEED FOR FREEDOM

This fact—that on all detailed practical manners men differ in their opinion and that this difference of opinion between them is something about which reasonable men can disagree—this fact leads to two practical consequences. These practical consequences, as you hear them, you will think they appear to be opposed to one another; for one of the practical consequences is human freedom. The other practical consequence is our need for authority. Let us turn to each of these two consequences, first, each by itself, and then having examined each, let's see if we can reconcile them to one another.

Let me go to the first consequence of the fact that our practical judgments are judgments in regard to action or opinion. Here my point is that this fact is one source of human freedom. Let me clarify the point. When I talk about opinion in regard to action I am thinking of all those particular, practical judgments we make about whether to do something or not to do something, whether to adopt a certain policy or not to adopt it, whether to follow a course of action or not to follow a course of action. Now that such particular, practical judgments are only opinions is not the only source of human freedom; but it is one source of human freedom, and I should like to explain now why that is the case.

I think there are three reasons or steps in my explanation. In the first place, whenever we act voluntarily, that is, when we are not constrained or coerced to act, but act of our own will—we act in terms of our own judgment concerning what we should do, what we want to do, or what we ought to do. In fact, one might say that our actions are voluntary simply because they execute, they carry out our own judgments.

Now the second point applies to our practical judgments about what to do or not to do, about doing this or doing that, our opinion about what is good or bad, right or wrong in the particular case. Let's remember the nature of opinion in general, the nature of opinion which is the same for practical judgments or theoretical judgments, opinions in the practical order or opinions in the theoretical order. Whenever we opine about practical matters or theoretical matters we are free to make up our own minds. The thing we are thinking about doesn't compel or necessitate us to think one way or another. The thing we are thinking about leaves us free to think this way or that. Summing this up, we can see the fact that our practical judgments are judgments about how to act, what to do. The fact that these judgments are opinions makes them also free judgments. In other words, not only is our action voluntary in the sense that it follows from our own judgments, but those very judgments are our own, because we form them voluntarily; because being opinions, we are free to adopt them or to reject them as we see fit. That is why I think the traditional Latin phrase which we translate in English "free will," if it were literally translated, would mean not "free will" but a "free judgment" of the mind. The phrase is *"Librium arbitrium."* And it means just that, "a

free judgment." It is in such a free judgment of the mind, which every opinion is, that we have our freedom.

This, I think, indicates what I mean by saying that our voluntary action is doubly free, free because it follows from our judgments and free because our judgments themselves are free, since what we're thinking about in matters of action are objects about which we can only form opinions, and form them quite freely.

Now there is another way of seeing this connection between opinion and our freedom. The other way is by supposing the very opposite. Suppose with me for a moment, what is quite contrary to the nature of the case, what is not real, but try to suppose that with regard to matters of action we really could know with absolute certitude what was good or right in every particular situation. Now suppose we could do that, suppose we could know what was good or right for us to do in every particular situation. Well, in that case, on that supposition our action might still be voluntary in the sense that our actions follow from our own judgments, but it would not be free in that ultimate sense, because in that case our judgments themselves would not be free.

Let me tell you a story which I think illustrates this most strikingly. Some years ago at the University of Chicago I had a colleague who was an ardent devotee of democracy. He was devoted to democracy because he thought it was that form of government which most fully promoted and supported human freedom. At this time I myself was not persuaded that democracy was the best form of government; and we used to argue a great deal. A little later I became convinced, because I found that I could demonstrate the truth of the proposition that democracy is the best or the most just form of government.

I wrote an article on this subject and sent it to my friend. I thought he would be very pleased to have me demonstrate, and I mean demonstrate as rigorously and conclusively as a mathematician demonstrates a conclusion, that democracy was the best form of government. To my great surprise and shock he was very displeased with my article. In fact, he told me he thought the article was antidemocratic. Why? Because it was opposed to the very freedom that democracy supported. Why? Because if I could demonstrate that democracy was the best form of government, then that would not leave men free in their thinking about democracy; they

would have to accept democracy; they could not choose freely between democracy and some other form of government.

Lloyd Luckman: That's wonderful, Dr. Adler. Apparently then, to be free and democratic about democracy, a person must be free and open to make up their own mind and opinion on the subject.

Mortimer Adler: That's what my colleague thought, but I don't think he was right. In my view, the proposition that democracy is the best form of government is a matter of knowledge, not of opinion. And this fact that it is a matter of knowledge, not opinion, does not destroy freedom one little bit; for it is a freedom on the level of detail, not on a level of so high a principle as the general principle that democracy is the best form of government.

Opinion and the Need for Authority

Now let me turn to the second practical consequence of this fact that our practical judgments are matters of opinion. The second consequence has to do with, as I said before, our need for authority. What do I mean by our need for authority? I mean the fact that men cannot live together in society, that they cannot live together peacefully and harmoniously unless there is some settled rule of action to which they all can agree and to which they all can give their assent. And usually there must be some authority, something to make this settled rule of action binding on them all. Now here I say that opinion in regard to action is not merely one source of our need for authority; it is *the* source, the thing which creates our need for authority.

Let me see if I can tell you why this is so. First, in matters of opinion human beings are free to make up their own minds, are they not? And reasonable persons can disagree with one another and still remain quite reasonable. Now since individuals act always in the light of opinion; they never act in terms of knowledge; they act in terms of opinion, it follows that they can always disagree about matters of action. But they cannot act together, as they must act together if they are going to live together in society, they cannot act for a common goal, unless they can resolve their differences, unless they can find some way of agreeing about a single course of action or a single policy they can all adopt or pursue.

Now then, how is this agreement to be reached on matters of opinion concerning actions to be taken? It cannot be reached by reasoning, because if they could be reached by reasoning, it would be a matter of knowledge, not a matter of opinion. And since it is a matter of opinion, the debate could go on endlessly and action would never get started. How then is the debate to be resolved and action to be taken? So far as I know there are only two answers to this question. It is either to be resolved by superior force used against the parties with inferior force to which the parties without such force must submit or is resolved; or, the only other alternative, it is resolved by some authority to which they willingly accept.

Lloyd Luckman: Dr. Adler, you said a while back that opinion about action was really the source of our need for authority in society.

Mortimer Adler: I did, yes.

Lloyd Luckman: But now you admit that force is an alternative to authority. And so if that is the case, why bother with authority? Why don't we just rely on force? If that will do the trick, how can you say that we definitely need authority?

Mortimer Adler: What I should have said, Mr. Luckman, is that we need authority, an authority we willingly submit to rather than a force we are compelled to accept, *if we are going to remain free.* I ought to have said even more than that, if political authority is to be quite consistent with political liberty, then that authority must be of the sort which ultimately involves the acceptance of majority rule rather than authority invested in the decisions of one person or of some small group. Does that answer the question you asked a moment ago, Mr. Luckman?

Lloyd Luckman: Well, I think it does. But I must confess that I am really not too clear about it, Dr. Adler.

Mortimer Adler: Well, in the short time that is left it might be better if I were to review the ground we've covered so far to see how we've come to the point that we have now reached.

Lloyd Luckman: All right.

Mortimer Adler: And then perhaps that will show why this problem about majority rule emerges from the fact that our practical judgments, being opinions, being the basis on the one hand of our freedom and on the other hand of our need for authority, lead to majority rule as the only way to reconcile that freedom with our need for authority.

Let me go back over the track which we have followed. First we saw that in the sphere of action, men have opinions rather than knowledge about which policies to pursue or which particular actions to take. I will remind you again that, in the practical order, in the sphere of action, we have knowledge only about the most universal principles in ethics or jurisprudence or politics, underlying all our practical judgments in detail.

Then we saw that our freedom of choice with regard to action stems, in part at least, from the fact that our practical judgments are opinions, that they are free judgments, judgments about which we are free to make up our own minds, judgments about matters concerning which reasonable persons can disagree and still remain quite reasonable.

Next we discovered that this very freedom of judgment raises the problem of how men can act together in society peacefully and harmoniously, since such concerted action requires them to agree on some single decision or policy or course of action. What can produce agreement about matters of opinion concerning action?

It was at this point that I think we saw the need for either force or authority as a way of getting a decision or a policy adopted or acted on by all. Now clearly force is opposed to freedom, and I would think just as clearly that any authority except the kind of authority that involves majority rule would also be inconsistent with freedom.

Lloyd Luckman: Well now, that is just the point that I would like to see a little more clearly, with more discussion.

Mortimer Adler: Well, that is the point I think we shall have more discussion on in our next and concluding session concerning The Great Idea of Opinion. That is the point I hope we will be able to develop a little more clearly next time.

What we have learned today is that opinion in regard to action is both one source of human freedom and also the source of our need for authority. And I hope what we can learn next time is how the principle of majority rule makes authority quite compatible with freedom in society. In the course of doing that, we cannot help but face the conflict between the majority and the minority opinions, and with that the problem of controversy about the fundamental social issues of any society at any time.

5 Opinion and Majority Rule

Today we shall largely be concerned with the problem of majority rule. And with that, of course, goes the problem of the conflict between majority opinion and all the minority opinions, and the other connected problem of controversy about basic social issues.

To prepare you for the examination or exploration of these two points, I should like to remind you of certain things. First, at the center of opinion is the realm of our freedom in regard to action. Not only are individuals free in making up their minds about matters of opinion, but where opinion concerns action, individuals have a right to disagree about what policies to adopt or what courses of action to pursue. This leads to a second major point, that there must be some way to resolve or settle reasonable differences of opinion if human beings are going to live together peacefully and harmoniously, if people in society are going to act in concert for a common goal.

Lloyd Luckman: Now, Dr. Adler, before you go on, I'm not sure that I see, and it may not be clear to others either, why such differences of opinion on political problems can't be settled in just the same way as we settle problems in science or philosophy. In these disputes, what do we do? Why, we simply look at the facts or weigh the evidence.

Mortimer Adler: Well, that all depends, Lloyd, on whether you regard science and philosophy as knowledge or as opinion. If you regard it as knowledge or more like knowledge than like opinion, then such disputes can be solved in a way that is not available for settling political differences of opinion.

To the extent that science and philosophy are knowledge, not opinion, Mr. Luckman is right; these disputes can be settled by

41

investigating the facts or examining the reasons. But if in politics we act on opinion, not knowledge, then there must be some other way of resolving disputes and reaching practical decisions which all parties will accept.

Let me try to make this point concretely clear. Let's consider the case of the Supreme Court of the United States. Now let's suppose that the Justice to whom the case is assigned, after studying it, comes back to conference with his colleagues and tells them that he is able to demonstrate the right decision of that case. Be sure you understand the supposition I am asking you to make. I admit it may be some strain on your imagination, but imagine this one of the nine Justices telling his colleagues that he can demonstrate to them as rigorously as a mathematician can demonstrate a conclusion in geometry that this decision of the case is the only right decision. If that were possible, then you can see at once that there would be no room for dissenting opinions. And there would be no point in taking a vote to see whether the majority stood on one side or the other side of the decision that was up for consideration.

But now let's return to reality. As Aristotle said, "We don't expect demonstrations from judges any more than we expect deliberations and the taking of votes from mathematicians." It would be preposterous—wouldn't it?—for a congress of mathematicians to decide whether a certain solution to a mathematical problem was the right solution by taking a vote. But since political and judicial decisions are matters of opinion and not knowledge, then it seems to me it is not preposterous to take a vote and let the majority decide; for that is a reasonable way to proceed whether the case is a kind of case that is before the Supreme Court of the United States, whether the issue is the kind of issue that is before the Congress of the United States, or whether it's the kind of issue that's before the whole people in a national election. I almost was about to say that that is the only reasonable way to decide the case.

Lloyd Luckman: I really wish that you had said it because, you see, then I could ask you, Why is it the only reasonable way to proceed? Is there no other way of settling a difference of political opinion than the one you've just described?

FORCE, AUTOCRACY, AND MAJORITY RULE

Mortimer Adler: Yes, Mr. Luckman, there are at least two other ways. One of them, by the way, is force. We all know societies in the world today where differences of opinion are settled by shooting the opposition or by putting them into concentration camps. Perhaps it would be more accurate to say that in the totalitarian societies in the world today, differences of opinion are not even allowed to arise. Force is used to suppress differences of opinion, or certainly to prevent them from being heard. Now this is hardly a reasonable way of settling differences of opinion. And even if differences of opinion cannot be settled by reasoning, as matters of knowledge can be settled that way, nevertheless they should be settled by debate rather than by force, because matters of opinion are the sorts of matters about which reasonable men can always disagree and therefore they should be heard. The sides should be heard in debate.

Lloyd Luckman: Well, I agree and I am sure that most people agree that force is out, Dr. Adler, but for the reason that it is the very antithesis of the reasonable way to settle these political differences. But then what is the other way that you had in mind, if force is out?

Mortimer Adler: Well, the other way is giving one man authority to decide and having everyone else agree in advance to accept his decision and act on his authority. Now that might appear to be a reasonable procedure, especially if the one man who is given authority to decide happens to be the wisest man that can be found in a given society. Nevertheless I don't think it's reasonable. At least I don't think it's as reasonable as letting the majority decide, as giving authority to the majority's decision. In any case, I am quite sure that the latter way, giving authority to the majority decision, is a way that is compatible with human freedom and with the institutions of a free society.

Now let me summarize what we have seen so far and then see what remains to be shown. Individuals should be free to disagree about questions of policy or political action, because these are matters of opinion. Because they are matters of opinion, differences cannot be resolved by reasoning or proof. And concerted political action depends on (a) force, (b) the authority of one man, or (c) majority rule.

Now force is out. It's perfectly clear that force is an unreasonable procedure. What remains to be shown then is that, first, majority rule is the only principle of decision that's compatible with freedom. But that isn't enough. I would also like to show that majority rule is also preferable on other grounds, namely, that the opinion of the majority is likely to be the wisest decision that can be reached. When I have shown these two things I will face the problem of the conflict between majority opinion and the dissenting opinion of the minority, or one or more minority.

Now let me go at once to the defense of majority rule, and first, its defense on the ground that it is the only procedure consistent with human freedom. To explain this let me just tell you quickly of the two essential ingredients in political liberty, the liberty that is possessed by the citizens of a republic. The first ingredient is that they be governed for their own good or for the common welfare of the State. Men are free under government when it is government for the people, not for the private or selfish interests of their rulers.

The second ingredient is that the men who are governed in that way have a voice in their own government. Men are free under government when it is government by the people, when they have some say in the making of the decisions that affect their own welfare or the common good of the society in which they live. Hence it is perfectly clear—is it not?—that the subjects of an absolute monarch or a despot are not fully free, even if that absolute monarch or despot is the wisest and most benevolent of rulers. For even if he is that, and even if he decides everything for their good, that way of deciding things takes away from them the second essential ingredient of political liberty which is having a voice in one's own government. Only the citizens of a republic are completely free, for only when the opinion of the majority prevails by voting or other means, does the voice of each citizen finally have some weight in the making of the decisions that govern the society and the individuals in it. It follows therefore from the very basic requirements of political liberty that majority rule as a way of deciding questions of action or polity is the only way that's consistent with the fullest political liberty that men can enjoy, and by right should have.

Lloyd Luckman: Now, Dr. Adler, I follow the argument so far and I agree with it as I'm sure most Americans certainly would. But

you said a little while ago that majority rule is preferable on other grounds. And I think at that time you said that it had a greater chance of reaching a wise decision, for example, than the rule of one man even if he would be the wisest man to be found.

Mortimer Adler: I did say that, Lloyd. I did indeed.

Lloyd Luckman: Now that's not so clear to me, because I'm sure that you know even better than I that there are eminent political philosophers who disagree with this point of view. In antiquity it was Plato and in modern times it was Hegel. And so, as I understand both Plato and Hegel, they felt that it was better for men to be ruled wisely for their own good rather than to have a voice in their own government. Their precise point was that the opinion of the majority is likely to be unwise and usually men are ill-advised, aren't they, even as to their own good, their own common interests?

Majority Rule Defended

Mortimer Adler: Well, I know, Lloyd, that the greatest political theorists disagree on this very point. And that fact tells me that this point in political theory is a matter of opinion, not of knowledge. Hence the best thing I can do is to present as strongly as I can the opinion on the opposite side. And I'm going to do that by reading you some passages from eminent authors in which majority rule is defended as being on the side of wisdom as well as on the side of freedom—that is important—on the side of wisdom as well as on the side of freedom.

Let me read you, first, a passage from Thucydides. Thucydides wrote *The History of the Peloponnesian War,* and he saw a great deal of struggling in the ancient world between democracy and the opponents of democracy. And Thucydides says in this passage, "Ordinary men usually manage public affairs better than their more gifted fellows." "For," he says, "on public matters no one can hear and decide so well as the many."

And then let me turn to some passages from Aristotle's *Politics.* It always surprises me that Aristotle comes out as strongly as he does, as I am going to show you, on the side of the majority. Listen to this very carefully. Aristotle says, "The many of whom each individual is but an ordinary person when they meet together are

likely to reach a better decision than the few best men. For each individual among them has a share of virtue and prudence. And when they meet together they become in a manner one man who has many feet and hands and senses and minds. Hence the many are better judges than a single man; for some understand one part, and some another, and together they understand the whole."

And then in another place he says, "If the people are not utterly degraded, then although individually they must be worst judges than those who have special knowledge, as a body they are as good, as better." And in still another place he says, "As a feast to which all the guests contribute is better than a banquet furnished by one man, so the multitude is a better judge of most things than any individual." And it is here that the multitude includes all sorts of opposite and conflicting interests that tend to cancel each other out. He adds, "The many are more incorruptible than the few, just as a larger body is less subject to contamination than a smaller body."

Finally I would like to read you two passages from our own American writers, writers in *The Federalist Papers,* John Jay and Alexander Hamilton. John Jay says, "The people of any country, if like Americans they are intelligent and well-informed, seldom adopt and steadily persevere for many years in an erroneous opinion, respecting their interests." And Alexander Hamilton adds, "The people commonly and usually intend the public good. They sometimes do make errors, but the wonder is that they so seldom do."

Now I think these passages are an eloquent defense of majority rule both as wise and as on the side of freedom. And this view of the wisdom of the majority and the soundness of majority rule is a view taken by those who defend republican and constitutional government against absolute monarchy or despotism. That is why Aristotle says it is essential to every form of constitutional state or republic that whatever seems good to the majority of the citizens should have authority. And certainly any democrat would agree to this, for democracy rests on faith in the sound sense of the people as a whole.

John Stuart Mill, a defender of democracy in the modern sense, tells us that democracy is the government of the whole people, by the whole people, in which the majority outvote and prevail—

Lloyd Luckman: Well, on the subject of John Stuart Mill, Dr. Adler, am I wrong in recalling that he was a man who also greatly feared the role of the majority?

Mortimer Adler: No, Lloyd, you are not. You are not wrong at all.

Lloyd Luckman: Well, among your quotations, if you have a copy of Mill's *Essay on Representative Government,* I think I could find you a very interesting passage.

Mortimer Adler: I had it a moment ago, as a matter of fact. Here it is.

Lloyd Luckman: All right. I'll see if I can find this passage. Now I have it.

Mill says here, "Democracy as commonly conceived and hitherto practiced, that is the government of the whole people by a mere majority of the people exclusively represented." Did you get that? "A mere majority of the people exclusively represented."

Mortimer Adler: Yes.

Lloyd Luckman: That is the common conception of democracy. "And in contrast," he says, "the pure idea of democracy is government of the whole people by the whole people equally represented." "By the whole people *equally* represented."

Mortimer Adler: That is a powerful distinction, yes.

Lloyd Luckman: And I feel that even though Mill is a democrat, you see, he accepted this principle of majority rule. Did he try also to get some safeguards for the minority?

Mortimer Adler: He did.

Lloyd Luckman: And I recall that his idea of protecting the minority was a very ingenious system of proportional representation, was it not?

Mortimer Adler: It was. I don't want to take the time, Lloyd, to go into the merits of Mill's or any other system of proportional voting as a way of giving weight to the minority opinions. But I would like to take the remaining time of today's discussion to talk about a subject closely related to that, namely, the question of how we make majority rule and the opinion of the majority responsible, how we make it live up to its responsibility. And the only way we can do this I think is by making majority rule fully responsible to the opinions of all of the dissenting minorities in this society.

CONTROVERSY IS GOOD

Let me turn to this point at once and see if I can give you my state-
ment of the case, of the way to make majority rule secure in its
responsibility. This, I think, is the problem we face in our society
today, the problem of how we take a stand with respect to political
controversy or controversy on all fundamental social issues. In my
view, three things are required to make majority rule responsible
to the opinions of all minorities.

In the first place, we must regard political controversy as good,
not bad. In fact, what we ought to fear is uniformity of opinion, not
difference of opinion. Each of us, if this is so, has a moral respon-
sibility either to engage in controversy or to be friendly toward
controversy, to want it to go on, and certainly to pay attention to it
when it does go on.

Now, in the second place, we must take every precaution to
safeguard political controversy, the public debate of public issues,
from the things that could ruin it and make a farce of it. Just think
for a moment about the Lincoln-Douglas debates. When the
Lincoln-Douglas debates were going on, slavery was the hottest
issue of the day. And yet, neither side in those debates was intimi-
dated by sinister pressures or counteracted by insidious propa-
ganda. When the majority tries to settle controversial issues by
using pressures and propaganda instead of resorting to rational
persuasion, then the weight of numbers, the force of numbers is as
bad as the force of guns and bombs.

The most important of these three points is this one: the pub-
lic debate of public issues must be carried on as long as it is prac-
ticable to do so, until every side is adequately heard and everyone
who has an opinion is given a chance to voice it. In fact, even after
the decision is reached, his majesty's loyal opposition must con-
tinue to oppose and criticize the government's position and try to
get the matter changed or rectified according to their own view.
Only when all these things are done as much as they can be done,
does the principle of majority rule have the fullest chance of
reaching a wise decision on political questions.

This completes our discussion of Opinion, though it by no
means covers all the points and interests in the field of this Great
Idea. But before I leave this point I would like to support the last
thing I said by reading you a passage from John Stuart Mill that

gives the reasons why every side in political controversy must be heard.

This passage, by the way, I think is so relevant to American life today that I would like to see it engraved on the minds of every American citizen. According to Mill there are three grounds for freedom in the expression of opinion. Let me read you what he says. "First, if any opinion is compelled to silence, that opinion may, for ought we can certainly know, be true. To deny this is to assume our own infallibility. Second, though the silenced opinion be in error, it may and very commonly does contain a portion of the truth. And since the general or prevailing truth on any subject is rarely or never the whole truth, it is only by the collision of adverse opinion that the remainder of the truth has any chance of being supplied. And third, even if the received opinion be not only truth, but the whole truth, unless it is suffered to be and actually is vigorously and earnestly contested, it will by most of those who receive it be held in a manner of prejudice with little comprehension or feeling of its rational ground."

That, as I say, is something which I think every American citizen should keep in mind. I think it is a fitting conclusion to this discussion of Opinion, particularly of opinion in the field of politics, in the field of our social life.

But there is one more thing I would like to spend a closing moment on, Mr. Luckman. In my mind it is the most poignant of all differences of opinion. It is the difference of opinion between the generations, the conflict of the generations, the difference of opinion between parents and their children. This is a difference of opinion about which very little can be done. The generations seem to be involved in an irresolvable dispute. I say this feelingly to the point of view of being in one generation, of having children, and feeling totally inadequate ever to persuade them of my point of view. I personally think that parents, being older, being more mature, having more experience, have a chance of being wiser than their children on immediate practical manners. But they have very little chance of persuading their children of this for the simple reason that the experience on which their wisdom rests is an experience their children do not have. The child has to suffer the same experience, has to live through it, suffer it, before he comes around, if persuaded of the opinion his parents tried to hand on to him. And then often it is too late; often the mistake is made.

I regard this as one of the saddest facts about the human race. If we could only do something about this, if we could only find a way of having children profit somehow by the experience of their parents, of accepting somehow the wisdom that is in their parents' opinions as a result of that experience, I think we could change the course of human history overnight. Progress could be made to move with much greater speed than it ever has in the whole course of human history.

6 How to Think about Man

Today we begin the discussion of Man. In dealing with other Great Ideas, we usually proceed by considering in the course of several programs a whole series of questions. But in dealing with this idea, the Great Idea of Man, our procedure will be somewhat different. During this whole month, we shall concentrate on a single problem, a problem that can be stated in two questions.

The first question is about man's nature. Is man's nature different in kind or is it different in degree from the natures of other animals? Is man the only rational animal on earth or is man just a more intelligent brute? That is the question about man's nature.

Second, there is the question about man's origin. Does man come to exist on earth by God's special creation of him or does he come into being in the course of time by the processes of natural evolution? Is man made in the image of God or is he a perfection of the ape?

In all our past discussions you probably have not felt the challenge of this comparison between men and other animals because that wasn't the main point. But if now, if now I were to make that comparison the substance of a challenging thesis directly to you and were to say to you that I held the thesis that man stands apart from the rest of nature, the thesis that *there is a discontinuity between man and the rest of nature,* I think many of you would disagree. Or if you didn't disagree at once, you would feel very uncomfortable about agreeing. Why? Why would you feel uncomfortable? Because of what you've been taught in school or because of the prevalent beliefs, the beliefs that prevail among educated men and women in the twentieth century.

Lloyd Luckman: Now, I'm not certain that I understand you completely and even correctly, Dr. Adler, but you seem to be saying in that statement that everyone today accepts the Darwinian theory of the origin and the descent of human beings from ape-like ancestors. Now, I'm sure that our viewers will think of the Tennessee trial with that marvelous cast of characters of Clarence Darrow and William Jennings Bryan, and the young teacher who was attempting to teach Darwin—

Mortimer Adler: That was Scopes.

Lloyd Luckman: Scopes, right, in the public schools. Now in that particular instance, of course, Bryan represented a very fundamentalist point of view which insisted that the book of Genesis, the first chapter on the creation of the world, must be taken very literally. Now, that might be a point of departure here, but also I'm thinking too that there are many people today who have in mind the Christian dogma, the central dogma of Christian teaching, which is still at variance with the Darwinian theory of evolution. I'm wondering where you are going to make room for that if you don't agree that there is still some area of difference here.

Mortimer Adler: Well, Lloyd, there is still certainly a live issue between science and religion on the question of man's nature and origin, at least between the Darwinian hypothesis and fundamental or orthodox Christian beliefs. But what I'm thinking of is that, apart from religious faith, there is in the twentieth century among educated men very little defense of the traditional view of man. That is, apart from men who hold the traditional view in terms of their faith, there are few in the twentieth century who stand out against the Darwinian hypothesis on the grounds of reason or in terms of the facts and the interpretations of the facts.

Lloyd Luckman: Yes.

BEFORE AND AFTER DARWIN

Mortimer Adler: Perhaps what I should have said is that the predominant view, I mean the predominant secular view in the twentieth century, is the view that tends to reject the thesis that there is a discontinuity between man and the rest of nature. If one looks at the whole history of Western thought, Darwin is the dividing line. Man's conception of man is one thing b.d. and a differ-

ent thing a.d.; one thing "before Darwin" and another thing "after Darwin." Let me tell you, let me just tell you this history briefly.

The traditional view of man which begins with the Greeks and runs right down to the middle of the nineteenth century is the view that man is a rational animal, the only rational animal on earth, and so, essentially distinct in kind from all other animals. This view, by the way, was held in antiquity by thinkers who disagree about many other things. Plato and Aristotle disagree about much, but they agree on this, the Roman Stoics and the Roman Epicureans disagree about many things, but they agree on this. They agree upon man's special character. And the ancients looked upon man as the only thing on earth which was descended from the gods.

The same thing is true in the Middle Ages. And when I say the Middle Ages, I am not thinking only of the Christian Middle Ages, this is true of the Mohammedan culture in medieval times and the great Jewish philosophy of the Middle Ages. The Jews, the Mohammedans and the Christians, differing in many other articles of faith, agreed on this point. And they agreed not merely as theologians, but as philosophers as well, in terms of reason. And when one comes down to modern philosophy, one finds again that thinkers who differ as much as Descartes and Spinoza and Leibniz or as Locke and Kant and Hegel, all agree on this point.

Let me read you for a moment a statement by John Locke. I'm quoting here from Locke's *Essay concerning Human Understanding*. Locke says, "It is understanding, man's understanding, that sets man above the rest of sensible beings. Men and other animals," he says, "have alike the powers of sense and memory and imagination, but brutes abstract not. . . . This power of having general ideas is that which puts a perfect distinction between men and brutes." Or if one leaves Locke and goes to Adam Smith, what does he say? Smith says, in his *Wealth of Nations,* "The propensity to truck, barter, and exchange one thing for another is common to all men and to be found in no other race of animals." And I could go on quoting Hobbes or Kant or Rousseau, each of them finding man's difference in some other particular, but all of them agreeing that man is essentially distinct in kind, not different merely in degree from other animals.

Perhaps the best summary of this great traditional point of view is to be found in the eloquent statements that our English

poets make. You all, I think, remember the scene in Shakespeare's *Hamlet*, where Hamlet makes this magnificent statement about the nature of man. It is in some sense the most eloquent summary of the traditional point of view that existed in Europe, in the West, for over twenty-five centuries. Hamlet said, "What a piece of work is a man! How noble in reason! How infinite in faculty! in form, in moving, how express and admirable! in action how like an angel! in apprehension how like a god! the beauty of the world, the paragon of animals."

And then not quite so eloquent, not quite so magnificent, but nevertheless extraordinarily clear and pointed is the statement one finds in Milton's *Paradise Lost*, "A creature whom not prone and brute as other creatures, but enbued with sanctity of reason might erect his stature and upright with front serene govern the rest, self-knowing and from thence magnanimous to correspond with heaven."

Now let's look at the opposite point of view. This opposite point of view did not become popular until the end of the nineteenth century and did not prevail among educated men until today. It didn't begin in the nineteenth century. One finds the first appearances of it, I must admit, as early as the sixteenth century. The Italian political philosopher, Machiavelli, looks upon humans as if they were beasts. Like the lion and the fox, they act against one another with craft and strength.

And in the same century the great French essayist, Montaigne, does the opposite. He looks upon animals as if they had as much reason as men. He is very fond of the story of the hunting dog, who coming down to a triple branching of the ways sniffs at the left hand, sniffs then at the middle road, and without sniffing at the right road, runs down it. Says Montaigne, "You see," he reasons, "there are only three ways to go. The first is not right, the second is not right, therefore the third." "Animals," says Montaigne, "syllogize as well as men."

But though these two authors, Machiavelli and Montaigne, introduce some doubts, these doubts make no real inroads into the traditional conviction or conception about man until we get to the nineteenth century, until we get to Darwin and post-Darwinian biology and psychology. It is modern science, modern biology, and modern psychology more than anything else, which have so radically altered man's view of man.

It is Freud who makes the classic statement at this point. He says that in the course of modern times, man's self-esteem has suffered three cruel blows at the hands of science. And he even tells us who the men are who dealt these cruel blows at man's self-esteem. "The first of these great scientists who changed man's conception of man," he says, "is Copernicus." Copernicus, and his great book, *The Revolution of the Heavenly Spheres,* which displaced the earth, man's earth, from the center of the universe.

And then the second figure in Freud's story of the attack upon human self-esteem is Charles Darwin, and Darwin's book, *The Descent of Man,* which with *The Origin of Species* did more than anything else to change man's conception of man.

"And the third figure," Freud modestly or immodestly says, "is myself." And now with Freud's book in hand, the book, *A General Introduction to Psychoanalysis,* let me read you in Freud's own words the statement, this classic statement that I have just summarized. Freud says, "Humanity has in the course of time had to endure from the hands of science two great outrages upon its naïve self-love." Notice I said man's proper self-esteem; Freud says humanity's naïve self-love.

The first was when it realized that our earth was not the center of the universe, but only a tiny speck in a system of a magnitude hardly conceivable. This is associated in our minds with the name of Copernicus.

The second was when biological research robbed humankind of the special privilege, the peculiar privilege, of having been specially created, and relegated the human species to a descent from the animal world, implying an ineradicable animal nature in man. This transvaluation has been accomplished in our own time at the instigation of Charles Darwin.

Then Freud comes to himself and says, "But man's craving for grandiosity is now suffering the third and most bitter blow from present-day psychological research, which is endeavoring to prove to the ego of each one of us that he is not even master in his own house, but that he must remain content with the various scraps of information about what is going on unconsciously in his own mind."

Lloyd Luckman: Before you comment on Freud, Dr. Adler, may I interrupt just to ask if in the development of our topic you are going to deal with Copernicus and Freud, because I got the

impression that our whole emphasis was going to be on Darwinism and the evolution of mankind. And I wondered if that was to be the emphasis, if you had a particular reason for staying with the one scientist.

Mortimer Adler: Oh, your assumption is quite right, Lloyd. I am going to make Darwin, not Freud, not Copernicus, central in the course of these discussions. And I do have a reason for it. I tend to think that the most serious, perhaps the only serious attack upon "man's proper self-esteem," as I say it, or humanity's naïve self-love, as Freud says it, comes from Darwin.

How Are Humans Different from Other Animals?

If any of our viewers disagree with me about this, I wish they would let me know. If any of you think that Copernicus is the more serious threat, modern astronomy is a more serious threat to our conception of mankind, or Freud is, rather than Darwin, I wish you'd let me know. But I'm going to assume that I am right, that Darwin is the most serious threat to man's conception of man. And the reason why I think so is that only Darwin, not Copernicus, really attacks the issue of whether man differs in kind essentially and radically from other animals, or only in degree. Copernicus doesn't do this. And insofar as Freud does it, he does it in virtue of himself being a Darwinian, a follower of Darwin's and proceeding a little further along the same line.

Let me show you in Darwin's own words how the issue was made. I am reading now from that book which caused this great intellectual stir, *The Descent of Man*. And Darwin said, "The difference in mind between man and the higher animals, great as it is, is certainly one of degree." Notice the words, one of *degree*, not of *kind*. I am not putting that word into Darwin's mouth; there it is. "We have seen that the senses and the intuitions, the various emotions and faculties such as love, memory, attention, curiosity, imitation, reason, of which man boasts, may be found in incipient or even sometimes in a well-developed condition in the lower animals. They are also capable," he goes on to say, "of inherited improvements," as we see in the domesticated dog or jackal. A dog is compared with the wolf or jackal. "If it could be proved," he says,

"that certain high mental powers, such as the formation of general conceptions, were absolutely peculiar to man," which he doubts, then he goes on to say that these would merely be the result of man's having a more perfect language than other animals.

Now this issue which Darwin makes so pointedly and bluntly, I think, is a most serious issue. In fact, I think I would say that this question about the nature of the human species and its origin is with one exception, that exception being the question about God's existence, the most serious question anyone can face. The issue which turns on this question involves all of human science, philosophy, and religion.

I want to say now, as I think I indicated before, that I am going to proceed in these discussions not by arguing in terms of religion, not appealing to faith, but taking the argument entirely in terms of science and philosophy, in terms of the facts and the interpretation of the facts, with no appeal to faith whatsoever. Nevertheless, the questions of fact in which we are going to have to deal have the most serious and far-reaching consequences, practical consequences for morals and politics and religion. And even more serious than that, in my view, is that on this question is one of the great divisions between East and West, between the culture of the West and the culture of the East.

For example, in the West, is it not true that man is the only sacred animal, that man's life is the only sacred life? If that is true, think of the East now, think of India, in which monkeys and cattle are sacred animals, in which their lives, the life of monkeys and cattle is more sacred than the human life. And human beings are allowed to starve and die so that monkeys and cattle are not touched. This is a deep, deep rift between East and West on this one issue.

Now recently, within the last year or so, a very witty French novelist, his name is Vercors, wrote an extraordinarily good satirical novel called, *You Shall Know Them*. Let me just tell you the story of this novel for a moment. It is an extraordinary novel I think. A party of scientists goes for an expedition into the Malay jungle. And while they are on this expedition, they run into some animals which look like apes, but act like men. And they observe them very closely and they can't tell by any signs whether they are apes or men. They even begin to think that this is the living missing link between ape and man. Now on that expedition a young writer by the name of Douglas Templemore is more disturbed than the scientists. This

really upsets him. And he gets particularly upset when he finds that some capitalists, some industrialists in Australia are going to try to take these animals to Australia and exploit them in factories, use them without paying them because they aren't men, you see? And so he wants to establish the question, face the question, whether they are men or animals. And what he does is by artificial insemination becomes the father of a cross-bred offspring between himself and a female of these creatures. And when this child, this mixed offspring between this creature and Douglas Templemore is born in London, Templemore kills the child. He kills the child, calls in the police or the coroner and submits himself to British law on the charge of murder. Did he murder or not? Well, whether he murdered or not depends on whether this is a human being or not. And so the case goes to the high court of Parliament.

Now I'm not going to tell you how it ends. You certainly ought to read the novel. But I want to draw from the novel this question which is the essential question. You can see the whole point. Let's look at the question this way: It all turns on what you mean by murder or by killing. As I understand the novel, if that offspring is a human being, you can murder it, not merely kill it; just as if it is a human being, you would be enslaving it if you made it work without paying it justly. But if it was just another animal, not a human being, then you could kill it and the killing would not be murder. Or you could use it as a beast of burden and the use of it would not be enslavement.

Notice that distinction, how deep it goes. If it's human, killing it is murder; using it is enslavement. If it's not human, killing it is just killing it and using it is all right. According to this division, humans and only humans have dignity, the dignity which requires them to be treated as ends, not used as means. Whereas non-human animals have no dignity. And this distinction comes down to the basic one with which we are going to be concerned so much in the next few weeks, whether humanity differs in kind from other animals or merely differs in degree from other animals.

MAN'S NATURE AND ORIGIN ARE INSEPARABLE

Lloyd Luckman: Now I think I've been following you all right, Dr. Adler. But there is going to be one thing that troubles me and

I'm sure that it troubles some viewers too. You now seem to be talking about just one issue. On the other hand, we seem to have two distinct questions here, the origin of man and the nature of man. Am I not correct?

Mortimer Adler: Yes.

Lloyd Luckman: Well now, are these separate questions? If they are separate, is one more important than the other? Are they inseparable?

Mortimer Adler: Well, Lloyd, I think the questions are inseparable. If anyone answers the question about man's origin, for example, by regarding him as having appeared on earth by natural evolution, by descent from apelike ancestors, then they will also say in answer to the other question that man differs only in degree from other things. But if they answer the second, the other question about man's nature, by saying that man differs essentially and in kind from other animals, then they will not accept the answer to the question about man's origin, except the answer which is based upon natural evolution. So the two questions are inseparable. As you answer the one, so you will answer the other. But though they are inseparable, they are by no means, I think, equally important. I think the question about man's nature is more important than the question about man's origin.

Though I think the contemporary way of looking at the thing goes from an hypothesis about man's nature, about man's origin, his evolutionary origin, to a conclusion about man's nature, whereas the older point of view went from a conclusion about man's nature to some hypothesis about his origin, I think the right way is to go from man's nature to man's origin. In fact, the reason for that is that the facts, the observable facts about man's nature, are clearer than the much more conjectural facts about man's origin. I would almost say that to go in the opposite direction, to start with the question about man's origin and try to conclude from that about man's nature, is to beg the whole question, scientifically speaking.

This is not a minor point, the order of these two questions. I think you will see as we go on in the next few weeks that it makes a great deal of difference whether one looks first at man's nature in terms of the facts that are relevant to that and then asks, "What could man's origin be?" or tries by hypothesis and a kind of conjectural history to look first to man's origin, and draw from that a conclusion about man's nature.

As I say, this difference in mode of reasoning, this difference in the direction of inference is part of the difference between the two points of view. There is the contemporary, biological point of view that tends to put the main emphasis on genesis and conclude nature from genesis; whereas the older point of view, the traditional point of view that Darwin set aside, puts the main emphasis on nature and lets the question of origin or genesis be determined by the answer to that.

Now let me tell you what the course of our discussions will be. Next week I want to spend the whole time we have on the logic of the issue, getting as clear as I can a distinction you all use when you say, "Oh, that differs in degree, not in kind," or "That differs in kind, not degree." I want to get that distinction clear. Then in sequence I want to present Darwin's point of view and the opposite point of view on the nature and origin of man. And finally, in a concluding session I would like if possible to see if I can make as clear as I can the significance of this issue both theoretically and practically, and see if I can tell you why everyone must take sides on the issue and face the consequences of taking sides.

I do take sides myself. I am opposed to Darwin. I am going to explain why I am opposed to Darwin. But I'm going to try to argue the case as fairly and squarely as I can. And I hope you will help me argue it fairly and squarely by sending your own objections, your own questions in, so that we can control the discussion as we go along in the next few weeks, by your thinking as well as by mine.

7 How Different Are Humans?

Today we continue with the discussion of man, concentrating on one problem which involves two related, in fact, inseparable questions: the question about the nature of man and the question about the origin of man.

Last time I presented the issue historically by telling you of the two opposed sets of answers to these questions. On the one hand the answer given B.D., or before Darwin, the view that man is essentially distinct in kind from other animals and therefore has or must have a special origin. And the opposite view, the view A.D., the view after Darwin, which is that man, the human species, has originated in the same way as all other species of animals and therefore that man differs only in degree from other animals. This fight about kind and degree goes to the very heart of the matter.

You will recall a passage I read to you last time from Darwin. Let me read it to you again. In *The Descent of Man* Darwin says, "The difference in mind between man and the higher animals, great as it is, is certainly one of degree and not of kind." That expressed one view. The opposite view is expressed in this passage from Descartes that I am going to read you. Descartes, in the seventeenth century, said, "A difference merely of greater or less makes no difference to the essence. Hence those who think," and Descartes makes it quite plain that he does not agree with them, "those who think," he says, "that the only difference between the beasts and us is that there is less reason in them, will conclude that our minds and theirs are exactly of the same species."

Now today I am going to deal with this issue logically. I want to get the issue as clear as I can for all of us because it is important as preparation for the arguments to follow. Unless we understand

the issue as clearly as we can, we will not be able to understand and access the arguments on opposite sides of the case.

Lloyd Luckman: You know, my impression was exactly as you're reporting, that, well, you have here a presentation of an argument, an issue rather, not arguing one side as against the other. And I was concerned in reading the letters that came in last week that at least some of them reacted as though you had already taken a side. And two in particular seemed to think that you had taken Darwin's side in this particular issue.

Mortimer Adler: I think that's quite wonderful, Lloyd. As I recall, I said the very opposite. I thought I said quite frankly that I disagreed with Darwin about the origin and nature of man. And hence, though this is a misunderstanding, I am quite pleased by this misunderstanding because it shows, if anything, that I was quite fair in presenting the issue; I didn't favor my own view of the matter. Nevertheless, to prevent a similar misunderstanding from happening, let me repeat, I did not argue last week for one side of the issue. I am not going to argue this week for one side of the issue.

Next week and the week after I will present the opposed arguments. But today I want simply to get the issue clear by getting the logic of it as plain as I can. Doing this is going to involve us in three efforts. Now let me say at once, it is going to be difficult, more difficult than many other things which I have tried to do on this program. It will tend to be, as the saying goes, a little abstract, but it really isn't difficult. If you'll pay close attention and follow carefully, I'm sure it will be made clear and can be understood by all of us. Please try.

Differences in Kind and Differences in Degree

Let me begin with the first effort to get the issue clear in terms of the definition of man. There have been many definitions of man given. Man is said to be a featherless biped, the only laughing animal, the only talking animal, the only tool-using animal, and sometimes the human being is said to be the rational animal. Now this last one, the definition "rational animal," is the best and the most precise. That's because it underlies all the rest. But it isn't the definition which makes the issue. It's the interpretation put upon the

definition, an interpretation which says that humans and humans alone are rational. No other animal is rational in any degree whatsoever, so there is a sharp distinction in kind between men and all other animals.

Now look, I'm sure all of you have used the phrase, "Oh, that's a difference in kind, not in degree," or "Oh, that's a difference in degree, not in kind." But few of us stop to think precisely what is involved in saying "difference in kind" as opposed to "difference in degree." I'm going to try to get that simple thing understood because all of us do refer to it, all of us do appeal to it. Now let's see if we can commonly understand together what is involved in saying "difference in kind" or "difference in degree."

The first point is this: Here is a line and here is another line. This line is shorter than that line. And this line has length and that line has length. Now we say this line differs from that line only in degree because both of them have the same traits. Both of them have length or extent and one is longer—this is the longer and this is the shorter.

In contrast, look at a circle and a square. The circle has no angles at all, not fewer angles, not angles in less degree, no angles at all, and the square has some angles, four angles. That difference between the circle and the square, the circle with no angles and the square with some angles is a difference in kind.

Lloyd Luckman: Now is that difference, the difference between a difference in kind and a difference in degree, itself a difference in kind or of degree? Why I raise this question is that in talking with many scientists about this very problem, I have found them to have this feeling, that eventually a difference in degree can ripen into a difference in kind. And I give you as an example a many-many-sided polygon which eventually approaches the circle and appears as a circle.

Mortimer Adler: Lloyd, the example is I think very good. Of course, the more sides you have in a polygon, a thousand, ten thousand, fifty thousand, the more it will approach a circle. But it only approaches the circle and never becomes a circle. A difference in degree is never a difference in kind or *vice versa.*

Wherever two things like two lines differ in degree, one having more of what the other has less, namely length, there always can be intermediates. Intermediates are always possible. Intermediates are always possible when two things differ in degree. So

there can be a third line, intermediate in length between the first two lines.

But is there any intermediate possible between a triangle and a square? A triangle is a three-sided figure; a square is a four-sided figure. Can any of you think of a three-and-a-half-sided figure, a three-and-three-quarter-sided figure, a three-and-one-quarter-sided figure? No. Between a three-sided figure and a four-sided figure there is no intermediate possible. And that fact is what distinguishes a difference in kind from a difference in degree.

So I come back, Lloyd, to the point that no matter how large a difference in degree may become, it never really becomes a difference in kind. Nevertheless certain differences in degree may seem to be differences in kind or be treated as such for all practical purposes. And I emphasize here, "all practical purposes." On the other hand, some merely apparent differences in kind are really only differences in degree.

When two things really differ in kind, as I've shown you already, no intermediates between them are possible. And when two things really differ in kind they will have much in common, but one of the two will have some property or characteristic or trait which the other totally lacks. And as a result of this fact, one of them, the one that has the additional property will be higher than the other. There will be a hierarchy of these two kinds or grades of things.

Lloyd Luckman: I'm not certain that I'm following you exactly, so I would like to ask you some questions if I may.

Mortimer Adler: Please do.

Lloyd Luckman: All right. There are many species of animals, aren't there?

Mortimer Adler: Yes, as a matter of fact, according to the estimates of contemporary biological science there are more than eight hundred thousand species of animals.

Lloyd Luckman: That's a large number. And all of these eight hundred thousand species of animals differ in kind, don't they?

Mortimer Adler: Yes, they do.

Lloyd Luckman: And as I understand it, evolution recognizes that they differ in kind, isn't that true?

Mortimer Adler: Yes.

Lloyd Luckman: Now furthermore, am I not right in thinking that the theory of evolution as it regards these species, regards some as lower in form and others as higher forms of life?

Mortimer Adler: Yes, as a matter of fact, the familiar evolutionary picture is of the tree of life, a sort of scale of organisms from lower to higher. So that is a part of the evolutionist's picture. Yes, Lloyd.

Lloyd Luckman: All right, now if that is the case, it looks to me as if what you're calling a real difference in kind were also accepted in the theory of evolution. And so, I want to know how an issue arises between the evolutionists and those who make their central thesis that man differs really or essentially in kind from other animals. Now suppose he does, now so do apes and horses differ in kind, right?

Mortimer Adler: Yes.

Lloyd Luckman: And then horses from birds and birds from frogs and so on. Now if evolution applies in these latter cases of birds and horses and apes and so forth, why doesn't it apply also to man? And that makes me ask you, where is the issue? I don't see where there is any issue.

Mortimer Adler: Well, Lloyd, that is the important thing, the issue. We are not arguing, you and I aren't differing for a moment, as to which side is right.

Lloyd Luckman: No.

Mortimer Adler: But you don't see the issue? I say there is one. Well, let me see if I can get it clear.

DIFFERENCES IN KIND EXCLUDE INTERMEDIATE FORMS

To get it clear, Lloyd, I must first, I think, correct you on one slight misunderstanding. I think you made this one misstatement. And when I get that corrected I think the issue will become quite plain. You are right in saying that the evolutionist does regard some forms of life as lower and some higher. But the evolutionist, when he regards some of them as lower and some as higher, thinks of the lower and higher as differing only in degree. And the reason why I know this to be so is that he insists on an underlying continuity in nature. And there could be no underlying continuity in nature unless intermediate varieties were possible as between different species in the scale of things or the greater things. I emphasize the fact that there must be intermediate varieties between any two

kinds of species. Intermediates *must* be possible, even when they are only missing links. That is exactly what we mean by the notion of the missing link, a possible intermediate variety which isn't known at the moment. Hence I would say, Lloyd, that species, which the biologist classifies and calls kinds, are only apparent kinds; whereas the argument made by the definition of man, which the biologist is rejecting, involves not apparent kinds, but real kinds.

And so to get this clear I must make my third effort now to state the issue. I have made two approaches to it and this third one I think will get us, at least I hope, right on the point where we can see the evidence coming in on both sides. The third way of stating the issue is in terms of two conceptions of species: a conception of species with missing links between them, with intermediate varieties; and a conception of species without any missing links or without any intermediate varieties.

According to the contemporary biological conception, species are only apparent kinds. Species are kinds that are separated by the possibility of intermediate varieties. And that being the case, there can be differences in degree between the two species.

Let me pause for a moment to add one fact. Modern genetic science has in the course of great research done since the day of Darwin, presented us today with a most extraordinary hypothesis that confirms this picture. It is this, that if all the possible forms of life were to coexist simultaneously on earth, that is, if every possible organism that could be bred were to exist at the same time, there would be no species at all. There would just be individual differences, one individual and another differing in degree. In fact, of course, that hypothesis is contrary to fact because all possible organisms don't coexist on earth at the same time. That is why I say that the biological view is of species as apparent kinds which really and deeply differ only in degree.

Now let's take the other conception of species, the philosophical conception of species as real kinds. In the view of modern biology, species are kinds separated by the possibility of intermediate varieties, by the absence of them and the possibility. Philosophically, species are kinds separated by the impossibility of intermediate varieties.

Let me make the point as sharply as I can. If man differed from ape as ape differs from horse or horse from bird or bird from frog,

then the evolutionist's hypothesis would be as applicable to the origin of the human species as it is plainly applicable to the origin of all other species of animal life. But if man differs from all other animals by a marked discontinuity, a marked discontinuity in the hierarchy of nature, then I'd say that the evolutionist's hypothesis is not applicable to man.

So at the very heart of the issue the whole question really is a question of how man differs from other animals, in kind or in degree. And when we say in kind we mean really and essentially or radically in kind with no intermediate varieties possible, no reduction to degree possible. And when we say in degree we are admitting the possibility of an apparent difference in kind which does admit intermediate varieties and takes account of the possibility of its being reducible only to a difference in degree. The question is then, does man differ really and essentially in kind from other animals or does he differ only in degree or only apparently in kind as apes do from horses or horses from birds and birds from frogs?

Let me repeat once more that in presenting the issue to you today by sharpening the meaning of difference in kind and difference in degree, I have not argued for one side of the issue or for the other. I hope that my presentation is fair and hasn't prejudiced the question. I've just tried to make the issue itself clear so that as we go on now we can see the evidence and the arguments coming in on one side or the other.

Next time I am going to try to present the evidence and the arguments for the evolutionist's view, arguments and evidence that the evolutionist offers to show that man differs only in degree from other animals; which if it were the case, would then lead to the conclusion that the origin of the human species can be by natural evolution and is by natural evolution just as the origin of other species of animal life is a natural evolutionary process. Then in the program after next I'm going to try to present the arguments and evidences on the opposite side of the question, tending to show that man differs in kind, really, essentially, radically in kind from other animals, which will then make it impossible to hold that man's origin is by a natural evolutionary process. For if man differs in kind from other animals and that difference in kind permits no missing links, no intermediate varieties, then the evolutionist's hypothesis will not be applicable to the origin of man.

I hope you will stay with us, I hope you will be with us during our consideration of both sides of the argument so that you see the issue that you now understand carried out in argument first on the one side and then on the other.

8 The Darwinian Theory of Man's Origin

Today we continue with the discussion of man, and we consider the arguments and evidences for Darwin's theory of the origin and nature of man. That theory was not stated in *The Origin of Species* which Darwin published in 1859. It was not presented until somewhat later, in 1871, when Darwin wrote his second book on the subject, *The Descent of Man*. This second book, applying the theory of evolution developed in the first, depends for its truth upon the truth of the first book, the truth of the great theory of evolution that Darwin propounded in *The Origin of Species*.

Let me show you this by turning to the structure of the argument in Darwin's second book.The three steps in Darwin's argument are, first, that man differs only in degree from other animals; second, that man's origin can be like that of other species; and third, that if man's origin were like that of other species, then missing links must have existed and may be found.

Now of these three statements the first is crucial. The whole argument rests on the first proposition, that man differs in degree and only in degree from other animals. The argument does not rest, as many people seem to think, on the discovery of fossil remains, which will then show the existence of missing links. Because there cannot be missing links if there are no intermediate varieties possible between man and apes or other mammals. And intermediate varieties are not possible, simply are not possible, if man differs from apes and other mammals in kind, radically and deeply in kind, not simply in degree. Now that is the nub of the argument.

Lloyd Luckman: What you were just saying, Dr. Adler, is just like waving a red flag in front of most scientists and particularly in

the face of people whose education has been along the lines of modern empirical science. Now the people of scientific training whom I was talking to this last week about our whole discussion of kind and degree take one of two positions. The one position is that there are *only* differences in degree, and the other position is that these apparent differences in kind are always reducible to differences in degree. And therefore they take very definite difference with you as you state your distinction, namely, that there are real kinds without possible intermediates. And they hold that this is untenable when you say that are also apparent kinds which can be reduced to differences in degree. And as they call this an untenable distinction, they even go one step farther and say that it is almost an unintelligible distinction.

Mortimer Adler: In my view, Lloyd, they beg the question. Of course, if they are right, if things differ only in degree, then there is no issue, then there is no question even to face concerning man's origin and man's nature. They may be right about that and that's part of the argument we want to consider today. But one thing they cannot say, this very last thing you mentioned, they cannot say that the distinction between kind and degree is itself unintelligible. Because when they say that a difference in kind is sometimes reducible to a difference in degree or that sometimes a difference in kind emerges from a large enough difference in degree, they cannot also say that the distinction between kind and degree is unintelligible, for then their own statement itself is unintelligible since they themselves have apprehended a distinction between kind and degree.

We received a number of other letters on this, Lloyd, which I would like to quickly summarize and read. We received a letter from Mr. Lewis C. Noble of San Francisco which asks, "Isn't the difference in degree at times also a difference in kind? Doesn't a change in quantity at times also produce a qualitative change?"

Yes, Mr. Noble, if you'll put the emphasis on the word "at times," for it is true that some differences in kind are only apparent. They result from and are really only differences in degree.

Then there is the question from Dorothy and Ira Jerolomon of Berkeley. They point out that kinds often grade imperceptibly from one to another and that examples of intermediate forms— they give many examples as a matter of fact between things that are said to differ in kind. And they are quite right about this. When

kinds are only accidental or apparent kinds, not essential or real kinds, then there are intermediates connecting them for they are ultimately reducible to differences in degree.

And then finally there is this this letter, a very good letter indeed, from Mr. Roger Gillette of Palo Alto. Mr. Gillette points out difficulties with my mathematical examples of last week. The triangle and the square are different in kind. He points out that they can be interpreted as differing in degree as well, since the square has one more side than the triangle. He is quite right about that. Any two mathematical objects will appear to differ in degree as well as in kind. But I used those figures, the square and the triangle, merely to illustrate an integral difference, a whole step, the impossibility of intermediates.

And that is the critical point, Mr. Gillette. Let me put it to you this way, are there kinds between which intermediates are impossible? Now in mathematics clearly there are, because the square and the circle, the triangle and the square permit no intermediates. But the question is, are there such kinds in the world of living things? For if there are, they do not belong to a continuum of things graded in degree. Now this brings us back to the question about man. How does man differ from other animals with or without intermediates, intermediate varieties?

THE MAIN POINTS OF DARWIN'S THEORY

Darwin is not the first to say that man differs from other animals by degree alone and with intermediate varieties. Hume and Kant said that more than a hundred years before him. Hume points out that animals and men both reason in the same way: by analogy, by custom, and by instinct; that man surpasses other animals in reasoning just as one man surpasses another, but only in degree. And Kant, emphasizing deeply the principle of continuity in nature, which William James later called "the basic postulate of evolutionary theory," interprets this principle of continuity in nature as meaning that there always are intermediate species or subspecies between any two kinds. "The gap between one species and another," he says, "always admits of differences in degree."

What then is Darwin's contribution? What did Darwin add to this insistence upon the difference in degree? He took that point

and connected it with an hypothesis about man's origin as a theory of evolution. Let's look at the main points in Darwin's theory of evolution to see if we see how he made this connection.

There are three main points in Darwin's theory of evolution. They are, first, that from generation to generation organisms vary. There is a variation in organisms. They vary by heredity, their genetic constitution changes from generation to generation. And the second point in Darwin's theory of the origin of species is that there is an accumulation and a persistence of the extreme variety. And third, this persistence of the extreme variety is accompanied—if it does not happen this way, there'll be no origin of species—by the extinction of intermediate varieties.

It is these last two points which really are essential to understand. If one only has the first point, there would be no origin of species. It is only when, with the persistence of extreme varieties, there is an extinction of intermediate varieties that new species come into being.

Let me read you Darwin's own statement of this point because it is terribly important to hear this in Darwin's own words. He says, "On the theory of natural selection the extinction of old forms and the production of new are intimately connected." The extinction of old forms and the production of new are intimately connected. "The only distinction," he says, "between species and well-marked varieties is that the latter," the well-marked varieties, "are known or believed to be connected at the present day with intermediate gradations." Whereas species were formerly thus connected and their connections are now the missing links. If his theory is true, Darwin writes, then "numberless intermediate varieties linking closely together all the species of the same group most assuredly have existed. The number of intermediate and transitional links between all living and extant species must have been inconceivably great. Yet," Darwin adds, "if this theory is true, they must have all existed at the same time on earth, linking together all the species in each group by gradations as fine as our existing varieties."

Now if all these intermediate varieties were to coexist at the same time today with all the species that now are on earth, the groups now called species would cease to be species, for all you would have would be a continuous connection of one with another.

Now what about the fossil remains of the varieties that became extinct? Darwin answers this by saying the geological record is imperfect. And he goes on to say, "And with respect to the fossil remains serving to connect man with his ape-like ancestors, the discovery of these fossil remains has been a very slow and fortuitous process. Nor should it be forgotten," he adds, "that those regions which are most likely to afford such fossil remains connecting man with some extinct ape-like creatures have not yet been searched by geologists."

Now let's apply Darwin's theory of evolution to man. Let's begin by assuming the very point that is in question. Let's assume that man differs in degree only, only in degree from apes. On that assumption, making that assumption, the discovery of fossil remains then does fill in the missing links between man and apes.

In a chart of man's family tree, presented in *Life Magazine* some few years ago, you can see at the top modern man contemporaneous with the four anthropoid apes: the orangutan, the gibbon, the chimpanzee, and the gorilla. And then moving down you see modern man's most immediate ancestor, Cromagnon Man, who lived about twenty-five thousand years ago in Southern France. And a little earlier in the insert there is a man recently discovered, a fossil recently discovered, the Hottu man in the direct line of the Cromagnon man. But then there are other shoots off to the side, there are other possible missing links, the Neanderthal Man, who is now dated in somewhere between fifty thousand, a hundred thousand years ago and earlier and more remote, the Heidelberg Man and the Swanscombe Man about six hundred thousand years ago. And toward the bottom of the line, still more remote, are *Pithecanthropus erectus,* found in Java, and the South African ape-man probably living a million years ago, both of whom are really questionable as to whether they are humans or apes.

MENTAL DIFFERENCES BETWEEN APES AND HUMANS

Now all of these are reconstructions from a few bones, usually the jawbones or the bones of the skull. And all of these reconstructions from fossil remains, bear only on man's anatomical resemblance to the apes or other primates.

Lloyd Luckman: As I understand it, man's resemblance to the apes and to other mammals doesn't depend solely on anatomical resemblances, Dr. Adler. There are physiological resemblances as well. And in particular I would like to emphasize the embryological resemblance because in the fetus, the developmental stage of the human fetus, there are direct parallels in the evolution, anatomically and physiologically, between man and mammals.

Mortimer Adler: That is quite correct, Lloyd. All of these evidences, the physiological and the embryological along with the anatomical, all of them I think, however, show just two things: first, the evolutionary origin of man's human body; and second, man's very close bodily affinity with the primates and especially the anthropoid apes. On the other hand, we must not forget the great differences anatomically and even physiologically between man and the apes.

Here in a fundamental book on the subject by Ashley Montague, *An Introduction to Physical Anthropology,* Professor Montague lists some fifty differences, anatomical differences between man and ape, and then says there are many other physiological differences as well. Nevertheless these differences, all of them, do not separate man from ape. It isn't in body that the separation takes place. The human species, as you know, is not defined by any particular bodily part or characteristic. What is the name the biologists give to the human species when they separate the *Hominidae*, which are the class of men, from the *Pongidae*, which are the class of apes in the *Anthropomorpha* class. How do they do that?

The *Hominidae* they define as a genus having one species, that species being defined as *Homo sapiens*. The only species which is sapient or has enough intelligence to become wise. And that, it seems to me, is the main point. It is the mental difference or the psychological difference that counts.

Let me tell you a story that I think illustrates this point very nicely. It was during the first years of the last war and young men were being drafted on all sides. A colleague and I were teaching a Great Books class and as sometimes happens in a Great Books class the question of man's nature arose. Was man different in degree or kind from the anthropoid apes? And my colleague said to the class, "Well, now let's suppose that into this room walked an ape-like creature, long arms shaking, hairy chest, protruding jaw, and

receding brow." "And suppose," he said, "that though he looked like this, he also appeared to be quite thoughtful." And showing a picture of a chimpanzee apparently deep in thought, my colleague said, "Why, that even looks like a philosopher. It looks like Dr. Adler here." "Now," he said, "if this ape-like creature in appearance were to talk and act like a man, particularly if he were to talk philosophically," he said, "would you call him a man?" And a girl sitting in the back of the room said, "Times are hard."

That I think is the story and makes the point. Because the heart of the matter really lies in the psychological difference between man and ape, not in the physical resemblances or differences. The question is, is the psychological difference between man and ape a difference in kind or degree? Is it bridgeable? Is the psychological difference between man and ape bridgeable by intermediate varieties or not?

So there are two sides to the argument. If bridgeable, if the psychological difference between man and ape is bridgeable, then the fossil remains I referred to do then become significant because we can on that statement of fact imagine these intermediate links, these missing links to be psychological missing links to fill in the gaps psychologically, in the psychological series as well as anatomical missing links. We can imagine them to be psychological intermediates between man and the extant anthropoid apes. But if on the other hand the psychological difference is one in kind and is unbridgeable, then the fossils prove nothing. Then the fossils, I say, prove nothing because if the psychological missing link is impossible, then evolution cannot account for the origin of man's mind, even if it does account for the origin of man's body.

Lloyd Luckman: Now what you're just saying right now, Dr. Adler, makes me want to hear your comment, on this letter that we received from Dr. Judith Poole. She says, "Dr. Adler, I am a physiologist and find it simply impossible to doubt the evolutionary continuity of man's physical being with that of other species. But on the other hand, I feel equally sure that man's rationality represents a true difference in kind between him and these same species. His rationality then must have a unique origin but what logically demands that his entire being have this unique origin? Why cannot his special rationality have become superimposed on an organism that developed in the same evolutionary line as the other species?

Mortimer Adler: I have another letter here which bears on this same point. Let me answer Dr. Poole first and go on to the other letter.

Dr. Poole, I would say that the evolutionary origin of man's body, which accounts for all his physical resemblances to apes and even in embryological development is not—those facts are not inconsistent with the creation of man's soul or mind. Instead of saying that God created man out of dust, we can say that God created man out of an ape-like body by infusing a rational soul or mind into it.

As this letter here that I have in my hand points out, this letter from Mr. Robert Cush of San Francisco suggests that something new, a new ingredient could have been added at the moment of man's origin and that new ingredient would separate man in kind, really and irreducibly in kind, from all other species of animal.

Now let's come back to Darwin because his argument is of exactly opposite character. Let me return to Darwin on man and read you what I think are the crucial passages on this point. Let me make my point as sharply as I can: Darwin did not rest his case on the anatomical or the physiological resemblances. For him the core of the argument was presented in chapters three and four of *The Descent of Man* on the comparison of man's mental powers and the mental powers of animals. For he knew, Darwin knew well that if he could not show the continuity between man and other animals *in the line of mental development,* he would not be able to establish his hypothesis about man's evolutionary origin.

Now let's follow Darwin's argument in his own words. Let me summarize a bit since our time is so short. "We have seen," Darwin says, "that man bears in his bodily structure clear traces of his descent from some lower forms." "But it may be urged," he points out, "that as man differs so greatly in his mental power from all other animals, there must be some error in this conclusion." "My object" he says in these two chapters, chapters three and four of *The Descent of Man,* "is to show that there is no fundamental difference between man and the higher mammals in their mental faculties." "Animals," he points out, "possess the power of reasoning just as much as men do," even the power of abstraction. They even have rudimentary language. And as he points out, the higher mammals can understand human speech, even if they cannot speak. He discusses the language of monkeys and the higher apes.

And he, finally summarizing this evidence in which I will give you more completely next time, says there is a difference in degree here only. "The lower animals differ from man solely in the fact that man has a larger power of associating together the most diversified sounds and ideas." And his concluding point is that the difference in minds between man and the higher animals, great as it is, certainly is one of degree and not of kind. "A difference in degree, however great," he concludes, "does not justify us in placing man in a distinct kingdom."

Now there is more evidence that I have not time today to present to you. I would like to start next time by giving you more fully Darwin's evidence for thinking that man differs only in degree, mentally as well as physically. And then add to Darwin's evidence the considerable evidence that has accumulated in the last fifty years of experimental research on animal learning, animal speech, and animal thought. When one takes all this evidence together, there is a very strong case indeed for the evolutionary point of view. It tends to suggest that the missing links we considered today were psychological missing links as well as physiological and anatomical missing links.

Now if this evidence were undisputed or if this evidence were indisputable, that would be the end of matters. Darwin would be quite right and there would be no other theory of man's origin or nature, I think, that could be tenable. But I say that the evidence is not indisputable. I say it can be disputed. And after I have presented it at the opening of the next discussion, I am going to try to dispute it for you and show you the evidence I think equally strong if not much stronger on the opposite side of the case which tends to prove that man differs radically, essentially, tremendously, in kind, from all other animals, even the apes to whom we bear so close a physical or physiological resemblance.

9 The Answer to Darwin

Last time I didn't finish presenting the evidence for Darwin's view of man's nature and origin. I want to complete that today before going on with presenting evidence on the opposite side.

You will recall that I made the point very emphatically that Darwin never rested his argument on anatomical or physiological resemblances between man and ape, nor even on the evidence from embryology or fossils. He knew that even if it were completely established that man differed from apes or other animals only in degree, in all bodily respects, as, for example, in the amount of brain waves, that that would not make his point. Darwin saw that the crux of the argument rested right on the point of man's differences or sameness with respect to *mental powers*. His whole argument turned on the comparison of the mental powers of men and other animals.

At the very opening of chapter 3 of *The Descent of Man,* Darwin says, "My object is to show that there is no fundamental difference between man and the higher animals in their mental faculties." And he knew that if he could not establish the mental continuity between man and other animals, he could not establish his hypothesis about man's origin. Hence in these two crucial chapters in *The Descent of Man,* chapters 3 and 4, he offers evidence to support his conclusion, his conclusion, that I now quote, "The difference in mind between man and the higher animals, great as it is, certainly is one of degree and not of kind."

What is the evidence he offers? It all comes down to comparison of human and animal behavior. And that ultimately is the only relevant evidence on the question of the sameness or the difference of human and animal nature. Darwin's evidence, for exam-

ple, as he goes through these two chapters giving evidence after evidence is something like this: animals reason too as well as men, only animals to a lesser degree; animals use tools as humans do only perhaps in a more rudimentary way; animals have speech and communication though it is much more primitive than human speech.

Now since Darwin's day all the evidence collected by experimental animal psychologists from the study of animals in laboratories tends to confirm Darwin's conclusion. For example, all these laboratory works on animal learning, on trial and error learning by animals tends to show how clever they are in solving the problems the psychologists give them.

And then a great deal of work has been done on the question of animal communication. I shall mention later the work of Yerkes, who studied the speech of chimpanzees and his attempt to show how elaborate the speech of chimpanzees is. But most frightening of all of the studies are those made by the great German psychologist Wolfgang Köhler during the first world war on the island of Tenerife. Let me tell you some stories about what he found. He had a chimpanzee, for example, in a cage. And at the top of the cage some bananas were hanging. And around the cage scattered were boxes. Well, this chimpanzee put the boxes one on the other, scampered up the boxes, reached for the banana before the boxes fell, and pulled the bananas down.

Another chimpanzee was in a cage and outside the cage in front of him, but out of reach of his arm, were some bananas. And there were two bamboo sticks lying around. At first he tried to reach with one bamboo stick, and still couldn't reach the bananas. And then he tried to reach with another bamboo stick and still couldn't reach the bananas. And he sat back and held the two bamboo sticks in his hand and looked at them and nothing happened. And finally as he was looking at them they came into parallel lines of one another. And as soon as he saw them in parallel lines, he tried to fit one bamboo stick into the other, making a stick that was longer than either of the two sticks, he succeeded, reached for the bananas, and raked them in. Intelligent chimpanzee.

Now if all evidence of this sort that I have just been reporting were indisputable, then I think the problem of man's nature and origin would be solved so far as scientific reasoning is concerned. But as I told you last time, I do not think it is indisputable. In fact, I am going to dispute it right now. I'm going to try to show you that

in mind if not in body men differ essentially in kind from the ape and all other animals. I am going to present evidence for you on this point. And the evidence is going to be presented under three main headings.

Three Things Only Humans Do

Let me call your attention to three things that only humans do. One, only humans make artistically. Two, only humans think discursively. Three, only humans associate politically.

Now I'm going to proceed exactly as Darwin did, which I think is the right way to proceed, by comparing human and animal behavior. But I am going to come out with the opposite result, proceeding in exactly the same way. Because as I compare human and animal behavior, I find that there are certain things under these three headings that humans do and humans alone do, things that no animal does at all in any degree whatsoever. And these special things that humans do indicate a special mental power which humans have. That is the power of reasoning. And if this is established, it establishes the definition of man as a rational animal, which means that man and man alone is rational, not that man has more reason or more reasoning power or more rationality or more intelligence than some other animal. It means that man and man alone is rational.

How will the evidence of human behavior show the presence of something you can't observe, namely, reason, the power of reason? What right have we to interpret the evidence as showing the existence in humankind of this special power? I say to you that there are two marks in the evidence itself which tend to show the presence of reason. One, if human behavior is highly variable and, two, if it seems to show some understanding that no animal has, an understanding that is found or expresses itself in a grasp of the universality of things, of the universal aspect of things.

Only Humans Make Artistically

Last week I outlined the general shape this evidence would take to Mr. Luckman. And I asked Mr. Luckman during the week to pre-

sent it to people, including professors, and get from them their comments and objections. He has done that. And as I go on now to present the evidence, he is going to present the objections he picked up during the week and I am going to try to answer them. Are you ready, Lloyd?

Lloyd Luckman: Ready.

Mortimer Adler: Let me go to the first point then. Only humans make artistically.

Lloyd Luckman: Now I have an objection here.

Mortimer Adler: So soon?

Lloyd Luckman: Right away.

Mortimer Adler: Right away.

Lloyd Luckman: In discussing this particular point, the immediate reaction that even I have to this challenge of yours is that we know how beautifully a spider spins his web. We have seen the perfection of a bee's hive. We have seen beavers engineering excellence in the dam. So how can you say that only man can make things and make them artistically?

Mortimer Adler: My answer to that objection, whether it comes from you or anybody else is, first of all, that I am not concerned now with the excellence, which is the way you are using the word *artistically*, the excellence of the animal's production. Because it is quite true that the spider's web is often more perfect, more subtly perfect than any human lace could be. It is not the excellence of the animal's production, but rather the way in which animals make and humans make. I say that animals are makers by instinct and humans are makers by art. And in that difference, makers by instinct and makers by art, lies the whole difference between man and animals because animals act instinctively and human art represents the influence of human reason.

What is a sign that animals make by instinct only and men by art? It is that in a given species of animal, whether it be a beaver or a bee or a bird, the production is exactly the same, generation after generation, because the instincts are the same. Whereas in human production, works of human art from one tribe to another, from one century to another you have a great variability, and more than that an improvement, a perfection of the art.

We received a letter last week which perfectly makes this point. It comes from Thomas McGurney, who is a high school student in San Mateo. It is an extraordinarily good letter. Young Mr.

McGurney quotes the eminent French naturalist, Henri Fabre, a great student of insect life, as saying, "There is never any improvement in the spider's spinning of its web during the spider's life span. Furthermore a spider living today spins his web in the same manner his ancestors did a hundred or a thousand years ago." There is no improvement in the course of generations. "Contrast this," young Mr. McGurney points out, "with the way in which the individual man increases his skill during his own lifetime in any art or the way in which the human race increases all its skills and arts in the course of human history. This shows a gap which," as young Mr. McGurney says, and I agree with him, "is an unbridgeable difference between man and animal."

But there are two more ways of seeing it. First, it is true, Darwin is right when he says that animals use rudimentary tools. He describes monkeys as using rocks as weapons or stones to crack nuts. And I showed you a while back how a chimpanzee made a tool out of these two bamboo sticks and used it. Yes, it is true that animals may use tools of this kind and therefore one shouldn't say of humans that they are the only tool-using animal. But think of this: man is the only animal who makes machine tools.

What is a machine tool? Think of the production of Grand Rapids Furniture. Think of the assembly lines on which automobiles are turned out. Humans have made a machine and puts into that machine specifications that are represented on a blueprint so that the machine then turns out an indefinitely large number of pieces of the same kind, pieces of furniture, automobiles. This shows that humans can separate the idea of the thing to be produced from the individual production. Humans don't just make things individually. They can put the making into the machine and the machine turns out a number. This is a sign of art in human making and here is seen man's grasp of the universal, the plan, the idea, apart from the individual instance.

One other point about human making, I would say that only man produces works of fine art. The kinds of things Mr. Luckman referred to, the beaver's dam, the bird's nest, the bee's hive, these are useful things satisfying biological needs. Only man makes things which satisfy no biological need at all. They are made for pleasure, for enjoyment. That's why I would say that the Cromagnon Man, who lived about twenty-five thousand years ago

in the caves of Southern France, and drew charcoal drawings of reindeer on the cave walls was truly human, because Cromagnon Man was there making something strictly for the pleasure of imitation and not for any biological utility in the struggle for existence. Human making is different from animal making.

ONLY HUMANS THINK DISCURSIVELY

Now let me go to my second piece of evidence, under the heading "Only humans think discursively."

Lloyd Luckman: Well, now right from this point, Dr. Adler, you've already given us some very compelling evidence and as I talked to the professors whom you referred to about this particular point, they were most emphatic that animals do solve problems, and problem-solving is another way of expressing intelligence. When you talk about intelligence, you say, "What is the ability of this student or this animal to solve a problem?" So with the emphasis on problem solving being the same as intelligence, intelligence meaning thinking, I would say that animals think discursively.

Mortimer Adler: Let me answer that objection, Lloyd.

Notice what Mr. Luckman said. Animals solve problems. Certainly they do. In fact, all animal thinking takes place in the course of problem solving.

Now what is the next point? All the problems that animals solve are problems that arise from basic biological needs, problems they must solve in order to survive in the struggle for existence. And they solve them by trial and error or by perceptual insight the way Köhler's apes did.

Now men solve problems like that in that way too. Put a man in a room, lock the doors, close the transom, seal the windows, pour smoke under the door, yell fire, and that man, as soon as panic seizes him, will start to fight his way out of that room by trial and error, claw his way out just as an animal does.

But the point is that men think in another way. In the first place, they think about problems that there is absolutely no need for them to solve so far as their biological needs, their struggle for survival, are concerned: the problems of mathematics, the problems of philosophy, the problems of any of the theoretical or speculative sciences.

And in the second place, the manner in which they think about those problems is quite different. An animal, when thinking about or solving a problem, is active. He uses his senses, uses his limbs, runs around. But a man thinks in a different manner. You all I'm sure have the image of the human thinker. It is given us by that statue of Rodin's which is here in San Francisco, *Le Penseur.* If you think about that famous statue, I want you to notice something. There is the posture of human thought. And what you see about that posture is intense bodily inactivity. Only men sit down to think about what is important and not urgent.

Now I said at the beginning that only men think *discursively.* Why did I say "discursively"? The word *discourse* connects with the word discussion. I meant that only men think in words, in words that are abstract. Now you may say, and I've already told you, that Yerkes has discovered a fairly elaborate language in the possession of chimpanzees. Sure monkeys chatter to one another and chimpanzees are the highest form of monkeys and they chatter to one another. But what is this monkey chatter like? What are the 125 so-called "words" that Professor Yerkes found in the language of chimpanzees? They are all emotional outcries, expression of need, of pain, of pleasure, of rage, of hate, of hunger, of sex. Humans have such cries too. We say, "Oh, ah, ouch." That is like the monkey's cry. But we also have a syntactical language. We, in thinking, make sentences. And in those sentences are words that are abstract, that refer to things that cannot be perceived, but only understood. Human language is the only language that is syntactical, has parts of speech and sentences. And, believe me, the day the first monkey or chimpanzee utters a single sentence, one single sentence, I'll be quite willing to believe that there is only a difference in degree between man and ape.

ONLY HUMANS ASSOCIATE POLITICALLY

Now let me go to my third main point, that only humans associate politically.

Lloyd Luckman: Now, Dr. Adler, as I discussed this point I got an immediate reaction and almost a violent reaction in terms of the resistance to the implication that animals don't associate. They pointed out the herd instinct but they also indicated, for example,

among insects, whether you are thinking of wasps or you are thinking of termites or you are thinking of ants, a tremendous hierarchy, an authority structure. And this again gives evidence, you see, of their direct parallels with mankind's actions. And so my challenge is how in the face of that kind of evidence on the side of those who argue against you that you could say that only human beings associate socially in this fashion?

Mortimer Adler: Well, Lloyd, I didn't say that only humans are social. I didn't say that only humans are gregarious. Obviously it is quite true what Mr. Luckman says, that there are many other animals that are social and gregarious. I said, "Only humans associate politically." Man is the only political animal.

Let me explain that. All the other animals that are social or gregarious are so instinctively. The organization of the beehive, of the ant colony, of the termite colony, these are all instinctive organizations. They do not change from century to century, from generation to generation. But humans form *by reason* the conventions, the constitutions, the laws, the rules unto which they live. And that is why in human families or in human states, political societies, there is such a great variability from tribe to tribe, culture to culture, epoch to epoch, century to century.

Man is the only animal who devises the constitutions and laws under which he lives. This is the evidence of his reason and freedom. In fact, instead of saying man is the only political animal, what I perhaps should say even more sharply here is that man is the only constitutional animal.

Now are there any more objections, Lloyd?

Lloyd Luckman: Yes, I have one or two more objections and these would come under the heading of concern for the development, for example, of human beings. Take the infant for instance. There is a period in the infant's life when it isn't fully rational. And in that period then it is also human. And another closely allied questioned would be based on the unfortunate human being who is either imbecilic or moronic and therefore is in a state really of vegetation that people say they are vegetables. How can you call them human beings or humans and rational beings?

Mortimer Adler: Well, I think in answer to Mr. Luckman's question, which is an objection I'm sure that many people would make, I would say that the baby and the idiot or imbecile are clearly humans. And we treat them as such in terms of our laws of

murder and general laws concerning the treatment of persons. Both the baby and the idiot have the potentiality of reason even though reason as a power has not yet matured in the human infant to the point of use. And even though in the idiot or imbecile there is a pathological impediment to the use of reason.

But let me show you this. Think of a baby and a pig. You don't see any more reason in the baby than you do in the pig. They act very much the same way, but there is this difference: the baby usually grows up to be a rational human being; the pig never does. Or take the idiot and the dumbest of animals. Modern medical research is able to cure the idiot—we are able to cure creep idiocy, for example. And some day may be able to cure Mongol idiocy. But the stupid animal is not subject to cure. This shows the presence in the baby and the idiot of the potentiality of reason absent from the animal who has no reason at all.

Now I would like to add to this one very important point. To say that man is a rational animal is not to say that humans are always reasonable or that they always act rationally. On the contrary, that is too seldom the case. An interesting point is that only man is ever unreasonable. Only man is irrational. Only man goes insane or becomes neurotic.

Lloyd Luckman: Hold on.

Mortimer Adler: Yes?

Lloyd Luckman: In this matter of neurosis and man becoming neurotic, we have evidence that psychologists have been able to make rats in their mazes frustrated and neurotic, so it's not only humans who can degenerate in that fashion.

Mortimer Adler: The experimental evidence Mr. Luckman mentions is very interesting. It's true that in recent years psychologists with laboratory animals, usually rats, sometimes cats, have tormented them into developing what the psychologists call neuroses. Actually by creating, through conditioning in the animal, a kind of tight conflict of impulses, the animal breaks down under the tension of that conflict into a severe frustration that I admit might look like a neurosis. But think of this difference. It takes a psychologist to give a rat something like a neurosis. Rats, cats, other animals left to themselves don't get that way. But human beings are quite able to become neurotic without the help of psychiatrists. For the most part that is the case. And that I think is quite remarkable evidence of the difference between the rational

animal who can become irrational, unreasonable, insane, neu-
rotic, and the poor rat or cat that it takes a psychologist to upset.

Next week I'll go on to sum up the issues. I am going to weigh
as carefully as I can the evidence on both sides. But when we have
weighed the evidence on both sides, I then want to go on to see if
I can show you the deep importance that this issue has or should
have for all of us, both theoretically and practically, affecting our
lives morally, politically, and spiritually.

10 The Uniqueness of Man

In this concluding discussion on Man I want to sum up and assess not only the evidence on both sides of the question but also the importance of the issue itself.

Last time I began by reporting to you the experimental evidence in regard to animal intelligence, especially the perceptual insight of the chimpanzee. And to demonstrate some of the experiments that Köhler did with chimpanzees, I showed you how a chimpanzee made a crude tool to fetch bananas by fitting together two bamboo sticks to make a longer one. And as a matter of fact, I fumbled doing this last time and someone who saw the show told me during the week that I had fumbled and didn't do it as well as the chimpanzee. Well, it's hard to be an intelligent chimpanzee. And though I practiced, I didn't quite succeed.

Then I went on to present the evidence to support the conception of man as distinct in kind from other animals on the ground that man and man alone is rational. I presented this evidence under three main heads. Let me remind you of what those were: first, that only humans make artistically; second, that only humans think discursively; and third, that only humans associate politically.

ONLY HUMANS HAVE A HISTORY

In connection with this third main heading there are two further points I would like to make now which I did not have time to make last week. The first of these is that only human life has an historical development. Let me explain that. In the case of all

other animals, all that they pass on from generation to generation is a biological inheritance, a physical inheritance contained in the germ plasma. But humans, in addition to inheriting biologically from their ancestors, inherit culturally. There is cultural transmission, the transmission from generation to generation of ideas and institutions.

Mrs. Postel of Mill Valley raised this very question when she said, "Is not a difference in kind indicated by the fact that man is able to leave to his posterity a recorded collection of knowledge which his thinking and experimentation in all forms of human endeavor have produced?"

Yes, Mrs. Postel, that is precisely the point. Without such an inheritance of ideas and institutions, no history would be possible. And that is why only man has such an inheritance, because man and man alone is an historical animal.

This leads me to my second additional point which is that only humans either merely subsist or live well. In the case of all other animals, they are more or less successful in the struggle for existence. They are more or less successful in a matter of degree in satisfying their biological needs. But only man can lead two different kinds of life. In fact, only man on earth has lived two different kinds of life, prehistoric man leading a life on the level of a beast or brute, historic man leading a civilized life.

And the reason why man even now can lead two different kinds of life is the fact that is nature is compounded of two different principals: animality and rationality. This I think answers the question raised by Mr. John Marlow of San Francisco, this fact that man has capacity for two modes of life. For if prehistoric man, Mr. Marlow, was really man and yet did not do some of the things that civilized man now does, then prehistoric man must nevertheless have had the potentiality for doing it, just as the young baby does today. The development or maturation of potentiality is not evolution.

MAN ALONE IS RATIONAL

Now what does all this prove? All the evidence I gave you last time and the evidence I added today, what does all this evidence prove? I think it shows that man and man alone is rational.

Lloyd Luckman: Now it seems to me really, Dr. Adler, that you've been conducting a one-sided argument. As between man and animal, you've allowed man to speak for himself, and once more to be the judge in his own case. No one asked the animals what they think about this. And this reminded me of Bertrand Russell's comment on a very famous quotation from John Stuart Mill in his *Utilitarianism.* May I read it?

Mortimer Adler: Please do.

Lloyd Luckman: John Stuart Mill wrote, "It is better to be a human being dissatisfied than a pig satisfied. It is better to be Socrates dissatisfied than a fool satisfied. And if the fool or the pig are of a different opinion, it is because they only know their own side of the question." Now Bertrand Russell's comment on this was, "No one has asked the pig how he feels about it." So, you see, I say no one has asked the animals what they think about the difference between themselves and human beings.

Mortimer Adler: Well, Lloyd, that point, it seems to me, cuts both ways. Mr. Bickle of Burlingame this very week sent us a clipping from *Time Magazine* which reports that the bower birds of Australia decorate their nests. Now you recall I said last week and repeated just a moment ago that only man is a fine artist, making things sheerly for enjoyment and not for use. But according to this clipping from *Time Magazine,* the investigator of the bower birds says that, I quote, "Sometimes you can see the bower birds indulge in purely decorative art, solely for recreation and entertainment of friends," end quote. Well, all I can say is that I wish we could ask the bower birds why they make such a fuss about their nests. And I would be willing to bet that if we could ask the bower birds, the answer they gave us would be on my side of the issue, not on the side of those who think that the bower birds are fine artists.

Now it seems to me, Lloyd, that the argument does not depend on our asking questions of men and animals. It depends entirely on our observing behavior, our behavior and their behavior. It is what the behavior tells us men do and animals don't do, not what men say they do and animals don't talk about. Nevertheless this objection of Mr. Luckman's raises for all of us, I think, a very important point of logic.

Negative evidence is always inconclusive. We can never be sure that the negative evidence is not the result simply of our failures in observation. On the positive side, we can infer man's powers from

what we observe men doing. But on the negative side, we cannot be certain simply from the fact that we don't observe animals doing certain things that they lack the powers that men have.

Now notice, I said we cannot be certain. But certitude is not to be expected in the course of scientific reasoning. We must be satisfied only with probability. And it is in terms of probability, the opposed probabilities, that I am now going to try to sum up the weight of the evidence on the two sides of this great and important issue.

First, in regard to man's body, here let me say that the evidence seems to me to be overwhelmingly in favor of believing or holding that man's body differs only in degree from the bodies of other animals. This, supported by further evidence from embryology or by the discovery of fossil remains, I think, tends to render highly probable Darwin's hypothesis about the evolutionary origin of the human body. But on the side of the human mind I think the evidence is equally overwhelming, showing the equally great probability that man's mind differs in kind from animal intelligence.

The intelligence of animals is a sensitive intelligence, an intelligence active in perception, memory, and imagination. Humans have that kind of intelligence too, although as a matter of fact they often have less of it than some non-human animals do. Animals often have greater perceptual acuity than humans, or longer memory. But though animals sometimes have a higher degree of perceptual intelligence, or sensory intelligence, they don't have the kind of intelligence that man and man alone has, the kind of intelligence that I think is abstract or rational intelligence.

Lloyd Luckman: I just wanted to ask you two questions about what you've been saying, Dr. Adler. First of all, you said in regard to man's body that the fact that it is differing only in degree supported the hypothesis of evolutionary origin, Darwin's hypothesis. Now if man's mind differs in kind, what does that imply about the origin of the human mind? That is my first question. And my second question would then be, How can human nature, which is only one thing, not two, have more than one kind of origin, differing origins?

Mortimer Adler: Let me answer your two questions in the order in which you gave them. First, if there is nothing in nature like the human mind, nothing at all like it in degree, then it seems to me that the human mind could not have evolved from natural

things by natural causes. Its origin would require supernatural causes, divine creation.

And I see no difficulty whatsoever in the hypothesis that God introduced a new principle into the world at a certain stage of its development, thus transforming what already existed into a new kind of things. Thus, for example, taking an animal body and by introducing into it the principle of a rationality or a rational soul, at that moment creating man. This is also what might have happened at an early stage of development of the earth when God breathed life into inorganic matter.

In the very last chapter of *The Origin of Species*. Darwin says, "I see no reason why the views given in this volume should shock the religious feelings of anyone." And he leaves open the question whether vegetable and animal organisms develop from one or from distinct primordial forms created by God. And then in his very last paragraph, in fact, his last sentence, he says, I quote, "There is grandeur in this view of life with its several powers having been originally breathed by the Creator into a few forms or into one. And that from so simple a beginning, endless forms most beautiful and wonderful have been and are being evolved."

Now I say that if God, according to Darwin, could have created living organisms as distinct in kind from inorganic matter, so God could also have created the human mind, man's rational soul if you will, as distinct in kind from all forms of sensitive life as it exists in other animals.

I turn now to the importance of this issue, its importance considered theoretically, that is, the importance of it as it affects your thinking. And I should like to begin by asking you a direct question. Is your own mind on this issue open or closed? Is this issue itself an opened or closed issue for your mind? Now I know from much experience that most educated men and women regard this issue as closed.

CLOSED MINDS ON MAN'S NATURE AND ORIGIN

I remember giving a lecture on this subject at the University of Chicago before a large audience of students and faculty in the division of the biological sciences. And I was shocked when I discovered at the end of the lecture that most of those advanced students

and scientists in the field of biology and evolution had never before heard anyone in their lifetime argue the facts against Darwin's theory of man's origin and nature.

And only in the last few weeks people who have been watching and taking part in this series of discussions and watching these programs have said to me that they had never heard anyone before, as they went to school and carried on discussion, never heard anyone before offer evidence on man's nature or origin against Darwin. This seems to me a very sad state of affairs. This one-sidedness, this closed-mindedness, is an unwarranted dogmatism that is, in my judgment, dangerous to the spirit of free inquiry and, according to the late Alfred North Whitehead, absolutely contrary to the true spirit of science itself.

Whitehead tells us how he overcame such dogmatism in his own life when early in his life, at the very turn of the century, he was shocked by the fact that Newton was being proved wrong my modern physics. For centuries Newton's laws of motion had been supposed to be the last word on the structure of the physical universe. And then in this century, modern physics changed all that. And this awakened Whitehead from his own dogmatic slumber. He says, "Nothing is more curious than the self-satisfied dogmatism with which mankind at each period of its history cherishes the delusion of the finality of its existing beliefs. Skeptics and believers are all alike." And then he adds, "At this moment scientists and skeptics are the leading dogmatists. Such dogmatism," he goes on, "is the death of philosophic adventure. The argument on any basic issue is never closed." This certainly applies, does it not?, to the issue about man's nature and origin. Like Newton, Darwin too can be wrong.

Now I don't hope to convince you, I do not expect I can convince you in this short series of discussions that Darwin is wrong. But I would like to persuade you that the issue itself is far from being closed, that there is evidence on both sides, that there is reason to weigh the evidence on both sides. Why, I keep asking myself and I'm asking you too, are there so many closed minds on this subject? I think partly the reason is that science is taught dogmatically in our schools. But I think there is another reason in part and that is the fact that evolution is one of the things which has emancipated man from religion, from the belief that God created man in His own image with a special dignity and a special destiny,

including divine rewards and punishments. Let me repeat that: including divine rewards and punishments.

Lloyd Luckman: Now, Dr. Adler, on that point is this merely a theoretical matter or does it also have a practical aspect? In fact, isn't it more practical than theoretical, this issue that you are just raising? Because doesn't it concern human actions and emotions as much as, if not more than, it concerns thought?

Mortimer Adler: It seems to me that the belief or disbelief that God created man with a special dignity and a special destiny that accords therewith has profound practical consequences for the conduct of life, consequences which many persons wish to avoid. But it also has profound consequences of another sort that many persons wish to embrace. And this brings me to the consideration of the issue in practical terms which in some sense is my chief interest today.

DARWINISM IS INCOMPATIBLE WITH HUMAN DIGNITY

Let me begin this consideration of the issue in practical terms by asking you to face one fact with me. Central to the whole moral, political, legal or juridical, and religious structure of Western civilization is the distinction which you all know and you all use every day, the distinction between person and thing. You have no doubt about this. You never call a shoe a person. You never call even a beloved domesticated animal, a house pet, a cat or a dog a person. You know the difference between persons and things. And this distinction you recognize is not one of degree, but one of kind. You don't say that something is a little more or less of a person, a little more or less of a thing. There is a sharp line that divides persons from things. Now this distinction between person and thing is identical with the distinction between man as a rational animal, distinct in kind, not degree, from all other animals as brutes.

Notice the basic or the fundamental properties which follow from man's possession of personality, from the fact that man is a person, not a thing. If man were not a person, he would not have special dignity or special status, social or political status in the world. Things do not have this dignity. Things do not have this status. Moreover all the rights and liberties we demand for human

beings, their natural and legal rights, their natural and legal liberties, these belong to human beings as persons. They do not belong to things. Only persons have moral responsibility. We do not hold things morally responsible. And personality is the essence of human equality and of man's superiority to other animals.

Let me spend a moment more on this last point. When the Declaration of Independence says all men are equal, what that means in its deepest understanding is that all human beings equally or alike have the quality, the character, of being persons. Their equality is the equality of persons and all the rights and privileges and liberties that go with being a person. Not only is human equality to be understood in the fact that all men are persons. But the superiority of men over animals is also in terms of humans being persons and animals being things.

Justice requires us to treat equals equally and unequals unequally. And when the unequals are regarded as unequal in kind because one is a superior kind and the other is an inferior kind, justice requires us to treat that kind of inequality different from the inequality which is merely an inequality in degree. Now I say that if man is not superior in kind to other animals, then the rules of justice in terms of which we treat men one way and animals another way would all be wrong. We would have to revise all our standards in the treatment of humans and animals.

Now we regard humans as superior in kind and that justifies us in regarding humans as ends, to be treated as ends whereas brute animals or other things to be treated as means, can be used. Because all humans are equal in kind with one another, because all are persons and as persons equal in kind, one human being must treat another human being as an end.

But suppose that humans were superior to other animals only in degree, that humans were higher animals and other animals were lower animals. Then if humans being higher animals and other animals being lower justifies humans in treating other animals as means, then by the same principle of justice if there are superior races of humans, they would be justified by that difference in degree in treating inferior races as things, exploiting them, enslaving them, even killing them. In fact, if man differs from man only in degree and man from animal only in degree, then by the principles of justice we have no defense against Hitler's doctrine of superior and inferior races and the justifica-

tion he would give for the superior to enslave, exploit, and kill the inferior.

Finally I come to my last point of practical significance, the validity of the three great religions of the West: Judaism, Mohammedanism, and Christianity in both its Catholic and its Protestant forms. The validity of these three great religions depends on the truth of the proposition that man is created by God in His own image with a special dignity and a special destiny. If this proposition is not true, then in honesty and frankness and clarity of mind we ought to repudiate Judaism, Mohammedanism, and Christianity as idle myths, as deeply and essentially false.

I'm not asking you to accept my view that the basic tenets of Western moral, political, legal, and religious beliefs are true and that Darwin's view of man's origin and nature is false. But I am saying to you that you must decide, decide you must, between these two views. Both cannot be true. You cannot have it both ways. You cannot keep your religious, your political, your moral beliefs and also with another part of your mind hold Darwin's view of man's origin and nature to be true.

Let me be sure that I've got this point clear. Our actions, I think, should be consistent with our beliefs. A letter from Mrs. McLord raised three points that I would like to consider finally. She said, "Why do you think it is important to take sides on the issue about man's origin and nature? And how does taking sides influence one's behavior? And why isn't it enough," she says, "merely to be informed about the opposite views of the question?"

I think I have answered these questions, but to be sure let me repeat these two basic points. I think one's actions should be consistent with one's beliefs. We are all guilty of hypocrisy if we believe that Darwin is right and that at the same time go on acting as if he were wrong, enjoying the privileges of human dignity, even demanding those privileges but at the same time denying the very facts on which that dignity and its privileges are based.

11 How to Think about Emotion

Today we shall consider Emotion as one of the Great Ideas. Sometimes we speak of the emotions, calling them passions and sometimes we use other words like sentiments or feelings. In any case, when we talk about the emotions we are talking about such things as anger, fear, love, joy, and sorrow.

The approach to the study of the emotions is quite different in modern times than in ancient times. In modern times the emotions are the subject matter of psychology and physiology. The physiologists and psychologists are concerned mainly with describing the facts of the emotions of men and animals and the conditions under which the emotions are aroused and the course they follow. There is, of course, one exception here. In modern times that branch of psychology called psychoanalysis or psychiatry is concerned with the emotions more practically. It's concerned with the therapy or cure of emotional disorders.

But in the ancient world, it wasn't psychology or physiology that was concerned with the emotions, but two other disciplines: ethics and politics. Because in the ancient and medieval world, in fact, almost until modern times the chief concern with the emotions was a moral concern, not what the facts about the emotions were so much as how to control emotions, what to do about the emotions.

EMOTIONS ARE WIDESPREAD BODILY COMMOTIONS

As we consider the emotions today, let's postpone for a while the moral problem of the control of the emotions and begin our

consideration with a psychological discussion or description of the facts about the emotions. And there is no better place to begin than the one fact about which everyone, ancient and modern, every student of the subject is agreed. And that fact is that the emotions or the passions are not simple feelings like pleasure and pain but very complex, organic disturbances, widespread bodily commotions. I think, though it may sound a little queer to say that emotions are commotions, it is true that the emotions are widespread bodily commotions involving many changes in the deep internal organs as well as in the surface of the body.

The ancients knew this as well as the moderns. Aristotle, at the very beginning of his study of the emotions was perfectly aware that an object does not cause flight unless the heart has moved. And then in the Middle Ages, Aquinas makes it perfectly clear that he understands that the passions occur only where there is widespread bodily change. Still a little later, long before modern times, the great English physician and physiologist, Harvey, the man who did the work on the circulation of the blood says, "In almost every affection, appetite, hope, or fear our body suffers, the countenance changes and the blood appears to course hither and thither. In anger, the eyes are fiery and the pupils contracted." He was wrong about that. As a matter of fact, in anger the pupils dilate; they don't contract. "In modesty, the cheeks are suffused with blushes. In fear and under a sense of infamy and shame, the face is pale."

The ancients, knowing that the emotions were widespread organic or bodily disturbances, knew two other things as consequences of this. One of the reasons why the word *passion* is used as a synonym for emotions is because the word *passion* signifies the very opposite of action. When we are emotional we are suffering something that attacks us. In fact, an emotion is a passion in the sense of the body being passive to something affecting it from outside, some object that is causing this bodily change that we suffer. And the other fact that is a consequence of this understanding of the emotions as deep organic disturbances is that only men and animals can suffer emotions. It is wrong to attribute emotions to God. When it is said that God is angry, that statement can't possibly mean that God suffers the emotion of anger because no purely spiritual being could have an emotion. An emotion is a bodily disturbance.

There is one twist that the moderns have put upon this fact. And that twist in the history of the subject is associated with the names of William James and a German psychologist by the name of C.G. Lange. It is called the James-Lange theory of the emotions. William James in his great work on psychology said, "We do not run away because we feel afraid. On the contrary, we feel fear because we run away." Let me read you the statement that James makes. "The emotional experience is nothing but the feeling of the bodily changes which follow directly the perception of the exciting fact." Common sense says we meet a bear, are frightened and run. But according to William James we do not run away because we are afraid, we feel afraid because we are trembling and running away.

Both James and common sense are each in a sense right. Now there is one really great addition that is made to this understanding of the emotions in modern times. In the psychological laboratory and in the physiological laboratory great efforts have been made to study very precisely by accurate measurement and recording the ways in which the body changes under emotional excitement.

I hope you'll permit me to speak of my own work in this connection. As a young man I spent a great deal of time in the psychological laboratory doing experimental work in psychology and physiology. And one of the things I worked on was the physiology of the emotions. Let me just briefly describe the kind of experiment we performed. During emotional change, emotional excitement, there is a change in the speed of the heart beat, in the speed and depth of breathing, in blood pressure, in the way that the blood is distributed throughout the body, a change in the size of the pupil, a change in all of the internal and external secretions. The sweat glands, for example, start acting up. And blood sugar is poured into the blood, and adrenaline is poured into the blood from the internal glands. All these changes happen during emotional excitement, and in a laboratory experiment it is possible to take a subject and attach various instruments to him so that when as we did in this case, fire a revolver off behind his head, or wind a boa constrictor around his neck, or kick him the shins to make him angry, you get an emotional reaction and all these various bodily changes are registered at once so you can see them all taking place.

The amazing thing that we discovered—and it's been verified many times since, is that in all the emotions, whether it's fear or anger or love or shock, any intense emotional excitement, all the bodily changes are exactly the same. When emotional excitement takes place these bodily reverberations take place. Well then you may say to me, "Well, why do we feel anger differently from the way that we feel fear or love?" And the answer is that it isn't in the feeling of the bodily change, but a difference in the object we're reacting to, a difference in the direction of the emotion, the bodily move we make away from or toward the object, and the accompanying feelings of pleasure and pain. It is these three things, not the actual internal physiological change, that makes us feel emotional excitement as being of a different sort, of anger or fear or love or joy or sorrow.

EMOTIONS ARE INSTINCTIVE

What I have just said becomes more intelligible when the emotions are understood as parts of a more complex psychological process. The emotions are the middle phase of a threefold instinctive pattern of response, a pattern of response that always originates with the perception of some object and terminates with some kind of bodily movement or overt action.

A man perceives some object in the field of his vision, that object excites, let's say, the emotion of anger, and it terminates when his arms and legs make the movements which are involved in fighting. But in between, the beginning of that distinctive reaction which begins with the perception of the hateful object and the termination of it in the actual acts of fighting, there is an emotional response inside the man. This emotional response has two aspects: one is the aspect of impulse, the emotion of anger that is aroused in him by this object tends to motivate his body and to make him want to fight; and at the same time, the response of anger is the feeling that results from those movements themselves.

Now, when I say that emotions are instinctive, that they are parts of a complex, instinctive process, what I'd like to have you understand is the meaning of that word *instinct*. The things which are instinctive in us are unlearned. And emotions are as unlearned as sensations are. For example, you don't have to teach a child, an

infant, to see blue. The child's eye is open, has normal vision, in the presence of that color the child sees blue. There is no need to teach the child how to fear. Given certain objects to which the child instinctively reacts, the child immediately feels fear. There is no learning involved.

In animals these instinctive patterns which involve emotions are often fairly complex. Think for a moment of the cat's instinctive reaction to a mouse, no learning involved. That's a very elaborate pattern of response. Similarly the sheep's reaction to a wolf, the reaction of fear and running away. Given the perception of the wolf, the smell of the wolf, the sheep starts to get afraid, and starts to run away.

But in human beings the instinctive responses are reduced to a very few things and they are extremely simple. For example, in the human infant, the instinctive response in emotional content of anger may be produced by the child being held. The restraint of the child's body causes the child to feel rage and to thrash about furiously. Or the human infant feels fear under two stimulations. A very loud noise and the child will cry and be afraid. And the other thing is a loss of support. These are the only two instinctive reactions in the human infant that are accompanied by the emotion of fear.

Though the emotions are instinctive in man in the sense of being unlearned, they are not free from acquired modifications. Human emotions are subject to many acquired modification. Unlike the lower animals, where there is very little emotional training or learning possible—very little modification of the emotions in the course of an individual animal's growth and experience—unlike animals humans learn a great deal in the field of the emotions.

Many things are acquired through experience and thought that change the character of an adult's emotional responses from what it was in infancy or childhood. For example, as we grow up we acquire the fear of certain objects, a fear which was not instinctive in us at birth. The fear that people have of high places, the fear that they have of certain smells, the fear that is aroused by certain sights, these are not instinctive but learned. They come from experience, so that there is some modification of the emotions on the side of perception.

As we grow up and undergo various types of social training in the home, in our communities, and in school, we learn to control

our emotional response—we change the direction of our action. We, in fact, often inhibit the action, don't let it come out as easily as a child would. We don't cry, for example, the way children cry or get into the kind of temper tantrum that children display. This is the control of an emotional response that comes with growth and training. And in these two ways, on the side of perception and on the side of action, the adult's emotions differ from those of the child and there is a great deal of individual difference among adults according to their experience and training. The amazing thing about human adults as opposed to the adult of any other animal is how much individual difference there is from one person to another in the character, the intensity, the general pattern of their emotional life. Some of these changes or modifications result from training and some are merely the actions of experience.

Two Opposed Views of Human Emotions

This fact, that human beings have an emotional life that is subject to education or training, to being modified by experience, raises a fundamental moral problem, and from the point of view of psychoanalysis, a fundamental medical problem. And that problem is simply, What should be done about the emotions in the course of training human beings? As human beings grow up what should be done about their emotions? How should they be trained or controlled? Let's now turn to that problem.

Here there are two fundamentally opposed views about what man should do with his emotions. What is common to both of them is this, both views look upon man as having in him a fundamental conflict between reason and the passions, or as is sometimes said, between the higher and the lower natures of man, between his rationality and his animality. But one view regards the emotions, because they are the animal aspect of man—the bodily aspect of man—as wholly bad, and recommends that the emotions be purged, eliminated, extirpated, expunged from human life; whereas the other view regards the emotions as natural, being part of human nature and as such neither good nor bad, but able to be either, capable of being either good or bad according to the way in which they are controlled or used, put to use shall we say, in the moral life.

Now this first point of view, the one that looks upon the emotions as bad, has as its basic principle the conviction that the good human life is the *purely*—and I emphasize the word purely—the purely rational life. And to be a purely rational life, life must involve the elimination or avoidance of emotion. This view is extremely prevalent among certain mystical religions in the East. It is not so frequent or prevalent in the West. In fact, there are only three great examples or exponents of this view in the West: the Roman Stoics, Benedict Spinoza, and Immanuel Kant.

Let me read you what they have to say on the subject. The Stoics urge us, "Not to yield to the persuasions of the body and never to be overpowered by the motion of the senses or of the appetite. For to live well is to do one's duty and to set aside all contrary desires or emotional inclinations."

And then many centuries later the philosopher Spinoza said, "When a man is governed by his passions he is in bondage." That's what Spinoza means by human bondage, that famous phrase "human bondage" comes from Spinoza's *Ethics*, where he explains that bondage is enslavement—enslavement to the passions. He said, "When a man is governed by his passions he is in bondage. For a man under their control is not his own master, but is mastered by fortune in whose power he is, so that he is often forced to follow the worst course though he sees the better before him. A free man is one who lives according to the dictates of reason alone. Human freedom, human freedom insists then in the life of reason and as purely a rational life as possible for a man to live."

Finally, Immanuel Kant, the German philosopher, says, "An action done from duty must totally exclude the influence of every bodily or emotional inclination. Duty consists in obeying the moral law which I must follow even to the thwarting of all my inclinations."

Now let me summarize this. These three, the Stoics, Spinoza, and Kant, all of them recommend a policy of attrition toward the passions. Their force, the force of the passions, must be attenuated or even destroyed in human life in order to emancipate reason from their influence and to protect the will from their seduction. And according to these thinkers nothing is lost even if as a result of this the emotions completely atrophy and dry up.

The opposite view has a quite different character. Here the passions or the emotions are regarded as having a natural place in

human life and the aim therefore should be not to get rid of the emotions or eliminate them entirely but to keep them in their place. The passions are to be made to serve reason's purposes by restraining them from excesses and by directing their energies to good use in the course of the moral life.

This second view is one in which the same fundamental fact is recognized. There is in man a basic conflict between his reason and his passion, between his higher and his lower nature. But this second view does not think that that conflict must be resolved by completely eliminating the emotions. On the contrary, it thinks that the good life is one that can be lived not purely rationally but in accordance with reason, by which is meant a life in which the emotions so far as they play a part in human life are under control or moderated or disciplined by rational thought and rational principles, so that the emotions themselves and the energy of the emotions, have some role to play in a man's moral life.

Let me illustrate this point of view by telling you Aristotle's theory of the moral virtues. The moral virtues are, according to Aristotle, nothing but good emotional habits. According to Aristotle, the trouble is not with fear; fear is neither good nor bad, but it is fearing the wrong things or fearing them to excess or fearing them at the wrong time and place. A man who is emotionally controlled is a person who still has fear, but fears the right things at the right time to the right amount in the right way. And the person who has fear thus under control is a man who is courageous. It is wrong to think of the courageous man as a man without fear. On the contrary, the courageous man is a man who has fear but under control. He fears the right things and fears them to the right degree and under the right circumstances.

What are the vices here? Cowardice, which is fearing the wrong things or fearing too much or foolhardiness, which is not fearing enough or not being fearful when one should be fearful. And the same thing can be said of another basic virtue, the virtue of temperance, which is a moderation of appetite or lust or desire. And again, the extremes are of not having enough desire or having an excessive desire; these are emotions out of control and therefore vicious, whereas the virtue of temperance is a proper control of appetite or desire.

Now let me say at once that this is not only a view of Aristotle's and an ancient view of the matter; it is a view that a great modern psychologist like Freud also shares, though Freud tends to speak of these things in medical rather than in moral terms. For example, where Aristotle talks about reason and passion or reason and emotion, Freud talks about the ego and the id. Where Aristotle talks about virtue and vice, Freud talks about health, the healthy person, the integrated personality and the neurotic. But for the most part Freud is saying very much the same thing that I just reported Aristotle as saying. For according to Freud, mental health, having an adult character, comes about by a control of the emotions and not by giving them completely free reign.

I said that Freud used the words *ego* and *id*. What does he mean by ego? He says in his own language, "Ego stands for reason and circumspection, and the ego has the task of representing the external world." And by id, he means the untamed passions, the source of the instinctual life. Now Freud says quite plainly and I quote him word for word, "It is out of the question that part of the psychoanalytic treatment should consist of the advice to live freely, express yourself, give your emotions free reign." He points out, "That to give vent to all the emotions without regard to the demands of society or reality is to revert to infancy."

Now where the moralists speak of the necessity for regulating or moderating the passions or the emotional desires, Freud has, I think, an even more striking term. He says it is necessary to domesticate the emotions. It is as if the emotions were like a beast that had to be trained or housebroken. Freud's notion of growing up is a notion of domesticating the passions as one would train a beast to serve the ends of human life.

Now there is one further point here I should like to call your attention to. For Freud, a man acts reasonably when he uses his reason, what Freud would call his reality principle, to control his emotions. There the reason, the rational principle, is in the proper relation to the passions or the emotions. But if a man acts in an infantile fashion, and that means for Freud neurotically, if instead of controlling his emotions by reason, he lets his emotions go their own way and then rationalizes, reason comes in, but by rationalizing, giving an appearance of rationality to his conduct, such rationalization is neurotic and infantile and is not what Freud would mean by the ideal of an adult or reasonable life.

THE PASSIONS AND ORIGINAL SIN

We have been considering the central problem, a moral problem, concerning the emotions, which is the problem of how they should be trained or developed, controlled in the course of human life. Now this moral problem has a very interesting theological aspect, one that is connected with the Christian doctrine of original sin. Let me summarize the essential points of that Christian doctrine of original sin.

First of all, it is connected with the sin that Adam committed at the beginning of time, the sin that Adam committed when he disobeyed God's commandment not to eat of the tree of the knowledge of good and evil. And in consequence of that sin on Adam's part, according to the Christian doctrine of original sin, the whole human race inheriting this sin from Adam suffers the consequences of that sin by having a fallen or sinful human nature.

The really important question here is, What is the difference between Adam's nature, the nature that Adam had as God created him before Adam sinned, and man's present nature, the nature we speak of as man's fallen nature or man's sinful nature? According to the Christian doctrine, I am speaking now only of the Christian doctrine, the difference between Adam's nature and man's fallen nature, lies more than anything else in the altered relation between the reason and the passions, in the altered relation between the reason and the emotions in human life and in the constitution of man.

Before Adam sinned the lower nature obeyed the higher nature. The passions were perfectly obedient to reason and were under control. There was a perfect harmony, no conflict in the nature of man when man was in a state of innocence, and as the theologians say, he had preternatural grace. But in fallen man, in the man in this world who suffers, according to Christian doctrine, the consequence of original sin, there is a conflict between reason and the passions. The passions no longer obey the reason perfectly or are have perfect harmony with reason. They get out of control, get out of hand. And that is why we need to cultivate the moral virtues to form good habits of feeling, good habits of emotion, to put the passions under control, or as Freud would say, to domesticate them.

Let me summarize this by reading you a passage from the great Christian theologian, Thomas Aquinas. He said, "Man was from the beginning so fashioned that so long as his reason was subject to God, not only would his lower powers serve him without hindrance but there would be nothing in his body to lessen his body's subjection to his soul. But no sooner did his reason turn away from God by disobedience than his lower powers rebelled against his reason and his body became subject to sufferings that counteract the life it receives from the soul."

12 How to Think about Love

Today we begin the discussion of the Great Idea, Love, and we shall deal with this idea in successive weeks under four main headings: The Kinds of Love, Love as Friendship, Sexual Love, and The Morality of Love.

To begin with, we're concerned with these questions: Are love and desire the same or are they distinct? Does love exist in separation from desire, desire in separation from love? Is love ever born of desire or desire of love?

Lloyd Luckman: Dr. Adler?

Mortimer Adler: Yes?

Lloyd Luckman: I have another question that may be a bit off the point but may I ask it?

Mortimer Adler: Please.

Lloyd Luckman: Well, last week while I was discussing this problem with some people, they were a little bit puzzled about the idea of love and reference to love as an "idea." See, they rather think of love as something to be experienced or something that you feel or suffer rather than an idea. Now, if they don't want to think about it, how do you answer this?

Mortimer Adler: Well, Lloyd, it seems to me that love is both. After all, taxes are something you pay and suffer and complain about, but you can also *think* about taxes. People have written theories of taxation. The same thing is true of love; there is a theory of love. I think the Great Books show this very significantly.

There are two kinds of Great Books about love. On the one hand there are the theoretical or analytical books written by the scientists and the philosophers; on the other hand there are the stories of love and lovers written by the poets and the historians;

and it is these books, these latter books which contain the experience, or shall I say, the vicarious experience of love. Let me illustrate this by going to the poets and taking from them celebrated examples of love or of lovers.

I would like to begin with one you all know, the love of Paris and Helen. You remember Paris came from Troy, visited King Menelaus and stole his wife Helen away, took her back to Troy, and she became famous as Helen of Troy. And that story of the abduction of Helen reminds us all, of course, of the Trojan War, as told in the great epic by Homer, *The Illiad.*

Another picture of love, the love of Achilles, that great Greek warrior who loved himself so much, was so proud, that he sulked in his tent during most of the nine years of the war until his dear friend Patroclus, whom he loved dearly, was killed by Hector in battle, then that love overcame his great love for himself, his hurt pride, and he went forth, did battle with Hector and avenged Patroclus.

Well, let's compare these loves, the love of Paris and Helen or of Achilles and Patroclus, with some other loves, the loves, for example, of Romeo and Juliet. Nothing could keep Romeo and Juliet apart, not even at the moment of death. Romeo has before this moment said to Juliet, "My bounty is as boundless as the sea. My love as deep, the more I give to thee, the more I have, for both are infinite."

Now compare that love, the love of Romeo and Juliet, with the love of Dante for Beatrice. The legend as we have it is that Dante met Beatrice only once in his life. And having met her only once, he loved her forevermore, idealized her, almost reverenced her.

Compare Dante's love for Beatrice with two other loves, the love of Othello for Desdemona. And this love, ends as you know in the tragic fate of Desdemona. For in a fit of absolutely insane jealously, the insane jealously of love, Othello kills her. And as he kills her, confesses to the world that he loved too wisely, but not well. I misstated that, he loved her not wisely, but too well.

Compare these loves, the love of Romeo and Juliet, the love of Othello and Desdemona, with still another love, the love of Cordelia, the one good daughter of King Lear for her father. This love of the good child for a parent is certainly a different kind of love. And as you think of this kind of love, think also of the love of

patriots for their country, men who die, lay down their lives for their country. Or think again of the love of Christian martyrs, the martyrs, who for the love of Christ, offered their faith in God and the love that goes with it, allowed themselves to be thrown to the lions in the arenas of Rome.

Lloyd Luckman: Dr. Adler?

Mortimer Adler: Yes?

Lloyd Luckman: Do you recall that you said a moment ago that we are concerned today with the difference between love and desire and then you presented us with some case materials, examples of famous loves and famous lovers?

Mortimer Adler: Yes.

Lloyd Luckman: Now are all these examples of love or are some of them examples of desire as opposed to love?

Mortimer Adler: They are all love but they are not all love of the same kind. The main difference, as a matter of fact, in these kinds of love that I have just more or less exemplified, turns on their relation to desire. And perhaps the best way I can explain or begin to explain this difference in kinds of love is to state for you briefly the striking distinction between two different theories of love, one theory which identifies love with desire and one theory which admits that some love may be like desire or close to it, but that there is another kind of love distinct and separate from it.

Love As Desire

The first theory, the theory which everyone I think has some knowledge of, is the theory which says that love is desire or that love has its root in desire. To love is to desire, and according to this theory, all love is erotic or carnal or sexual love.

In the ancient world one finds evidence of this conception of love in the common mythology of both Greece and Rome. You all know who the goddess of love was. She was Venus. And what you know of Venus tells you that she represented not any love, but sexual love, love between men and women. It is a significant fact that Venus's son, Cupid, is called *Cupid,* for that name indicates the character of Venus. *Cupid,* the word "cupid," the name "Cupid,"

comes from the Latin word, *cupiditas*, from which we get the English *cupidity*, which means "intense desire." This fact about mythology fact shows how the ancients thought of love as rooted in intense desire.

Let me turn for the moment to another evidence of this same fact. Lucretius, a great Roman poet, felt that Venus and the love that she represented was a terrifying thing, that men would do well to avoid it; for of all of the things that might plague man, this kind of love most of all destroyed their peace of mind.

Let me turn to the words of Lucretius on this subject in his most famous passage in which he issues forth a great invective, a diatribe against love. My glasses on, Lucretius says, "Venus should be entirely shunned, for once her darts have wounded men, the sword gains strength and festers by feeding. Day by day the madness grows and the misery becomes heavier. This is the one thing whereof the more we have, the more does our heart burn with the cursed desire. When the gathering desire is sated, the old frenzy is back upon them." And he concludes by saying, "To avoid being drawn into the meshes of love is not so hard a task as when caught amidst the toils, to issue out and break through the strong bonds of Venus."

This conception of love runs through the whole tradition of modern science, especially modern psychology. One finds the beginning of it in a work in the seventeenth century by the physicist Gilbert, who wrote the first book on magnetism. In this book on magnetism, Gilbert speaks of the love of the iron for the lodestone, the love of the iron filings for the magnet.

Let me just show you what Gilbert had in mind. Here are some iron filings. And if I hold the paper there and then hold the magnet, see what happens to the iron filings. They are caught by the magnet and drawn after it, pulled, as it were, by the most intense line of force, attracted by the motion of the magnet. Now what is interesting about that is the comment that, some centuries later, William James makes, a comment that by the way connects the iron filings in the magnet with the story of Romeo and Juliet. William James says, "Romeo wants Juliet as the filings want the magnet. And if no obstacles intervene, he moves toward her by as straight a line as they. But Romeo and Juliet, if a wall be built between them, do not remain idiotically pressing their faces

against its opposite sides, as in fact the iron filings do, pursuing the magnet."

Finally, of course, as you all know, this conception of love is epitomized by Sigmund Freud. Freud's theory is that all love is sexual love or sublimations of sexual love. Let me state this for you in Freud's own words. Freud says, "The nucleus of what we mean by love consists in sexual love with sexual union as its aim. We do not separate from this, on the one hand self-love and on the other hand love for parents or children, friendship and love for humanity in general, and also devotion to abstract ideas." All these tendencies, according to Freud, "are expressions of the same instinctive drive, the instinctive drive of sex."

LOVE AS INDEPENDENT OF DESIRE

Now let me return to the second theory of love, which holds that surely some love is sexual love, but there are other kinds of love that are distinct from sex and separated from sexual desire. One finds this theory expressed in Aristotle's chapters or books on friendship in the *Ethics*, where he recognizes that some kinds of friendship are based upon desire. But he says quite plainly, these kinds of friendship are not true love. I shall deal more fully with this distinction of Aristotle's next week. But I do want to say right now that the way he exemplifies true love as opposed to a friendship based upon desire is in terms of the love of parent for children or the love of patriots for their country.

As a matter of fact, if any of you think of what a patriot does when he lays down his life for his country, you will see an example of love that is quite distinct from sexual love or erotic love rooted in desire. Or one other thing, think of the love of God, the love which is called Christian love. Think, for example, of the word that one knows from the Gospel according to Saint John, where Saint John says, "God is love and he that dwelleth in love, dwelleth in God and God in him." Or one more thing, think of the law of love which is the Christian law of love, the two precepts of charity; the first being, Love God with all thy heart and all thy soul; the second being, Love thy neighbor as thyself.

THE KINDS OF LOVE

Lloyd Luckman: You know, Dr. Adler, as I've been listening to you, I've been wondering why you use the same word for all those things which are so very different. Isn't that really the cause of the confusion? I think if you used different names for different things, we'd recognize that we have more than one idea here, maybe two or three ideas instead of one.

Mortimer Adler: Well, it seems to me that the matter of words doesn't solve it, but the matter of words, the names of love, is interesting. The Greeks had three names and the Romans had three names for the distinct or different kinds of love. In Greek, there is the word eros, which means "erotic love." The English word *erotic* comes from that. And the second kind of love in Greek is called *phileo*. This is the word which has as its root, is the root of words like *philanthropy* or *philosophy*, the love of mankind or the love of wisdom. And the third word in Greek is *agape*. And going to the Latin and translating now, the Latin equivalent of *agape* is *caritas*, in which we get the English charity, which means "the love of God," as *agape* does in the Greek. And the Latin equivalent of *phileo* is *amicitias*, which means "friendly love." We get the word *amicable* in English. And the Latin equivalent of *eros* is the word *amor*, which of course we use when we say young people are amorous, they are erotically in love.

Now we don't have three words in English, but what we have to do in English is to name the different kinds of love by using phrases. And so, we name these three kinds of love by saying erotic, carnal, or sexual love is the first kind. And the second kind is friendly, fraternal, or benevolent love. And the third kind is charitable or divine love.

But the naming of the different kinds of love doesn't solve the problem. In fact, it only calls our attention to the problem. The problem as I understand it is, How are these different kinds of love related to one another? How do they differ? How particularly does the first kind of love, erotic, carnal, or sexual love, differ from the other two? And even the more difficult question, If they differ, how are they all the same, essentially the same as varieties of love, even though they are different kinds of love?

This is a hard problem and I would like to propose to you a way of solving it. I would like to propose to you an experiment in thinking about love. The experiment requires you to construct with me an imaginary world, a world without sex in it, a world without gender, without male or female, without the normal processes of reproduction, a world in which everything else would be the same without sex, or perhaps not quite the same, since a good deal of advertising probably would be different—a world without sex, which we can then contrast with the real world in which we live, in order to see and understand a little better how love is distinct from and separate from desire.

Now let me proceed at once to ask you, even though it puts a little strain on your imagination, to construct right now in your minds, a world without sex. Ask yourself, would there be *desire* in that world? Would desire exist in that world? Would there be *love* in that world? And if there would be both love and desire in that world, would they be distinct?

Let me answer the first question: Would there be desire in that world without sex? Of course there would. Men would be hungry, thirsty, cold, tired. They would have the emotions or the passions of rage and fear which are desires. And we can see in terms of these desires what desire is like. Let me take hunger, which seems to me always to be the prototype of all the bodily desires. When a man is hungry, the first thing we notice is that he is empty. He lacks something. He is in deep need of something because of an emptiness or lack in himself. And this drives him toward some object like food which can fill him up, actually fill up the emptiness in him. The object of his desire satisfies him only when it actually is incorporated in him and fills him up. And this object of desire which fills him up when he is empty is something which he consumes or uses.

When you understand that this is the nature of desire, particularly bodily desire, of which hunger is the obvious prototype, you also understand why we do not say that God is desire. We say that God is love. God could not be desire. God could not have desire, for only things that are wanting, only things that are imperfect or in need can desire. And you also understand why we think that no one should desire a person, for that which is the object of such desires is a thing to be used and one shouldn't use a person.

Let me turn to the second question and the third question. In this world, this imaginary world without sex, would there be love

as well as such bodily desires as hunger and thirst and cold and such things? Yes, there would be. In this world without sex, wouldn't there be love between parents and children? Wouldn't there be the love of friends? Wouldn't there be patriots who would love their country and die for it? And wouldn't there be religious martyrs or deeply religious persons whose love of God would govern their actions? And certainly when you understand love and desire in this imaginary world without sex, you can see that they are distinct.

TRUE LOVE IS UNSELFISH

And now that we see they are distinct, perhaps we can go a little further in trying to understand how they differ. Love is to desire as liking is to wanting, as giving is to getting. And that means, if you understand that, that love is fundamentally altruistic and generous, whereas desire is fundamentally selfish and acquisitive.

Lloyd Luckman: I think I understand the difference that you've pointed out. I can see that patriotism is quite different from a desire like hunger. But isn't there another sort of desire which is associated with a kind of love that is pure friendship? I think in terms of purely philanthropic love.

Mortimer Adler: I think there is. Let me repeat Mr. Luckman's question because it's a very good question. He asks whether in addition to bodily desires like hunger and thirst, there is something like a desire that is associated with, perhaps even arises from or springs from the kind of love I've been talking about, which is distinct from bodily desire. The answer to that question is yes, there is.

Still in this imaginary world without sex, one can see that love leads individual humans to do things for other humans. When you love a person, you wish that other person well. You want to benefit or help that other person. You want to do good to that other person. That is a desire; only unlike the selfish desires of things like hunger, this desire or wish of love is a benevolent impulse. This is the meaning, I take it, of what everyone understands when He says, "Greater love than this hath no man, that he is willing to lay down his life for his friend." And the sharp contrast here between bodily desires and the wish of love is a contrast in direction. Bodily desires

are acquisitive. They are instances in which I try to benefit myself, improve myself, make up for my own lacks or needs; whereas the wish of love is to benefit the other, to improve the other.

Now let me see if I can apply this insight for you by one clear case. What do we mean when we say, as we so often do, that children should be loved, that children thrive on being loved, that being loved is the most essential ingredient in the rearing of children? What do we mean by that? I think we mean that it is necessary for children to be admired and respected, that they should receive courtesy and consideration on the part of the adult world. And that only through such care and consideration do they grow properly, to have proper self-respect. In this sense, the tenderness, the care, and consideration given a child is almost its spiritual nourishment.

And you can reverse this. Think now of what some people call the fourth commandment and what others call the fifth commandment. The commandment is, "Thou shalt honor thy father and thy mother." It doesn't say love. But what does honor mean? As I understand this commandment, be it fourth or fifth, it is that children should respect their parents, show them courtesy, consideration, act with goodwill toward them.

Now this is, I think, a beginning of the discussion of love. We shall go on from here in the next two discussions. Next time I hope we can achieve a much fuller understanding of the love we began to talk about today, the love between friends, the love of parents and children, the love of patriots for their country, or of martyrs for their God. And then in the time after that, in the discussion to follow, I hope we can turn our attention to the other kind of love and give it more full attention, the kind of love I have called sexual or erotic or carnal love, which in the real world, not the imaginary world, exists side by side with, and is so often fused with, the love which is separate and distinct from sex or desire, the love of friendship.

13 Love as Friendship: A World Without Sex

Today we continue with the consideration of The Great Idea, Love. As we saw last time, there is a distinction, difference, or contrast between two kinds of love: sexual, erotic, or carnal love on the one hand and friendly or fraternal love on the other.

These two kinds of love are often fused. It's very difficult sometimes to separate them. And that is why I would again like to propose an experiment, as I did last time, an experiment in thinking about love in which we create for ourselves at some points in this discussion an imaginary world, a world without sex, so that we can see the difference between love and desire.

In such a world there would be desire, such desires as hunger and thirst and there would, on the other hand, be love, the kind of love that exists between friends, brotherly love, the love of patriots for their country, Christian love. And not only would love and desire be quite separate but they would appear, I think, to be sharply opposed to one another as liking is to wanting or as giving is to getting. One can see these two things, love and desire, as impulses moving in opposite directions, the impulses of love being generous and benevolent, giving to the other; the impulses of desire being selfish and acquisitive, getting something for oneself.

Now today's discussion centers on love as fraternal or friendly, the brotherly love or friendship which is quite independent, is not rooted in acquisitive desires.

ARISTOTLE'S THREE REASONS FOR ASSOCIATION

Lloyd Luckman: Now, Dr. Adler, I want to stay with you in this discussion but to do so, there is something I really have to know and I think a lot of other people do too. And that is, in which world are we going to carry on this discussion, the real world or your imaginary world without sex?

Mortimer Adler: Well, let's start off, Mr. Luckman, where we really are, in the real world. And then when it becomes necessary to us to move into the imaginary world, the world without sex, I will give you notice so that you have plenty of time to get your imaginations in tune with mine.

Now I'd like to begin by giving you very briefly Aristotle's account of the reasons why men associate with one another. He says that men value three things. They value things for their utility, they value things as pleasant or as sources of pleasure, and they value things for their intrinsic excellence, they value them as they are honorable or admirable. And accordingly, he points out, there are three types of human relationships or associations.

There are those human associations which are based on utility, such things as business relationships, for the most part, political alliances, and marriages of convenience. Then there are human associations that are based on pleasure, such things as sexual attachments, infatuations, or perhaps one might even add all instances of conviviality, the conviviality of *bons vivants*. And finally, in the third place, there are human associations based on the excellence of the persons themselves. These are the friendships of persons who mutually admire and respect one another, mutual friendships.

Aristotle's thesis is that the first of these three associations is not love at all. And that the second, when it is separated from the third, is not love either. And that only the third is love, truly, deeply love. And it is love without any admixture of the second or the first.

Let me see if I can tell you why Aristotle says that. Let me see if I can explain this basic point that he makes. First, he points out that the first two relationships, the relationships or human associations based on utility and pleasure have some resemblance to true love. They can be almost counterfeits of that love because they do involve some mutuality. Mere desire involves no mutuality

at all. When I desire a steak, the steak doesn't desire me in return. But in these cases of friendships or associations based on utility or pleasure, there is some mutuality. But then he goes on to point out that this resemblance is very superficial. Because in the case of associations based on utility or relations based on pleasure, there is a condition of give and take, the relation is one of *quid pro quo*. It is a matter of fair exchange; I give you this, you give me that; I please you, you please me. As a result, these associations are very precarious and unstable in contrast to love, which is deeply permanent. You all know that wonderful line in Shakespeare's sonnet, "Love is not love that alters when it alteration finds."

And finally, Aristotle makes the point that whereas the first two relationships, that based on utility and that based on pleasure, arise from or have their root in desire, the third relationship, the relationship which is based upon the excellence of the persons who are associated, does not arise from desire but, if anything, there is a friendship which is itself the source of some wish or desire.

Lloyd Luckman: Dr. Adler, would you recall that you said that love differs from desire as giving differs from getting? Now when you speak of love as being the root or source of some desire, do you mean the desire then to give as distinguished from a desire to get?

Mortimer Adler: Precisely. The desire to give, the benevolent wish or impulse is the very essence of loving. Loving someone may involve more than this wish to give, but it must involve that at least. If one does not have the impulse to benefit the other, to give something to the other, to do something good for the other, then one is not in love.

LOVE AND JUSTICE

There are various ways of making this point, of saying this thing. All seem to be phrases that express the same point. We can talk about benevolent impulses, generous impulses, the wish to benefit the other, the person in love, the desire to give, or we can speak of goodwill toward men. But as soon as one mentions goodwill, a question arises. Is love the only source of goodwill? What about justice? Do we not think in general that when a man is just to his

fellowmen that he has goodwill toward them? And so we are faced with the question, What is the difference between the goodwill which is the loving will and the goodwill which is the just will? What is that difference?

And I think the answer to that question is very illuminating about the nature of love. The answer is that in loving, we give without getting in return. We are not asking for a fair exchange. We give what is not owed, what is not due to the other person. That is why, on the whole, we think that it is better to have loved and lost than not to have loved at all. And that is why many men continue to be in love with other persons, continue to love, even though their love is not requited.

Let me see if I can give you a more concrete explanation at this point, this point of the difference between love and justice. When someone does not love us as we would like them to, we don't say, "Be fair to us, be just to us," rather, we ask them to care for us, to show us consideration. We demand justice from our fellow humans. We have a right to demand it; justice is ours by right. But we don't demand love; we have no right to make that demand. When it is love we want, it is not a demand we make; we beg, we plead for love.

Now let me see if I can summarize this distinction between justice and love, because I think it throws a great deal of light on the nature of love. As I said a moment ago, both justice and love involve goodwill towards one's fellow humans. Then how do they differ?

Justice consists in paying one's debts, love consists in giving gifts. Justice consists of acts which are obligatory, we are under obligation to be just; love consists in acts which are gratuitous, acts we do not have to do; we do them from love and love alone. Justice consists in acts of fairness, in being fair to our fellow human beings; love consists in acts of consideration, in showing them consideration.

All one has to do is to think of heroic examples of love to see how different they are from dutiful acts of justice. Let me take for a moment that legendary hero of ancient Rome, Marcus Curtius, who threw himself into a chasm in the Roman Forum in order to fill it up. Marcus Curtius plunged his horse and himself into this chasm in the center of the Roman Forum in order to fill the chasm. It had been prophesied that unless Rome's most precious

possession was thrown into the chasm, it would never fill. And Marcus Curtius thought that Rome's most precious possession was its good citizens. And so, he sacrificed himself for his country.

Or think of an American hero, Nathan Hale. At the bottom of the statue of Nathan Hale are written his last words, which you remember are, "My only regret is that I have but one life to give for my country."

These two examples, I think, make quite clear the difference between the acts of love and the acts of justice. But I would like to pursue the point just a step further and see if I can suggest to you how different, how very, very different human society would be if it were based on love and friendship instead of upon law and justice.

I am always impressed by what seems to me one of the most penetrating insights in Aristotle, one which he expresses as follows: that when men are friends there is no need of justice among them or between them. As between friends, there is no need of justice. Of course, there are no human societies that have ever existed which are based on love and friendship instead of law and justice. Almost all, in fact all historic societies are of a negative sort. They are societies in which justice prevents discord rather than societies in which love produces concord.

Lloyd Luckman: You know, that's a very interesting point. I wonder if you would mind pursuing it even a little further, please.

Mortimer Adler: I would be glad to, Lloyd. And as I do so, to see if I can push this point a little further, make it a little clearer, let me read the passage from Aquinas, from the *Summa Theologica*, the treatise on charity, and the treatise on love, which compares love and justice as causes of peace. And you understand, of course, that what Aquinas means here by peace is the peace of a civil society. And so when he is comparing love and justice as causes of peace, he is also considering love and justice as the causes of society, of what binds men together in society. The passage is as follows, he says, "Peace," and he might just as well say society, "Peace is the work of justice indirectly insofar as justice removes the obstacles to peace. But it is the work of love directly, since love by its very nature causes peace, for love is a uniting force."

Now what does this mean? It means, in the first place, there's justice, that is, just government; the enforcement of just laws prevents men from injuring one another, fighting with one

another. And it is certainly true that without justice human societies could not long endure. They would fall apart or, as it has often been said, justice is the bond of men and states. But we must add, is justice enough to make a society a good society? Is justice enough to make society to serve its human purpose? Is a society in which justice prevails good enough for all human interests and ends?

The Definition of Love

Your answer to this question depends a little bit on your view of the purpose of society, the reason for its origin, why human beings associate. If you think that they associate because they are afraid of one another and they want society for it to protect them from one another, then you are satisfied if justice prevails and justice holds society together. Then a society built on justice is quite satisfactory for you. But if your view is that men associate in order to perfect themselves, in order to lead the best human lives of which each of them is capable, then it is not quite satisfactory to have only justice. You want love and friendship because love and friendship are required if men are going to help one another, help one another through their goodwill, through benefiting one another to lead good lives. Now both principles are needed in human society, but only a society of angels could exist on love alone. All human societies need both love and justice. And beyond justice, they are better in proportion as love and friendship prevails more.

Does that on the whole answer your question?

Lloyd Luckman: Yes, indeed it does. Thank you very much.

Mortimer Adler: Good.

Now are we ready for the definition of love? I think we are. But instead of giving you a definition in my own words, I would like to read you from the Great Books, two famous passages which I think are magnificent, brief, eloquent statements of what love or friendship are.

Let me take first a passage from Montaigne. This is from Montaigne's *Essay on Friendship*. Montaigne says, "In true friendship I give myself to my friend more than I endeavor to attract him to me. I am not only better pleased in doing him service than if he incur benefit upon me, but moreover I would rather he should do

himself good than me good." That is a perfectly clear statement, is it not?, of the benevolence of love, the interest of the lover in the good of the beloved.

Now then let me turn next to a statement in Aristotle's *Ethics* in book nine, chapter four, the book on friendship where Aristotle, after the analysis, part of which I have reported to you in this discussion, comes to his attempt to say finally what a friend is. And this is the way he says it: "We define a friend as one who wishes and does what is good for the sake of his friends, as one who wishes his friend to exist and to live for his own sake, which is what mothers wish for their children, and as one who grieves with and rejoices with his friend, and this, too," Aristotle says, "and this, too, is found in mothers most of all." It is quite remarkable, though it is perfectly understandable, that Aristotle should have taken the love of mothers for their children, mother for a child, as the prime example of basic human love, the love which is benevolent and friendly, which involves care and consideration of the other.

Lloyd Luckman: Now, Dr. Adler, are we to understand that true love is entirely benevolent, entirely selfless, entirely unselfish, that the lover doesn't require or desire anything for himself, not even to be loved in return? If that is what you mean, then you are thinking and discussing and living in an imaginary world, a world not only without sex, but a world without anything much of human nature in it.

Mortimer Adler: No, no. I'm not going that far. But I am saying this: I'm saying that love can be unselfish, that love can be benevolent without being entirely selfless. It seems to be quite proper for a lover or a friend to wish some good for himself as well as some good for the person he loves. These two wishes, the wish for the good of the other, the good of the beloved, as well as the wish for my own good are quite compatible under certain circumstances.

LOVE THY NEIGHBOR AS THYSELF

Let me see if I can explain how they go together. In the first place, let me point out that proper self-love is really inseparable from true love of another person. One might almost say that unless one has self-respect, genuine, deep, self-respect, one hasn't the basis for respecting other persons either. This, I think, is the meaning of

that second precept of Christian charity. You know, the second precept of charity doesn't say, "Love thy neighbor." It doesn't simply say, "Love thy neighbor;" it says, "Love thy neighbor as thyself." The emphasis is on "as thyself." For it means that one's love of oneself, one's proper self-respect is the basis and the measure of a genuine love of others. More than that, for the mutuality of love to exist, I must respect in myself, I must value in myself the same excellence that I value in my friends or in the person that I love.

Now when we love another, we wish, as I've been saying many times now, when we love another we wish them well. We wish some good to befall them. Hence, when in loving another, we also love ourselves, what do we wish for ourselves? What good is it that we are wishing for ourselves in our self-love? I think the answer to this question is that we wish to be loved. And with that wish we wish the joy of love, the joy of companionship, of being in the company of, in the presence of the person we love, of living a common life with that person, perhaps ultimately the joy of perfect union.

The wishes of love are threefold. First, to benefit the other; this is the wish which expresses goodwill. This is only the beginning of love. This is not its full fruition. The second wish of love is to be loved in return. And with that wish follows the third and the deepest, the ultimate wish of love, to enjoy the closest union with the beloved.

Lloyd Luckman: You know, I'm sorry but that word *union* still bothers me. Because I can't help asking you just once more, in which world are we discussing—the real world or the imaginary world without sex?

Mortimer Adler: Well, I would like to propose that we try to understand union, the union of love quite apart from sex. Hence, please try now to go once more with me into the imaginary world we have been constructing in order to understand love as separate from sex and desire, a world without sex. And in that world let's see if we can, eliminating all physical contacts, ask what sort of union do we mean when we say that the lover wishes to be united or to have almost perfect union with his beloved, with his friend. The answer I think is that what is wished for is to be acquired or is to be attained through compassion, through sympathy, through charity and liking the same things, through all the acts of leading a common life, and perhaps most deeply of all, through knowing

and understanding the other person well through knowledge and understanding.

Now that word *knowledge* gives us a clue to what sort of union is involved in love, love apart from sex. For there are two ways in which men possess things: physically and spiritually. We possess them physically when we consume them or use them; we possess them spiritually when we behold them or know them. Now loving is like knowing. Love is like knowledge. The things we love we possess in the same way as we possess them when we know them. But love, though it is like knowledge and is united to its object as the knower is to the known is much better than all the forms of intellectual knowledge. It is a much deeper union than that. That, I think, is why Saint Thomas, speaking of man's relation to God, says, "It is better to love God than to know Him and it is better to know things than to love them."

Now let me conclude this discussion with a letter that we received, which I think raises the question that it is worth facing at this point. I have this letter in my file. The letter quotes a contemporary writer as saying that love is merely a cultural accretion that is in no way essential to man's existence and that the human race will sometime properly learn to dispense with it. The writer of this letter asks for my comment on that statement. I am glad to give it.

I think the statement quoted is quite wrong. For it seems to me that the human being's need for love is the deepest need of human nature, because man is by nature social. We are social persons, not just social animals. That is why we cannot be satisfied by herding together as the gregarious animals do. We cannot be satisfied by being useful to one another merely, but by giving each other pleasure. We, because we are social persons, want, deeply want, to share one another's lives.

How can this be done? Only in one way. One word gives the answer, *conversation*. Love and the union of love is impossible without conversation. Each of us is alone. Each of us is quite lonely. Without the communication of love, without the conversations, the heart-to-heart talks, which are love's way of achieving union, each of us would be as isolated, as shut out from one another as animals are, even when they are herding together physically, most closely. Only the communion of love produced by the conversations of lovers overcomes our human isolation and our human aloneness or loneliness.

Now everything I have said today about love as friendship indicates, I think, that love can exist in a world without sex. This very last remark about conversation as the way in which lovers become united makes this quite clear. But we also know, I think, that friendly love exists in the real world where it is often mixed or fused with carnal love, erotic love, or sexual love. That is our problem as we go on next time with this discussion, the problem of understanding how love can be sexual and at the same time truly human love.

14 Sexual Love

Today, as we continue with the consideration of love, we shall be concerned with the nature of erotic or sexual love. We shall try to understand how love can be sexual and at the same time, truly love.

Someone listening to this program for the first time might be surprised by that statement. They might say, "What? Is that a problem, how love can be sexual and at the same time truly love? Isn't the problem quite the reverse? How can love be love unless it involves or in some way has the participation of sexual interest or the sexual instincts?"

A word or word or two of explanation is necessary right away. I think that every one of us uses the word *love* in a broader or wider sense than simply to refer to sexual love. Granted that when the word "love" appears in newspaper headlines or in advertisements, it usually does mean sexual love or erotic love. Granted that most of the great love stories tell the stories of love between men and women. Granted even that when used with such phrases as "first love" or "love at first sight," the image that comes to mind is that of a boy and a girl. Nevertheless, it is not just the philosophers and the theologians who have a broader meaning for the word "love"; we all do. We all speak of the love of children for parents, of parents for children, of the love of patriarchs for their country, and of the love of religious persons for God.

FREUD VERSUS ARISTOTLE

Lloyd Luckman: Well, now, Dr. Adler, while I'm not myself a Freudian, I think that those who are Freudians might certainly object that all these loves that you've enumerated are, according to Freud at least, merely extensions of sexual love. I think Freud's word is *sublimation,* isn't that it?

Mortimer Adler: That is exactly the word. And your question, Lloyd, anticipates what I was just about to say.

We are concerned with two opposed theories of love. Freud represents one extreme and Aristotle the diametrically opposite extreme. For Freud, all love is sexual in origin and sexual in basis. Even loves that do not look as if they involve sex are, as Mr. Luckman said, sublimations of sexual interests or sexual drives. For Aristotle, on the other hand, relationships which are based on a desire for sexual pleasure are not in his judgment, in his conception, love. They do not even originate in that way. For Aristotle, the mainspring of love is benevolence. And sexual desire participates in the nature of love only insofar as it is associated with benevolent impulses.

Now these two points of view do look quite irreconcilable. But I think it is not as bad as that. I think I can show that there is some agreement between Freud and Aristotle, at least on the main point of today's consideration, the nature of sexual love.

Now what I'm going to do as I proceed is to first get the problem stated a little more clearly, then see if I can propose steps toward a solution, and finally, if that is not quite the solution, I shall deal with some difficulties that remain to be met with and considered.

Let me begin at once with an attempt to get the problem stated for us. Everyone, including Aristotle and Freud, I think, agrees on the essential characteristics of love with or without sex. Everyone, I think, agrees that certain things must be present if a relationship is to be properly called a relationship of love.

Nothing is love which does not involve, first, benevolent impulses, impulses to benefit the other person to do good to the person loved. And secondly, nothing is love which does not involve desire for union, the desire to be with, the desire to become with the other person, the person loved. Without these things we have mere sexuality, not love.

By mere sexuality I mean the gratification of sexual impulses or desires, the fulfillment of the sexual or reproductive instincts. Now we find this mere sexuality, this and only this, in the mating of animals. It seems to me that the mating of animals is an act of sexual union totally devoid of love. There is no evidence whatsoever of love in the behavior of non-human animals.

Lloyd Luckman: Now would you hold on just a moment, Dr. Adler? Before you go any further—now you really are, I think, going a little too fast for me because I feel that most people who have animals for pets believe that their dog or their cat or their horse loves them. In fact, they would say that the pet loves them even better sometimes than humans do. And more than this, you said that the desire for union is a mark of love, right? Well, now isn't animal mating an expression of the desire for union? And if it is, why isn't that love?

Mortimer Adler: Let me begin by answering your first question. I must say flatly that I don't think domesticated animals or pets love their domesticators. But this is one argument that I don't want to get into. I know I can't convince people on this point. I've tried and failed.

Now let me see if I can state the problem with which we are concerned in the light of this last point. We are not concerned today with sexuality apart from love nor with love apart from sexuality. We are concerned with those relationships involving both sex and love. When fused together to form that quite remarkable amalgam which we call sexual love or erotic love, which draws upon man's animality, his physical nature, and also upon his rationality and the spiritual side of his nature.

It is here in the understanding of this fusion of sex with love to produce erotic love that I think Freud and Aristotle tend to agree. Perhaps it's only here that we can find them in agreement. For Aristotle says that the desire for pleasure, the desire for sexual pleasure must be sublimated to consideration for, admiration for, respect for the other person if that desire is to participate in a relationship that is genuinely love. That is what Aristotle says.

FREUD'S VIEW OF SEX AND LOVE

Now listen to Freud, for Freud says that uninhibited sexuality, sexual impulses that are not restrained, controlled, inhibited, or sub-

limated result in mere sexuality, sexuality on an animal or bestial level. For Freud, as well as for Aristotle, though the terms are different, for Freud, love results when the sexual impulses are sufficiently inhibited to produce tender emotions, feelings of tenderness, tender impulses. And Freud even says, I think, that in proportion as sheer sexuality is inhibited and tenderness comes to predominate in the relationship, you have more and more love of the human sort and less and less mere animal sexuality.

Now I could easily appreciate many of you thinking that I've made this up, that I've attributed to Freud words or even ideas that are not his own. And therefore I would like to turn to Freud and support what I've just said is his view. And this point seems to correspond so directly with that of Aristotle's. Freud says, "Being in love is based upon the simultaneous presence of directly sexual tendencies and of sexual tendencies that are inhibited in their aim so that the object draws a part of the narcissistic ego libido to itself." That's a big word.

What does Freud mean by this last statement? Well, he means first of all that when a person is in love, he ceases to love only himself. That is what he means by narcissistic ego libido, that concentration on loving oneself—you remember Narcissus was the ancient man who admired himself and only himself as he looked at himself in the reflection of the pond—so that with the control of one's narcissism, some of that love is given to the other person, the loved object.

But more important than this point about narcissism, what does Freud mean by the phrase "sexual tendencies that are inhibited in their aim," which for him is the cause of the shift from purely selfish desire to love? To understand that, I must turn to another passage in which he does explain that, in which Freud tells us that when the sexual instincts are inhibited in their aim, "the emotions which we feel toward the objects of our sexual interests are characterized as tender." And then he goes on to say, "The depths to which anyone is in love, as contrasted with purely sensual desire, may be measured by the size of the share in the love taken by the tenderness resulting from inhibited sexual instincts."

How Can Sex and Love Be Combined?

Now let me see if we can, in this point on, take some steps to solving the problem that is our problem now, the problem of how these two things can be fused. How can sexuality on the one hand and the benevolent impulses of love be fused to form one relationship? The first step in approaching a solution to this problem is, I think, to understand how sexual desire differs from all other bodily desires. It is a bodily desire but it differs from all the other bodily desires like hunger and thirst.

There are three things we should look at now to see how sexual desire differs from other bodily desires. In the first place, all other bodily desires are desires for things to be used or consumed; while sexual desire, like love itself, is a desire for another person, another human being. In the second place, sexual desire is never simply a desire for pleasure; it arises and is associated with the reproductive instincts. And for this reason it has an aim beyond pleasure: a reproductive or procreative, a genuinely creative aim. It seeks to produce an image of itself. An image of what? Not of the persons each by himself but an image of their union. And this leaves to the third and perhaps deepest point about sexual desire, that its aim, its direction is toward union.

Let me summarize these three points about sexual desire. The elements of sexual desire are, as we have seen, first, that this desire is satisfied by a person, not by a thing; second, that it is a desire associated with a procreative and in a sense a genuinely creative aim; and in the third place and most important of all, it is a desire which is culminated in physical union.

Lloyd Luckman: You know, Dr. Adler?

Mortimer Adler: Yes?

Lloyd Luckman: I think now I'm beginning to see exactly what it is that you are driving at. First you made desire for union, as I emphasized in my other question, an essential of love. And now you make union the main aim of sexual desire. Is this how you then fuse sex and love into sexual love?

Mortimer Adler: Yes, that is the heart of the matter. But I don't think I have fully clarified this last point about union, which seems to be so important, as you've just said, that I'd like to spend a moment more to clarify it.

Let me see if I can go more deeply into the understandings of what it means to have union as the aim both of sex and of love. Let's ask ourselves the question with sex left out for the moment. What is the nature of the union that lovers seek? The answer is it must be a spiritual union, a spiritual union achieved through sharing the same things, through knowing and understanding one another, through knowledge, and above all through conversation. Without these things, two persons cannot enter spiritually into one another's lives.

Sexual Union as Knowledge

Let me call your attention to what for me is one of the most striking facts. What are the words in our tradition of English speech that we use to refer to sexual union? What are the words used in the English Bible? What are the words used in the tradition of English and American law?

Well, in the Bible the word is *known*. It is said there that Abraham "knew" Sarah and begat Isaac. And here in another passage in the Bible in Genesis, we find Lot speaking of his two daughters who are virgins and saying of them that they "knew not men." If we turn to the law, what is the word we use in the law for sexual union? Most amazing, the word is *conversation*. And when the sexual union is illegal, we speak of *carnal conversation* or perhaps *criminal conversation*. But even if you add carnal and criminal, the point remains; it is called "conversation." I can't exaggerate what for me is the importance and significance of this simple fact. For what it signifies to me is that the desire for sexual union or even the existence of sexual union is a physical expression of the desire for spiritual union. Or you could put that in the reverse, that the desire for spiritual union is a sublimation of the desire for physical union. In either case what we see is that union in body together with union in soul constitutes sexual or erotic love.

Now let me see if I can make then a full statement or a fuller statement at least of the solution or as much of it as we have now reached. It seems that human sexuality can take two directions in human life. We can have sex in the service of love and then we have it elevated and humanized, or we can have sex divorced from love, and then we have it degraded to the level of bestial or animal

conduct. When you have sex divorced from love, you have mere sexuality, you have something that is like lust, like animal desire. In fact, this is the very opposite of love because it's selfish, because it's entirely acquisitive and worse than that, it's often quite cruel. But when you have sex in the service of love then you have genuine erotic love, not just sex, not just love, but the combination which is erotic love.

And this it seems to me, this combination, can be defined by three things. Sexual love involves the desire to please as well as to be pleased. It involves *com*passion and sympathy, compassion for the other person as well as passion. And most important of all, this third point, it involves an understanding of sexual union, an understanding of sexual union as a physical form of knowledge or conversation.

Lloyd Luckman: I think that now you have a very dramatic demonstration of how sex and love can be fused to constitute this one thing that you are calling, and I will call too, erotic or sexual love. Now I guess we have the complete solution of the problem, is that right?

Mortimer Adler: Not quite. Because, Lloyd, there's still one further difficulty that I kept till the end and I think we can see it now and I think we have to face it. It involves a question to which both Freud and Aristotle give answers, and opposite answers, and I don't know which is right. It is very hard to tell which is right.

Lloyd Luckman: These aren't in agreement?

Mortimer Adler: No. Let me see if I can talk about this problem a little and get it somewhat clear. This problem is stated as follows: In erotic love is sexual desire the source, the root of the love or is the benevolent impulses of love the root of erotic love?

Let me put that question quite concretely. When people fall in love, which do they say first, "I want you," or "I like you"? We know that when a man falls in love with a woman he is saying one of two things, both "I like you," and "I want you." But which is he saying first, "I like you," first and then subsequently, "I want you"? Or "I want you," first and then subsequently, "I like you"?

Now I don't know which is the way that love does occur. One looks at Aristotle and Freud, one finds them saying opposite things here and I don't know which is right. But I do know this, that it makes a great difference, it makes a great difference to the result which way it does occur. For if sex comes first, and if wanting

comes first and remains primary, then the love is likely to be fickle and short lived, as changeable as sex itself. But if the love comes first, that is, if liking comes first, then the relationship is likely to be quite stable. It probably can endure all the vicissitudes of love and perhaps even outlast a total dissipation of sexual interest.

And there is one further point here. The selectivity of erotic love, the choice of its object, this man loving that woman, this woman loving that man, this selectivity, this choice is much more intelligible to me, and when you think of it, it may be to you, if liking comes first and precedes wanting rather than the reverse, rather than the other way around.

Now so much for today's problem. The problem we shall consider next time is the morality of love, not just the distinction between moral and immoral love, between lawful and illicit love, but the deeper and more difficult difference between loves that are good as loves and loves that are bad as loves.

15 The Morality of Love

Today we conclude the discussion of love with the consideration of the problem of the morality of love. Now when the words love and morals are used together as in the phrase "the morality of love," only one problem comes to most people's mind. They tend to think of a problem concerning only one kind of love, that is, erotic love, and even there they are concerned with one aspect of that love; for the only moral problem about love that most people consider is a problem that involves the distinction between proper and improper sexual behavior. So much so is this the case that the words "moral" and "virtuous" have almost come to mean "proper sexual conduct."

When we speak of a man, or more usually a woman, as being moral or virtuous, we usually mean that he or she is chaste, not that he or she is courageous or temperate or just in most of the affairs of life. Now there is no question at all that chastity is a virtue. But it's certainly not the only or the chief virtue. And what is even more regrettable it seems to me is that we speak of lawful and illicit love or of sanctioned and forbidden love. And the reason why this is regrettable is because it tends to obscure or confuse the problem of the morality of love. For these phrases suggest that the distinction between the lawful and the illicit, the sanctioned and the forbidden, applies to love itself, usually the love between men and women. Whereas, in fact, the distinction much more properly applies to sexual conduct which is a consequence of such love.

There is no question that certain sexual conduct is lawful and other sexual conduct is unlawful. And there is no question moreover that this should be so. But after we recognize that it is so and

135

why it is so, why there should be some prohibition of certain types of sexual behavior, we are left with what seems to me a deeper, a more interesting, and I think also a more difficult problem. And that is the problem of distinguishing between good and bad love, between loves that are good as love and loves that are bad as love.

Lloyd Luckman: I'm going to interrupt you, Dr. Adler, because I have to be certain that I understand what you're driving at at this particular point. Now are you saying that there are two distinct problems here concerning the morality of love? Or on the other hand, are you saying simply that there is really only one such problem and that the other problem which is often confused with the problem of the morality of love is really a problem of, well, the morality of sexual behavior?

Mortimer Adler: I would like to be understood as saying the second of these things. My reason is that I think the problem of the morality of love is a much broader and a more difficult problem than the problem of the morality of sexual behavior.

For example, let me see first if I can distinguish between these two problems for you and tell you why I shall deal with the second. And I am going to use Mr. Luckman's phrase for naming the two problems. The first problem is the problem of the morality of sexual behavior. The second is the problem of the morality of love. And since most people tend to confuse the first problem with the second problem, I'm going to try to not only distinguish it, but clarify it.

The problem of the morality of sexual behavior, dealing with that first, seems to me for the most part to be a problem of injustice rather than a problem of love. In all societies certain types of sexual behavior are prohibited. And in the West, in the Western tradition they are prohibited by divine law as well as by human law. It is by these prohibitions that we draw the line between lawful and illicit sexual behavior or between sanctioned and forbidden sexual behavior.

Now these prohibitions are like the prohibitions against killing and stealing. These prohibitions of certain types of sexual conduct are prohibitions against injuring other persons, against taking what is not one's own, or against degrading oneself. Moreover, just as the prohibitions against murder and stealing and all similar prohibitions have as their purpose the protection of the very fabric of

society, so these similar prohibitions of certain types of sexual conduct have as their purpose the protection of the institution of the family.

Lovers Who Break the Rules Are Viewed as Heroes

I would like to give you evidence that such prohibitions do not solve the problem of what makes love good as love or what makes love bad as love, even though the love in question may lead to sexual conduct that is prohibited. The evidence I am going to offer on this point comes from the great storytellers about human love, the great novelists, the great dramatists, the great poets. But the evidence that I am going to give you, I think, is verifiable in your own experience. You can test it by your own moral judgments. The poets, the storytellers show us that love has a privileged status, that love retains some honor, even when it defies the laws or standards of sexual conduct. The great lovers in fiction, even the great lovers in history remain heroes, even when they are also transgressors of the moral code.

Now this is not true of persons who are immoral insofar as they have failed to control other passions. Let me illustrate this point for you quite concretely. When persons are immoral because they fail to control other passions, we tend to call them brutish, childish, self-indulgent. We tend to compare them with animals. Thus, for example, when a man is a coward because he can't control fear, what do we say of him? We say he is a jackal, we say he is a scaredy cat. When a person can't control his lust for food, we say he is a glutton—or when another person can't control his thirst for alcohol, what do we call him? A drunkard? We speak of people like this as pigs or as swine. And when a man is simply lustful, not in love but merely expressing sexual desire, what do we say of such a man? In the contemporary vernacular, we call him a wolf.

But when persons fail to control their sexual behavior because they are in love, we regard them as full human beings. We regard them as human, perhaps all too human, but human, not as brutish or as childish. We can forgive them. More than that, we may even admire them. As literature depicts such men, they are often heroes.

Think now for a moment with me of Lancelot and Guinevere, of Tristan and Isolde, of Abelard and Héloise, of Faust and Margaret, or think of Anna Karenina. As literature depicts them, they are heroic in spite of their transgressions, though perhaps because of their transgressions they are also tragic heroes. Such individuals seem almost justified in acting as if their love were a law unto itself. In fact, one of Chaucer's great lovers, the knight in *The Knight's Tale* says precisely this, he says, "Love is a greater law than man has ever given to earthly men."

CHRISTIANITY ON THE THREE BAD LOVES

Lloyd Luckman: Now just a moment, Dr. Adler. The knight in Chaucer may be right, that love is a greater law than man has ever given to man, but aren't you forgetting that in the Christian tradition God has given a law of love to man? Why, in the course of these discussions you've said many times that the most fundamental of all Christian teachings is the divine law of love, the two precepts of charity. Remember? Don't these have some bearing on the morality of love? And I do mean the morality of love, not the morality of sexual behavior.

Mortimer Adler: Indeed they do, Lloyd. And when we understand the precepts of charity, I think we understand in terms of those precepts the difference between good love and bad love, not just the difference between right and wrong sexual conduct. For example, consider the love of money, the love of all worldly goods. That, according to Christian teaching, as you know, is the root of all evil. It is said in the New Testament that the love of money is the root of all evil. It is also said there that you cannot serve, you cannot love, both God and Mammon. But the love of money is only one type of bad love. There are at least two others. And all three of these types of bad love are bad according to the same principles of Christian teaching about love.

Let me name for you the three bad loves. There is the one I've already mentioned, the love of money. And then there are two others: pride and romantic love. Now you may be shocked at first. You may think, "Well, I see how the love of money and pride are prohibited, are in some sense condemned as bad loves by Christian teaching; for it is said not only that the love of money is the root

of evil, but also that pride is the great sin at the basis of all other sins. But where does romantic love come in?" That may puzzle you. Where does romantic love come in with the other two things, pride and the love of money?

Well, let me show you. They are bad in quite related senses. The love of money is a bad love because it is a *love of the wrong object.* Pride and romantic love together, each in its own way, but in a very similar way, are the love of a right object *but in the wrong way.*

To show you how these three loves violate the Christian precepts of charity, I want to restate the Christian commandments of love for you in terms that will show you this. The first one is: Love God, not worldly things. The second one is: Love thyself as God loves thee. And the third one is: Love others, love other human beings. as creatures of God.

The three bad loves, the love of money, pride, and romantic love, violate these commandments. The love of money is a love of worldly things, not of God. Pride is not loving thyself as God loves thee but loving thyself as if you were God, loving yourself as if you were God, deifying yourself. And romantic love is not loving other human beings as creatures of God but loving them as if they were divine; not merely loving them but worshipping them, venerating them in a manner that displaces God and puts a human being in place of God.

Lloyd Luckman: Well, now, Dr. Adler, I'm very much concerned personally with the question that I raised about the Christian law of love and the precepts of charity which you have commented on, and I think you've answered my question.

Mortimer Adler: Yes.

Lloyd Luckman: But I'm wondering now if the answer which satisfies me will satisfy everyone. Probably not all our viewers, because some may want to know if, apart from these commandments of love and the Christian law of love, there is any real morality of love outside of religion. Is there any way then that you could distinguish between good and bad loves apart from religion?

Mortimer Adler: I'm glad you asked that question. Because I am sure there are many others who will want to know the answer to it as well as you, Lloyd.

Mr. Luckman asks whether without reference to God or divine law, but in purely naturalistic terms, we can distinguish between good and bad loves. The answer is certainly yes. We can. And when

we do, we will find exactly the same three bad loves, which are bad as love, only I think we will find that they are differently named.

FREUD ON THE THREE BAD LOVES

Now to show you this, let me go to a psychologist like Freud who is deeply interested in love, not just in sex as is so often mistakenly thought of Freud, and who certainly approaches the problem of love in scientific and not in religious terms. When we go to Freud, we will find him naming these three bad loves. Of course, we have to make a translation. The names will be different. But you will see as soon as I show you this that though he names them differently, the loves are the same. And you will also see that the reason why they are bad is in principle the same.

Here are the bad loves according to Freud. First, the love of money. For Freud, that is the Christian way of speaking of it. For Freud, the love of money is a neurotic object fixation. Only a person with a very deep neurosis would have his desires, as Freud would say, his libido fixed on an object like money. The thing that the Christian tradition calls pride, overweening, excessive self-love, Freud calls again a name that indicates it is neurotic. It is not normal and healthy, a narcissistic attachment to the ego. Narcissism is one of the great neurotic manifestations. And the thing that in the Christian tradition is called romantic love is by Freud called adolescent overestimation, adolescent idealization of a sexual object. Now according to Freud, each of these loves is a bad love. It either is, or is symptomatic of, a neurotic condition. To be a healthy person in love, to be an adult in love, to be normal in love, one must get over these bad loves or be cured of them.

I think most of you will see how the love of money and pride are in Freudian terms, bad love. But you may here as before be puzzled as to why Freud calls romantic love a bad love or what he calls adolescent overestimation. And I think perhaps the easiest way to explain this third point which may be puzzling is to go to Freud and read you the passage that make the point quickly and simply. Freud points out that the adolescent tries to combine unsensual, heavenly love with sensual earthly love. "That is usually defeated," he says, "by the phenomenon of overestimation or idealization of the object." Now as this overestimation or idealization,

this exaggerated estimation or idealization of the object increases, Freud says, and I quote here, "The tendencies whose trend is toward directly sexual satisfaction may now be pushed back entirely as regularly happens with the adolescent's sentimental passion. The ego becomes more and more unassuming and modest and the object more and more sublime and precious until at last it gets possession of the entire self-love of the ego, whose self-sacrifice thus follows as a natural consequence." The object has, so to speak, consumed the ego. "This happens," Freud points out, "with greatest intensity when erotic love is not consummated sexually as it is in marriage." And Freud compares such adolescent or romantic love with being hypnotized. He says, "The hypnotic relation involves the devotion of someone in love to an unlimited degree with the object loved, completely replacing all ego love and with all sexual satisfaction excluded."

This explains psychologically what is wrong with romantic love, why it is adolescent rather than adult. I think it explains it in terms that have a striking resemblance to the theological criticism of romantic love as the overestimation or idealization of a human being as if that human being were divine, something to be worshipped. And on the naturalistic claim and without reference to God, I think the proper object of human love is, for Freud, a human person. And I think I can show you that these three bad loves of which Freud speaks are bad as loves because each in its own way defeats the love that enriches human life and is therefore good as love.

Good love is defeated by bad love. For the love of money distorts and impedes the love of persons. And one should love persons. And pride or narcissism more seriously prevents our loving another human being or being loved by another human being. And so such self-love usually ends in loneliness and utter lovelessness. And finally, romantic or adolescent love destroys one's *amour-propre*, one's proper self-respect. And since love cannot long endure without such self-respect, this destroys love itself.

It seems to me that the morality of love can be summarized in two simple statements. The first is that one should love only that which is lovable, God or persons, not things. And the second is that one should love whatever is lovable in proportion as it is lovable, neither more nor less. In a sense then, the morality of love is the whole of morality or the very essence of morality; for does not

morality consist in having a right sense of values, in putting all good things in the right order and loving them accordingly? If this is what the morality of love is, then it might almost be said that a man whose loves are in the right order is a man who can do no wrong.

Lloyd Luckman: Then, Dr. Adler?

Mortimer Adler: Yes, Lloyd?

Lloyd Luckman: Just reflecting on that conclusion, I wonder if Saint Augustine didn't say precisely the same thing. My recollection is that he says, "Love, and do what you will." Now doesn't he mean that you can't go wrong if you act in the light of love?

Mortimer Adler: Yes, he does mean that. But I think one qualification must be added because the love that Saint Augustine is speaking of in that passage is a perfect love, the love of God, hence he does not need to qualify his statements. But if we talk about anything other than the love of God, I think it is necessary to say, "Love that which is better, more, and love that which is less good, less, then you can't go wrong."

Now the poets have said this in their own way. I think you all know the famous lines of Sir John Suckling in a poem *To Lucasta, Going to the Wars.* "I could not love thee, Dear, so much, loved I not honor more." And I think you may not know some equally extraordinarily good lines on this subject, the lines of Wordsworth in *The Ode to Duty.* Wordsworth says, "Serene will be our days, and bright, And happy will our nature be, When love is an unerring light, And joy its own security."

Now that, it seems to me, sums up the morality of love, but it does not completely exhaust all the problems of love in human life. There are many other problems.

Lloyd Luckman: I have an appetite for discussing these problems in some future meeting.

Mortimer Adler: Maybe we can, some time. But this must conclude our discussion of love.

16 How to Think about Good and Evil

Today we are going to consider the Great Ideas of Good and Evil. In the time we have, we cannot consider everything these terms include nor comprehend all the problems that they raise. We should be concerned largely if not exclusively with the human good, the good for humankind, and, more specifically, human happiness.

Let me enumerate quickly for you some of the ways in which these terms *good* and *evil*, particularly the term *good* are used. For example, in economics we talk about goods. We often say goods and services. And by economic goods we mean commodities, the things that people buy and sell. And such things we speak of as having value. The word *good* has the other meaning here of something that has value. We speak of goods as having value in use or value in exchange. And in politics we speak of a good society or a good government. And here the meaning of the word *good* very often has the connotation of justice. For a good society is a just one and a good government is a just one. Then in ethics we use the term *good* often to mean the character of a man. We speak of a good man, we speak of a man leading a good life.

But here there are two further points worth paying attention to. Sometimes when we speak of a good man, we have in mind that he is a happy man. And sometimes we put the emphasis a little differently, on the fact that he is a virtuous man or even more strictly, a righteous man. And this calls our attention at once to the possible shift or change in meaning, that shade of difference in meaning when we use the word *good* and when we use the word *right*.

Good and evil on the one hand and right and wrong on the other are not strictly synonymous. For example, we apply right

143

and wrong only to human acts. We speak of them as right acts or wrong acts, and we don't speak of right things or wrong things, whereas we do use the word *good* and *evil* for everything in the universe. Anything that we can talk about we can speak of as good or bad.

And this brings us to the third or the fourth major use of the term *good* as it is used in metaphysics, where everything in the world is spoken of as good. And here the word *good* has the meaning of perfection. Some things are better than others because they are more perfect in their being or their reality than others. Here the grades of goodness in things is the same as the grades of perfection in them. All the way from the least perfect things in the universe, the things with the least being or reality, atoms and molecules, through the scale of living organisms, up to God.

Moral Good and Moral Evil

In this discussion I would like to spend all of our time on good and evil as they are discussed in ethics, the moral good and the moral evil. And here the great problem, certainly the one I think it's worth our time to concentrate on, is the question about our judgments concerning good and evil. When we say something is good, when we call something bad, is that judgment we make an expression of knowledge on our part or just our personal opinion?

Here there are two answers to this question that represent two extreme views. On the one hand there is the answer that Hamlet gives, and that Montaigne also gives when—in almost the same phrases they say, "There is nothing good or bad, but thinking makes it so." And what they mean when they say that is, it's just a matter of opinion. You may think something is good and I may think it is evil; it's only my thinking that makes it good or evil.

The opposite view holds that we can have knowledge about what is good and evil, and that it is even possible, that the knowledge is so precise, that we can have a science of ethics just as we have the science of physics. We can have the science of ethics that gives us clear-cut knowledge concerning what it is good for man to seek, what it is good for man to do.

This issue between those who say that there is nothing good or evil, that thinking makes it so, and those who think there is a sci-

ence of ethics is the central question about the objectivity or subjectivity of these fundamental values: good and evil.

I should like then as we go on to consider first this problem of the objectivity or subjectivity of good and evil as it concerns these terms themselves, then extend the consideration to the question of the objectivity or subjectivity of our conceptions of human habits.

Both of these problems, the narrow ones and the broader one about good and evil, the narrow one about happiness, I think, are serious and important, practically significant problems. Because as individuals take one or another stand with respect to the objectivity or subjectivity of good and evil, they take different attitudes toward life, they act differently, and they judge their fellow human beings differently.

What do we mean when we call anything good? What would be the full answer to that question? One thing is certainly clear. Anything we call good we regard as desirable. The good is the desirable; the desirable is the good. The good is the object of our desires.

So much is this the case, that it really is a self-evident truth to say that we seek the good. Anything we seek, we seek because it is good and there is nothing else in the world we would seek except the good. So one could almost say as a matter of fact that all men do seek the good. This is something that Socrates said many, many centuries ago. He said, "No man ever seeks or craves for or pursues that which he deems harmful or injurious to himself, but rather he only seeks that which he regards as to his advantage or benefit."

APPARENTLY GOOD AND REALLY GOOD

You may ask me, "What about some people, neurotics, who look as if they were seeking to be hurt or harmed?" There is no problem there really because their very neurosis, their pathology, amounts to making them regard what we would think of as pain or hurt as something pleasant or advantageous. So as they seek it, even though it looks abnormal, they are seeking something they deem pleasant or advantageous. But you may ask, "Don't persons ever seek what they deem to be advantageous though it is in fact an injurious thing? Don't they ever make a mistake about what they

seek?" Here, of course, we face a very difficult question that leads us to the first consideration we can have of the distinction, a very important distinction, between the real and the apparent good. Let me see if I can make that distinction for you.

Suppose you say that something is only *apparently good* or is an apparent good, if it is that which people suppose is to their advantage or benefit, something which they in fact do desire. And let's call something really good, not just apparently good, if it is something which is in fact to their benefit or advantage and something which they should desire even if they do not. Now when you make the distinction this way you are entitled to come back to my original statement about the good being the desirable. Because if the good is the desirable, how can we call something good if men should desire it but in fact do not desire it?

The answer to that question depends on the answer to an even deeper question, the question that Spinoza put many centuries ago when he asked, Do we call something good because we desire it or do we desire something because it is good? Now it makes all the difference in the world whether you say we merely call it good because we desire it—that puts the emphasis on the desire first—or if you say we desire it because it is good. And as you answer the question one way or the other you really are taking sides on this fundamental issue about the objectivity or subjectivity of good and evil.

Let's look at the two sides of this issue a little more closely. There is the side which says the good is simply that which we in fact desire. It is that which pleases us because it satisfies our desires. And that being the case, the good is entirely relative to our desires. That is good for you which satisfies your desires, that is good for me which satisfies my desires, and there's no distinction at all between the real and the apparent good. This is the position which is often called hedonism, the position which identifies the pleasant, that which satisfies desire, with the good. Whatever pleases me is good, whatever pleases you is good. Whatever pleases me may, of course, be something different from that which pleases you.

Let me read you three statements of this position that I think are worth hearing. Spinoza says, "The terms *good* and *evil* indicate nothing positive in things considered in themselves. One and the same thing may at the same time be both good and evil or indifferent according to the person who makes the judgment. The

good is merely that which individuals regard as useful to them, that which satisfies or pleases them." And Hobbes says, "Pleasure is merely the appearance or sense of the good, as this pleasure is the appearance or sense of evil." And Locke says, "What has an aptness to produce pleasure in us, that we call good. And what is apt to produce pain in us we call evil."

And one other great writer, John Stuart Mill, in his essay on utilitarianism also identifies the pleasant with the good, that which satisfies us as the good. But Mill raises a further question. Mill asks, Are all pleasures of the same quality or are there not some higher and some lower pleasures? And shouldn't we be concerned with persons of higher and lower quality, a cultivated person and a less cultivated person? And if so, doesn't one introduce at this point into the order of pleasures some criterion other than pleasure itself for talking about the better and the worse?

For example, Mill will say, "It is better to be a human being dissatisfied than a pig satisfied. It is better to be Socrates dissatisfied than a fool satisfied." And this sounds as if one could not hold completely to the simple statement that the good is whatever pleases you or me because this doesn't give us a way of distinguishing between the human being and the pig or Socrates and the fool.

The opposite side, the side which maintains the objectivity of good and evil, insists upon the distinction that I began to suggest to you between the real and the apparent good. And it uses this distinction in the following way: it says that the real good is the objective good. The real good is something I have knowledge about. The apparent good is something I merely form my own personal opinion about. And moreover this distinction between the real and the apparent good goes as follows: it says that the apparent good, the good which is merely an expression of my personal judgment or opinion, is the object of my conscious desire. What I consciously desire from moment to moment is that which appears to me to be good, whereas the real good which I can know to be good, and which is good even when I do not consciously desire it, is something which is the object of my natural desire as opposed to my conscious desire.

What is this distinction between conscious and natural desire? Well, my conscious desires are the particular cravings I may have in mind at any moment. I may want a fountain pen of a certain

kind, I may want a large automobile, these are conscious desires. Natural desires are the cravings, shall I say, the tendencies, the appetites that are built into my human nature. For example, I have hunger as a natural appetite and therefore food is a real good because it satisfies a natural appetite. I have a mind that seeks to know and therefore knowledge is a real good because it satisfies my natural desire to know. And I have a social nature that craves friendship in society and so friends are real goods because that satisfies my natural desire for companionship. And whether I consciously desire these things or not, these things are naturally good for me. So that a miser who seeks only gold is actually seeking that which is not really to his advantage and is frustrating himself because he does not consciously seek those things which are needed by him to satisfy his natural desires and fulfill his natural capacity. If this is understood, then you see at once that the real good, because it corresponds to the things which satisfy our natural desires, the desires that are constant on a human nature, must be the same for all human beings everywhere at all times.

According to the view I've just been describing, the real good is what a man naturally does desire and consciously should desire. And therefore one can measure his conscious desires as themselves either good or evil according as they conform or do not conform with his natural desires or in other words, with the things he should desire.

What Is the Highest Good?

There is one other problem we have to face considering good and evil and that is the question about the highest good. What is the highest good in human life or what is sometimes called in the tradition of ethical discussion the *summum bonum*, which is Latin for the highest good and sometimes—simply means the ultimate goal, the end, the final objective of all human seeking?

When one considers the *summum bonum* or the ultimate goal or end of human life, one must begin to consider goods as means and ends. Some things we seek not for themselves, but as conditions of getting something else—they are means. I think most people recognize that money is not an end but a means. We want money for the things it purchases, the goods and services. We do

not want it for itself. We want health for the most part, not for its own sake but because health is a condition of good activity. We are able to do the things we want to do when we're healthy as we cannot do when we are ill.

So the question arises, what is that which is good ultimately in itself, that which we seek for its own sake and not for the sake of anything else, whereas all of the things we seek for the sake of it? Now this is a common understanding that everyone has of happiness. Everyone, I think, uses the word *happiness* to name that which he seeks for its own sake and not for the sake of anything else. Now I would defy you to try to complete the sentence I'm going to begin now. I want to be happy because—now you fill the rest in, because why? Why do you want to be happy? The only answer anyone can ever give to that question is simply because I want to be happy. There is no "because" for happiness except itself. One wants to be happy because happiness is the ultimate good that everyone seeks.

There is general agreement on this, by the way, in the history of European thought. Again if I turn to the Great Books, I can read you a series of classic statements that indicate how wide the agreement is on this conception of happiness as the ultimate goal which every man seeks. Aristotle says, "We call ultimate without qualification that good which is always desirable in itself and never for the sake of something else. Such a thing, happiness, above all else is. For this we choose always for itself and never for the sake of something else."

And then Pascal, centuries later says, "Man wishes to be happy and only wishes to be happy and cannot not wish to be so, and wishes happiness for its own sake." And John Locke says, "What ultimately moves our desires?" "Happiness," he answers, "happiness and that alone. It is the utmost pleasure of which men are due."

And finally still later in time as we come down through the centuries, John Stuart Mill says, "The utilitarian doctrine is that happiness is desirable and that the only thing desirable as an end is happiness, all other things being desirable only as means. Each person so far as he believes it to be attainable desires his own happiness. That is enough to prove that it is a good. To show that it is *the* good, not just *a* good but *the* good, the ultimate good, it is necessary to show that not only do people desire happiness, but they

never desire anything else." And this is not too hard to show, I think, because if we examine what we mean by happiness, I think we see that the meaning contains this fundamental note or insight: that a man is happy if he is in a condition which can be described as desiring nothing more. Happiness is that state which leaves nothing more to be desired, nothing can be added to it, no additional good can be enriched. That is why John Stuart Mill sometimes refers to it as the sum of all satisfaction. And if it is the sum of all satisfaction, it clearly is—being the sum of all satisfaction, it is an ultimate good, there is nothing beyond it for us to seek.

As the sum of all satisfaction, it is the complete good, it is the whole good, and all other goods are parts of it. And one might say because all other goods are only partial goods, whereas happiness is the whole of good. Happiness consisting in all good things, those parts are like means in our quest or pursuit of happiness as the whole which is the end. Each part we accomplish, each part we obtain means it is a little nearer to the object of our pursuit, the whole good, which is happiness.

Now again, we face the same old problem we faced earlier in this discussion: Is happiness something that is objective or is it just subjective? Is it the same for all men or does each man seek happiness differently, seek it according to his own desires and his own judgments? This is a very important question because on this question rests the whole validity of the science of ethics, so far as ethics is concerned with happiness. Is the content of happiness the same for all persons or does it vary from individual to individual?

Here again, we face the position of the relativist, the subjectivist, who says that to each individual his happiness is whatever he thinks it is. Each person views his happiness differently from every other person and judges it according to his own temperament, his own desires. For example, John Locke says, "Though all men's desires tend toward happiness yet they are not moved by the same object. Men choose different things and yet all choose right." Locke here quarrels with the philosophers of old, who in his opinion vainly sought to define the *summum bonum* or happiness in such a way that all men would agree on what happiness is. And according to Locke, the greatest happiness which each man seeks for himself consists in having those things which produce the greatest pleasure. "And these," says Locke, "to different men are very different things."

The opposite view here relies once more on the distinction between the real and the apparent good. The real happiness is the happiness that persons should seek. And this happiness is the same for all human beings. The apparent happiness is the happiness that in fact people do seek and this may vary from person to person. But you may say to me, "What does the real happiness consist in?" And I will say in answer, "Since happiness is the whole of goods, the sum of all good things, real happiness must consist in the sum of all real goods, which is the same for all men."

THE FOUR GOODS

Well, you may think, can you answer that question? Can you say what all real goods are? I think I can. If I look at human nature and consider natural desires, I think all the goods that constitute happiness fall into these four major classes. First, external goods, the things we call wealth, all the economic goods and services we employ, all the commodities. Second, bodily goods, things like health and physical pleasure and rest. Third, the social goods that satisfy our human social nature, our friends and the society in which we live. And finally, fourth, the goods which are especially goods to the soul: knowledge, truth, wisdom, and the moral virtues. Now these correspond to all of our natural desires and the happy man is the man who has all these goods, some wealth, health, some pleasure, friends, society, wisdom or knowledge, if you will, and the virtues.

But among these goods there is one basic distinction. In the first three categories, there is an element of chance in all these goods. Whether I have wealth, whether I have health, whether I have friends in society even, depends not entirely upon me but upon some external accident, so that in varying degrees these are all goods of fortune. I can lose them, through no fault of my own. And I may even fail to gain them without my being at fault. The goods in the fourth category are the only goods that are entirely within my control, entirely within my power of choice and action. And so these goods are the specifically moral goods, the goods upon which the possession of all these other goods depend. This is the view that sees happiness, or the pursuit of happiness, as dependent very largely on the amount of knowledge and virtue we

possess, because upon the amount of knowledge and virtue we possess depends our pursuit and gaining of these other goods, into the possession of which some element of chance or fortune enters.

I cannot close this discussion without telling you of the attack upon the theory of happiness that I just expounded for you. This attack comes from the Stoics in the ancient world and from the great German moral philosopher Immanuel Kant in the modern world. The Stoics say that all the goods in the first three categories, goods that I have called the goods of fortune, goods into which some element of happenstance enters, are indifferent, that they really are neither good nor evil. And the Stoics go on to say that the only thing which is really good in the whole wide world is a man's own good will. And this consists in obeying the law and doing one's duty.

Marcus Aurelius, the Roman emperor who was a Stoic, says, "We should judge only those things which are in our power to be good or bad. Suppose that men kill thee, cut thee in pieces, curse thee; what can these things do to prevent thy mind from remaining pure, wise, sober, just?"

Now Immanuel Kant elaborates a little bit on this Stoic view. He points out that happiness can be regarded as the *summum bonum* or highest good but that moral conduct is not conduct that is involved in seeking it as an end. Moral conduct is conduct that involves doing our duty. He agrees with the Stoics that the only really good thing in the universe is a good human will which is a dutiful will. But Kant goes on to say that though we should be doing our duty and though the only thing that is important is to have a good or a righteous will, happiness enters the human life in the following way, "It is not right," he says, "for men to seek happiness or to wish to be happy, rather they should wish so to conduct their lives that they deserve to be happy." And that is quite a different kind of statement.

17 How to Think about Beauty

You are all acquainted, I'm sure, with the familiar phrase "the true, the good, and the beautiful." And when any of us use this phrase we are referring to those three great values that are present in any human culture, in any civilization: truth, goodness, and beauty

But though these three: truth, goodness, and beauty, are usually named in that order, I don't think the order is properly one, two, three. I think it is more like this, that truth and goodness come first and are coordinate with one another; and that beauty is somehow derived from these two or somehow dependent on these two. Somehow beauty is not of the same order as truth and goodness.

Why do I say this? John Keats, the English poet, seems to say exactly the opposite. You will recall the last line of his *Ode on a Grecian Urn*, in which he says, "Beauty is truth, truth beauty; that is all Ye know on earth, and all ye need to know." He might have also said, "Beauty is goodness and goodness beauty, that is all ye know on earth and all ye need to know." And if this way of speaking of truth and goodness and beauty makes these three great values all equal, it also makes them quite indistinct from one another. I tend to think that the remark of another Englishman and great contemporary English designer, Eric Gill, gives us a deeper insight into the matter than the famous line by John Keats.

The poet Eric Gill said, "Take care of truth and goodness, and beauty will take care of herself." This suggests that somehow truth and goodness are more fundamental and that beauty is dependent on truth and goodness. When we understand this, as I hope we can in the course of this discussion, I think we shall come very close to understanding the nature of beauty.

There is one problem which is common to all three of these values. The same problem arises in the case of truth and in the case of goodness and in the case of beauty. That is the question of their objectivity, the question whether these values are subjective relative to the individual judgment, relative to personal taste, or are they objective values, values concerning which one man might be quite right and another quite wrong? In this connection, in connection with this problem we tend to think of beauty first because the problem is most frequently, most insistently raised about beauty.

The ancients, you know, had a saying that summarizes this, that ancient Latin saying, De gustibus non disputandum est, concerning matters of taste, there is no arguing. There is no disputing. One can't argue with a man about what he likes in the way of the beautiful.

And though this was first said about matters of taste, about things in the field of beauty, the idea spreads to goodness and to truth in the course of history. You know, we have a modern way of saying this, too. You have heard the man who says, "I don't know whether its good or I don't know whether its beautiful, but I know what I like." And when he says it in that tone of voice, he means to say, "Don't argue with me. I know what I like and you can't persuade me of anything else."

As I say, one tends to be subjective and relative about judgments of beauty first and then this kind of subjectivism and relativism spreads to goodness and truth. In fact, when we say about matters of good and evil or about matters of true and false that they also are just matters of taste, that the true is what seems to a man to be true, or that good is what appears or tends to be true, what he likes, then we are saying, I think, that these other two values: truth and goodness, are brought to the level of beauty.

Such relativism tends to deny the universality and the objectivity of these three great values. And this is a serious problem, a serious problem in morals, in logic, and in the theory of the arts or aesthetics. I'm going to deal today in talking to you with only one part of this problem, the problem of relativism or subjectivism, in connection with beauty—where it is, I think, a very difficult problem, because there is good reason on both sides. There is something that favors those who think that beauty is subjective and

relative. And there is certainly something to be said on the other side of that question.

In view of what I have just said, I would like to point out the two main problems we are going to consider. The first question, what beauty is, what it is in itself and in relation to and distinction from truth and goodness; and then come to this second problem, the problem of the objectivity or relativity of beauty as a value.

WHAT BEAUTY IS

The problem of saying what beauty is, requires us to say how beauty is distinct from truth and goodness. And that might at first seem like a very easy thing to do. Because ordinarily we say that truth is a quality of statements, the statements we may make about the things of the world which we receive and know, and that goodness is a quality that inheres in the things we desire or use, and that beauty is something that we find in works of art. So the distinctness of these three values or qualities would seem to be clear.

But upon further examination it is not quite so clear. Let's consider for a moment what truth in statements is. A statement is true when it conforms to the way things are. Truth is in the mind when the mind agrees with reality. That is one relation between human beings and reality.

Goodness is in things when the things satisfy our desires. And that is another relation between reality and man. The things of the world in relation to our desires are good or bad according as they satisfy or don't satisfy our desires, according as they please us or don't please us. Note that good things please us, but so do beautiful things please us. At once you have to ask the question: What difference is there in the pleasure afforded us by things we call good and things we call beautiful?

Furthermore, knowing and desiring, or—what is very much the same—thinking and acting, seem to be the two major ways in which men are related to the world in which they live. In fact, they seem to exhaust man's fundamental relations to his environment. We either know or think about things or we desire them and act in relation to them. But knowing and thinking is the sphere in which the true occurs, and desiring and acting is the sphere of the good.

What room then is there left for beauty? Where does beauty come in? That is the problem.

I think there is a way of solving this problem, by looking at beauty as a kind of synthesis, a kind of combination of aspects of the true and the good. Let's consider desire first. Here we find that beauty is a special form of the good because it is the object of a very special desire, a nonacquisitive desire, much more like love than ordinary desire for it is a desire that seeks to enjoy its object without using it up, without consuming it. The ordinary acquisitive desires, the desires that are like hunger and thirst, the desires which lead us to purchase things, are desires that aim at the use of and the consumption of the things we see. But the desire to know is satisfied simply by beholding the object itself. When we desire to know something we possess that object of our desire when we do know it. And knowing is not like eating: when we know something we don't consume it and destroy it. Knowing, unlike eating and other acquisitive desires, leaves its object untouched.

The knowledge involved in the experience of beauty is also a special form of knowledge just as the desire that is involved in beauty is a special kind of desire. The knowledge involved in the experience of beauty consists in comprehending, almost embracing, its object. Not just in making analytical or discursive statements about it, like two plus two equals four or x is y or some statement of fact; truth or the ordinary mean by logical truth exists in such statements. But beauty exists in the object of an intuitive knowledge and an intuitive apprehension of the individual thing as a whole. That is why we ordinarily speak of the experience of the beautiful as involving an aesthetic intuition and use the word *intuition* to mean this special kind of knowledge which can't be expressed in statements or in words. But it is an almost immediate experience, grasping the individual object in front of you, beholding it, possessing it through knowing it here and now.

The beautiful thing, the thing which is beautiful, is an object of contemplation. It is never an object of scientific knowledge in which truth is involved nor an object of action in which goodness is involved.

Let me see if I can summarize what I have just said by calling your attention to the respects in which the beautiful is like the good and also like the true. The beautiful is like the good in that it pleases us and that it satisfies the desire, but the beautiful is also

like the true in that it is an object of knowledge and not of action. And it is precisely because the beautiful is both like the true and like the good that it is distinct from both of them.

The two great, classic definitions of beauty make this point each in its own words. One of them is the definition given by Thomas Aquinas. He said very simply, "The beautiful is that which pleases us on being seen." Let me repeat that: "The beautiful is that which pleases us on being seen." And I must just caution you that as he uses the word *seen*, he is thinking of this intuitive apprehension of the object. It doesn't mean seen with the eye; he means that intuitive, immediate experiential grasp of the individual thing as a whole. "Beautiful," he says, "is that which satisfies our desires simply by our intuitive knowledge of it."

And Immanuel Kant in his words says very much the same when he says, "The beautiful is the object of an entirely disinterested pleasure." We aren't interested in owning the thing, using it, possessing it in any other way. We seek only to know it. And this desire is a disinterested desire and the pleasure, which comes from the satisfaction of it, can cause a disinterested pleasure.

Beauty Is Not Only in the Eye of the Beholder

With this much said about the nature of beauty, of what beauty is, let's consider whether beauty is really in the object itself, really in the thing or whether beauty is something which we merely attribute to the thing when it gives us this special kind of pleasure.

To that question, different people have given one or the other of two extreme answers. At one extreme they have said that beauty is entirely in the thing itself, that men have or do not have good taste according as they appreciate beautiful things for what they are. But at the other extreme men have said that beauty is entirely a matter of personal or individual taste; what is beautiful to one person is ugly to another, or, as the saying goes, "One man's meat is another man's poison."

Let me read you a passage from Montaigne that summarizes this point of view. "We fancy its forms," Montaigne says of the beautiful, "according to our appetite and liking." And here he is obviously thinking of beauty in the human form itself. And he lists

some examples of different cultural norms of beauty. He describes tribespeople "painted black and tawny with great swollen lips, big flat noses, and [who] load the cartilage betwixt the nostrils with great rings of gold to make it hang down to the mouth. In Peru," he goes on, "the greatest ears are the most beautiful. And they stretch them out as far as they can by art. There are, elsewhere, nations that take great care to blacken their teeth and hate to see them white, elsewhere, people that paint them red. The Italians fashion beauty gross and massive, the Spaniards gaunt and slender. Among us one makes it white, another brown; one soft and delicate, another strong and vigorous, and so on."

I think that there is between these two extreme divisions a middle ground, because I think it can be shown that beauty is both objective, something in the object itself, and subjective, something in our own experience and relative to our experience of the object.

Let me first talk about the subjectivity of beauty, the way in which it is relative to our own experience and our own temperaments and sensitivity. Now it is perfectly obvious at once—is it not?—that different things please different people. What children regard as likeable or beautiful is obviously not the same as what adults regard as beautiful. The untrained person has different tastes from the cultivated person. What a cultivated person in any field of the arts likes is usually quite different from what an uncultivated, untrained person likes. And certainly, according as people are less or more sensitive or have less or more training, their experience of what is beautiful in painting or in poetry or music will vary.

There is another way of showing the relativity or subjectivity of beauty in terms of the conditions which affect our experience of something. For example, if I asked you whether a snowflake was beautiful, whether as you looked at that little spot of white on your hand or on your coat when the snow comes down, whether that little snow flake is beautiful, you would probably say no. Because as you experience it under normal conditions it in no way catches your eye or gives you any pleasure to behold. But once you have seen a snowflake, or several snowflakes, under high magnification, you change your mind. Almost anyone looking at those wonderful patterns would have to say that each of them is an object of beauty or a beautiful thing.

The thing that is interesting here is that no matter how relative to the individual experience or the individual taste beauty is, there is also always the same basis for the pleasure which the beautiful object affords us. Let me see if I can say what that is. It is a kind of proportion between the complexity of the object and our capacity for apprehending it intuitively. For example, if the object we are examining or beholding is too complex so that we can't take it in as one thing, as having an orderly connection of parts, as one thing we see as one, then it will give us no pleasure to apprehend; we will not call it beautiful. Or if on the other hand it is too simple, if it has no structure, if there is nothing for our eye or our ear or our mind to explore as we examine it, then again, we will not call it beautiful. So that relative to the state of our sensitivity and our training, the object we are looking at must neither be too complex for us to grasp nor too simple so that we have no effort in getting to know it, no effort in grasping it. The thing we call beautiful is that thing which relative to our capacity is just difficult enough so that it requires some effort on our part to know it as an individual and yet not too difficult so that when we make the effort we succeed, and in succeeding are pleased. And that pleasure, that pleasure of success in knowing it, having made the effort to know it, is the experience of beauty.

It's perfectly obvious, is it not, then, that, if this is the relativity of beauty to the individual, individuals can be trained in the experience of beauty, their tastes can be improved or cultivated as they can be trained to apprehend more and more complex objects. And this fact, while it indicates, of course, the subjective aspect of beauty, also points to something in the object which is itself beautiful. For otherwise, if this were not the case, there would be no sense in which we could speak of the improvement in a person's taste. If there is any sense at all for speaking of improving the individual's taste, it must be because objects are more or less beautiful and the person whose taste is improved is able to appreciate the beauty of the more excellent thing.

Let me make that point a little more clearly. The better the individual's taste is the more beautiful will be the objects he can appreciate. Or say it the other way, the more beautiful the objects an individual is able to appreciate the better his taste. But you are certainly entitled to ask then: What is it in the thing itself which makes it beautiful regardless of how we see it or what our

experience of it is? What is it about the thing which makes it a measure of poor taste or of good taste?

Unity, Order, Clarity

Now there is, I think, an answer to this question which I should like to give you in three words. The three words are *unity, order,* and *clarity.*

That is, an object is beautiful if, in the first place, it is one. It hangs together as one thing; it has unity. And in the second place, if it is a complex thing as anything we examine is, its unity must consist of a proportion, an order, an arrangement of parts. And in the third place, if it consists of an arrangement of parts, the structure of those parts as a whole must be clear; it must have clarity of structure. Unity, order, and clarity, in the thing are the elements of its beauty, of its objective beauty.

There is another way of saying this. You will all remember, I'm sure, a rule of composition when you were in school. When you were asked to write a composition, what was the basis or the standard of writing a good composition? It was that the thing you wrote had unity, clarity, and coherence. Those were the three words used. To write a composition well, it had to have unity, clarity, and coherence. So those three words, tell you what it is about a thing that makes itself beautiful and makes us appreciate it when it is beautiful, and have good proper taste.

All I have said really is something we all know, that anything we make can be well-made or poorly made. It is well-made when it is put together well, when it is unified, when its parts are properly related and when its structure is clear. And to say that something is well-made is just another way of saying it is beautiful. And the rules of art in making things well are the same as the canons of good taste in the appreciation of beauty.

These two aspects of the beautiful, the objective and the subjective can be reconciled. There is no conflict between them. On the one hand the grade—the fact that there are grades of excellence, grades of beauty in works of art, that fact does not deny variations in individual taste, that different people like or enjoy, find quite different things beautiful. And on the other hand the fact that there is a scale of taste in human beings is possible. There

could not be a scale of taste in human beings unless there were grades of objective beauty in works of art. For otherwise, there would be nothing to measure this scale of taste and enable us to say that some people had poor taste and other people had better taste and that by training and experience and cultivation, the taste of an individual could be improved and elevated.

Beauty in Natural Objects

So far in our consideration of beauty we have been mainly concerned with beauty in works of art, particularly works of fine art. But there is, of course, beauty in natural objects also or as we say, beauty in nature. And so far as the general analysis of beauty goes, the principles of what is beautiful, the conditions of what is beautiful, are the same in nature or in natural objects as in works of art such as paintings or poems or pieces of music.

What most people think of when they talk about beauty in nature is something like a sunset or a landscape. And when they think of the beauty of a sunset or a landscape, what they tend to do is to make—in seeing it, to make a picture. They are in fact somewhat like the painter for in the way which they look at the scene that they call beautiful, they almost put it in a frame and by the way they see it with their eye, they are in a sense making a work of art and not seeing beauty in nature itself.

A much better example, a much clearer example of natural beauty, a beauty that is there in nature without any artistic effort on our part is the beauty that is to be found in flowers or in trees or in animals or in such things as snowflakes. Aristotle, for example, often talks about the beauty of plants or animals. And in his book on poetry he applies the same principle in discussing what makes a poem a good poem, a beautiful thing to contemplate—he applies the same principle to that as he applies to the beauty of an animal. He says, "To be beautiful, a living creature like every whole made up of parts, must not only present a certain order in its arrangement of parts but must also be of a certain magnitude. If it is too large to be seen, too small to have its structure clear, it will not be beautiful. It must be of such a size and its parts must be so ordered and its unity so clear and its structure apparent that as one sees it, one takes it in as a well-formed whole."

Everyone, I think, knows the difference between a well-formed rose and a misshapen one, a well-formed animal and a deformed one. We, all of us, I think, recognize the ugliness of deformity and recognize the beauty in that which is well-formed. What we mean by well-formed is that its unity is clear, its parts are well-ordered to one another, and its structure is orderly and apparent.

We have emphasized the fine arts in this discussion of beauty. And there is good reason for putting emphasis on the fine arts because works of fine art, such as paintings and statues, sculpture, poetry, music; these are objects that men make primarily for the sake of producing beauty. The works of fine art are primarily made to give men objects to contemplate, objects to enjoy.

We are not to be too narrow or highbrow in the way we talk about beauty. For all spectacles, even such things as prize fights or ballgames or ice skating performances, all of these things as spectacles can give men, men who see them, the experience of excellence and performance which is the experience of beauty. Not merely in the high arts, in the great arts, but also in all the popular arts, men can experience the beauty of beholding a thing well-done.

18 How to Think about Freedom

There are few words in the English language, or for that matter in any language, that have more meaning than the word "freedom." There are few words or few notions that can cause us greater perplexity, because as one reads the vast literature on this subject, it is very difficult to tell who disagrees or who agrees with whom.

Now to discuss this very complex subject in the short time we have, it's necessary to distinguish the several different objects that men have in mind when they use the word *freedom*. We have time to discuss only one of these. Let me see if I can briefly indicate to you what different things, different objects, men have in mind when they use the word *freedom*.

THREE KINDS OF FREEDOM

First, they have in mind a freedom that men have in relation to one another in their action, in society, and in relation to the state. This might be called a social freedom or a political or an economic freedom. For example, it is in this sense of the term freedom that one speaks of a man as a slave, when he is enslaved, mastered by another man. And it is in this area of freedom also that one would think of monopoly, economic monopoly as interfering with freedom, because a monopoly prevents competition and prevents men from having a choice of competing commodities to purchase. And it is in this area also that a certain restrictive legislation or restrictive covenant can interfere with the freedom of action that men have in relation to one another or in their social life.

A second and totally different area which carries the notion of freedom is that of the freedom a man has within himself in deciding what he is going to do. This we might call psychological freedom as opposed to social freedom. And here conventionally what we have in mind is what is referred to as the freedom of the will, a free will, a will that itself determines what a man is going to do and exempts a man from being determined in what he does by his background or other external causes.

And there is a third area of freedom, that freedom in which a man is said to be free from conflict within himself and to have the development of a perfection in his nature so that he becomes what he ought to be. This freedom is sometimes called moral freedom. And an example of what is meant by moral freedom is given us by the theologians when they talk of freedom from sin. And in modern times psychiatrists will talk about the freedom of an integrated personality as opposed to the lack of freedom, the compulsiveness, of a neurotic.

As I said, there is a social freedom, a psychological freedom, and a moral freedom. And when men use the word "freedom" they may mean any one of these three. These different objects which men call freedom, these three different things, are quite distinct and yet quite compatible. I think no one would ever confuse the freedom of a man in society and his action in relation to other men with the psychological freedom of decision or choice on the part of the will. And no one would confuse that with the moral freedom that has to do with freedom from inner conflict. And yet, though they are distinct, they are also combinable. There are some elaborate theories of freedom which attribute to man all three of these freedoms, whereas there are other theories of freedom which say no, man only has social freedom or only has moral freedom. And sometimes there are theories which assert that the psychological freedom is the fundamental freedom underlying both social and moral freedom.

With respect to these three freedoms, there is one fundamental issue that I want to talk about quickly and then not come back to again because it is too difficult and I don't want to have it occupy the center of attention in our discussion today. Often, writers about freedom or liberty or those who emphasize either social or moral freedom tend to deny the reality of psychological freedom. The one of these three freedoms which is most frequently

denied by authors who are affirming freedom in some other sense is the freedom of the will. And the reason for the denial of the freedom of the will is this: it is supposed that this freedom would violate the fundamental laws of physics, that if man in all his behavior is governed, as everything else in the universe is, by the laws of motion, the mechanical laws of motion that the physicist has discovered, then man cannot have freedom of decision or free will. That is the issue about free will, a very special issue in philosophy that we will not explore today.

SOCIAL FREEDOM

In the time that we have together today I would like to discuss only one of these three freedoms in detail, and that is the first one, social freedom—the freedom that men have in relation to one another and in relation to the society in which they live. I think you will see in many ways this is the best choice for our purposes. And in the area of this freedom there are many problems and issues. Let's turn to these at once.

First of all, I would like to say a word of further clarification about this type of freedom we are now going to consider in detail. I am referring, to this first type of freedom which we have called social freedom. When one considers this freedom, one sees at once that men have it or lack it or have it to a greater degree or a lesser degree, according to the circumstances under which they live and act. When the circumstances are favorable they have this freedom; when the circumstances are unfavorable or unpropitious, they are deprived of this freedom. And the circumstances that are favorable are those which permit a man to act as he wishes, to do as he pleases. The circumstances which are unfavorable are those which prevent a man from doing as he pleases or acting as he wishes.

That is why, I think, we would gain some clarity if we called this type of freedom not social but circumstantial, to indicate that men have it or do not have it depending on favorable or unfavorable circumstances. And then the distinction between this freedom, this circumstantial freedom, and the other two can be further clarified by recognizing that what we previously called psychological freedom is better named natural. For those who hold that men

have this freedom hold that they have it in their very nature; they are born with it—it's an innate freedom. It is built right into the constitution of man when this freedom comes to men from living under favorable circumstances.

And finally then, this third freedom which is called moral, I think, is better understood if we recognize that such freedom—if there is such freedom, is acquired. It is neither natural, neither innate, nor something that men have at birth; nor is it something which they have or do not have according to their circumstances, but rather it is a freedom that some men, as they grow and develop and change in their growth, acquire. So it should be called acquired freedom.

Now let's come back to this freedom which depends upon favorable circumstances. Do you remember what I said about favorable circumstances? You will see at once what the freedom consists in. The freedom consists in a man acting as he pleases, being able to do what he wishes, being able to execute, carry out his desire. A man can have this freedom even if his wishes or his desires were themselves determined.

Jonathan Edwards, an early American theologian, once said that a man is free if he can do as he wishes, even if he cannot wish as he wishes, meaning that I may not be able to determine my own wishes, but if whatever I wish I am able to execute and carry out, then in so far forth, I am free.

FREEDOM AND COERCION

Since this freedom consists in execution, in carrying out my desires or wishes, its great nullifier, the thing that opposes it, the thing that prevents it, we call coercion. For when a man is coerced by physical force he is not able to do what he wishes. In other words, here it is not the laws of nature or the physical laws, the laws of causality, which oppose freedom but simply the force of coercion.

I'm sure you know what I mean by coercion. For example, if a man is trying to walk against a very strong wind and isn't able to force himself against the wind, even that natural force is coercing him, is restraining him. Or if a man is caught in a thicket so that the underbrush holds his clothing so that he can't walk, he is being coerced, or in this case he is being restrained. Or to take another

case, if I come along and take your arm and by sheer physical force move your arm against your will, you are then being coerced in that movement. And so men are coerced sometimes by the natural elements and sometimes by other men in society.

When you stop to think of what coercion means and how coercion is the opposite of freedom in action, you can see, I think, that the essence of this freedom lies in action itself. For when a man is coerced he is not acting; he is being acted upon. He is suffering someone else's action upon him. He is being pushed about, if you will, or moved and he is not initiating the movement himself.

Hence this freedom of which we are talking has both a positive and a negative aspect. Negatively, this freedom consists in exemption from coercion. And positively, this freedom consists in action, in the execution or carrying out of my own desires. When I act, I am free. And as you think about that for a moment, that statement, when I act as opposed to being acting upon, I am free, you will, I think, get what for me is at least the deepest insight into the meaning of freedom.

Let me show you what that insight comes to quickly in another chart. The essence of freedom requires us to understand two terms: *self* and *other*. When what I do is caused, or if you will, is forced upon me by the other, when I am under the power of the other, I am not free. But when what I do, what I think, how I become, flows entirely from myself, I am free. Self and self-expression, self-determination, is the essence of freedom. When the self is subject to the other you have not action but passion, being acted on. But when the self is the source of motion or change you have action and with action you have freedom. So that one could almost say from considering this type of freedom that the essence of the matter, the essence of freedom, lies in the power of the self to do, to think, to become, as it itself determines. And the absence of freedom consists in being subject to the power of the other.

There are some fundamental differences of opinion here that I should like to report, about what is involved in acting as I please. I am going to report these differences of opinion by asking you three or four basic questions, having you think about the questions and then let me tell you what the conflicting answers to these questions are.

The first question is, Do objects like stones, or other living organisms other than human beings, all have this freedom, as well

as human beings? Do other things like stone or plants or cats have the freedom which consists in acting as they please? Well, Thomas Hobbes said yes to that question. He said, "When a stone is rolling downhill it is free if there is nothing in its path. It is not free if something like a twig or another stone stops it from rolling." And we often, I suppose, tend to think animals in cages are no more free than people are in prison. But while Hobbes and others say that all things that can move have freedom when they are allowed to act as they please, carry out their motions without being interfered with, there are other authors who say no. Only man has this kind of freedom because only that being who has conscious and deliberate desire can be regarded as free in the execution of his conscious and deliberate desire, and stones don't have conscious and deliberate desire.

Now there is a second question. And that question is, Is this freedom we are talking about, ever interfered with by anything other than actual coercion, by the imposition upon the body of a force that restrains it or compels it to move? Again, Thomas Hobbes says no. Only coercion, the only thing that can prevent this freedom is sheer physical force in compelling an act of motion or preventing a motion. But other authors say yes, there are many other things that can interfere with this freedom, that are obstacles to this freedom. For example, what is sometimes called duress. I can so intimidate you, I can so threaten you, I can so induce a fear into you, that you will not act even if I don't touch you. Thus many men are prevented from acting by fear of the consequences even though they aren't touched. And the way in which fear of the consequences prevents them from acting as they please is regarded by these authors as an obstacle to freedom.

Or sometimes I can interfere with your freedom, according to this other view, by removing the means. You want to go downtown, you are in a hurry, you have a car, I take the key of your car so that you can't do it. Am I interfering with your freedom of action? Can you do what you please? No. I have removed a means from you. So there are things other than coercion that can interfere with this freedom.

Another question, Does this freedom require alternatives? Must a man have the opportunity to do this or that? Must he have the opportunity to act or not to act in order to be free? Let me give you an example. A man is sitting in prison. The bars of his cell will prevent him from going out of the cell. But he doesn't want to go out of the cell. He is quite content to sit there. Is he free? Thomas

Hobbes would say, "Yes, he's free. He is at this moment not being coerced. He wants to sit in the cell and nothing is stopping him from sitting in the cell, therefore he is free." "But no," says Locke, "that isn't so. Because for a man to be free he must have both alternatives open to him." Suppose he wanted, just suppose he wanted to go out of the cell, then he wouldn't be free. According to Locke a man is free only if he is able to do otherwise than as he wishes. He may wish to stay in the cell, but he is free only if he could have gone out of the cell had he wished to do so. This is the view of freedom that requires an openness of alternative, the opportunity to act in a number of contrary fashions, not merely act in one way.

And finally there is the question whether or not this freedom depends upon success in attaining the goal. I must not only be able to act in a certain way but if I want to reach a certain objective or a certain goal. There are some authors who say I am not free unless I have the power to succeed in attaining my objective. It isn't merely that I am able to perform this act or that act, but my wish for the goal requires that I have the power and the means for achieving the objective before I am entitled to be called free.

The questions we have just considered indicate the different theories that men have of freedom when they conceive it as acting as I wish or doing as I please. These questions also indicate, as you saw a moment ago, the different kinds of obstacles that can be conceived of as standing in the way of or preventing freedom. But one great question remains which we have not yet considered. And that question is, Is law, the law of the state, civil law, always an obstacle to freedom?

The one answer to this question, one of the great answers to this question is that law or government is always an obstacle, that it always infringes on or abridges liberty. According to men who say this, law always represents the will of another man. And so when I obey the law I am not doing as I will but as another man wishes me to do or as he wills. And if I disobey the law, I am powerfully subject to physical coercion by the force of the law.

Must the Law Always Curtail Freedom?

Those who hold this theory see that there are two ways, two kinds of interference to which men are subject. They are subject to

extralegal coercion, coercion outside the law by other men and forces, and by legal coercion. And therefore they recognize that sometimes when the law protects a man from extralegal coercion, it is in a sense promoting his freedom by preventing that kind of coercion. Nevertheless those who hold this view of law and liberty always say that even when the law promotes freedom by preventing extralegal coercion, it also simultaneously abridges it.

Let me read you what Bentham has to say on this subject because in a way he is the clearest exponent of this view. He says, "By creating obligations the law to the same extent in so far as it creates obligations trenches upon liberty. It is impossible to create rights, to impose obligations, to protect persons, except at the expense of liberty." Hence he goes on, "There is always a reason against every coercive law. And that reason is that every law is an attack on liberty." And following him John Stuart Mill points out this conception of law as opposed to liberty, that the spheres of law and liberty, the sphere of action as lawful, and the sphere of free action are mutually exclusive. According to Mill, since freedom consists in exemption from externally imposed regulations or coercions, the sphere of freedom enlarges as the sphere of government and law diminishes; the more laws the less liberty, the fewer laws the more liberty.

How much liberty should an individual have? It is a fair question. Mill answers this question by saying, "As much as he can use without interfering with or injuring others." I quote, "The only part of the conduct of anyone for which he is answerable to society is that which concerns others. In that part which merely concerns himself, his freedom is by right absolute."

The opposite answer to this great question about law and liberty is that men have freedom under law and have freedom through law as well as freedom from law. The opposite answer really says that the law, when it is just, never infringes upon anyone's liberty.

Let me call your attention to a point on which the two theories agree. For this second theory that looks upon law as favorable, as in some sense a foundation of freedom says that men are free to do as they please in all matters where the law is silent. On such matters as are not regulated by law, my freedom obviously consists in my doing as I please. But this theory unlike the first theory goes on, and this is its distinctive mark, it goes on to say I am also free

under certain conditions, I am also free when I obey the law under certain conditions.

What are those conditions? First, if the law under which I live is one to which I've given my consent, the law is made with my consent, as with any constitutional state, and any republican form of government the laws are made with my consent. And secondly, only if I have consented to the laws, but if I have actual voice, a participating voice in the making of the laws through my suffrage as a citizen. In other words, when men live under a republic and a constitutional government and have the status, the rights, and the privileges of citizenship, they are free even when they obey the law, because under these conditions, when men live under a body of laws to which they have given their consent and in the making of which they have had some voice, they act according to their own will, their own will by their consent, with their own participating voice, when they obey the law. This shows us a conception of freedom as self-government, not freedom from government but freedom through having a voice in government and through one's own voluntary consent to government.

Let me read you here some classic statements of this point of view. William Penn says, "The most natural and human government is that of consent. For such government binds us freely when men hold their liberty by true obedience to laws of their own making." And Rousseau points out, "Constitutional government in which men are citizens is one under which each individual obeys himself when he obeys the law, and so remains quite free." That is why Rousseau says over and over again that it is to law and law alone that men owe justice and liberty. And John Locke says, "The end of law is not to abolish or restrain, but to preserve and enlarge, freedom. Where there is no law, there is no freedom. For liberty is to be free from restraint and violence from others which cannot be where there is no law." And finally, Immanuel Kant says, "Freedom is independence of the compulsory will of another. And so it is the citizen in a republic who has constitutional freedom because he obeys no other law than that to which he has given his consent or approval."

Now according to this theory men are unfree when they live under tyranny or despotism because then they are subject to the arbitrary will of another man, the will of another man to which they have not given consent and rules in the making of which they

have had no voice. Freedom is the very opposite of this. Or "Freedom consists," according to Locke, "in not being subject to the inconstant, uncertain, unknown, arbitrary will of another man." Hence according to this theory, far from limiting freedom or opposing it, law always tends to increase freedom, promote it, and is in fact its foundation stone.

In the few minutes that are left I would like to mention one other point in this fundamental conflict concerning liberty and law. Those who take the view that law is the foundation of freedom also make a sharp distinction between liberty and license. Just laws never infringe upon liberty; only unjust laws can interfere with man's freedom. And when a man disobeys the law he is not free, he is committing a licentious act. To disobey the law is to exercise license not liberty. And license according to this theory is the very opposite of freedom. For freedom is action which serves a man's own good and license according to this theory defeats his good.

The opposite view is that law always infringes freedom whether it be just or unjust, that unjust laws interfere with a man's liberty, but no more than just laws do. And so according to this view there is no distinction between liberty and license. Freedom always consists in exemption from law, just or unjust. And a man who disobeys a just law is as free as a man who disobeys an unjust law. As Bentham asks, "Is not the liberty to do evil, liberty? If not, what is it?"

19 How to Think about Learning

Today we begin the discussion of the Great Idea of Learning. Mr. Luckman is here to ask questions, questions of the sort that may arise in our minds as we proceed with this discussion.

Lloyd Luckman: And may I ask a question right away, Dr. Adler? You see, during the last week I've been thinking about the subject you've chosen for this series of discussions of The Great Ideas and I've been wondering why you've chosen the idea of *learning* as against the idea of *education.* Are they the same in your mind? Shall we be dealing then with the same problems and the same ideas under the head of learning as we would if you were discussing education?

Mortimer Adler: I think answering that question is a very good way to begin. Mr. Luckman asks a question that you may be asking yourself: Are the ideas of education and learning really the same idea under two names? Are the problems of education the same as the problems of learning?

No. I think they are not. Education is a much larger, and a much more comprehensive subject than learning is. The problems of learning, I think, are only one small segment in that larger field of problems which we call education.

If I have some books here, as I think I have, on education, I think I can show you precisely what I mean. If I have here two basic texts on the philosophy of education and on problems of education, and if you were to take one of these books and look through it or as a matter of fact just look at the table of contents, this is what you would find: it would deal with the problems of the organization of the school system or the problems of the state control of education or the role of politics in education, the problem

of who shall be educated in the schools and how long they shall be educated there, whether all should be given the same kind of schooling, the problems of different kinds of education, the relation of liberal and vocational education or religious and intellectual education. And finally, among all these problems we would come, I think, finally to the problem of the content and methods of education, what should be taught and how it should be taught. And it is only here that we would begin to touch on the problems of learning.

Now that, I think, shows that the problems of learning are only part of the problems of education. To my mind, the most interesting part; the rest deals with externals. Learning is the very heart of education.

Learning itself is a large subject. Just consider for a moment what learning covers. Learning represents the whole, or every aspect of acquired modifications of human behavior. Learned behavior is modified behavior. The process of learning is the process by which we acquire all the modifications of our emotional or moral or intellectual behavior.

John Dewey has said this more expertly than anybody else when he said that the process of learning is identical with the process of growth, leaving out, of course, the physical growth of the body. In his view of learning, the extent to which a man has learned something in the course of his lifetime is measured by the amount of emotional, intellectual, moral, and spiritual growth he has accomplished.

Lloyd Luckman: Well, just as you were touching on that very definition, it seemed to me then that the problems of learning are the problems of educational psychology. Now if that is so, is it that you are going to deal with these problems in the same way as you would with the psychological aspect of this whole idea of learning? Are you going to discuss the various theories? The Gestalt theory, the conditioned-reflex theory, the trial and error and all—

Mortimer Adler: No, not quite that way, Lloyd. I think that would take us too far afield.

Mr. Luckman has just referred to the controversy among experimental psychologists about what learning is. And there are, as he indicates, four or five major conflicting theories based on researches in the experimental laboratory on the behavior of animals and sometimes human beings, though most of this experimental work is based on animal behavior.

Now, again, let me see if I have a book here that will help us make this more concrete. If one were to take up any ordinary textbook of Psychology and turn in it to the chapter on learning, one would find that it dealt with the following kinds of things. It would deal with how rats learn to run through mazes by trial and error. Or it would deal with how cats, again by trial and error, learn to solve the problem of getting out of boxes into which they are locked. Or as in another case, the chapter might deal with the conditioned-reflex, with the conditioning of the behavior of a dog as in the case of Pavlov's dog, whose salivary reflex was conditioned in the laboratory. Or finally, it might, as you mentioned the Gestalt experiments, it might deal with how chimpanzees or other apes learn by perceptual insight.

There is no question that some human learning is on the level of this kind of animal behavior which is studied in the laboratory. But certainly this is not true of all human learning and certainly it is not true of the most significant aspects of human learning.

Let me read you what Professor Hilgard of Stanford University has to say on this subject in what to my mind is the authoritative book on it, his book on the theories of learning. Professor Hilgard reaches the conclusion that all these theories of learning are unsatisfactory, "because they are too largely based," he says, "on the behavior of animals and on the assumption that human learning can be best understood by comparison with that of animals." He says, "This comparative approach studying animals in relation to men and men in relation to animals neglects the fact that human beings are brighter than animals and are able to use language." And therefore probably learn differently because of these advances over the lower animals.

I would like to deal here with human learning, with what is most characteristic about human learning, with the kind of learning that involves the use of language and of symbols, with the kind of learning that involves ideas, maybe even The Great Ideas, and with the kind of learning that results in the acquisition of understanding or knowledge or wisdom, not just the acquisition of bodily habits or the solution of practical problems.

Lloyd Luckman: You certainly have narrowed the subject considerably by restricting it to what is characteristically called human learning. Do you also intend to go even further in narrowing the subject? From your last remark I am asking this question in partic-

ular because it seems you are saying you are going to talk only about intellectual learning, the acquisition of knowledge.

Mortimer Adler: Yes, Lloyd, I'm afraid I'm going to narrow the subject even further because human learning, though it is a part of the subject of education, is itself a very large problem.

Only a small segment of the field of education deals with learning, and human learning, as opposed to animal learning, is only a part of the field of learning, and human learning is a wide-ranging subject dealing with emotional learning, how we change and cultivate our emotions; with moral learning, how we form our moral character; and with intellectual learning, how we improve and stock our mind.

All these subjects are interesting. I don't mean to say that intellectual learning, the improvement of the mind is more important than moral learning or emotional learning; I simply mean that we can't discuss everything at this time. I would like to deal now with intellectual learning, with the kind of learning that involves teachers and the role of teaching in learning. Teaching is not involved in animal learning. And as we understand teaching, as you and I understand teaching, the kind of thing that goes on in classrooms, it is mainly a process that involves the improvement of the mind, not the formation of character or the clarification and readjustment of the emotions.

DISCOVERY COMES BEFORE INSTRUCTION

As soon as we see that we are dealing with the kind of learning that involves teaching, this leads at once to a problem that I should like to present to you. It is the problem of the role of the teacher in human learning. And I would like to begin by asking you to think with me of what is perhaps the most fundamental distinction in the whole field of human learning, the distinction between learning with teachers and without teachers or, as it is sometimes called, learning by instruction, that is, with teachers and learning by discovery, by discovering things for yourself, that is, without teachers.

There are three consequences that follow when we understand this distinction between learning by instruction, or with teachers, and learning by discovery, or without teachers. The first is that nothing which can be learned by instruction cannot also be

learned by discovery. Or to put it positively, everything we can be instructed in, someone else must have learned by discovery. Discovery must ultimately in the history of the race precede instruction; for if this teacher who teaches something learned what he teaches from someone else who learned it from another teacher, that cannot go back indefinitely. Somewhere in the knowledge that we pass on in the process of teaching, someone must have discovered it for himself. So we see, first of all, that learning by discovery is primary.

Learning by instruction is secondary. And if this is so, then we also see that teachers are, in an absolute sense, dispensable. Not indispensable but dispensable, for nothing which can be learned by instruction with teachers is impossible to learn without teachers. I don't mean that teachers aren't useful; they are. And I don't mean that for most of us teachers aren't necessary; they are. For most of us would not be able to learn without the help of teachers or learn as rapidly or learn as easily the things we have to come to know in the course of our lifetime. But I do mean that teachers are only helps. And this understanding of the teacher as an aid, as something which helps in the process of learning, is the deepest insight into the nature of teaching in relation to learning.

Perhaps another way of seeing this is to consider the way in which the teacher is like the farmer or the physician. The farmer doesn't produce the grains of the field; he merely helps them grow. The physician does not produce the health of the body; he merely helps the body maintain its health or regain its health. And so the teacher does not produce knowledge in the mind; he merely helps the mind discover it for itself.

Socrates, who was the greatest of teachers and really the model for all teachers, epitomized this point about the art of teaching when he compared himself as a teacher to a midwife. He said, All I do is assist in the birth of knowledge, the birth of the understanding of ideas in someone else's mind. And by helping them in the labor of discovery, I make the process of discovery easier for them and less painful.

LEARNING IS ALWAYS ACTIVE

This indicates, I think, another fundamental fact about teaching and learning. Learning by instruction, learning with the help of

teachers is no less active than learning by discovery. To suppose it is, to suppose that when we are taught, we are passive, is to make the most grievous error one can make about both learning and teaching. In fact, one ought to say, I think, that if you understood Socrates's conception of teaching, it is the learner himself who is going through the process of labor to give birth to knowledge or understanding. The teacher, like the midwife, is merely standing by, is merely assisting. And when we understand this we ought to, I think, reexamine that very distinction we began with, namely, the distinction between learning by instruction and learning by discovery because discovery, the labor of discovery, the labor of thinking for oneself is involved in all learning. Perhaps it would be better then, instead of saying learning by instruction and learning by discovery, to call them both learning by discovery; learning with a teacher could be termed "aided discovery" and learning without a teacher, "unaided discovery."

In both forms of learning it is the learner who must be active. It is the learner who must work. The fact that the learner may be helped by the teacher doesn't permit the learner to sit back passively and absorb knowledge like a sponge or like a block. In other words, all learning is fundamentally an active process, a process of learning from experience, of learning by doing, not by having something done to oneself. That's why it's so wrong to say, "I'll learn you" instead of "I'll teach you." For even when I am teaching you, it is you who have to do the learning by yourself.

Lloyd Luckman: Dr. Adler, did I really hear correctly? Did I hear you say that all learning is learning by doing and must involve experience?

Mortimer Adler: That's what I said.

Lloyd Luckman: Well, then I wonder if this means that you accept the view of human learning that has become the platform of progressive education, at least in the United States for the last fifty years.

Mortimer Adler: Well, I can see why you could hardly believe your ears. I have the reputation, I'm afraid, of being an opponent of progressive education. But I'm only opposed to what is wrong with progressive education, not to what is right about it. Let me see if I can explain this distinction.

Let's take the sentence or the statement that is, as Mr. Luckman says, the platform of progressive education: all learning

is by doing. Now what is wrong with that statement is a certain interpretation that is put upon it. If the word *doing* is very narrowly interpreted to mean only practical activity, certain forms of social action, certain forms of artistic production, then I think the statement is not true for it excludes such activities as reading or as listening to a lecture, or most important of all, thinking. And if the progressive educator says to me that he doesn't mean to exclude thinking, but only thinking as divorced from practical projects or problems, then I'd say his conception of the project method is as narrow as his conception of doing.

What is right or sound about the statement that all learning is by doing is contained in the insight that all learning involves activity. It can't be a passive process. It can't be like the habits formed in matter, something that they receive when something is done to them. May I have a piece of paper there, Lloyd, please? You take a piece of paper and I actively crease it and the paper, as you can see, then retains the crease. It retains the crease but that crease in a piece of paper is not like a human habit. *A human habit isn't formed by having something done to you; a human habit is formed by your doing something.* And that is the difference. And the more activity there is in learning, the more genuine learning takes place.

In the second place, the doing or activity which is involved in learning can never be simply bodily activity; it must involve mental activity, and above all, thinking. For there is no genuine learning that does not involve thinking. Now if thinking is not doing, then the statement "All learning is by doing," is false and we ought to say, "All learning is by activity and mainly by the activity of thinking." For without active thinking, all you could possibly have is rote learning. And when we use the very words "rote learning," we mean that it isn't real learning.

There is a third point that I should like to make. And that is that among the activities that are involved in learning are things that ordinarily aren't classified as doing in the ordinary sense of doing. They are such things as reading or listening. And the point is that they are just as active, those things are just as active as writing or speaking. The progressive educator is right only when he rejects the caricature of these things, the kind of caricature that is expressed in that definition of a lecture as the process whereby the notes of the lecturer become the notes of the student without passing through the minds of either.

THE STUDENT'S INTERESTS SHOULD NOT GOVERN LEARNING

Finally, the project method with which the progressive educator is so concerned is, I think, quite sound if what it insists upon is that the student have a genuine interest in the problem, that he be engaged in the problem before he comes to understand the answer. Certainly the deepest motivation in learning is to be concerned with the problem and to seek the solution of it. Problems or questions come before answers and we don't motivate people in learning unless we make them genuinely feel the problem for which the answer is the solution. This we know to be true in the case of animals. They won't learn unless they are motivated by deep biological drives of hunger and sex. And as John Dewey, summarizing this point, says, "The problem is the very principle, the point of departure of learning." He says the problem is the very first principle of learning, problems that connect with the experience of the learner, problems that are within the range of his capacities, problems that arouse in the learner an active quest for knowledge and for the production of new ideas.

Lloyd Luckman: And there you have another basic point in the program of progressive education, that there can be no learning without interest or motivation. Now I wonder, do you think that that point of theirs is partly right and partly wrong, or do you accept it?

Mortimer Adler: No, Lloyd. There I would say there is nothing at all wrong with their point about motivation. There my only quarrel is that they draw a wrong conclusion from the very truth of the proposition that interest is essential and motivation is essential for learning. Let me see if I can explain what I mean by answering Mr. Luckman in this way.

No educator, no teacher, I think, has ever supposed that learning was possible without motivation or interest. The progressive educators didn't discover this truth. In the fifth century B.C., Plato, in one of the first great works of education made the point that there should be no hot-house forcing of the child, that interest must be cultivated not only at the child's stage of learning, but at all later stages of learning.

Many progressive educators have drawn a wrong conclusion from this fundamental truth. That wrong conclusion consists in

thinking that we ought to begin with the interests of the student. The child comes to school with certain interests and we ought to take those interests as dictating to us what the child should learn and what the child should be taught; this is what is meant by the child-centered school, in which the child's interests are the pivots of all learning and teaching. I think this goes against the grain of the normal child. I think the normal child would much rather have new interests aroused in him by teachers than have what he is to study derived entirely from the interests he brings to school.

I can never forget the story told me about a little boy in a "progressive" school in New York. The teacher found him crying in the hall one day and asked him what he was crying about. He said tearfully, "Teacher, do we have to do what we want to do today?" That seems to me to sum the matter up.

Now the right conclusion to draw from the fundamental truth that all learning must be motivated by interest in the very subjects or problems to be solved, the right conclusion puts the burden on the teacher, not on the student. It is up to the teachers and the educators to decide what should be taught. And then having decided what the student should learn, their duty, their task, is to arouse a deep and lively interest in the very things that should be learned.

For example, I would be a very poor teacher with regard to The Great Ideas if I merely talked about them, if I merely expounded them, if I didn't do what I could, however poorly I may do it, to arouse your interest in them, to see if I can motivate you to be interested in them for the sake of the understanding that they can be derived from considering the ideas and the problems they raise.

How to do this, how to cultivate interest, how to motivate people in the process of learning is a question we will not have time to discuss today. In fact, it is a very difficult question because so much of it depends on the art of the teacher. And so much depends on the employment of that art in particular situations, particular classrooms, particular students. But perhaps we shall be able to return to certain aspects of this problem next time when we consider individual differences in learning and above all the difference between children and adults as learners.

Teaching Should Combat Weaknesses

Now perhaps I can say a word more about this problem of individual differences in learning.

Lloyd Luckman: Please do.

Mortimer Adler: We, in the schools and all in our adult life, are aware of the fact that human beings differ one from another in their talents, in their temperaments, and their interests. And we too often, I think, draw the conclusion that people should be guided in their learning and we should be guided in teaching them, by what they are interested in, by their talents, let them follow their talents, let them develop their talents, let them only pursue their interests. Though this seems like an obvious conclusion, it is nevertheless the wrong conclusion. If there are certain things fundamental to human life, if there is a body of wisdom which all persons should have, if there are certain kinds of knowledge, certain arts that all persons should acquire, then they should be in the possession of all, regardless of their individual differences, regardless of what their talents or their interests may be.

I would almost say that in the schools, particularly, our task is to work against the talents of the child. For the talents of the child indicate where the child has strength. And where the child doesn't have talents is where the child is weak. And the job of teaching that child or educating that child is the job of pushing the learning process on the side of the child's weakness, not on the side of the child's strength. The child that is interested in poetry and says, "I'm not interested in mathematics," and "I can't do mathematics," should be helped and persuaded to study mathematics. Because if that child has a talent for poetry, that talent can't ever be suppressed and will lead to learning in its own way.

Our task, I think, is to find those basic subjects which all human beings, in school and in adult life, should learn. And then somehow, by the way in which we teach them, by the way in which we suggest they be learned, overcome the differences between human beings, the differences that arise because they are born with quite different talents and quite different temperamental interests.

Lloyd Luckman: Well, I do hope in our succeeding discussions you'll be able to develop this very challenging thought further, Dr. Adler.

Mortimer Adler: Well, I don't know that I'll be able to delve into it much further because next time I would like to deal mainly with the problems of adult learning.

If you agree with me that none of us is ever too old to learn, then I feel sure that you will be interested in the problems we shall deal with next time, mainly arising from the learning of adults, which is quite different in its problems and its nature from the learning of children.

20 Youth Is a Barrier to Learning

Learning is a large subject, not quite as large as education, but nevertheless quite large. And so we are dealing mainly with human learning, the kind of learning that results in the improvement of the mind, the kind of learning in which teachers can be of some help to us.

Now I would like to make a wager with you. I would be willing to bet that I can guess what images come into your mind as I use the words "learning" and "teaching." My guess is that you tend to call before your mind the image of a teacher standing in a classroom at a blackboard with children at their seats. Am I right? Is that what you think of when you think of learning and teaching?

Lloyd Luckman: Well, I won't tell you whether that's what I think of until you tell me what's wrong with the picture.

Mortimer Adler: There's nothing wrong with the picture itself. Learning and teaching certainly go on in classrooms. But I think that it's wrong to let that image and the conceptions of learning and teaching that go with it crowd other images and meanings out of our minds.

A Lifetime of Learning

I think the deepest and most serious error we can make about education, and one by the way that is made on all sides by educators and teachers as well by the public generally, is to identify education with schooling; or even to suppose that the kind of learning that goes on in schools, and I mean everything from kindergarten

to college, is the main part of education. Or to suppose that the kind of learning that children do in school is the main business of childhood, and that learning belongs to childhood primarily, and that most learning can be done in childhood, and that all adults have to do is to use the learning they acquired in school when they were very young.

Does anyone watching this program suppose that? I fear that many of you may. I would like to have you follow me closely now because I'm going to try to convince you of the very opposite. I'm going to try to show you three things.

The first is that learning is the process of a whole lifetime. The second is that adult learning is the most important part of anyone's education. And the third is that schooling or learning in school is at best only preparation for the kind of learning that must be done because it can be done only in adult life.

Let me comment for a moment on that third point. Schooling fails miserably if it does not prepare young people to carry on learning after they leave school, to carry on learning for the rest of their lives. Anyone who doesn't understand this fails to understand one of the most important points in the philosophy of education, the point that John Dewey repeatedly stressed when he said that all learning is for the sake of more learning, just as every phase of growth is for the sake of further growth. And so one might almost say that the whole purpose of schooling or of the learning that we do in school is to prepare us for the kind of learning we have to do and ought to do for the rest of our lives.

I just used the phrase "the kind of learning we have to do or ought to do." I don't mean, in saying that, to imply that adult education is or ought to be compulsory. We know that it isn't. We know that it shouldn't be. But the fact that it isn't compulsory by no means excludes it from being necessary. Adult learning is necessary for all of us, for everyone, whether we have been through school and college or not.

Lloyd Luckman: You know, I think I see what you mean, but I'm really not sure that you've made the point quite clear, Dr. Adler. Because the question that remains in my mind is, Is this adult learning that is so necessary, necessary to the same extent and in the same way for those adults who have had an adequate schooling, as against those who were not fortunate enough to have quite as much schooling as this other group?

Mortimer Adler: No, I think I haven't made my point quite clear. Let me see if I can distinguish two things.

Lloyd Luckman asks whether adult learning is necessary to the same extent and in the same way for those who have gone through school and college and those who have not. My answer is no. Those who in their youth have been deprived of the advantages of schooling may have to return to school in adult life. But that return to school is adult schooling, not adult learning. One might better describe it as *remedial adult schooling* because it makes up for the deficiency, for the deprivation that these people suffered in their youth. This would not happen in a perfectly good society. In a good society, no one would be deprived of adequate schooling in youth.

And that quite makes the point. In a good society in which no one was deprived of adequate schooling in youth, adult learning would still be necessary for everyone, as necessary then as it is now for those who have completed school and college. And the reason why that is so is that learning is a lifetime affair, not just something that belongs to childhood, not just the duty and privilege of children. Learning is far too important to be restricted to childhood.

Let me explain what I mean by a whole lifetime of learning. We begin with preschool learning for the very young at home before kindergarten. And then the second phase of learning is all the grades, all the degrees of schooling from the beginning grades through college for children and young people. And then two subordinate kinds of schooling, adult schooling for those who didn't have adequate schooling in youth and postgraduate schooling for those who want to specialize in their profession or some special field of learning. All this is schooling. And what I am talking about is something that comes after all schooling and out of all schools, adult learning, which is for everyone.

Grownups Are More Educable than Children

That's the picture I would like to have you hold before you as you proceed with this discussion. And what I would like to have you remember about this picture is that it is the last part which is the most important part, the part which all the rest is preparation. Do

you remember the lines of Browning, "Grow old along with me; the best is yet to be"? Well, that applies to learning as well as to married life.

Lloyd Luckman: Well, you may be right about this but I'm really sure, Dr. Adler, that there are a lot of people who think otherwise. And I feel it's not because they think of learning as the duty of childhood alone but rather that they think of it as young people having a capacity to learn, a capacity that adults lose. The older we get, the less we are able to learn. You know the old adage, "You can't teach an old dog new tricks."

Mortimer Adler: I'm afraid you're right, Lloyd. That's what people do think. And I think what we ought to do about that is to see if we can change their conception on this point, their impression. Perhaps you can't teach an old dog new tricks, but human beings are not old dogs and adult learning does not consist in acquiring new tricks.

I think the source of the error lies in a fundamental confusion that many people make between the confusion of bodily growth with mental growth. Now there's no question that our bodies grow very rapidly when we are very young and that we physically cease to grow when we have reached the ages of sixteen or eighteen. But short of pathological senility, the mind can grow beyond that point, the mind short of pathological senility never loses its power of growth. It retains that power of growth as long as our bodies remain healthy.

The simple, basic truth is that we are never too old to learn. Along with that goes another basic truth that we are sometimes too young to learn. This is the reason why adult learning is necessary for all of us. Because when we are immature, we are simply too young to learn some of the most important things that every human being must come to know.

Let me explain this last point a little more clearly. Let me tell you what every school student doesn't know. Now what is it that every school student doesn't know, especially at the moment of graduation? It is how little he knows and how much he has to learn. But that is precisely what everyone who has been out of school or college for five years comes to realize very clearly. That is true, Mr. Luckman, is it not? Do you find most of the people you know who are out of college for four or five years, haven't they come to realize how little they know and how much they have to learn?

Lloyd Luckman: I not only think so but I strongly hope so, Dr. Adler.

Mortimer Adler: Well, if there are people who don't know this, the only charitable thing to do is to not to speak of them any further as we go on.

Though most college graduates do know that they didn't learn very much in college, most of them give a wrong interpretation of the fact. In fact, they give one or another wrong interpretation. They say that the school they went to wasn't good, or the curriculum wasn't good, or the faculty was poor, and that is why they learned so little in school or college. Or they say the school was good and the curriculum was good and the faculty was extremely good, "but I frittered away my time." I didn't work hard or conscientiously enough; that's why I didn't learn enough in school or college. Now any of these things may be true but none of them is the correct reason why we do not learn enough in school or college.

To prepare you for what I think is the right interpretation of the fact, let me ask you to imagine this case: imagine the very best school with the very best faculty, the perfect curriculum, and imagine the student who for the year that he is in school applies himself most conscientiously to the business of study and learning. Now even in that case, that student would not graduate an educated man, needing no further education, not needing to go on with learning, finding it unnecessary to go on with learning throughout the rest of life. And the reason why that is so is that youth is itself the great and insurmountable obstacle to getting an education.

Now this may seem like a shocking or an exaggerated statement. I don't think it is. Let me try to explain it. The explanation, I think, is to be found by looking at the end products of the whole of learning. Let's consider what it is that the whole of learning aims at.

I would say that what all of us want, or certainly should want, is to acquire some understanding of ourselves and the world in which we live. Only fools have no desire to become a little wiser. All the rest of us, I think, hope to get some wisdom as a result of our efforts at learning. But the point is, that's the end result. Wisdom cannot be acquired in school when we are young. Would anyone, for example, think of calling a college boy or girl, while they were in college or just as they were getting out of college,

wise? Well, what is true of wisdom is equally true of understanding, the understanding which consists of basic insights into the nature of life or of society, of the world in which we live. The immature person lacks the experience and the seriousness of purpose to gain such understanding. One might almost say their minds or souls are too shallow soil for basic ideas to take root in.

CHILDREN LEARN SKILLS; ADULTS LEARN WISDOM

Most of the great educators have recognized this, and certainly all teachers should know it, even if some of them unfortunately do not. For example, if we were to take Plato off the shelf here and examine that passage in the *Republic* where he deals with the profits of human education, we would find that he does not think that the consideration of fundamental ideas should be begun until a man is almost forty-five. The study of ideas and the acquisition of wisdom is really postponed until the latter half of life, until after fifty.

Or if we were to go to Aristotle's *Ethics*, I think we would find Aristotle at the very opening of the *Ethics* saying that moral subjects, ethics and politics, should not be taught to young men because they lack the experience, they lack the emotional stability, they lack that deep seriousness without which the subject cannot be understood.

Let me talk briefly of my own experience as a teacher. I have always found it easy to teach abstract and theoretical subjects to young people in college. It is much more difficult to teach moral philosophy, to deal with moral and political questions. It is very difficult, for example, to read great novels and plays with young people, novels and plays that deal with life's most serious problems. I've read and discussed novels and plays with young people in college and with adults and the difference is as day and night.

Let me give you one further piece of evidence. When I left college I was pretty sure that I understood some of the great books I had had the good fortune to read there. But I was more fortunate in my teaching career to have to reread some of those books many times. And I know now that I didn't understand those books at all when I was in college. In fact, I know now that I didn't understand them very well ten years ago. It's not that I'm any brighter now; I'm

simply older. Hasn't that been your experience, Lloyd, as a teacher also?

Lloyd Luckman: Yes, it has indeed. And I am sure that we can say that it is the experience of most teachers who go on studying subjects after their experience in school.

Dr. Adler, I agree with you in this main point that you've just made so well and what you're saying, but I think you are going a little too far. And why I think so is that I think you're giving the impression that almost nothing can be learned in school; that we are absolutely wasting education on young people.

Mortimer Adler: Well, I don't want to give that impression, Lloyd. Let me see if I can correct the impression Mr. Luckman says I'm giving. I certainly am not saying that children are uneducable. But I am saying that adults are more educable than children, just as children are more *trainable* than adults. What I really mean to say is that children can form habits, habits of body and even habits of mind, more readily than adults. The pattern of the growth of habits follows very closely the pattern of bodily growth.

Habits are accumulated very quickly in life and are formed during the early years of life, but not after the twentieth or twenty-fifth year. They don't go on the way the real growth of the mind goes on until the end of life. Certainly the thing we should understand here is that adults can learn better. It takes depth of thought and breadth of experience to learn to understand ideas. If adults can think better than children can, then certainly on all fundamentals they should be able, and I think they are able, to learn better. That's clear, isn't it?

Lloyd Luckman: Yes, but I'd still like to know what sort of learning then you think should be done in school, Dr. Adler, and how then schooling really differs from adult learning.

Mortimer Adler: Well, Mr. Luckman asks what should take place in school. In my opinion, the major part of learning, the major acquisition of knowledge and wisdom occurs in adult life. My answer to Mr. Luckman and to you, if you are interested in the question, is that there are two things that a good school should do if the school performs its function of being preparation for the life of learning that takes place when school is finished, when men and women leave school.

The first thing a good school should do is to give the child the skills of learning. If learning is to go on for a lifetime after school,

one should learn how to learn. The art and skills of learning in school, all the techniques like reading and writing and talking and listening that are involved in learning, should be acquired in school. That is one of the main functions of schooling. And the second is—in view of the fact that human beings, if they are going to acquire any wisdom or deep understanding of the nature of things, must do it after they leave school—the second thing a good school should do in preparation for the life of learning that is to follow is to give the child some acquaintance with the world of learning. And not only an acquaintance with it, but some incentive, some real stimulation to go on learning when the child leaves school. The child in a good school should realize that he hasn't learned everything and should have a feeling about what there is to learn and the drive and the motivation to go on with that life of learning.

WHEN LEARNING STOPS, THE MIND ATROPHIES

Now that's part of the answer to your question, but only part. The other part has to do with the real distinction, the whole distinction between learning in school and adult learning. And I think, what I would like to add to what I've already said is that learning in school is something that takes place for a period of time, always a limited period of time, whereas adult learning by its very nature is interminable; it goes on without end.

It's perfectly all right for a schoolchild to say, "I have finished with my schooling." But is it all right for an adult to say, "I have finished with adult learning," unless he is also willing to say, "I am done with my life"?

One reason why adult learning is endless, must go on interminably throughout a whole life, one reason for this is that it aims at wisdom. And wisdom is hard to come by. Not much of it can be acquired short of a whole lifetime of pursuing it. But that is not the only reason. It's not enough that it takes a lifetime to gain wisdom. The other reason is that to live is to grow. And as soon as we stop growing, we begin to die. The body, the human body, when it stops growing, really begins to die, begins to decline, but the mind however can keep on growing past this point when the body stops growing and begins to die, but only on condition that we go on

learning. When we stop learning, then the mind also ceases to grow and begins to die. It begins to atrophy just the way the body does.

Everyone, I think, understands what is necessary for the care and feeding of their bodies. They know that they must give their bodies daily sustenance if they're going to keep them healthy and strong. They know they must exercise their body if they are going to keep their muscles from becoming flabby. And what applies to the care of the body applies equally to the care of the mind. Just as, to keep our bodies healthy and strong we must feed them regularly and exercise them, just as we can't keep them healthy and strong on last year's feeding and exercise, so we can't keep our minds alive and growing on last year's reading and learning.

You know Mark Twain's remark, "The reports of my death are greatly exaggerated." Well, when anyone stops learning, the reports of his death, the death of his mind, are not greatly exaggerated no matter how long he continues to live after that.

Now last time we talked about the role of motivation in learning. But at that time we were thinking mainly of children and of learning in school. And there the problem of motivation is hard to solve. But in the case of adult learning which we are considering now, I think the problem of motivation is not nearly so hard to solve. When any adult realizes that wisdom is the end result he is pursuing and that it is hard to acquire wisdom, when any adult realizes that unless he goes on learning, he cannot go on growing and keeping his mind alive and strong, those two realizations are almost enough as the motivation for adults to carry on learning for a lifetime.

And last time we talked about the role of teachers. And there we were thinking mainly of classroom teachers or college lecturers. But that is the wrong image in the case of adult learning. If we are thinking about adult learning, a much better image to have in mind is a man sitting down by himself with a book, reading. Or an even better image, a group of adults talking to one another, discussing some basic problem or issue, and each of them teaching the others and learning from the others. For in the *republic of learning,* of adult learning, the most important thing is that each adult is himself a teacher and also a learner.

Books are teachers for adults. And adults can learn by discussing important ideas or problems with one another. So in the

next two sessions of this discussion, I would like to deal with these two things: how adults can learn by reading books and how adults can learn by discussing problems with their fellow man. And then in the final discussion of learning, I would like to have us face together the problem of whether and how adults can learn from television.

21 How to Read a Book

Today, as we continue with the subject of learning, we shall consider how we can learn from books or in other words, reading as a form of learning. Mr. Luckman is here to ask me questions, questions of the sort that may arise in your minds as the discussion proceeds.

We have seen that all genuine learning is active, not passive. No one, not even the best teacher, can help us to learn anything unless we ourselves make the primary effort to learn it. Now, when most of us think of teachers helping us learn, we think of another person, another human being in the same room with us, talking to us, showing us something, or giving us some sort of directions. But certainly, teaching may take other forms.

All teaching involves language and symbols, some form of communication between persons. And hence the written word, in the form of book and document, may function as a means of teaching just as much as the spoken word. In fact, I think I'd say that the process of learning in the course of reading books is essentially the same as the process of learning in the course of listening to lectures. The art of reading and the art of listening are very much alike.

Lloyd Luckman: Well, I think everyone can see, Dr. Adler, and I think they'll agree too, that when one individual learns from another, communication is necessarily involved. In fact, the only kind of learning that doesn't involve a process of communication is that which you have described and yourself have called pure learning or unaided discovery, where a man learns something entirely by himself through observation and through thought.

Well, so far so good. But one thing really isn't clear to me. And that is that books and lectures really aren't the only forms of communication by which one teaches or by which one learns from another, are they?

Mortimer Adler: No, Lloyd, they are not. There are other forms. For example, when two individuals sit down to discuss a subject in which both are very deeply interested and both have some competence, the chances are very good that they will learn something from that discussion. And what is true of that discussion, two persons with one another, is equally true, I think, maybe more true of a formal discussion in which a large group of people participate.

The problem of learning in such situations is quite different from the problem of learning from books and by reading books. Language isn't the only means of communication; pictures also serve, sometimes more effectively than words. And the combination of pictures and words is perhaps the most effective means of communication. It is certainly the most popular means of communication today. Think of the picture magazines, the motion pictures, and television. Therefore I should like to devote the last program of this group of programs on learning to the consideration of whether and how we can learn from the combination of pictures and words, whether on the motion picture or on the television screen.

Lloyd Luckman: Well, it's going to be very interesting indeed to hear what the author of *How to Read a Book* has to say about how to learn from television. I'll bet when you wrote *How to Read a Book,* Dr. Adler, that you never dreamed you'd ever be doing this. I can remember some really unkind remarks you made about, oh, such things as going to the movies or listening to the radio in contrast to reading a really good book.

Mortimer Adler: You've got me. But that was fifteen years ago and times have changed and so have I. Remember my motto?

Lloyd Luckman: Never too old to learn.

Mortimer Adler: Times have changed and I think I have changed in some respects, but there is one thing about which I have not changed my mind. And that is the importance of reading as a form of learning. Nor have I changed my mind about how to read a book in order to learn in the process of reading books.

How to Learn by Reading

That's what I want to talk about today, the whole business of how we learn by reading. And I think perhaps the best way to begin is to consider with you the different kinds of reading, because certainly we do not do all our reading simply to learn. And many of the things we read are not all equally serviceable as means of learning. So let's consider the different kinds of learning.

Lloyd Luckman: Well, this can be pleasant too, can't it? Reading can be serious and learning can be serious but it doesn't have to be grim.

Mortimer Adler: No, but let me first deal with the kinds of reading and then let's consider whether pleasure is involved in all of them.

Lloyd Luckman: All right.

Mortimer Adler: The first division which I should like to present is a perfectly obvious one, I think, to all of us: We either read for pleasure and relaxation or we read for learning. Now there is not much that we have to say about reading for pleasure. We all do it, just as we all play games, go to the theater, listen to the radio, watch television in order to pass the time, and get some amusement or entertainment.

Sometimes learning does happen accidentally or incidentally in the course of such reading for pleasure. But precisely, because it is not intentional, we cannot consider any rules for such learning. One can't make it happen by the development of any skill.

Reading for Information and Reading for Enlightenment

Now the other kind of reading is where our intention is to learn something. And as Mr. Luckman indicated a moment ago, this kind of reading where our intention is to learn something may, of course, involve some fun, maybe pleasure. But I don't want to give learning a false boost by saying what some people do say, "Learning is always fun." It isn't always fun. Sometimes learning is hard work. In fact, it's quite often that. And in my own experience, it's usually the case that when the process of learning is itself some-

what painful, the end result tends to be more profitable. Now, though learning is not always fun and though reading may involve some work when reading is for the sake of learning, all reading is not equally difficult. There is an easier form of reading for learning and a harder form.

Let me make a distinction now between these two forms. The first of these is reading for the sake of information, where our aim is to acquire some knowledge of facts. We all do this kind of reading when we read newspapers or guidebooks, magazine articles, or simple historical accounts of past and current events. In fact, what in this country we mean by a literate person is a person who can do just this kind of reading. That isn't a very high standard of literacy, but that is what we mean when we talk about the literate electorate or the literate population of the United States, people who can read at the level of reading magazines or newspapers for the sake of information.

The harder and much more profitable kind of reading, I should like to distinguish from reading for information by calling it *reading for enlightenment,* where our purpose is not to get to know some more facts, but to understand ideas, to increase our understanding. Now here there is a problem, and I think there is no problem about reading for information. Because this kind of reading, reading for enlightenment, is difficult to do. And not many people are able to do it, at least not very well, even among all those who would regard themselves, and would be called by others, literate persons. The reason for this is that this kind of reading, reading for enlightenment, is not taught in our schools, or at least not taught very well in our schools; though in my judgment, there is nothing more important that our schools could do if our schools have as their main function the preparation of young people to go on with a life of adult learning after they have left school.

Lloyd Luckman: You've touched on a very, very sore spot because I'm a teacher at the college level. And I must confess that you're right; the students we get simply don't know how to read, or not read well enough certainly to get enlightenment, as opposed to information, out of what they're reading. And I'm afraid the worst of it is that there isn't very much we do in our colleges to help these students improve their ability to read for enlightenment.

Now my guess is that the problem is that we don't keep this distinction that you've just made continuously in our minds. So that

when we've completed the job, as we do in grade school, and teach them to read for information, it stops right there. I would like to hear what you have to say in a little more detail on this problem of reading for enlightenment.

Mortimer Adler: Before I do what Mr. Luckman asks, expound more fully what I mean by reading for enlightenment, let me comment briefly on the remarks he has just made. I think he is right that our schools think they've done enough when they've taught children in the early grades the simple kind of reading for information, the kind of reading that involves reading newspapers, magazines, or even school textbooks, for these textbooks are books written so that they are not very difficult to read, in order to get from them the information that students have to memorize and pass back to teachers on examination papers.

The other kind of reading, reading for enlightenment, could not be taught in the grades where at the present time most reading is taught. It would be my guess that the kind of reading I'm now talking about, reading for enlightenment, would have to be taught in college. It would have to be one of the main things we teach in college. And in my judgment, colleges would do well if they did this primarily, if our college graduates were able to exhibit, to use the skill of reading in this way. To make this point clear, let me do what Mr. Luckman asks and explain precisely what I mean by reading for enlightenment.

I think the most direct way I can do that is to present you with a series of alternatives. Let's begin with the fact that here you are sitting in your own room with a book in your hand. Now then, let's take the alternatives: either this book you have in your hand is a book which, as you read it, you understand perfectly and immediately, with no difficulty, or you don't understand it. Now in the first alternative, if you understand this book perfectly and immediately as you read it page after page, there is no problem of reading for you. Nor, by the way, will the book help you to learn anything; for if you can understand it that readily and quickly and perfectly, you cannot increase your understanding by reading that book.

Let's take the other alternative, where you don't understand it that way. Now here again, there are two alternative possibilities: either you can't understand it at all, really can't understand it at all, in which case there is nothing one can do, or you can understand it somewhat. Let's say that you understand it just enough to

know that you do not understand it all, that there is more there for you to try to grasp.

It's in this last case that we have a problem. And there are just three things that you can do in this condition. The first one is to give up, just to give up, either because you do not want to make the effort of reading that you will be called upon to make or because you do not know how to make that effort. The second thing you can do is almost as bad as that. You can go to someone else and ask them to explain the book to you. Now it is my guess that this can't be done very well because if you could understand their explanation, you could understand the book in the first place. And if they did succeed in explaining the book to you, you wouldn't have learned to read. What is the third thing you can do? The third possibility is that sitting with this book, a book that's somewhat over your head, you lift yourself up from a state of understanding less to a state of understanding more.

That, it seems to me, is the definition of reading for enlightenment. And with that definition I can give you a simple test by which you can determine how much skill of this sort you have. Learning, the kind of learning that is most important for an adult to do, consists mainly in acquiring insights and increasing or deepening one's understanding. And this can be done by reading, if with a book that is "over your head," you can lift yourself up from a state of understanding less to a state of understanding more. But remember those books that are over your head don't lift you up, as it were, by capillary attraction. You can't sit back and just expect to be uplifted by a book that is over your head simply by gazing at it. You have to work, you have to exert some skill, you have to climb up, hand-over-hand, as it were, on the ropes of learning.

THE ART OF READING FOR ENLIGHTENMENT

Here then is the test. Here's a good sign by which you can tell whether you have this skill. When you are faced by the challenge of a book that is over your head, which you know that you do not understand well enough and try to understand more, what can you do to solve the problem? How many things do you know how to do that will succeed in making that book clearer and more intelligible to you?

Lloyd Luckman: Are you going to give us the answer to that question?

Mortimer Adler: Yes, at this very moment, at this very moment. The answer to that question, of course, consists in a statement of the basic rules of reading, of the art of reading. Before I state the rules themselves, let me remind you of one thing, preliminary to all the rules: the most important thing about reading as about learning generally is that it must be active, not passive.

This shouldn't be too hard to understand, for most people tend to think that writing is active or that talking is active and that reading and listening are passive. But just think of a baseball game for a moment. Is catching the ball any less active than pitching it? Well, if catching is no less active than pitching, then neither is reading or listening any less active than writing or talking.

What do I mean by active reading? By doing active reading I mean simply this, that you stay awake while reading. And when I say stay awake, I don't mean simply keep your eyes open while your mind goes to sleep. How do you keep awake while reading? The answer in a nutshell is by asking questions, by asking yourself questions about the book and asking the book questions for the author to answer.

The difference between active and passive reading is unmistakable. The signs would not let you ever make a mistake as to which you were doing, active or passive reading. For one thing, when you read actively, you really have some fatigue. Work is involved. When work is involved as opposed to play, you suffer fatigue. Yet if after reading a book for an hour or two you aren't at all tired, then you are not reading actively in this sense. And there is another sign of reading actively. Pencil and paperwork, making notes, marking the book, marking the margin, underlining passages on the page.

This is my best test of whether I'm reading actively or not. And I think I can show you this. I have on the shelf here some books that I read a long time ago. And I think if I took one off the shelf, I would be able to see at once that many years ago I read that book actively. Let me see if I can find one. Here is one. Here is a book that I read in college, William James's *Pragmatism*. It is torn a little bit and yellow to the ears and here in the front of the book are notes that I made while reading the book. The pages are torn and yellow. It was at least twenty-five years ago, but these notes indicate

that as I was reading the book, I read it awake, not asleep. And now as I look through the book itself, I find pages in which I have marked in the margins and written on the margins as well, writings that indicate I was thinking and asking questions as I read the book. I don't remember reading it, but I do know from these signs that when I did read it, I read it quite actively.

THE THREE QUESTIONS AND THE THREE SETS OF RULES

Now let me come back again. I said that to read actively, you must read by asking questions. What questions? Well, the answer to that I think is not too hard. There are just three main questions one can ask, though they can be broken down into subordinate forms. Let me show you what they are. I have them here in this chart. The three main questions are: What is the whole book about and how are its parts related to that whole? What, in detail, does the book say and what does the author mean by what he says? And the third question is, Is it true, and what of it?

Lloyd Luckman: Well, in *How to Read a Book,* didn't you give three sets of rules for reading a book three times or at least three different ways? Are those sets of rules related to these three main questions that the reader should ask in order to keep himself awake while reading?

Mortimer Adler: They are. The three sets of rules are directions for answering the three main questions I have just mentioned.

Let's talk about these three sets of rules. First, the four rules that tell you how to find out what the whole book is about and how its parts are related. The first rule is to classify the book according to the kind of book it is and the kind of subject matter it has. The second rule is to summarize the whole book as briefly as possible in your own words. The third is to see its major parts in their order and relation to one another. And the fourth is to define the problem or problems the author is trying to solve.

Let's consider that first and second of those four rules for a moment and let me see if I can illustrate how they operate. In the first place, in order to tell what kind of book it is, you must be able to use certain signs in the book, the title of the book, the subtitle,

the table of contents, often the author's preface, often the opening sentences of the book tell you the kind of book it is and what it is about. But you must also have in your mind a number of basic categories. You must know the distinction between poetry and history, the different kinds of history, the different kinds of poetry, and how these differ from science and philosophy, how politics and economics differ; so that as you read the book, the general categories of subject matter become significant for you in understanding what the book is about.

As for summarizing a large and difficult book, it can be done. Many people think that it's too difficult to do, but it really isn't. And sometimes the author does it for you. As here, for example, Herodotus, who wrote the great history of the war between the Greeks and the Persians, in his very opening sentence summarizes the whole book. He says, "These are the histories of Herodotus, in order that the actions of men may not be effaced by time, nor the great and wondrous deeds displayed by Greeks and Barbarians be deprived of their renown, and for the rest for what cause they waged the war upon one another."

Well, let me give you another example. Aristotle's *Ethics* is a difficult and elaborate book. And here, briefly, in my own words, is a summary of what that whole book is about, which grasps what the whole is. It's "an inquiry into the nature of human happiness and an analysis of the conditions under which happiness may be gained or lost, with an indication of what men must do in their conduct and thinking in order to become happy or to avoid unhappiness, the principal emphasis being placed on the cultivation of the virtues, moral and intellectual, although other necessary goods are also recognized, such as wealth, health, friends, and a just society in which to live."

Now let me go on to the second set of rules. These are rules about the interpretation of a book's content. And here you must first come to terms with the author by interpreting his basic words. Secondly, you must discover the sentences that state his major propositions. Third, you must find the argument by which he tries to support these propositions. And finally, you must determine which of his problems the author solves and which he did not solve.

These rules of reading would be unnecessary if language were a perfect medium of communication, if language brought your mind into immediate contact with the thought of the author. But

unfortunately, languages are a far from perfect medium of com-
munication. Language is much more like a mountain barrier
between author and reader, a barrier which both of them must
tunnel through if they are going to meet and have some coming
to terms or meeting of minds. It won't do just to have the author
do the tunneling toward you; you must know how to tunnel toward
him. And all these rules are rules which guide you in tunneling
toward the author and your understanding of what he means.

I'm not going to discuss the third set of rules now because the
third set of rules that deal with talking back to the author and crit-
icizing the book for its truth and significance are really rules for
discussion between the reader and the author and I shall treat
these rules next time when we consider how one learns by discus-
sion. This third set of rules will be useful for us as we consider the
whole problem of learning by discussion.

Now in the time that's left, I should like to add two further
comments on all these rules of reading for enlightenment. The
first is that it is much easier to read a good book than a bad one,
because the author of a good book is himself a man who knows
how to read well and therefore writes his books in a manner that
makes it readable according to these basic rules. The second point
is that there are not a large number of books worth reading this
way. But the whole point of reading for enlightenment is not the
number of books you read but how well you read them.

Abraham Lincoln read only a few books but he read them very
well. And the English philosopher, Thomas Hobbes, said, "If I read
as many books as most men do, I would be as dull-witted as they
are."

The only books to read in this way are the books that are over
your head. And that, by the way, is the definition of a great book.
The great books are the books that are worth everybody's reading
because they are over everybody's head all of the time.

Lloyd Luckman: Doesn't the average person though need
some help in reading these great books?

Mortimer Adler: Yes, the average person does need some help.
And one of the greatest aids in reading these books is discussion,
the discussion of the book between you and other persons who
have read the same book. But this is something we shall deal with
next time when we deal with how we learn by and from discussion.

22 How to Talk

Today, as we continue with the subject of learning, we shall consider the role of conversation or discussion in the life of learning.

The human mind can learn in a number of ways, but we have seen one basic division in the ways we can learn, the division between learning by discovery on the one hand and learning by instruction on the other or learning without the help of teachers and with the help of teachers.

LEARNING BY DISCOVERY AND BY DISCUSSION

Now I'd like to tell you about another basic division in the ways that men can learn, which looks very much like this first one but is really quite different. It is the distinction between learning by discovery on the one hand and learning by discussion on the other. Discovery, as you see, is common to both distinctions or divisions. But it would be a mistake to think that learning by instruction is the same as learning by discussion.

The first division is the distinction which is made in terms of teachers, learning by instruction and learning by discovery, with teachers and without teachers. The second division is made in terms of communication, learning by discussion and learning by discovery. Now, as you see, discovery is common to both. And if discussion were the same as instruction, then the two divisions would be the same. But I am going to try to show you that that is not the case.

Let me explain the principle of the first division. In the first division, everything turns on whether one human being helps

another to learn or whether a human being learns directly from nature without the help of any other human beings. The second division turns on the point of communication, whether or not, for example, the learning involves the communication of one man with another or just the communication between men and nature.

I am going to try to show you that discussion, properly considered, is the method by which adults learn from one another. And as so conceived, it differs quite strikingly from that sort of learning in which an older person teaches a younger person.

Lloyd Luckman: Now before you do that, Dr. Adler, there is a question I'd like to ask. A moment ago you explained the second division by saying that discussion involves some sort of communication between men, whereas discovery involved only communication between men and nature. I wonder, did you really mean that? Because if you did, then does learning by discovery involve actual conversation between man and nature?

Mortimer Adler: Well, kind of. Yes, in a metaphorical sense but only in a metaphorical sense. Let me explain. Human beings are talking animals. And so, we tend to introduce discussion into every aspect of our understanding or our theory of learning.

I'll never forget the words that were engraved in stone over the entrance of the science building at Columbia University in which I worked when I was a young man. The legend read, "Ask nature questions and it will answer you." There you see the process of scientific discovery itself being regarded as a kind of conversation between the scientist and the natural world.

Lloyd Luckman: Well, then I guess one metaphor would lead to another because didn't you yourself indulge in one last week when you suggested that the whole art of reading, that it is the whole art of reading a book that boils down to simply asking questions between yourself and the author and even talking back to him? That was a metaphor, wasn't it?

Mortimer Adler: Yes, that was a metaphor too, just a way of describing reading by comparing it with live conversation. In that very phrase "live conversation," you have the whole story. Real discussion consists of two or more persons talking to one another, each asking questions, each answering, making remarks and counter-remarks. When we ask nature questions, we ourselves, the scientists who do this, have to formulate the answers. In fact, the whole method of discovery is to formulate the answers which

nature is giving. And when we ask a book questions or an author questions, we have to figure out for ourselves—the author isn't there to answer—we have to figure out for ourselves what the author is going to answer.

So scientific discovery and reading a book are really quite artificial, one-way conversations. But real conversations, live conversation is a two-way affair in which all parties to it are equally active. And, I'd like to add that such conversation is at its best when the parties to it tend to regard each other as equal. That really is the heart of the difference between learning by discussion and learning by instruction.

Lloyd Luckman: Well, I'm not quite sure that I see what you are driving at. See, you promised a little while ago to explain this point. Now how about it?

Mortimer Adler: Well, now let me try to explain. To explain the point, we must first distinguish between three methods of teaching, the kind of teaching that goes on in classrooms and college lecture halls. The three methods are, let me name them first: indoctrination, lecturing, and questioning. Now *indoctrination* is that method in which the teacher tells the student something the teacher wants the student only to memorize, only to remember just long enough perhaps to pass the answer back in the examination. It is the worst method of teaching, if it can be called a method of teaching at all.

The second method, that of *lecturing*, is much better. It also consists in the teacher telling the student something but now not for the sake of mere memorization, but for the sake of the student understanding what he is told. And so the student in this case is encouraged to ask questions to pursue his understanding, to find out what the teacher means.

But the best method of the three is the method of *discussion* or questioning, teaching by asking instead of teaching by telling. It's much harder, but it's better. This is the method, by the way, that Socrates used in teaching the young men of Athens. And the reason why it is the best method is that like lecturing, it aims at understanding, not at memorization. But in addition to that, it is better than lecturing because it requires the greatest activity, the most active thought on the part of the student in the course of learning.

As against all of these methods of teaching, there is adult discussion or conversation. This is that sort of discussion in which

each person who takes part in it learns by asking and by answering. The heart of the difference is, the essential difference here, is that in adult learning by discussion, each party to the discussion is both a teacher and a learner. Just as in the political republic each citizen is ruler and ruled in turn, so in the adult republic of learning, each adult is both teacher and taught.

THE THREE PRECONDITIONS FOR DISCUSSION

With this background, let us consider the nature of adult conversation. And let's consider the rules which should govern it if such conversation is to develop into good, profitable discussion, profitable as a means of learning.

Let me begin by saying something which I'm sure all of us know, a perfectly obvious thing, that all conversation is not for the sake of learning any more than all reading is for the sake of learning. We saw last time, for example, the distinction between reading for pleasure, for amusement and recreation, as opposed to reading for learning's sake or information or enlightenment.

There are two kinds of conversation. The first kind is on the emotional or personal level. This is what we call the heart-to-heart talk. It is a wonderful phrase, isn't it? The heart-to-heart talk makes one think of people in love. In contrast to that, the other kind of conversation I would call the mind-to-mind talk about basic issues and fundamental ideas.

I am going to use the word "discussion" for the second kind of conversation, the mind-to-mind talk, which should result or may result in some enlightenment, in some increase of understanding on the part of all who are participating. What is the nature of such discussion? What must conversation be like in order for it to become discussion that functions as a means of learning?

There are three things that are required of conversation for it to become discussion in this good sense. First of all, the subject matter being discussed must be the sort of subject matter which permits genuine discussion to take place. Not everything is discussible and not all the things which are discussible are equally discussible. For example, facts are not discussible. To introduce facts into a discussion is to kill the discussion. If there is a question of fact, the best thing to do is to go to a dictionary, an ency-

clopedia or an atlas or reference book and look it up. You can't settle a question of fact by discussion. No, ideas are discussible and the more fundamental the ideas, the more controversial they are, the more discussible they are. Just as I think it is true that the Great Books are the ideal books to read if we are trying to read for enlightenment, so I also think that the Great Ideas are the ideal subjects for discussion if our aim in discussion is to learn.

The second condition or prerequisite for good discussion is that right motive must prevail. The purpose we have in carrying on our conversation must be to learn, really a deep, serious purpose to learn, not just to pass the time in idle chitchat or small talk. And if big talk happens to develop and persons get engaged in serious discussion of serious themes, then their aim must be, as they carry it on, to get at the truth, not to win the argument.

The worst thing we can do is to let discussion become a form of personal aggression. Our aim should always be to learn, to clarify ideas, not to do the other fellow in. Our rule here should be not to be contentious or disputatious. And above all, we should remember that there is simply no point in winning the argument if we know we are wrong.

The third and perhaps the most important requirement of good discussion is that we should talk to the other person, not just at them. This means that listening is an important, an essential part of discussion. In fact, I think I would say that listening is more important, even as it is more difficult, than talking. Because if one person doesn't listen to another, what that person then says in the course of the conversation is not going to be very relevant. And without relevance, you aren't going to have a conversation but only the appearance of one.

You all know the kind of conversation that I'm talking about. You've all had this experience in which two persons talk to one another and each talks and then remains silent while the other person talks but isn't listening to the other person because he is thinking of what he is going to say when it becomes his turn to talk when the other fellow stops.

Lloyd Luckman: Well, I certainly do, Dr. Adler. And in my experience, that isn't discussion at all. Why, it's really nothing more than the exchange, an expression of prejudices, first on one side and then on the other.

Mortimer Adler: That's right. Most conversations, most political discussions are like that. Now Mr. Luckman and I aren't actors. But I think we can show you what we mean. I make a long speech at you, Lloyd, not to you but at you, in which I argue with many repetitions that if the government would keep its hands off business and regulate the labor unions instead, the country would be a lot better off.

Lloyd Luckman: Yes, and while you're talking I'm waiting in a fidgety sort of way for you to finish, so that I can go on saying what I was saying before you started talking. And when you do stop, then I go back to my pet gripe, which is, of course, that if businessmen would just be farsighted enough to see that they have to support increase in foreign loan, everything would be all right.

Mortimer Adler: Then I, "Yes, but" you, and start saying in a somewhat louder voice that the Taft-Hartley Act wasn't strong enough.

Lloyd Luckman: And without even a "Yes, but," I go on in a louder voice and say that isolationism will be the ruin of us all.

Mortimer Adler: There you have it. A conversation? A discussion? No, just an ordinary spit back between a Republican and a Democrat.

The Ten Rules for Conducting a Discussion

Now, let's get back to real discussion. I just finished telling you the three basic requirements that conversation must meet if it is going to become discussion, that is profitable for learning. I would like to give you, quickly, some of the rules that we have to observe to make discussion profitable in this way. I'm going to give you two "external" rules, followed by five "intellectual" rules, followed by three "emotional" rules.

First of all, there are two rules about the externals of discussion, the mere externals of it. The first is to pick the right occasion, pick a time when everybody who is going to be engaged in the discussion is at leisure, not too busy, not occupied with other things; pick a time when they are free from distraction and so can be genuinely patient with discussion. You know, most business conferences go on with interruptions by telephones, by secretaries coming in, all sorts of interruptions, which, usually with too

little time allowed, makes for a discussion under the very worst circumstances.

The second basic external rule is, pick the right people. Not everyone is temperamentally fit for discussion. Some people are too shy, some too aggressive. Nor is everyone intellectually fit to discuss all subjects. There are some subjects on which persons have closed their minds; they've decided never to change their mind on that subject. Such persons are not the right persons to carry on a discussion about that subject.

Now supposing that these externals are provided, that you have the right occasion and the right people; now let's turn to the rules, the inner rules of discussion, the rules which govern your conduct of yourself, my conduct of myself, as we engage in conversation with one another. These rules fall into two large groups: first, a set of rules governing the use of your mind in discussion; second, a set of rules governing the control of your emotions in the course of discussion. Let me just tell you about these rules in that order.

First, let me state for you the intellectual rules, the rules concerning the use of your mind in the course of discussion. Here there are five rules which I would like to state for you simply and comment on briefly. The first rule is, Be relevant, which means "find out what the issue is and stick to it, but don't stick to it like fly paper." Divide the issue into its parts; every complex issue has parts, and move along from one part to another.

The second rule is, Don't take things for granted. Everyone, you included, I included, make certain assumptions as we come into a discussion. State your own assumptions and see if you can get the other pariticipants to state theirs. Make an effort to find out what the other person's assumptions are.

The third rule is try, if you can, to avoid arguing fallaciously. Now I haven't time to tell you all the many fallacies to which human discussion is prone. Let me take out some of the more obvious ones. First, don't cite authority as if they were conclusions. George Washington may have said to avoid entangling foreign alliances, but I don't think George Washington's authority controls American foreign policy in the twentieth century. Don't argue *ad hominem*. That means: don't argue against the person as opposed to against the point. And above all, avoid that most vicious of all fallacies, the bedfellow argument. Don't say to the

other fellow, "Oh, that's the kind of thing Republicans say or Communists say or Socialists say," as if calling it by that kind of name necessarily proves it wrong. That, I'm afraid, is a terribly fallacy of guilt by association. Don't take a vote as if that would settle the matter. And beware of using striking examples, for they often prove either too much or too little.

The fourth rule here is, don't agree or disagree with the other person until you understand what that person has said. To agree with another person before you understand what that person is saying is inane. To disagree before understanding is impertinent. Don't do what most people do, say all in one breath, "I don't know what you are talking about but I think you're wrong." This rule requires all of us to do something quite simple, yet it must be hard to do because we do it so infrequently. It requires you in the course of discussion to say to the other person, "Now let me see if I can say in my own words what you have just said." And then having done that, you turn to him and say, "Is that what you mean?" And if he says, "Yes, it is; that's exactly what I mean," then you are for the first time privileged to say to him, "I agree with you," or "I disagree with you," and not one moment sooner.

And the fifth rule is that if, after understanding the other person, you do disagree, state your disagreement specifically and give reasons why. Many people state their disagreement by simply saying, "You're a dope," or saying, "Oh, you're all wrong. Everything you say is wrong. You don't know what you're talking about." This doesn't help. Remarks like "You don't know what you are talking about" don't help anybody.

You can tell the other person what is wrong with his argument in four very sharp, specific ways. You can say one of four things. Kindly and politely you can say, "You are uninformed of certain relevant facts and I will show you what they are." Or you can say, "You are *mis*informed. Some of the things you think are relevant facts aren't facts at all, and I will show you why they are not." Or you can say, "You are mistaken in your reasoning and I will show you the mistakes that you have made." And finally you can say, "You don't carry your reasoning out far enough. There is more to say than you have said and I will tell you what it is." These are all very polite and much to the point.

Now let's turn to the other set of rules, the rules that govern the control of your emotions in the course of argument. And here

there are just three simple rules. The first is, keep your emotions in place. That means "Keep them out of the argument, for they have no place in the argument." The second rule is, catch yourself or the other person getting angry. And there are very simple signs of this. Starting to shout, repeating and overemphasizing the point by repeating it again and again, or pounding on the table, using sarcasm, teasing, getting a laugh on the other fellow, all these are signs that someone's temper is getting out of hand. And finally, the third rule here is, if you can't control your emotions, at least beware of the results of emotional disorder. Try your best to realize that your emotions can lead you either to say things you don't mean or stubbornly to refuse to admit things you really do see.

Asking Good Questions Is the Key to Good Discussion

The rules of good discussion are easy enough to state, as I've just stated them. And I think they are just as easy to understand. But the hard thing to do is to follow them. I'm sure that as you heard them you recognized at once that they were clear and sound, good rules to follow. But I hope I do you no injustice when I say that my guess is that you violate them just as I violate them every day of our common lives.

But the hardest thing of all to do in discussion is to know how to ask good questions, the kind of questions that by their very nature generate good discussion. And let me tell you, this is the hardest thing because asking good questions is much, much harder than answering them.

Lloyd Luckman: Do you have some rules then too for the asking of questions?

Mortimer Adler: Well, Lloyd, in one way the rules of logic, the rules of what I would prefer to call dialectic are just such rules. Let me give you a few examples of what I mean. We ought to be able to distinguish between questions of fact on the one hand and questions of interpretation on the other, such questions as whether something is the case or exists and on the other hand what it means, what it implies, what consequences it leads to. And then we should be able to distinguish between questions of fact and questions of value. Here we ought to know whether we are asking about

whether something happened or whether it was good, how some-one behaves or how he should behave, how he ought to behave, questions of what is the case as opposed to questions about what should be or what ought to be.

And then, it's very important for us to be able to distinguish between asking someone what he thinks and asking him why he thinks so. Asking him for a statement of his belief or his opinion is different from asking him for the reasons to support that belief or opinion. And above all, we should be able to ask hypothetical ques-tions and recognize them. Many discussions go on the rocks because someone says, "Let me ask you a hypothetical question. If such and such is the case, then—." And the other person says, "But that isn't the case." And the person says, quite rightly, "Well, I did-n't say it was the case; I only said if." And no one listens to the "if."

I wish there were time to go more deeply into this matter of how to ask questions, but we must now close. I would like to remind you that next time we are going to consider that important contemporary problem of whether and how we can learn from television.

23 How to Watch TV

Today we conclude our consideration of learning by facing the problem of whether and how we can learn from television. As you will observe, the scene has changed. Mr. Luckman is not here as he usually is to ask me questions. I'm not sitting at my desk surrounded by books. I'm here with a television set, a chair to sit in, and some notes to be sure that I remember all the points I want to touch on.

These changes are occasioned by the special character of the subject we're going to deal with. I'd like you to feel that we're sitting together in a room, watching a television set, as we discuss whether and how we can learn from television. Now you may ask, "What is so special about this subject?" Let me see if I can tell you.

When we considered learning from books or learning from discussions, we didn't ask whether we could learn from books, learn by reading, or learn by discussing; we only asked *how* we could learn from books, how to read them, or how we could learn by discussion. But today we have to ask the question *whether* we can learn from television before we can consider *how* to learn from television. Now you may still be puzzled by that. You may say, "Why *whether*? Why should that question come first?" And I think I could reinforce your puzzlement by giving you good reason for supposing that there is no doubt that people can learn from television, no doubt that television is an instrument of teaching and learning. But then, I would like to go on after doing that to tell you the difficulties that must be overcome if television really is to work as an educational instrument. In other words, what I want to do first is to present the case for television as a medium of education, then the case against television, and finally supposing the difficulties

can be overcome, I would like then in conclusion to talk about how we can learn from television.

Let me start at once by talking about giving you the case for television as a medium of education. It certainly is true that every improvement in the means of communication, almost on the face of it, becomes an advance or improvement in the methods of teaching and learning. We know this clearly in the case of printing. Not only did the invention of printing and the development of cheap printing cause a revolution in political communication, it caused an extraordinary transformation in education as well. And before television we saw this happen in the case of radio, which has tremendous power as a means of communication on the political level, and was effectively used in time of crisis by Churchill and Roosevelt.

Television more than doubles the power of radio and so we should expect that it has more than twice the potentiality for education that radio has. Certainly it is the case that pictures and words have more power because they simulate the living presence of persons and actions. It's a perfectly fair inference from the manifest power of television as a means of social or political communication to an estimate of television's tremendous potentialities for education.

Let's examine for a moment what those potentialities are. I think of them as potentialities because, in my judgment, they are still almost entirely latent. They have not been exploited by far.

First of all, is it not obvious that television extends the power of teachers? That through television they can reach a much larger audience than teachers could ever have dreamed of reaching? But that is superficial compared to the next point, for what is much more important is that television intensifies the power of the teaching. Teaching on television is more effective than the actual presence of the teacher in the classroom or the lecturer in the lecture hall. Now I admit this is paradoxical, it might seem strange at first, but I think it can be explained.

I have done a great deal of of popular lecturing over many years, and have only recently been teaching on television, but I think from my own experience I can explain why this is so. For one thing, the intimacy and power of the close-up brings the speaker very close to the listener. And for another thing, television communication is person-to-person communication. When I talk to

you on television, I am talking just to you, alone; whereas if I teach in a classroom or lecture in a lecture hall, I am talking to two hundred fifty or maybe a thousand persons, at none of whom I am looking and none of whom I can direct myself individually to. It is extraordinary that television personalizes communication.

The Obstacles to Learning from TV

In view of all this, certainly you have every right to ask, "Why then does one ever ask the question whether one can learn from television?" It would seem perfectly obvious that television is a great instrument of learning.

To answer that question, let me now tell you briefly the difficulties that must be overcome. There are two difficulties. The first difficulty, I think, involves the attitude of the producer, the persons who control the medium, the television medium, the persons who prepare the programs. The question is, Will those who create the programs on television give the public materials of genuine, intrinsic, educational worth?

The answer to that question depends upon two things. First of all, it depends on how much the producers succumb to the very prevalent tendency to underestimate the average human intelligence. This, by the way, is a great American failing, not only among those who control our mass media of communications, but even in our public school systems.

The second error which may prevent television from being used well educationally is a deep misconception of learning itself, the childish notion that everything must be fun or else people will have none of it. This reduces everything to the lowest level of entertainment.

I don't mean that education or learning cannot be entertaining; in fact, it can be, it must be, because the basic meaning of "to entertain" is to hold the attention of. And no one can teach anybody anything if he doesn't succeed in entertaining him in this sense, of holding his attention. But to understand education or learning as entertaining in this sense certainly does not mean that it must be painless or effortless. In fact, painless or effortless learning is a contradiction in terms. Hence, in my view, the producers must risk asking their audiences to make some effort and to take

some pains, otherwise they are not offering their audiences a genuine invitation to learning.

I have here some catalogues of what are called public service programs on our television today. And I should like for us to do a quick inventory of what we are given, of our current fare. I think there is no question, if one looks through this offering, that one finds that much progress has been made in presenting good literature on the television screen. We now can see the great plays of Shakespeare, we can see a dramatized version of the story of *Don Quixote,* see the plays of Eugene O'Neill, the Pulitzer Prize playwright.

Another thing that television does for us to bring us good music, and bring it to us in extraordinary ways because the television camera actually enables us to hear the music better by focusing on the instruments that are playing, particularly in orchestral music.

The same is true of painting. For with the help of the camera, our eye can be taken by the camera itself to look at the painting, explore it, see it analytically in a manner that makes television an extraordinarily good instrument for teaching us how to look at paintings.

Finally, television gives us current events, political reporting, and political commentary. Looking at all this part of the offering, one must say that educationally speaking, this is more on the level of reading for information than reading for enlightenment. It is good, but not good enough. It's important for the American public, particularly in the field of political current events, to be well-informed. But they must be more than well-informed; they must be able to think critically about public affairs. They must be able, knowing the facts, to evaluate and interpret them. For this purpose, there is some need for them to have an acquaintance with basic principles, with fundamental issues, and the ideas on all sides of the question that illuminate those issues. Here we come to teaching television or educational television in the strictest sense of the word.

Such educational television, which strictly is teaching, occupies a very small part of the total time devoted to public service programs on the television screen, and if we examine this small portion devoted to what is strictly educational television, what do we find? I have here another catalogue which gives a list of such programs. And I'm going to just categorize them generally. As I look

through this, I find that they fall into two or three main categories. First of all, and perhaps most numerously, are popular expositions of history or natural science or the social sciences, mainly or primarily intended to be informative. Then there are a few programs which deal with great literature and with the lessons that such literature teaches. And finally, there are very few programs like Professor Irving Lee's on *Men and Ideas* or my own program on *The Great Ideas,* which are philosophical, philosophical in that basic sense in which philosophy is everybody's business, philosophical in the sense that it deals with the consideration of ideas that everyone must face or the facing of issues everyone must try to solve.

WATCH TV ACTIVELY

Now then, let's turn to the second difficulty in the way of the effective use of television as a means of teaching or as means of education. Suppose I say the first difficulty is solved. Suppose the producers do give us a sufficient number of programs of genuine educational worth. There is still the difficulty at the other end, on the other side of the screen, on the side where you sit, looking at the television screen. And this difficulty has two causes, one of which is not your fault or anybody's fault and one of which you may be able to do something about. The one which is not your fault is simply this: This television set is in your living room. You come to it in hours after work for pleasure and for relaxation, in hours of weariness when you deserve relaxation. The whole atmosphere in which you approach this set, I think, militates against the use of television as an invitation to the pain of learning.

Perhaps you can do something about this, perhaps you can plan to set some few hours a week aside for the intentional use of the instrument as a means of education. But in my judgment, it will always be difficult for you to overcome, for any of us to overcome the soft seductions of the atmosphere in which we sit down to look at television.

The other part of the difficulty is one which you can do something about. Let's suppose for a moment that you do make plans, that you do definitely plan to set some time apart in which you are going to use the instrument for educational purposes. Then the question is, Will you make the effort, will you take the pains that

are requisite for learning? You will recall that through this whole series of discussions of learning, I have kept emphasizing one thing over and over and over. There is no learning without activity on the part of the learner. I made this point when I said that only by active reading, not by passive reading, can we learn. I made this point when I said that we can learn much more by actively participating in discussion than by passively listening to a lecture. Well, the same thing is true of television; we can only learn from television if we are active. And so that brings us to what is really the 64-thousand-dollar question, how do we learn from television? What sort of activity, what sort of work must we do if we are going to make television an effective instrument of teaching for ourselves?

Let me see if I can answer that question. What, in general, is the activity that must be involved when we are learning from television? My answer to that question, in general, is that the activity must be the same here as elsewhere, the activity known as thinking, not just remembering, not just passive listening, but thinking.

Let me see if I can make the point another way. When you watch a play actively, you must experience empathy. You must feel yourself into the emotions and thoughts and actions of the characters. Well, something like that is needed here, something I would almost call "intellectual empathy." When you watch thinking going on there on the screen, you must try to think with the thinking that is going on.

Now my second point has to do with what you can do in particular, what can you do in particular to be active in learning from television? Three things, I think. First of all, it seems to me that watching a television program that is educational should be supplemented by reading, by reading the books mentioned, by reading the books recommended, or the books that may be read from or quoted from, or even perhaps in some cases, reading the script of the show itself.

You know, I watched Professor Baxter talk about Shakespeare and he is continually telling his audience to go and read the plays of Shakespeare. For unless they go and read the plays for themselves, they can't really understand the plays or learn about them sufficiently merely by listening to Professor Baxter. And I do the same thing. I continually refer to books and recommend them.

MAKE NOTES, ASK QUESTIONS, CHALLENGE WHAT YOU'RE TOLD

The second point is that just as in active reading, you must make notes or mark a book, so you must do something very much like that in actively watching a television program that is educational. Let me illustrate what I mean by watching with you parts of one of my own programs on Opinion. Here, in the opening, I start out by asking some questions.

"First, what sort of objects are the objects of knowledge, as opposed to the objects about which we can only have opinions? Second, what is the psychological difference between knowing and opining as acts of the mind? Third, can we have knowledge and opinion about one and the same thing? And finally, a fourth question, what is the scope of knowledge? How much knowledge do we really have as opposed to the kinds of things about which we can only have opinions? What is the limit or scope of opinion in the things of our mind? And these are the questions we are going to try to answer as we proceed today. . . ."

You should have noted these questions in order to see whether I later got around to answering all of them. For example, you should have spotted the following passage, to see whether or not you detect that I am answering the second question, the question about the psychological difference between knowledge and opinion.

"A statement expresses knowledge when our assent to it is involuntary, when our assent to it is compelled or necessitated by the object we are thinking about, as in the case of two plus two equals four. But a statement expresses opinion, not knowledge, when our assent to it is voluntary, when the object leaves us quite free to make up our own minds to think this way or that way about the object, to think about the object exactly as we please. And usually, in the case of opinions, what makes up our mind one way or the other is not the thing we are thinking about, but our emotions, our desires, our interests, or some authority upon which we are relying."

The third thing you must do is challenge what the speaker says. If I am the speaker, you must ask me questions. For example, earlier in this opinion program I said, *". . . when I say this, when I say that ignorance is more like knowledge than error is, some of you may think it's a shocking mistake to suppose so. But though this may seem paradoxical, I think that I can explain to you why it is so. Any teacher will tell you that it is much easier to teach a student who is ignorant than one who is*

in error, because the student who is in error on a given point thinks that he knows, whereas in fact he does not know. The student who is ignorant is in a much better condition to learn. It is almost necessary to take the student who is in error and first correct the error before you can teach him. I think that is the meaning of saying that error is further away from knowledge than ignorance is. The path from ignorance to knowledge is a shorter path than the path from error to knowledge, because if a person is in error, you must first get rid of the error and reduce him to ignorance before you can start teaching."

And then later I tried to demonstrate how we can correct simple errors of perception when they are due to perceptional illusions. This is what I said, *"Now what is the answer to the skeptic? I have stated the skeptic's position; let me now give the answer to the skeptic. First of all, on the matter of perceptual illusion. How do we know they are illusions? If we know they are illusions, we can only know it because we regard some sense perceptions as accurate. If we could not have some perceptions verified as clear and acceptable perceptions, we couldn't know these others were illusions.*

"When we have two lines on a page that look to be of different lengths, we can put down a ruler against each of them, we can measure them. This convinces us they are really the same length. Here we are correcting an illusory perception by performing a measurement, but the measurement is itself also a perception. If this perception were not knowledge, I couldn't call the wrong perception an illusion. Hence, to even discover that there are perceptional illusions, I have to rely upon perceptions, I have to know by perceiving."

FOLLOW TV VIEWING WITH DISCUSSION

Doesn't that contradict what I said before about ignorance being superior to error? One viewer of that program wrote me a letter asking me whether I hadn't just contradicted myself. He was watching actively, thinking, asking questions as he should.

Now finally, and most important of all, is discussion, discussion by persons who are viewing or have just viewed the same program. We have discovered that reading the Great Books is not enough. Adults who read them must, after reading them, get together and discuss them—this is just as necessary. It can be done just as well—in fact, perhaps more easily done in the case of educational televi-

sion. Right now in the Oakland Public Library, a group of adults will come and sit in the library and watch a television program, and as soon as it's over they'll carry on immediately in discussion of that program. And I often try to end one of my own programs with some questions left unanswered, in order to evoke discussion which should begin as soon as the program is over.

24 How to Think about Art

Today we begin the discussion of Art. And we begin with the most general consideration of *what art is* and what its significance or role is in human life.

Now there is something I've been meaning to say for some weeks now, something that I think many of you have recognized yourself: the fact that in the discussion of ideas, words often get in the way. This is particularly true of The Great Ideas. Words make great difficulties for them. And among The Great Ideas it is especially true of Art. The word "art" itself causes us some difficulty in understanding what art is. And unless we face this difficulty about words in this series of discussions about art, we will not, I think, reach a truly philosophical understanding of art and the arts.

The evidence of what I've just been saying is, I think, quite plain in the letters we have received this week. In these letters there are many questions about art but they are all about art as if art were fine art only, and even more narrowly than that, as if art consisted mainly of painting or of sculpture.

This meaning for the word "art" is a very recent meaning. It has appeared only in the last hundred years or even less than that. It is quite different from the meaning for the word "art" that existed—the way that the word "art" was used—throughout many centuries before our own time. We must face, then, a deep and serious conflict in the use of the word "art," a contemporary use of it and an ancient and traditional use of it.

The Traditional Meaning of "Art"

And I think I should warn you as we start that I take sides in this battle between the ages, between the centuries; I favor the ancient and traditional meaning of art because I think it is broader, is more capacious, takes more in, and enables us to understand more.

Nevertheless, among the questions we received this week there were some, Lloyd, which do lead into a general consideration of art and which will enable us if we take them at the very beginning to help us to clarify the meaning of this basic and important word. I'm thinking particularly of the questions from Mrs. Springer and Mrs. Bertrand. Would you read those please?

Lloyd Luckman: I have them right here. Mrs. Springer is a resident of Sacramento and she asked the following question: She says, "From the beginning of civilization man's progress has been measured by the development of what are called the arts and sciences." That familiar phrase "arts and sciences" makes Mrs. Springer want to know how you distinguish between art and science.

Mortimer Adler: Mrs. Springer, I think that the distinction itself is as easy as the phrase is familiar. In fact there is another familiar phrase that all Americans are acquainted with that enables me to explain the distinction; the phrase is "know-how." We speak of people having "know-how." And when we say that a man or woman has "know-how," we mean that he or she has a certain skill or expertness or technique in making something or producing something. Art, then, in the most generic sense of the word is *technique*. In fact that word technique in English comes from the Greek word *techné*, which in Greek means "art." In contrast, science is not "know-how" but consists in knowing *that* something is the case or knowing *what* is the case or even in some cases knowing *why* it is.

Now the other question, Lloyd, from Mrs. Bertrand.

Lloyd Luckman: Yes, she's a San Franciscan and she has been reading a book on our subject, a book by Jacques Maritain.

Mortimer Adler: By the way, Lloyd, an excellent book. One of the best books on the subject, *Art and Scholasticism*.

Lloyd Luckman: That's the one. And she says that Maritain asked the following question: How does prudence, at once an

intellectual virtue and a moral virtue, differ from art, which is a merely intellectual virtue? Now she would like to know how you answer this question posed by Maritain.

Mortimer Adler: My answer, Mrs. Bertrand, is going to be exactly the same answer that Maritain gives us, the only answer I know. But first, let me say that you must understand how Maritain is using the word "virtue."

In America today, in the modern world in general, we tend to use the word "virtue" to name the moral virtues, things like temperance or courage or even prudence. But Maritain is using the word "virtue" in a broader sense, for good intellectual habits as well as good moral habits. Thus for Maritain, art and science and wisdom and understanding are virtues as much as temperance and justice and courage.

Now then, in terms of this understanding of virtue, let me say that these two intellectual virtues, prudence and art, both of them, consist in "know-how" but the difference between them is that prudence consists in knowing how to *act* well, knowing how to *do* something well, whereas art consists in knowing how to *produce* or *make* something in a good manner, to produce something that is good.

Perhaps, Lloyd, I can summarize the two distinctions that these questions call for under three headings: art, science, and prudence. Science and art and prudence, all three of them involve knowledge or knowing. But whereas science consists in knowing that something is the case or *what* something is or *why* it is, both art and prudence consist in knowing *how*. And whereas art consists in knowing how to *make* something well, prudence consists in knowing how to *act* well, how to behave well morally or socially.

Now let me come back to the generic meaning of art that I think we should face, which is the ancient meaning that I referred to at the very beginning. The generic meaning of art is skill in production, skill in making something, so that anything in which a human being has had a hand and has expressed his skill in the production of it, that thing is a work of art.

Now as I look around this room or as you look around the room in which you are sitting, I seem to be surrounded by nothing but works of art. This paperweight is a work of art, this telephone is a work of art, this cigarette box is a work of art, this pencil is a work of art, these cigarettes, that clock, the desk itself is a work of

art. In fact everything I see except you, Lloyd, is a work of art. And I include myself as well, but I think, perhaps, we ought not to get personal about ourselves in this respect so I'd like to show you a picture of something which is not a work of art. I have to go outside this room, outside of your room. Here is something which is not a work of art, a tree in a primeval forest, which came into being and grew without any human effort, an extraordinarily big and glorious tree.

And you remember, of course, those trite but quite true lines of the poet Joyce Kilmer, which says this very thing, "Poems are made by fools like me, but only God can make a tree."

Now then, consider another thing which is not a work of art. I hope you all agree with me that a human baby is not a work of art. But as soon as you agree with me—if you do agree with me—that a human baby is not a work of art, we get into difficulties at once, because I said that the tree was not a work of art because it came into the forest and grew there without any human effort. I can't say of the baby that no human effort is involved in its production, but I can say, and I shall have to explain this later, that the kind of human effort that is involved in its production doesn't make it a work of art.

THE RESTRICTED CONTEMPORARY SENSE OF "ART"

If I followed the contemporary sense of what art is and what works of art are, I would not have the difficulty I have just had. According to the contemporary sense of works of art, there is nothing on my desk or in this room which is strictly a work of art. Again, I must leave the room, I must go now to a museum, for the contemporary sense of works of art consists of thinking of things, referring to things, which hang on the walls of museums or stand on pedestals there. If I show to you a statue, one of the great statues by Michelangelo, *The Pietà*, a very famous work of art which stands at the entrance to St. Peter's in Rome, if I show this to you, you and all other contemporary persons would say, "Yes, that's a work of art." But if passing from this we were to look at a great tennis player playing tennis, you would not—most people today would not—think this was an artistic performance; they would regard it as an athletic exhibition, an exhibition of athletic prowess, not a

performance that reflected art, no matter how great the skill that it involved in the performance that this tennis player was doing.

Now this contemporary sense of art is, I think, summarized in phrases that we all use in which the word "art" seems to be most natural to us as we speak. We speak of museums of art, we speak of art institutes, we speak of an art student. And when we say "art student," we usually mean a person studying painting, or sculpture, or some other kind of plastic art. We even say, I think, and I really think the phrase is quite abominable, "literature, music, and the fine arts," as if literature were not a fine art, as if music were not a fine art. But even if that narrow meaning were mixed with the fine arts, or the meaning of plastic art were broadened so that the fine arts were understood by us to include music and literature as well, I would think that that meaning is still too narrow for a deep and proper understanding of what art is and the role it plays in human life.

The Broader Meaning of Art Is Still Current

Now let me ask you: Is this your meaning of art? This narrow, restricted meaning? You may think it is but I would like to show you that it isn't. I would like to show you that in your own vocabulary, in your daily speech, you have traces of the ancient and traditional meaning. For example, all of you talk about the industrial arts. You talk about the arts of war. You talk about the art of teaching and the art of medicine. Everyone uses the phrase "the arts and crafts." And everyone understands, I think, that in the meaning of that basic word "artisan" there is as much the meaning of art as in the higher word "artist." Now this meaning—which you have in your own vocabulary as these phrases that are familiar to you, I think, reveal—this meaning is the meaning that the word has had, the notion that it expressed, throughout Western cultural history.

One finds this, by the way, plainest of all in the writings of the two great Greek philosophers: Plato and Aristotle. The works of Plato are full of references to art, perhaps more frequently than his references to philosophy or science. And not only does he refer to art and talk about the various arts but he very frequently gives everyday examples of what he means by the arts and artists.

Plato, very frequently and with great pleasure, talks about a basic art, the art of the cook. The cook is an artist, in the deep Platonic sense of what human art is. Plato, even more frequently, talks about the art of the pilot. Plato, of course, thinking of the pilot as a navigator of a vessel on water. But for us today in modern dress, as it were, there are pilots in the air instead of on the sea, but nevertheless basically the same art that Plato is talking about.

And another familiar art in Plato's day is still a familiar art in our day and carries this basic meaning of the notion, "art." A physician, such as a surgeon performing an operation, is also practicing a basic human art.

Now when one understands this meaning, one is entitled to ask: Is it just a Platonic meaning? Or did this occur only among the Greeks? Did only Plato and Aristotle have this broad meaning of art to cover everything from cookery to painting and poetry? The answer is no. This meaning, this basic, broadened, widened, capacious meaning of art persisted through almost the whole of Western European civilization until yesterday. It ran through Roman antiquity, the Middle Ages, and the Renaissance and came down to the middle of the nineteenth century.

Let me show you this by reading two passages from the Great Books: one from Rousseau at the middle of the eighteenth century and one from Adam Smith toward the close of the eighteenth century. These passages indicate that as recently as a century or a half-century ago this basic, broad meaning of art, was still the common meaning in everyday speech. Rousseau, like Lucretius, the Roman poet, looked upon the rise of civilization itself as something that depended upon basic human arts. Lucretius had referred to the rise of civilization as a result of the fashioning of metal tools and the domestication of animals and the cultivation of the soil. And here, centuries later, many centuries later, Rousseau says, "Metallurgy and agriculture were the two arts which produced this great revolution."

Then in 1776, just as the Industrial Revolution was beginning—and in 1776, it had barely begun—in 1776, most production still went on in homes or in small shops with hand tools and by handwork. We didn't have industrial production by large machines and assembly lines. "At this moment," Adam Smith says, talking about the division of labor in the production of a coat,

(listen to the words), "the shepherd, the sorter of the wool, the wool comber or carder, the dyer, the scribbler, the spinner, the weaver, the fuller, the dresser, with many others, must all join their different arts." Hear the word? ". . . must all join their different arts in order to complete even this homely production, a woolen coat."

Lloyd Luckman: You know, as I listen to you, particularly reading that quotation from Adam Smith, I'm rather puzzled, particularly by this one thing: the enumeration in Adam Smith seems to me to fit the definition of art as "simply a skill in making," because in all of the instances and that particular instance of making a coat, an artificial product is produced.

And then there is another question that arises, too. If *making* is involved in art, I'm concerned about your illustrations of the pilot or of the doctor or of the teacher or the farmer. I don't see what they make.

The Natural and the Artificial

Mortimer Adler: Well, Lloyd, in the sense in which the cobbler makes a shoe or the cook a pastry or the various arts mentioned by Adam Smith make a woolen coat, in that sense these other artists you mentioned—the farmer, the pilot, the physician—they don't produce anything that you would call an artificial product. On the contrary, the things they help come into being, help generate themselves—like health in the case of the physician or knowledge in the case of the teacher or the fruits and grains of the field in the case of the farmer—these are the products of nature. And they are natural effects, not artistic effects. And I'm going to try to explain therefore—I can't today, Lloyd, but I'm going to try to explain next time—these very special and queer arts which are different from the other arts in that what the artist in this case helps to produce turns out to be a natural product not an artificial thing.

Lloyd Luckman: Well, now—

Mortimer Adler: One moment more.

Lloyd Luckman: All right.

Mortimer Adler: Because there is one thing that is clear from this, and that is that if you look at these arts like healing and teaching and farming as compared with shoemaking and cooking, the meaning of art must not be found in the products: art is not

connected necessarily with an artificial product, the meaning of
art lies in the skill. And we do know that the physician has skill and
the farmer has skill, even if the product is something natural, not
artificial.

Lloyd Luckman: Well, now I can come in with my concern
about this distinction between artificial and natural. And I'm par-
ticularly concerned because I remember a question here about the
distinction between these two words. It is the one that Mrs.
Stephenson sent in from San Francisco. And she asked right on
the point whether the distinction between the artificial and the
natural throws any light on the meaning of art.

Mortimer Adler: It does indeed. Mrs. Stephenson, that distinc-
tion between the artificial and the natural goes right to the heart
of the matter. Now let me see if I can state it for you. We call things
natural which can come into being without any human effort. And
when we call something artificial we call it that because some
human effort is necessarily involved in its coming into being, its
production.

That unfortunately brings us back to the baby again. Because
everyone has a right to say, "But human effort is involved in the
production of the baby. Why, then, don't you say the baby is artifi-
cial instead of natural?" And that is the question I've got to answer.

Let me see if I can answer it . . . I can't answer it directly; I've
got to answer it in terms of a threefold distinction that I think will
explain the differences between works of art, natural productions,
and the divine creation.

THREE WAYS OF COMING INTO BEING

There are three ways of coming into being: by natural generation,
by artistic production, and by divine creation. A baby is born by
natural generation. In fact, what do we say about the baby, about
the production of the baby? We don't say it is produced; we say it
is reproduced. We don't say it is created; we say it is *pro*created.
Now that is terribly important, the fact that we used "*re*produced
and *pro*created" there. Natural generation, which consists in the
reproduction by a body of another body out of itself or its life.
Notice that: a body out of a body or something like itself—either
its own body or something like itself.

As compared with natural generation, artistic production and divine creation both are alike in that the production is by mind, not by body, and by idea. The artist must have the idea, in advance, of the thing he is going to produce. No parent has in advance the precise idea of the baby that is going to be reproduced. But whereas the artistic production of man is by mind and idea out of natural materials—materials afforded him by nature—the divine creation, on any theory of creation, is by the divine mind and idea, as we say in theology, "out of absolutely nothing."

Let me come back to one of the points. The difference between a human reproduction—a baby—and a work of art is that the baby may resemble the parents or may not resemble the parents. And if the baby resembles the parents as opposed to the grandparents, they may resemble the parents in body rather than in mind. But any work of art, whether it be the simplest thing that is fashioned by man or a great painting or a great poem, resembles the soul or spirit of the maker. This shows you that art involves a human spirit, a human intelligence, a human mind, ideas, as reproduction in the case of the baby does not.

Now this leads to two concluding points I would like to make. The first is the distinction between making by instinct and making by art. Making by instinct is without conscious plan; making by art is with conscious plan by the application of rules and by the making of deliberate choices. This is the distinction, and a very important distinction, between human and animal making.

Let me read you one passage from Karl Marx on this distinction between human and animal making. Karl Marx says, "A spider conducts operations that resemble those of a weaver and a bee puts to shame many an architect in the construction of her cells; but what distinguishes the worst of architects from the best of bees is this, that the architect raises his structure in imagination before he erects it in reality."

This leads to my second concluding distinction, between making by rule and by choice as opposed to making by chance. If a piece of music happened to result from a cat walking on the keys of a piano, it would not be a work of art; but if a human composer sits down to imitate what a cat would sound like if a cat were to walk on the keys of a piano and produces something, a jazz piece of music like "Kitten on the Keys," that is a work of art. And this is terribly important because the very essence of human art is the

avoidance or elimination of chance in human affairs. To do something by rule, by preliminary and preparatory design, is what human art does for man as opposed to trusting to chance and accident.

The ancient Greek and Roman doctors made a sharp distinction between the physician who was an artist and what they call the empiric. The empiric tried to cure diseases by trial and error, whereas the physician who had art, art in the deep sense, proceeded by knowledge and by rule and trusted as little to chance as possible.

And one other way of understanding this is Aristotle's very deep insight that only the person who has an art can make a mistake in that art. Only a person who knows the art of grammar can intentionally make mistakes in speech; the person who makes unintentional mistakes in speech has no art in this particular respect.

I'd like to summarize and say that art is the principle of all human work, of all skilled labor. And I mean very deeply that all human labor is skilled, even the least skilled labor has skill in it.

The points we've considered today, I know, are not entirely clear, but I hope as we go on with this discussion they will become clearer, particularly next week as we discuss the different kinds of art: the distinction between the fine and the useful arts, the distinction between the liberal or free and the servile arts, and, above all, the distinction between the simply productive arts like shoemaking or cooking and the extraordinary cooperative arts like farming and healing and teaching.

25 The Kinds of Art

Today we continue with the subject of art. And I hope we can deal with the problem of the different kinds of art.

You will recall that last week I proposed to you a generic, a most general meaning for the term "art," that art referred to any human skill in the making or production of something. And in the light of that generic meaning of art as skill in making, it followed that art exists in the mind of the artist, in the person and in the habits of the artist, and is distinguished from the thing he produces, which we should not call art but the work of art.

Now, Lloyd, my impression from reading the questions we received this last week is that this generic meaning of art caused a general discomfort on the part of our viewers, a kind of very serious puzzlement because that generic conception of art requires us to see that every human being is an artist, that human life is almost impossible to live without the possession of the basic skills, which are art. In fact one would almost say that every act of work, every form of human work involves some skill which is art.

Now this doesn't disturb me because it reveals for me, at least, how broad and deep is the significance of art in human life. It is almost equivalent to saying that to be a human being is to be an artist or to be an artist is a human being. But I do see, I think, why it disturbs a great many of our viewers. For example, Lloyd, we had a letter from Mrs. Mimi Bradford in which she said it had always been her impression that only those gifted with specific abilities to express themselves with the medium of art could be called artists. And this is in contradiction to what I said, but you are quite right, Mrs. Bradford, that only a few men are artists; but that opinion is based upon the conception of art as fine art. It is true that only a

few men are fine artists and an even smaller number of those are really great fine artists.

Was it your impression, Lloyd, that from the letters you have received that the same thing happened? I mean, that people were disturbed by this generic meaning of art?

Lloyd Luckman: I have exactly the same impression. For example, a letter from C.B. Keiffer. "Well," he says, "it seems to me, Dr. Adler, that you are defining art in such a broad sense that it ceases to have any meaning as such." And he has here a very interesting suggestion. He says, "Wouldn't it clarify the subject if the word 'creative' were incorporated in the definition?"

Mortimer Adler: That same suggestion was made in a letter I have here from Mrs. Kathleen Edmonds. She asked, for example, whether every artist is creative or whether there are some arts which are not creative. And my immediate response both to Mr. Keiffer and to Mrs. Edmonds is that what you are both looking for is the distinction between the useful and the fine arts. And that is one of the points I hope we can get clear today.

Lloyd Luckman: Now there is a question here from Mr. Frank Delamater. He is from Modesto Junior College. And it seems, I think, to tend in this very same direction. He wonders, for instance, whether the artisan who was a skilled craftsman is an artist in the same sense as a painter or as a writer. And he suggests, then, that perhaps the essential difference between the craftsman and the artist lies in the significance of what each of them produces.

Mortimer Adler: My feeling, again, is that, Mr. Delamater, that you are looking for the distinction between the useful and the fine arts. Mr. Delamater, I gather, would like to use the word 'craftsman' for the useful artist and the word 'artist' for the fine artist.

Similarly, a letter from Mr. Jones in San Mateo asks whether the result of the sculptor's skill is art, whereas the result of a cabinetmaker's work is craftsmanship?

Now all these questions and many more like them, I think, indicate the work we have cut out for us today: the subdivisions of art into its various major types. And this isn't a verbal matter. For example, when we get the distinction between the sculptor and the carpenter or cabinetmaker clear, that distinction remains the same whether you call them both artists, and one a useful artist and the other a fine artist, or whether you call the sculptor and

artist and the cabinetmaker a craftsman; the distinction is exactly the same.

My only reason for still wishing to use the word "artist" for all of these kinds of skill and production, is that when you use the word "artist" in this generic sense to refer to both, it calls attention, and I think it should, to what is common in all these productive skills before we come to their differences and distinctions.

THE THREE COOPERATIVE ARTS

Now today, I would like to make three basic distinctions in the kinds of human art. And the first of these is the distinction between what I am going to call the cooperative arts and the simply productive arts. You aksed me last week, Lloyd, how I could look upon the pilot or the physician as an artist when he didn't produce anything. I mean, he didn't produce a shoe the way the shoemaker did or a cake the way the cook did or a house the way the builder did; in what sense, then, if he doesn't produce anything, is the pilot or the physician an artist?

Lloyd Luckman: That is just the point.

Mortimer Adler: Now, the answer to Mr. Luckman's question of last week is in terms of our understanding of the difference between the cooperative arts and the simply productive arts. And this, I think, is the least familiar of the distinctions, though for many reasons I shall try to make plain to you, it is the most interesting.

Let me see if I can say it to you this way, there are only three arts, only three which are cooperative; all other arts are productive. The productive arts produce or make artificial things like shoes and houses and ships, but the cooperative arts simply help in the production by nature of natural effects or results.

The three cooperative arts are farming and healing and teaching. The farmer has as his end the growth of plants. The physician or healer has the health of a body, the human or animal body as his end. And the art of a teacher has as its end the knowledge and skill which can be acquired by man.

Shoes or houses or ships would not exist if human artists didn't produce them. But you know as well as I do that the fruit and grain of the field would grow without human beings as farmers,

that human bodies and animal bodies would gain health, maintain health, and regain health when they were ill without physicians, and that human beings can learn and acquire knowledge and skill without teachers. Unlike shoes and ships, which require the artist to produce the artificial product, what then is the character of these three great cooperative arts, the arts of the farmer, the physician, and the teacher? The characteristic of all three of them is that they help nature reach its own results.

Let me show you that a little more clearly. The farmer merely watches, observes what things in the natural process of growth produce good crops, sunshine and proper soil, irrigation, and then he helps nature produce those very factors in the growth of plants; unlike herbivorous animals which live off the grains and fruits of the fields and therefore have to take their chances with the way in which nature produces these things. The farmer makes the plants, the harvest, come at a time and with a frequency and regularity that suits human needs and fits human conveniences. Similarly, the human body has health and often regains health. And the physician, watching the body in the process of healing, helps it along. And the same thing is true of the teacher.

These arts, then, have as their characteristic the primacy of nature and the subordination of the human artist to the processes of nature, almost as if they watched how nature worked, imitated nature's working, and worked with nature.

And one other characteristic of these three arts which I think is quite remarkable. These are the only arts that work with living matter; all other arts, whether they be the art of the sculptor or the art of the painter or the art of the shoemaker or the art of the shipbuilder, take dead matter and transform it. But these arts, these three cooperative arts, cooperate with living things, with living matter in their processes of change.

Lloyd Luckman: I don't want to keep on this point all the time, Dr. Adler, but last week, how about my pilot or my navigator? You were classifying him with the teacher and the physician. And here, now, it doesn't seem to me that he fits in with those definitions at all because he is working with dead matter.

Mortimer Adler: That's a very tough question. In fact, that question, Lloyd, has puzzled me for years. I searched through the great books on art where this wonderful distinction between the cooperative arts and the simply productive arts is made, and where they

talk about the pilot, the navigator, to see if I could find out what they had to say about the pilot or the navigator and I could never find any discussion of it. And I think I've got an answer, which if it is true, I am very proud of having discovered or invented.

Lloyd Luckman: I'll be listening.

Mortimer Adler: What is a ship? A ship is a human invention for getting from one place to another. And whether it be a wind-powered or a steam-powered ship, it is planned, always planned by the inventor, the maker, to be operated by men. It involves human beings working with the sails or a motor to get the ship where it is going.

Let me take an example that is better. Some of you are not pilots, you haven't piloted vessels or piloted airplanes but almost everyone in this audience, I think, has driven an automobile. And in driving an automobile you have a kind of secondary cooperative art. The automobile is not built to go by itself; it is built to be driven. And the human artist, the person who learns the skill of driving is cooperating with the machine for the end which the machine is built for, to get somewhere. And all the things, all the things the driver's manual tells you, are things that really instruct you in the art of cooperating, in the skill of cooperating with the machine as it is built. The extraordinary thing about man is that not only is he an artist that cooperates with nature, but he even builds machines which require other artists to cooperate with them.

Now I think that is a good solution to your problem.

Lloyd Luckman: I see your point.

Mortimer Adler: Well, think about it.

Lloyd Luckman: I will.

Mortimer Adler: I think that the more you think about it the more it will impress you. I have always thought it fascinating.

Lloyd Luckman: Okay.

Mortimer Adler: Let me see if I can come back now to one more series of brief points about these, I think, quite extraordinary cooperative arts.

THE COOPERATIVE ARTS HELP NATURE

In these cooperative arts nature is the primary artist and the artist is almost an auxiliary, almost as if you were to say, for example, that

as the architect is the master craftsman and all the other artists work with him, so in the arts of medicine or teaching or farming, nature is the master craftsman and the artist works with nature. In addition to that—this insight, by the way, was gained very early in the history of medicine and in the history of education— Hippocrates, who was the father of medicine, laid it down as a basic rule, in his maxims and aphorisms, that the physician should let nature take its course and that the physician was to help nature take its course. And Socrates, who must have known this Hippocratic wisdom, defined himself as a teacher—the most magnificent thing in the whole list of education—functioning the way a midwife functions.

Notice the example of the physician. The teacher functions like a midwife. The mother gives birth to the child but the midwife assists in the birth, in the production. So the teacher doesn't give birth to knowledge; the student, the learner gives birth to knowledge and the teacher is strictly an auxiliary artist cooperating with the learning process in the learner and helps that process occur more frequently, more certainly, and perhaps a little less painfully.

There is a third conclusion from this comparison between the teacher and the physician as cooperative artists, one that has always fascinated me and bears on the whole of education. Hippocrates, thinking of the physician as cooperating with nature, pointed out that there are three things you can do in the therapeutic process in helping to cure sick people. His three things, the three techniques of medicine, he said, were controlling the regimen of the patient, his hours of rising and retiring, his diet, his work, his exercise, his climate. And this he regarded as the best form of therapy. And the reason why he regarded it as the best is because it was the most natural, the one that fitted best with nature's own course, the one that did not introduce anything foreign or violent in the process.

Then he said if controlling the regimen didn't work well, then you were permitted to use medication, introducing drugs. And the point there is that drugs are a foreign substance. Some might do some violence to nature, and so he recommended medication only when the control of the regimen didn't work.

And finally, in the last resort, if nothing else helped in emergency cases, he permitted surgery. But surgery, strictly, was the

third of the three ways to be resorted to only in the emergency that the other two didn't work.

In teaching, if I may make the comparison, there are three ways of teaching that are like the controlling of regimen, medication, or giving drugs and surgery. Socrates's method of teaching, teaching by questioning, is the most natural process of helping the human mind learn. Lecturing, lecturing in a fashion which raises questions in the mind of the student, is next best, not as good as questioning; it is somewhat like medication, introducing a kind of foreign substance into the mind. But the worst form of teaching, which is like surgery, is telling the student what to put down in his notebook on your authority as a teacher, which is indoctrination, asking him to accept something as if it were a foreign substance incorporated in themselves. Just as surgery operates and takes something out, the teacher who indoctrinates operates and puts something in.

FINE ART IS USELESS

Now let me go to my second distinction, the distinction between the fine and useful arts. And, Lloyd, didn't we receive a question on this distinction?

Lloyd Luckman: Let me see. It's the one that we had from Mrs. Kincaid, I think, that you have in mind.

Mortimer Adler: That's right.

Lloyd Luckman: Her home is in Palo Alto, and she wants to know whether the difference between the art of the cobbler or cook and that of Raphael or Michelangelo is one of kind or one of degree.

Mortimer Adler: Well, my answer, Mrs. Kincaid, is that that is a distinction in kind, not degree. Because if both the fine artist and the useful artist, the cobbler and Michelangelo, were doing the same thing, working for the same end and one did it better than the other, that would be a difference in degree. But in this case they are doing quite different things. One is producing a useful work and the other a work of fine art. And if we understand what this means, you will see that this is a distinction in kind.

Now let me see if I can explain this. In fact, this distinction between the useful and the fine arts is the most familiar and, I

think, the easiest to understand. A work of useful art is a thing which serves an end, a means which function toward some ulterior end or purpose. And there is no difficulty in understanding that a shoe or a house or a desk is a work of useful art that helps us in some particular connection in our action or is practically useful.

Now does this mean, as you look at this as a distinction, useful art and fine art, that if the works of useful art are useful, serve as means, that the works of fine art are useless? The answer is in part yes. Oscar Wilde, in one of his witty epigrams, said, "All art is quite useless." And what he meant, of course, was not useful art but all fine art. The nonuseful arts are quite useless. Does this mean, if the works of fine art are quite useless, that they are of no value? Well, I'm sorry to say, Lloyd, that there are many people in America for whom the useless is the valueless. This country will place such a high value on utility that if you call something useless, it is like saying it is no good. But this, of course, is crazy, absolutely crazy.

In fact, the opposite is the case. Things which are not useful but enjoyable, good in their own right, things which we enjoy intrinsically, are much more valuable than the things which are merely useful as means to ends.

We'll see in our discussion of work and leisure that work or labor is useful and done for the sake of leisure which is intrinsically rewarding. In similar fashion, all the useful arts and their products are ordered to the fine arts which are the intrinsically enjoyable things.

Perhaps I can explain this by one more comment: Have you ever stopped to think about the meaning of the word *fine* in the phrase "fine art"? Did you suppose, for example, that it meant "excellent," that the work was an excellent work? Did you suppose it meant it was very good? Did you suppose it meant, for example, that it was for a refined audience or was a very refined, and elegant, or precious work? Not at all. That word *fine* has exactly the same meaning of the same root as the word *final.* It means "end." The arts we call "fine arts" in English are called in French *beaux-arts,* or in German, *schönen Künste,* the "beautiful arts." And the reason why *fine* has the same meaning as *beautiful* is that a thing of beauty is something which is enjoyed in itself, not used, not consumed, not referred to something else, but taken as itself, beheld, enjoyed, looked at. So that the meaning of the word *fine* as it

occurs in the phrase "fine arts" means these things produced are good in their own right just to be enjoyed, ends in themselves, as it were.

Though this distinction is clear, no one should understand it too sharply. Because there are two qualifications we have to introduce. In the first place, we must consider the fact that the intention of the person who receives the work of art may control what he does with it. For example, let's consider a lovely Chippendale highboy. This was intended by its maker as a useful thing, a chest of drawers to put clothes in. But it could become a museum piece, looked upon with admiration,and beheld with satisfaction just in looking at it. It was a useful work—I mean it was intended as a useful work, though it can be received by someone as a work of fine art.

Primary and Secondary Aspects of Works of Art

Similarly, I'm sure that there are many people who hang paintings on the wall just to cover spots or tears in the wallpaper. And I'm sure there are people who use a Brahms lullaby to put the baby to sleep. That is one qualification. The other qualification on the distinction is this, particularly with regard to the fine and useful arts. Almost every work has two aspects, a primary and secondary aspect. And it may be useful in its primary aspect and fine in its secondary aspect or the reverse.

For example, consider kitchen stoves. In the old days when I was a boy, a six-burner gas stove was one of the ugliest things in the world to look at because at that time the manufacturer of the kitchen stove had no interest in design; it was a perfectly useful thing. But now, kitchen stoves and iceboxes, all things of that kind which are still just as useful, in fact perhaps even more useful, are designed not only to be functional but also to be pleasant to the eye. They have an aspect of fine art, nice to behold even when you aren't using them.

And the reverse—well, I can give you one other illustration. Think of architecture for a moment. The great traditional art of architecture is at once a useful and a fine art because the building that is being made is made as a domicile or an office or some kind,

but also is meant to be looked at in a way that pleases the eye. So today you see in architecture and houses the combination of the useful and the fine.

The reverse is also true. Works of fine art, poems, pieces of music, and paintings, sometimes have, in addition to being beautiful, being pleasant to behold, and causing delight, are instructive. They give both delight and instruction. And as instructive, as causing men to learn something from them, they have a kind of intellectual utility. Nevertheless, they are primarily fine works. And how do you know this? You know it because if, for example, Lloyd, a piece of writing merely instructed you, as a guidebook does, you wouldn't call it a poem. You would call it a poem if in addition to its instructing you and giving you something to learn, it also delighted you as a thing of beauty. This same thing is true of architecture. If a building were merely beautiful and you couldn't live in it in any way, you wouldn't call it a house because architecture is primarily a useful art and only secondarily is it a thing of beauty. So poetry is primarily a fine art, producing things of beauty and only secondarily useful. And this indicates the combination of the two senses: one primary and one secondary.

LIBERAL AND SERVILE ARTS

Now, if a work that looked like a work of fine art were merely instructive, we wouldn't call it fine art at all, Lloyd; we would call it liberal. We would call it a work of liberal art.

Lloyd Luckman: Well, now that you use this phrase "liberal art," it reminds me of this question, I think we received one here from Mother Anne at the Urseline College. Yes, here it is. That is in Santa Rosa. And she said, "What is the meaning of the word 'arts' in the phrase 'liberal arts', as for example in 'liberal arts course' or 'liberal arts college'." And this is her question.

Mortimer Adler: Well, I can certainly see why Mother Anne is puzzled by the phrase "liberal arts." Because most of the things, Mother Anne, that are taught today in liberal arts courses and liberal arts colleges have little or nothing to do with the liberal arts. In fact, many of them, being entirely vocational schools, have to do with the useful arts and not with the liberal arts at all.

But to answer Mother Anne's question, Lloyd, I would have to go to my third distinction between the free and the servile arts. That, by the way, is the most difficult distinction to make. It is a distinction which I think I shall only be able to start today. I don't think there is time to finish it. If I don't finish it, you remind me and I'll pick it up next time as we start off to talk about these matters further. But just let me suggest it to you today and then go on next time.

The ancients made a distinction according to whether the artist had to work in matter, actually get his hands dirty, get involved in touching physical things and changing them, or whether the artist could produce his result simply in the soul of persons or in their minds. By this distinction—and the reason why they called the arts, which had to work in matter, servile arts is because for them in the ancient world only slaves worked and the free man didn't get his hands dirty. Hence they regarded the art of shoemaking or the art of building and even the art of sculpture or the art of painting as servile arts. And they regarded music as a free art. And they regarded poetry as a free art. But to explain the sense in which music and poetry are free I will have to come back to next time.

What I would like to do now is to summarize quickly what we have done today and close. We have understood today the distinction between the cooperative arts and the simply productive arts, the useful and the fine arts. And next time I would like to discuss the fine arts in detail, along with the liberal arts which we haven't fully discussed today.

26 The Fine Arts

Today we continue the discussion of art. And I hope we can concentrate on the fine arts. There are many interesting problems connected with the fine arts that I should like to discuss.

But first I would like to return to a point we did not complete last week. Last week I tried to present to you three basic distinctions in the arts and I only succeeded in dealing with two: first, the distinction between the cooperative arts and the simply productive arts, an art like farming on the one hand and like shoemaking on the other; and then the distinction between the useful and the fine arts, arts which produce things that serve a purpose or a function and the fine arts which produce things which are beautiful, whose aim is to delight the persons who behold them, to give pleasure in beholding.

Now there is a qualification on that distinction between the useful and the fine arts I want to remind you of as I go on. A useful work may delight as well as serve a purpose. For example, fine furniture may give delight to the eye and a building, a work of architecture, may be useful, but also delightful. On the other hand, a work of fine art such as a painting or a novel or a piece of music, in addition to being delightful, being a thing of beauty, may be useful as well.

But if something is merely instructive, useful in the sense of teaching, then it is not a work of fine art. For example, I think of Euclid's elements of geometry. To me, Euclid's elements of geometry is a thing a beauty. But it is not primarily so. It is primarily instructive and that is why I would call it liberal art, not fine art.

This brought us to the third distinction we were concerned

with last week between the liberal and other arts. Lloyd, do you recall the question I was answering when time ran out?

Lloyd Luckman: Very well, indeed. It was the question from Mother Anne of the Urseline School in Santa Rosa I believe. And she was asking you in terms of the liberal arts, what was the meaning of the term "liberal arts" as we use it today in colleges, liberal arts colleges? And you pointed out that while we call these colleges liberal arts colleges, they are teaching useful arts more than liberal arts. And then you went on with the distinction between liberal arts and both—

Mortimer Adler: The distinction between the liberal arts and the servile arts. Let me make that distinction now, Lloyd.

Let me say first what the meaning of "servile" is. An art is servile if it makes something out of matter and the thing which is made exists in matter. It is called servile because in the ancient world where this name originated only slaves got their hands dirty and callused, only slaves worked in matter. Most useful works, most material products of art are in this sense servile; they are made in matter and they exist in matter.

The meaning of "liberal" on the other hand is free, free from having to deal with matter, made in the mind and existing in the mind. For example, a speech, a great speech, exists in the human mind. A mathematical demonstration is made in the human mind and therefore exists there. And that is why any such work, a speech or a mathematical demonstration, is called a work of free art, liberal art. And this is what gives the name, Lloyd, to our traditional seven liberal arts, of which I'm only going to name three: grammar, rhetoric, and logic. These arts make works in the human mind.

But these arts, grammar, rhetoric, and logic, are useful arts, not fine arts. They are liberal but useful arts as the art of teaching is. Hence we have the interesting question: What about the fine arts? Are the fine arts servile or are they free? Now, my answer to this question may seem shocking at first. The answer is, some of the fine arts are free and some of the fine arts are servile.

For example, literature and music are free arts. And the way we know that they are free is that all that is physical about them is the notation by which the art is conveyed from the mind of the artist to the mind of the audience. I am thinking of literature now and

music, for example, without regard to the auxiliary arts of a performer, the stage actor necessary to produce a play or the orchestra necessary to play a piece of music. For example, if we consider a book of poetry. Its only physical existence is in words. But those words are merely there to convey the poem from the mind of the author to the mind of the reader of the poem. The poem doesn't exist there on the page. Or take a piece of music. The notations, the musical symbols in the score, are not the music and you don't even have to play the piece of music to "have" the piece of music, because the person who is competent in reading music can, by reading the notations, actually hear in the "mind's ear," have the physically unheard but imaginatively heard music that the composer intended. It is in this sense that arts like poetry and music are said to be free, because they are made in the mind and can exist in the mind.

But let's consider fine arts which are not free in this sense, for example, the arts of painting and sculpture. Consider reproductions of a famous statue. The original of the statue exists somewhere in the world in one place only, in a museum. If this statue is to be seen by anybody who doesn't go to that museum, we must make actual models of it, reproductions of it. This reproduction of the statue is not like the notes on a page of musical score or like the words in a book. They have to convey the statue by actually physically reproducing it. That shows that the statue in a sense is a servile work; it has to be made in matter and exists in matter.

Let me just add by the way that Leonardo da Vinci, the great painter, was very sensitive to this distinction between the liberal and the servile arts. He regarded painting as more liberal than sculpture because the painter could be in a studio with a fine velvet jacket and his hands could be kept clean, whereas the sculptor was covered by the dust of chipping marble and his hands got dirty and callused. That is why Leonardo thought painting was a more liberal art than sculpture.

Let me take another art to illustrate the point. Let's take the ballet. Is the ballet free or servile? Well, it has changed. At one time the ballet necessarily was servile art because the ballet could only be produced on the stage by these actors using their own bodies to produce. But now in recent years the notations of choreography have been developed. And these notations enable the dance, the ballet, to exist on paper in symbols just as music exists

on paper in symbols. So the person who could read the choreography could understand and can actually imaginatively reconstruct the dance without having to go to a theatre to see it.

Let me now summarize these categories. Literature, music, and choreography are free (or liberal) fine arts; painting, sculpture, and ballet are servile fine arts; grammar, rhetoric, and logic are free (or liberal) useful arts; finally, architecture, carpentry, and cosmetics are servile useful arts. "Literature" includes all forms of fictional writing, imaginative literature and poetry. Architecture is the most liberal of the useful servile arts, but nevertheless the building has to exist in matter—it doesn't exist in the architect's plans.

Lloyd Luckman: In that summary I'm missing something that you were stressing very much last week and you haven't mentioned today. Remember the cooperative arts are farming and medicine and teaching.

Mortimer Adler: Yes.

Lloyd Luckman: How do they fit in?

Mortimer Adler: Well, I should have mentioned them. The cooperative art of farming is a useful art and servile. Actually the farmer has to deal with the soil and the things of the soil. The cooperative art of teaching is like grammar, rhetoric, and logic, a liberal useful art. And medicine, partly dealing with the body and partly with the mind or soul, is partly free and partly servile.

Let me get back to the problem that bothers me. Because it may bother you, too. I can't get over being bothered by the fact that you have a sense that all the fine arts should be free. But if literature, music and the choreography of the ballet are free fine arts, why aren't all the others free? Now that is a hard question to answer.

In a sense perhaps they are free, even though they must exist in matter, as the statue exists in the stone or the painting exists on the canvas, perhaps in the deepest sense the fine arts do not exist except in the mind of the beholder. In this sense, then, they exist in the mind and are like free art.

THREE QUALITIES OF A WORK OF FINE ART

Let us now move on to three characteristics which are common to all the fine arts and distinguish them from useful art. In the first

place, a work of fine art has individuality. In the second place, a work of fine art is original. In the third place, a work of fine art says something.

Now let me briefly explain each of these three points. A work of fine art, we say, has individuality. What does this mean? It's a most astounding fact: every work of fine art has a proper name. It either has a title or an opus number or a number of production as in the case of a numbered print. Now we don't name shoes, we don't name desks, we don't name fountain pens or clocks. Among the works of useful art, only extraordinary things like great trains or great ships are given proper names. Why is this so? When we give a proper name to something we are giving it personality as when we personify famous trains and ships. And every work of fine art which has a proper name, its own individual name, therefore is regarded by us as having more personality than any useful thing has.

Secondly, we say that every work of fine art is original. What do we mean by this? Well, in all these letters we have been receiving in the last few weeks, people have talked about the creative arts. "The useful arts aren't creative," they say. The meaning of that is that a work of fine art is creative in the sense of being original. It's not an exact duplication of anything else, not a reproduction. Here it is, this for the first time is this thing produced, you see. And somehow the combination of these two, the individuality and the originality of the work of fine art give it its unique character.

Now I come to the third characteristic, a work of fine art says something. What does that mean? What does it mean to say that a work of fine art says something? I will never forget in my youth when I heard musicians talking. I heard one musician saying to another about a piece of music, "Oh, I don't think that is very good. It says so little. It says so little." And I said to myself, "Well, what can that musician mean by saying that a piece of music says so little"? I didn't think it said anything at all. And then I realized as the more I thought about the arts, I realized that that was the deepest remark I had ever heard made about the fine arts. Every one of the fine arts is a kind of language, not like our verbal speech, the kind of speech I'm using now, but a language of its own, a language which says only certain things.

Now let's ask that question again: What is it that a work of fine art says? What is the meaning of its content? To answer that ques-

tion I would say you have to think of each of the great fine arts: music, poetry, literature, painting and sculpture, in terms of the medium in which the work of art is produced, a language, a kind of speech utterly different from the ordinary speech of everyday discourse. Because it is a speech which says certain things and only certain things. If we look at the fine arts this way, we can reach a classification of the fine arts as so many different languages, each language in its own medium a special mode of communication or expression.

When we start to classify the fine arts, we make a distinction between fine arts which are in motion, which are in time, which take time for them to exist, and fine arts which are motionless.

In the fine arts which are in motion, let me take literature and music. The language of literature is not necessarily just words but it is what the words evoke, the images, the whole imagination, emotional and intellectual imagination that is evoked by the symbols of literature. The language of music is the language of tones and time, these are the elements out of which music is composed, tones and time, the elements of rhythm and temporal structured music. And the language of music is in terms of the grammar, if you will, of these elements. And so (moving on to motionless fine arts) language of the plastic arts, arts like painting and sculpture, is a language in terms of physical forms, forms that have to be seen. Forms, visible shapes and colors and patterns; they have to be seen to express what the painter or sculptor is trying to say.

Now, that classification is only exemplary.

IS PHOTOGRAPHY A FINE ART?

Lloyd Luckman: If it is only exemplary, then I think I can bring in this question at this point because we have a very interesting letter here from a Mr. Peterson in Oakland, and he wants to know about photography. Is the photographer an artist? And I'd like to know, since you mentioned ballet a moment ago, along with Mr. Peterson's question, where would you put ballet? Photography and ballet.

Mortimer Adler: Well, I would say in the first place, that photography is a plastic art; its works exist in the visible forms that they contain. As for ballet, ballet looks like a plastic art, it contains a vis-

ible moving form, but looking a little deeper into the content of ballet, you see that ballet is an art in time and not a motionless art. It is in motion and therefore it has more affinity to music and poetry, to narration and drama, than it does to the simple motionless plastic form. As a matter of fact, the art of the motion picture, one of my favorite arts, the art of the cinema, is partly plastic in the fact that it uses a pictorial medium, in part but not entirely; nevertheless it is an art in motion, the main point of which is storytelling. The only plastic art in motion that I can think of that is truly a plastic art in motion that isn't like poetry or music is the new art of creating mobiles, actually moving visible forms, the movement of which is part of the art.

CAN DIFFERENT ART FORMS HAVE THE SAME CONTENT?

Now, let me get back to my main question, Lloyd, which is about the different fine arts as so many languages. And the question I want you all to think about as hard as you can, is this question: Do they all say the same thing? Can you translate what one art says into another art? Can you say, "Oh, this in music says what this says in painting, what this says in poetry"? Think of that question for a moment before you hear my answer. Is the meaning, the content—so I put it this way, is the artistic language of one art capable of translation into the artistic language of another, as French, for example, is translatable into English or French into German?

The answer would at first appear to be yes. Because the arts have a certain kind of common content. They all refer to an objective world in which we live, which is common. They all somehow express common thoughts and feelings. So you would think the answer would be yes. Of course, you can translate, just as you can translate from French into German or German into English! But no. Deeply and more really the answer is no. And the reason why the answer is no is because in the fine arts the content can never be divorced from the form, the form given to it by the medium of communication which is the language of that fine art.

Let me say it another way. You get a sense of this when you recognize that to translate English prose into French prose is easy. But why do people say, "Well, French poetry, French verse can't be

translated into English verse," because there in poetry, not prose, something about the actual language and the imagery that language is not translatable into another foreign language?

Now there is a deep mystery here. I think this is the deepest mystery about the fine arts, the fact that there is something common to all of them which we can never express in words, and we can never express what one art says in another art. There is a kind of ineffability about the arts which makes it impossible to translate from one to another. Yet for most people, and I'm going to use a hard word here, the popular and almost the vulgar approach to the fine arts is to transgress this mystery, to avoid this mystery, not to be sensitive to this mystery. Most people when they look at paintings and the plastic works, paintings and sculpture, do no more than read the story off it; *they say it in words*. And when they do this they are in a sense violating that mystery. And I think as a matter of fact, you can actually see this done.

Let me take an example here. Most people looking at a certain, very famous statue, would say, "Why, that's a boy taking a thorn out of the sole of his foot." And having said it in words that way, they might be satisfied that they had seen the statue, whereas in fact all they had done was take a story from it. Or to take another example. There's a painting by Caravaggio. Most people looking at would see only the story, the great Christian story of Christ being taken down from the cross. Or take another painting they would read that way, a painting by Fra Angelico called *The Entombment of Christ*. Reading the title and knowing the story, they would not see the picture. They would be satisfied merely with this literary equivalent, with saying in words what the picture seemed to say. It is precisely this vulgar approach to the fine arts, especially of the fine art of painting, translating it into literary terms, that the modernists revolt toward abstraction and surrealism in art was an answer to, a quarrel with, an attempt to overcome.

The titles of some modern paintings, such as Picasso's *The Three Musicians*, Dali's *A Chemist Lifting with Precaution the Cuticle of a Grand Piano*, Mondrian's *Broadway Boogie-Woogie*, or Duchamp's *Nude Descending a Staircase*, these titles themselves express the artists' defiance. It is as if to say, "No, you are not looking at the picture. You are reading the title and trying to find in the picture what the title says. You can't do it," says the artist. On the other hand, one modern picture, by Kandinsky, has the title *Circles in*

Circles, and this doesn't disturb anybody. Anyone looking at it would say, "Why, yes—circles in circles."

My point is that modern art, the modernist revolt, is an attempt to overcome the literary interpretation of the plastic arts and the same thing is true in modern music. But this modernist revolt calls our attention to what, to me, is the deepest issue about the fine arts: the problem of imitation and creation in the fine arts.

Lloyd Luckman: I stop you for a moment, Dr. Adler, because I have a question here about imitation. And this particular problem is whether or not you have imitation in good art or not. "I would appreciate some consideration," says this writer—

Mortimer Adler: Mr. Carvel.

Lloyd Luckman: Mr. Carvel, "of the question dealing with the imitative nature of art. I am wondering what role imitation plays in the creation of a work of art."

Mortimer Adler: Mr. Carvel, imitation and creation supplement each other. They belong together. As I see it, imitation in the work of fine art signifies that which the artist draws from the object, the world of nature, whereas creation in a work of fine art signifies that which the artist draws out of his own soul or mind. But these two things fuse. Because in drawing something from the objects of nature, the artist, if he is an artist, must transform it subjectively. And in drawing something out of his own soul or mind, the artist, if he is an artist, must objectify it, put it in the object which is the work of art produced.

Hence artistic imitation is not simply copying, reproducing a mere photographic image. Artistic imitation is creative imitation and artistic creation is also imitative creation. Artistic creation is not pure creation any more than imitation is mere copying. And the reason for this is that only God is a pure or absolute Creator. Man is derivatively a creator, an imitative creator.

That is why the human artist must borrow from nature. There is a magnificent remark by the great French painter, Delacroix, which is that nature is simply a dictionary. Think of that a moment. Nature, for the painter, is simply a dictionary. It is as if for a writer the words are there, but he must compose the poem from the words. So nature provides, in its visible forms and shapes and colors, something like the dictionary, the words of painting but the artist, taking those "words" if you will, an analog of words, the ele-

ments of this plastic speech of painting, composes the picture or composes the statue.

Hence, Mr. Carvel, there is no *conflict*, I would say, between creation and imitation in the fine arts, for fine art is both creative and imitative. But there is a deep *tension* between creation and imitation that produces two opposed tendencies in the fine arts, the tendency toward *representation* on the one hand and the tendency toward *abstraction* on the other.

And this problem, Lloyd, I'd like to start off with next week when we have more time. I would like to begin next week with this deep and difficult problem of the opposed tendencies in the fine arts going toward abstraction on the one hand and representation on the other. And if I can finish that next week, I would also like to go on to the other problem of what is good and bad in the fine arts, both what is morally good and morally bad art and what is esthetically good and esthetically bad art.

27 The Goodness of Art

In this concluding session on the Great Idea of Art we shall deal with some moral and political problems in connection with the fine arts.

But first I want to return to a number of points which we did not fully complete in our discussion last week. We saw that each of the fine arts is like a language. It is a medium of expression, and because of that fact the form and the content of the work produced in that medium are not separable. This results in the untranslatability of what is being said in one fine art into another.

What a painting says cannot be translated into music. What a piece of music says cannot be translated into poetry. The arts cannot be reduced to a common denominator. And yet, there is a tendency on the part of the general public to try to reduce everything the arts say into the common ordinary medium of everyday speech. This has very two serious results.

First, it causes a misunderstanding of the arts, especially a misunderstanding of the nonliterary arts, as when people read the program notes to a symphony instead of listening to the music or when people allow the title of a painting to stir their imagination instead of actually seeing the plastic representation, the plastic form of the painting itself. The second result is the modernist revolt in all the arts: abstract painting, modern music, and a similar revolt in poetry.

Let me read you an example of the modernist revolt in poetry, a poem by e.e. cummings. I'm not going to read you the whole poem but only part of it. The title of the poem is "what if a much of a which of a wind." I'm going to read you the last stanza. "what if a dawn of a doom of a dream bites the universe in two, peels for-

ever out of his grave and sprinkles nowhere with me and you? blows soon to never and never to twice (blow life to isn't: blow death to was)—all nothing's only our hugest home; the must who die, the more we live." That is an example of modern poetry in which music, the sound of the words rather than the sense, is being emphasized because the poet is protesting against the attempt to reduce everything to the ordinary common-day meanings of everyday speech.

The modernist revolt in all the arts performs a very important pedagogical function. It should teach us to see the works of art, each work of art, each kind of art, in its own terms. In painting, for example, it should teach us to see that every good painting is both representative and abstract, neither one nor the other. Great paintings are neither purely representative, purely imitative, nor purely abstract. They are not simply like newsreel or newspaper photographs of a scene, mere reporting. And neither are they mere designs of form and color with no reference to objects.

Last week Mr. Carvel asked about the role that imitation plays in the creation of a work of fine art. And I said that I thought that imitation and creation supplement each other. I said, in fact, that they fuse; that artistic making is both creative imitation and imitative creation. And the reason for this is that what the artist draws from the object must be subjectively transformed by him. And what he takes from his own soul or mind must be objectified by him.

This is why I would answer another question we have received, one we received from Mr. Thornton of San Bruno, in a similar fashion. Mr. Thornton holds, for example, the view which many of you may share, that works of fine art divide into the imitative and into the abstract. "Imitative art," he says, "represents nature." "Abstract art comes entirely or mostly from the artist's mind. All or most of the fine arts," he goes on to say, "contain examples of both."

Lloyd Luckman: Well, then what is—

Mortimer Adler: Just a moment, Lloyd, I hold an opposite view to this. For me, as I look at most works of fine art, certainly all the good ones, are both representative and abstract. They involve both imitation and creation.

Lloyd Luckman: Well, I can't quite understand this controversy then, Dr. Adler, because if I understand you, you seem to be saying

truly that there is no conflict between abstract and representative art. But I'm quite certain on the other hand that there is quite a controversy raging in the minds of the public, and for that matter, among the artists themselves.

Mortimer Adler: Well, Lloyd, I think you are right on that point. I think I didn't say precisely what I meant. I shouldn't have said that there is no conflict. I should have said that there *need* be no conflict between representation and abstraction, that there *should* be no conflict. In fact, you are quite right, a conflict does exist.

And I think the reason why a conflict does exist is because, in great paintings and in any piece of music or poem that you read, you will see that there is a tension in every work of art between two basic polarities. And this tension often creates, I think, a tendency on the part of the artist to allow himself to go to one extreme as opposed to the other.

We have talked so far about the opposition between imitation and creation. And on the side of imitation we have talked about representation in a work of art as opposed to abstraction. But this emphasis on representation or the imitative aspect of a work of art is also an emphasis on its content, on its objectivity, its reference to an object and on its realism, its concern with the way reality is. On the other hand, the emphasis on the creative side or on abstraction leads to an emphasis on the subjectivity of the artist rather than the object, what is in him rather than what is in nature and primarily an emphasis on the form of his work, the form of the music or the form of the painting instead of the content.

Now as this tendency is emphasized particularly in the plastic arts, the public tends to give the plastic arts, painting or sculpture, a literary interpretation. And that is why, I think, the artist tends in the opposite direction toward abstraction. And the poet on the other hand, in order to get rid of this tendency, tends to go in the direction of form and subjectivity as opposed to objectivity and representation.

Now the question might be whether or not these tendencies can be carried to extremes, extremes that cause errors and perversions in the fine arts. In fact, we have a question here from Mr. E.V. Sayers of Palo Alto in which Mr. Sayers asks, "Is a work of art, however representative it may be, always in some degree an abstraction?" And then he goes on to ask, "Is there a limit beyond which art cannot go in this direction, in the direction of abstrac-

tion and still remain valid as art?"

I think, Mr. Sayers, there is a limit. When one goes to the extreme of abstraction, an extreme which removes all representation, all reference to objects, that totally eliminates the imitative aspect from the work of art, then the work cannot possibly have any intelligibility left. It becomes too subjective, it becomes almost incommunicable. Nothing is communicated because the person has nothing to refer to. And the work of art, then, in a sense, reduced to sheer form without any content becomes a perverted piece of work of mere formalism.

Now if you go to the opposite extreme, the extreme of representation without any abstraction, without any subjectivity, the work will then have no universal significance. It becomes mere journalism, mere reporting of a single historical fact or something present and seen. It becomes copying. And then the work says nothing either. It becomes sheer materialism as the other sheer formalism in which the mind of the artist is absent.

Now I think the great German poet Goethe has resolved this opposition of tendencies towards the representative, towards the abstract, towards the imitative, towards the creative in art, in a magnificent statement. Goethe says, "The artist stands in a double relation to nature. He is at once its master and its slave. He is its master in so far as he is creative and transforms it. He is its slave in so far as he is imitative and has to borrow from nature."

And the two bad extremes in art, in all the arts, come from slavishness on the one hand, where the artist is a slavish copyist, a slavish imitator of nature, or from the opposite extreme which the abstract tendency leads to, where the artist has contempt for nature.

BAD ART IS STILL ART

Lloyd Luckman: Well, Dr. Adler, right there—
Mortimer Adler: Yes, Lloyd?
Lloyd Luckman: You've been using this phrase "good art" and "bad art" quite a number of times. And we've received some questions here, one that I would like to bring up right now on good and bad art. This one is from Mr. John Hayes of San Francisco. And he suggests that in all fields of art, useful as well as fine, we ought to reserve the term "art" only for the good works and not to

apply it to these poor or mediocre works. Now, have you any comment on Mr. Hayes's proposition?

Mortimer Adler: Yes, Lloyd. Mr. Hayes, I do have a comment. I have, in fact, three comments on your proposition.

First, I don't agree with what you say though I think I understand why you say it. The term "art" is sometimes used as a term of praise and sometimes as a descriptive term. It is used as a term of praise when someone does a piece of work and we say, "Oh, that's really art," meaning it is a good piece of work. Well, we use the word "art" to say it is a good piece of work. But I think the word "art" should be used as a descriptive term and should be applied to good art and bad art, the best and the worst works of art.

And when it is so applied, when we apply the word "art" descriptively to good and bad, we face, of course, the problem that is left, the question, What is the distinction between good art and bad art? In fact, that is two problems, not one. There is an esthetic problem there, the problem of the good and the bad in works of art in terms of beauty and ugliness. And this leads to all the questions of appreciation, standards of criticism, and so forth. And then there is the moral or political question of good and bad in a work of art conceived as the work being beneficial or injurious. And this leads to questions of moral censorship and political regulations of works of art.

I'm going to take the second question first. The first question is about beauty, and that is dealt with in our program on the Great Idea of Beauty. But let me turn at once to the question of good and bad in works of art in terms of whether the work of art is beneficial or injurious, the morally or politically good and bad aspect of the fine arts—I'm talking only about the fine arts.

What is its problem? Here again, we have another basic tension, this time between two things, the artist on the one hand and the moralist or the statesman on the other. And this tension is sometimes expressed in terms of "art for art's sake," as the artist would have it, or "art for man's sake," as the moralist and the statesman would have it.

THE MORALIST VERSUS THE ARTIST

Let me see if I can state this issue by first stating what the moralist's side of it is and then what the artist's side of it is. From the

moralist's point of view the fine arts—painting, music, drama, poetry—these affect human beings. They have an effect on human emotions, on human attitudes, on human conduct. Hence, why shouldn't the moralist criticize a work of art in terms of its moral significance or its political effect? In the tradition of Western civilization, this has been done again and again. It started with Plato. Plato, you will recall, in *The Republic*, in his ideal state, threw the poets out because he thought they had a bad effect. And he wanted to regulate, as he did in *The Republic* and in *The Laws*, the music that children in the public would hear, because he thought that certain kinds of music would excite them in the wrong way. Throughout the whole of Western civilization the theater has been under censorship, music has been under censorship, and as you know, novels and other pieces of writing have been censored on moral grounds.

And in our own day, in our own day we see another example of this in Nazi Germany and in Communist Russia where the arts have been under political regulation to make them conform to the regnant ideologies in those countries. In our own country there has been a great stir, as you know, about motion pictures, about comic books, about jazz, particularly in connection with children. Well, these are arts, kinds of popular art, which are again subject to moral and political scrutiny in terms of their effects upon human beings.

The opposite point of view is that of the artist. The artist says, "I should be concerned only with the rules of my art. My only obligation is to produce well, according to the rules of my art, the thing I am trying to make. I have as much right to my freedom of expression as any other indivikdual has. It is the fact that my freedom of expression is part of a general common right of free speech. Moreover," he says to the moralist and the statesman, "you, being concerned with these matters, do not understand the technique of my art. You are ignorant with respect to it and incompetent to tell me how to produce a good work." In fact, he might go on to say, "The freedom of the artist in creating works of fine art is exactly the same as the freedom of the scientist in his pursuit of knowledge and truth."

The scientist is concerned exclusively with the pursuit of truth; the fine artist is concerned exclusively with the production of beautiful things, things of beauty. As opposed to both the scientist

and the artist, the prudent man, the moralist or statesman, is concerned with goodness, the moralist with conditions of the good life, the statesman with the conditions of a good society.

The suggestion is that the prudent man has no business telling the artist and the scientist how to produce beauty and pursue the truth, any more than they can tell him what are the conditions of a good life and a good society. Each should have an autonomy is his own field.

Lloyd Luckman: Now, I wonder really, Dr. Adler, if art and morality can be separated quite that sharply. After all, we have to admit that works of art do affect human beings, whether they affect them for good or for evil, right?

Mortimer Adler: Yes, indeed.

Lloyd Luckman: Well, then does the solution lie perhaps in distinguishing not the way you have but between the work of art and the man who made it? Now this distinction comes to me as a suggestion from one of our correspondents, a Mrs. Marilyn Follsis of Oakland, because she suggests it this way, that when we question the morality of a work of fine art we are questioning the artist as a person rather than the work of art itself. And I wonder if this distinction helps any.

Mortimer Adler: I remember Mrs. Follsis's letter. She draws her question as I recall, Lloyd, from Maritain's excellent book, *Art and Scholasticism.* Am I right about that?

Lloyd Luckman: Yes.

Mortimer Adler: Perhaps it might help then if I were to read a passage from Maritain's book, which has a bearing on the conflict between the artist and the moralist, between the artist and the man of prudence.

Let me do that right now because I think it has a direct bearing on this problem. Maritain was deeply concerned in this book with this question and he says that the work of art is the object of a singular conflict of virtues: the virtue of prudence on the one hand which is concerned with morality and the good life, the virtue of art on the other hand which is concerned with producing things of beauty. "What makes the conflict so bitter," he says, "is the fact that art is not subordinate to prudence as knowledge, for instance, is subordinate to wisdom." "Nothing concerns art," he goes on, "but its objects. It has no concern whatever with the good

life or the condition of the subject for the art and prudence each claim dominion over every product from man's hands. In finding fault with a work of art the prudent man, firmly established upon his moral virtue, has the certitude that he is defending against the artist a sacred good, the good of man. And he looks down upon the artist as upon a child or a madman. But perched on his intellectual habit the artist is certain of defending a good which is no less sacred, the good of beauty."

But Maritain seems to feel that this conflict is not easily resolvable, in fact, not resolvable except in what might be called the ideal case. I would like to add here, Mrs. Follsis, that in my youth, I was so fascinated with this problem that I wrote a whole book on this subject. This book, *Art and Prudence,* was mainly set off by my concern with the regulation of the motion picture, that great popular democratic art. I was concerned with the issue of artistic excellence in the motion picture as opposed to the moral and political problems of regulation. And in this book I finally came to the only solution I could come to on the subject, which in a sense is one I learned from Maritain. The solution, I think, can be expressed somewhat this way. Ideally—I am saying ideally—one and the same man should be both an artist and a moral or prudent man. If that could happen, then since the work of art expresses the whole man, the man as an artist as well as the artist as a man, it will have both moral and political excellence. But this is an ideal solution; it seldom is achieved in fact and so the problem remains just as difficult as you have so far seen it debated.

There is one other way of stating the resolution of this problem. And I did that in my book on *Art and Prudence.* It comes from the English typographer and art critic Eric Gill, in a book that I recommend to all of you, an excellent book called *Beauty Looks after Herself.* Eric Gill says, and this is his basic maxim, "Look after goodness and truth, and beauty will take care of itself," that is, if the artist is concerned with what is good and what is true, the work will be beautiful. Now I say that that proposition, that that basic maxim can be converted into this equally true one: let the artist look after beauty, if he looks after beauty well enough, then truth and goodness will also take care of themselves. That is as much as I can say in the resolution of that very difficult problem.

Fine Art As Spectacle

I'd like to deal in the closing minutes of today with one final question. And that final question I could almost say in these words, "What good is beauty? What human role, what human significance do works of fine art, which are things of beauty, have in our lives?" Now my answer to that question, "What contribution do the beautiful things produced by the fine artist play in our human life?" is in terms of a distinction between *action* and *contemplation*. Let me say that another way: we are at any moment in our lives either actors or we are spectators. I'm using the word *action* and *spectatorship* as the opposed words that perhaps are a little more clear than the more difficult word *contemplation*. And what works of art do for us, what works of fine art which are things of beauty do for us is they make us spectators. They give us that pleasure of spectatorship, giving us relief from the urgencies and exigencies of actions, giving us rest from action. This is their great human contribution, that they give us freedom from the day-to-day pressures and needs and utilities of our active life. They make spectators out of us.

But when one looks at the fine arts this way, as making us spectators, one has to say of them that they are all of a certain sort. They are all spectacles. And I would use another word; being spectacles, holding our attention as spectators, they are all entertainment. From the point of view of the sociologist, not from the point of view of the person who is concerned with one fine art, but from the point of view of the sociologist it is perfectly proper to say that all the fine arts have something in common with entertainment and spectacles in general. That what a parade does, what a prize fight does, what a ballgame does as a low form of entertainment is exactly the same ultimately as what a great work of fine art does. To say this is not to degrade the fine arts but merely to say that the fine arts play a role in human life at the high level that simple entertainments and spectacles play for mankind at the lowest level of human appreciation and enjoyment, the level, the function of making spectators and giving us a rest from action.

Actually, in a democracy we are concerned with a hierarchy of the arts, or let us put it this way: with a hierarchy of entertainments. We have all grades of people, all grades of sensibility. And it is perfectly proper to say that simple and low forms of enter-

tainment—I mean low in the sense of uncomplicated and easy to appreciate—belong to and are needed by a large public just as much as, for those with very refined and cultivated sensibilities, the highest and most subtle works of art are needed. In this hierarchy of entertainments, if you will, there is a proportion between their difficulty and their function and the scale of human sensibilities on the side of the audience.

Now this completes our discussion of art but that doesn't mean that the discussion is complete. We have by no means covered all the things we should deal with. And if I were to stress any one thing from these four discussions of art, it would be this point, that the fine artist has something to say, which he must try to understand in his own terms, in the language of his medium and not try to translate into our common human speech. Only in that way will we actually see paintings as paintings and hear music as music and read poetry as poetry.

28 How to Think about Justice

When anyone uses a word like *justice* or a word like *truth* it produces a reaction with which I am familiar from long years of teaching and long years of talking to people about such things. They often say—both students in the classroom and the adults that I have talked with about fundamental ideas—"It's impossible to say what justice is or what truth is." These words, they say, are almost empty—big words, but words without clear and definite meaning.

I think there are two reasons for this widely prevalent attitude that one can't say or can't tell the meaning of such terms as "justice" or "truth." One of the reasons is that people confuse two different questions. The question, What is justice? and the question, What is just in this case? I tend to think that it's much easier to say what justice is than it is to say what in any particular case is a just handling of that case, just as it is much easier to say what truth is than to say what is true in a particular argument. But that isn't the only reason why people shy off such "big" and "difficult" words as "truth" and "justice."

The other reason is that they have a feeling that there are so many conflicting senses of the word. They have a general impression that in the history of European thought eminent philosophers have given quite different meanings and that in ordinary speech people use the word "justice" with quite different meaning. They are right about that. They are quite right. Now you may have this impression, and you're quite right in thinking that the word "justice" has been defined in various ways by the philosophers, that even in ordinary discussion people use the word "justice" in a number of senses.

264

Let me give you quickly an indication of two or three of the different fundamental senses in which the word "justice" is used. These different senses that I'm going to enumerate for you are, I think, the senses in which you and I every day of our lives use the word "justice" or the adjectives "just" and "unjust." Whether we like it or not, whether we think we know the meaning of this word or not, we tend to use the word—you will say "that's unjust" or "that's just." And I would like us to remind you of the sense in which you and I, whenever we say "that's just" or "that's unjust," mean the word.

THREE SENSES OF "JUSTICE"

The first of these senses is carried by the notion of equality. Justice consists in treating equals equally and unequals unequally. Now let me give you a few examples of what I mean. Suppose two persons commit the same crime, let the crime be petty larceny. Is it just or unjust if one man is sentenced to three months' imprisonment and the other to nine months' imprisonment? Supposing the crime and all the circumstances to be the same, I think our general sense is that the individuals having committed a crime of equal gravity, they should be punished with equal severity. But take the opposite case, one person has committed petty larceny and another person has committed grand larceny, involving in addition to that assault and battery. Would it be just to give these two individuals, who have committed crimes of unequal gravity, the same punishment? Or shouldn't we punish more severely the one who has committed the graver offense? Now it is in this simple sense of equal treatment of equals and unequal treatment of unequals that I think we all use, almost every day of our lives, the words "just" and "unjust."

Or let's take another example. In a democracy all adults, with few exceptions, are granted the political rights and privileges of suffrage. Everyone can vote. We tend to think that this is just, and that the opposite would be unjust, that a society in which only a few persons were admitted to citizenship and other men and women were excluded on the grounds of race or sex or religion or lack of wealth would be unjust. Why do we think that? Because we think that all adult human beings are equal and in their equality

deserve equal status under the constitution of the law. That equal status is the status of citizenship. Hence we think that the equal treatment of persons involves giving them all the equal status of citizenship.

Or take one other example of the meaning of justice as equality in which we talk about a fair exchange as opposed to an unfair exchange. If I give you something of greater value than you in turn give me, this unequal exchange is unfair and we call it unjust.

Let me mention the second meaning of justice. Justice, it is said, consists in rendering to each individual what he is due, giving to each person what belongs to him. Thus an individual who pays his debts is a just person because he owes the other individual something and he is giving another individual what belongs to him, whereas a person who steals is unjust, for he is taking from someone else what belongs to him.

And so we speak of a just government as one which respects and secures the natural rights of individuals. Why? Because what we mean by natural rights are the things that belong to a person and are proper to him. And a government which does not give to a person what is his due is unjust, whereas those governments which respect and secure the natural rights of human beings are therefore just.

There is a third meaning of justice. And that one again we are all familiar with. We say that a person is just if he obeys the law of the community in which he lives. The just person is the law-abiding citizen; the criminal, the individual who breaks the law, is unjust.

THE THREE SENSES CAN BE RECONCILED

What I would like to do in the course of the next few minutes is to show you how these three senses all fit together, that they are not inconsistent or conflicting. I would like to show you how they fit together and in the course of doing that I would like to face with you one of the most difficult, perplexing problems that is raised by this fundamental idea of justice.

Aristotle, in his *Ethics*, has an analysis of justice which shows us how to put these three different senses of the just and the unjust together. He first of all makes the distinction between what he calls

general justice and special justice. He takes justice and divides it into general and special. What he means by special justice is that special virtue through which men are fair with one another in the exchange of goods or in the distribution of goods. It is the justice we have in mind when we speak of a fair wage or a fair bargain or a fair price or a fair exchange. It is that special virtue of justice which is concerned, in the economic order particularly, with the exchanges that occur between persons of goods and services, or the distribution of ranks and burdens and privileges.

Now what Aristotle means by general justice is something quite different. He looks at a man as acting in relation to other people, acting for the common good, acting in such a way that he does right, wrongs no one, does good to other people. "And such a man," he says, "is generally just, a man who is virtuous, quite virtuous, in his conduct toward his fellow men and in the service of the common good or the general welfare."

What is the basis of this notion of general justice? It is a fundamental justice of what is right and wrong in conduct and ultimately is based upon what is due other people, what rights they have that we must respect; not respecting them, we would be wronging them. So that you have here in these two senses the meaning of justice as fairness in exchange and justice as giving to another man what is his due when we act well toward the other man or toward the society in which we live.

Now what about the third sense of justice, the sense in which we say that justice consists in obeying the law? Aristotle treats this as a part of general justice. For he tends to say that general justice is to special justice as the lawful is to the fair. General justice is to special justice as the lawful is to the fair. That is, in so far as men obey the laws of the land in which they live, they are generally just. Only some of the laws of the land in which we live are concerned with such things as fairness in exchange: fair price, fair wages, and so forth. Thus you see that the special justice dealing only with fairness in exchange is a part of general justice which is concerned with obeying the laws, being lawful in general in the community.

But as soon as that's said, another problem arises. It is the problem of the justice of the laws itself. Because a man would not be just obeying the law if the laws he obeyed were not just. Suppose you were to live, for example, in a tyrannical state or in a totalitarian or fascist society, in which many of the laws were unjust. Would

obedience to the laws of such countries constitute a just person and just action? I think your answer and my answer would be no. Justice consists in obeying the laws only if the laws themselves are just.

And once one says this, one faces the most difficult problem of all. Notice, we speak of a just person as a person who obeys the laws. But we say that a person who obeys the law is just only if the law itself is just. Does the word "just" mean the same thing when we say that the man is just and when we say that the law is just? Hardly, for the meaning of the word "just" as applied to a person is determined by that person's obeying the law and therefore can't be the same meaning that we have when we apply it to law—saying that that law is just which the person obeys.

NATURAL AND CONVENTIONAL JUSTICE

Aristotle, faced with this difficult problem of the sense in which we speak of the law as just, quite differently from the sense in which we speak of the individual as just when that individual obeys the law, at least offers us a beginning of the solution to the problem. He distinguishes between natural and conventional justice. For example, in all the communities in which you and I live there are traffic laws. We are asked to stop at certain corners, drive at certain speeds, drive on the right or the left hand side of the road. There is nothing just or unjust about any one of these things until the law is made. But once in the community in which we live, it is conventionally decided, simply decided by the legislator or by some commission, traffic commission, that these are the rules of driving in the community, then the just person is one who obeys these laws simply because they are the statutes or ordinances of the community in which he lives. For there is nothing right or wrong about left hand driving as opposed to right hand driving.

Yet even if there were no law made concerning stealing or murder, to kill a man or to take what belonged to him and not to you, would according to Aristotle be naturally unjust. And so a law that prohibits murder or prohibits stealing is a law the justice of which is not conventional but natural. Justice is based upon the natural rightness or the natural wrongness of such things as stealing and murder.

Hence the measure of justice in the laws must be found, according to Aristotle, in a principle of natural justice. For only in this way can we talk about the laws being just and unjust in a sense that is different from the way in which we speak of a person as being just or unjust when that person obeys the law.

Suppose for a moment that there were no natural justice. In that case you could not speak of laws as just or unjust. And all you could say would be that men are just or unjust according as they do or do not obey laws. But there would be no way of saying anything about a just law or an unjust law since there would be no measure of justice in the law if there were no justice behind the law or prior to the law. The law itself, the existing law of the community, would be the only measure of justice, in which case what was just in one community might be unjust in another. But if there is a criterion or a principle of natural justice, then that principle is the same universally, at all times and places, and it measures the justice of laws in any community. In which case there is something behind the law, prior to the law, that determines whether or not men are acting justly when they are acting lawfully.

IS THERE NATURAL JUSTICE?

This problem, the problem of the justice of laws and government, which ultimately underlies the question of whether men are just or unjust when they obey laws, is the most serious problem, certainly the most serious political problem that men have ever faced in the history of Western thought, at least, in connection with the idea of justice. And I would like to expand on this problem a little further and tell you the two opposite positions in some detail. Let's turn to that at once.

Is there a justice which measures the laws of the state? That is the question we are now going to face on which there are two conflicting points of view. Does justice entirely consist in doing what is required of us by the laws of the state? Or is there a natural justice which requires us to do what is right even when not commanded by the laws of the state, and which is the measure of justice of the state itself in its laws and government?

Now to that question there is the answer of those like Aristotle and other philosophers—Greek, Roman, medieval, and mod-

ern—who have held that there is a principle of natural justice which is the foundation of justice in laws and government. Those who hold this view argue somewhat as follows: human reason tells us what is right and wrong; simply by the exercise of our natural faculty of reflection we know that such things as stealing and murder are wrong, and that those who commit these acts, stealing and murder, are committing unjust acts, and that laws are just laws when they prohibit such wrong acts.

And they argue further that the dignity of man involves the possession by each man of certain unalienable natural rights, like the rights mentioned in the Bill of Rights in our constitution, the fundamental rights mentioned in the Declaration of Independence, the right of every man to the pursuit of happiness, to liberty, and to such rights as liberty of speech and freedom of thought. And since these rights belong to man by his very nature, are part of his dignity, those who hold this view say that governments are just and laws are just when they respect and secure these rights, and that governments are bad governments in the sense of being unjust governments when they violate these rights. This again is the language of the Declaration of Independence, that just governments secure these fundamental, natural, and unalienable rights. Hence on this view, the laws of any given state are just when they command us to do what is right and prohibit us from doing what is wrong. And governments and constitutions are just when they secure and respect the natural rights which are vested in men because they are men and have the dignity of men.

The opposite answer to the question denies that there is any such thing as natural justice. And it holds that governments and laws determine what is just or unjust in any society and that as the laws or governments of different societies differ, so what is just or unjust differs from one society to another. According to the laws of the Medes and the Persians, one thing is just. According to the laws of the Greeks, another thing is just.

Now this position, this other view, this opposite view of justice which denies that there is any justice anterior or antecedent to law in government, and that all justice is determined by what the government is or the laws are, is held in modern times by such great political philosophers as Thomas Hobbes and Benedict Spinoza.

MIGHT MAKES RIGHT

Let me, just to give you the flavor of this position, read you the language of Hobbes and Spinoza on this very point. Hobbes takes the view that to human beings living in a purely natural condition, not in a society under government, but as it were to a state of nature, that to men living in a purely natural condition, there are no distinctions of justice and injustice. It is like saying, In that condition anything is fair, as in war. The notions of just and unjust, according to Hobbes, apply only to persons living in society. Hobbes says, "Where there is no commonwealth," that is, no civil society with government, "there is nothing unjust." So the nature of justice, according to Hobbes, consists in the keeping, in the obeying, of the laws set up by the sovereign state in which one lives. The breach of civil laws, the breach of the laws of the land, may be called injustice and the observance of them may be called justice, according to Hobbes, but nothing else.

This is Spinoza's opinion, too. According to Spinoza, everything has by nature as much right as it has power to exist and operate. "And therefore," he says, "that in a natural state," that is, in the state of nature, not in society, "there is nothing which can be called just or unjust." Things can be called just or unjust only in a civil state where men live in society under government as we live in the United States. As before with Hobbes, so it is with Spinoza: justice consists only in obeying the laws of the land in which you live, and injustice in disobeying them. Whatever the laws are, the state has the power to enforce them. But these laws themselves enforced by the state cannot be called just or unjust, for there is no principle or measure which determines anything like justice and injustice as applied to the laws themselves. Whatever a government makes law is a law. And that determines what is just in that society and there is no way of saying that the laws themselves are just are unjust.

Now you can see at once that this second position is a familiar position, the one that you know as "Might makes right." All the rights that people have are granted them legally by the state, and therefore the state can take them away from them. There are no natural and unalienable rights. All rights are legally granted rights and therefore they can be taken away by the change of laws. On this view justice is the same as expediency; the man who is just in

obeying the laws is merely being expedient, for if he doesn't obey the laws and gets caught, he will suffer punishment. In other words, he obeys the laws not because the laws are right intrinsically, but from fear of punishment which is the expedient thing to do. And in this view of the matter there can't be any such thing as international justice, justice between states. For there is only justice within each state where men are living, under the laws of a particular country. As between states, there is no justice. International law is no standard of justice in the conduct and international affairs as between one sovereign state and another.

This standpoint, which is the other great standpoint on this fundamental question of justice in relation to laws, comes down to us from antiquity. Just as the view that there is natural justice comes down to us from Aristotle, so this view that there is no natural justice comes down to us from antiquity. And I would like to have you hear the ancient expression of it because it is so marked.

Let me read you just one statement of this which comes to us from Plato's *Republic*. In the opening book of the *Republic* where the great Sophist, Thrasymachus, says this about justice: "I proclaim"—this is Thrasymachus speaking—"I proclaim that justice is nothing else than the interest of the stronger. The different forms of government make law democratical, aristocratical, tyrannical, with a view each to their several interests. And these laws which are made by them for their own interests are the justice which they deliver to their subjects. And he who transgresses these laws, they punish as a breaker of the law and unjust." Notice that the laws are not just. The laws say what is just and the man who breaks the law is called unjust. "And this is what I mean," says Thrasymachus, "this is what I mean when I say that in all states there is the same principle of justice which is the interest of the government. And as the government must be supposed to have power, the only reasonable conclusion is that everywhere there is one principle of justice, which is the interest of the stronger." And this in a word is saying that might makes right and that right consists in conforming to the existing power, that where the power is, there is the right, and we must obey or conform to the law of force.

Now you can see at once, can't you, that according as one takes one or the other of these two conflicting views about justice and law, one will take quite different views about the conflict in the world today between the democracies on the one hand and the

totalitarian powers on the other? For if one takes the view of natural justice, one can say that one of these two conflicting parties is in the right and the other wrong. And then as between states there is a measure of rightness and wrongness. But if one takes the second view that only might makes right, then the struggle of the East and the West, if you will, of the democracies and communism, or the democracies and the totalitarian countries, is merely a struggle of power. The only final arbitration of this is by might. The only measure of who is right will be by who wins in the struggle.

The issue we have just been considering is by no means the only problem concerned with the Great Idea of Justice. But it is, in my judgment, the most important problem about justice in the whole field of political philosophy. For there we are concerned primarily with the justice of laws and of government and of the justice of men in relation to society. There are other problems about justice which we don't have time for, as for example, the basic moral problem posed by the question, Which is better, to do injustice to others or to suffer injustice done to oneself by them?

29 How to Think about Punishment

Today we shall consider "The Great Idea of Punishment." And in the time we have together I would like to devote all our attention to what I consider the central problem in connection with this Great Idea, the problem of the *purpose* of punishment.

This is a perennial problem. It exists at every age and I think it exists for every human being, whether he considers it in relation to the punishment of criminals in a society to which he belongs, or the punishment of his own children, or punishment in the school as well as in the home, or punishment that sometimes he has inflicted upon himself.

Now there is no problem about what punishment is. On this almost everyone agrees. Punishment consists in the infliction of pain with a purpose, not purposeless or meaningless infliction of pain, but the infliction of pain for a definite purpose. There are, of course, different kinds of pain. And so there is some distinction in the kinds of punishment. The main distinction is between what the writers call the pain of sense as opposed to the pain of loss. What you might say is physical pain, the pain we feel when we are whipped or made to suffer the agonies of the flesh, that kind of pain as opposed to what you might call moral pain when we are deprived of something, as when we are deprived of our liberty when we are imprisoned and cannot do exactly as we wish, even though we may, perhaps, be very comfortably situated. There may be no physical pain, merely the deprivation of freedom.

Now the distinction that we have come to make between cruel and unusual punishment on the one hand and more humane punishment on the other turns on this distinction between the

pain of sense and the pain of loss. Imprisonment is a much more humane punishment than being lashed or being whipped or being hung by one's thumbs, or otherwise physically maltreated.

But the central problem is not a problem about the kinds of punishment or what punishment is more humane, what is more cruel; the central problem is the problem of the purpose of punishment. Why do we punish? What do we seek to achieve by punishing? What is our reason when we punish, whether that be in the State, in the execution of the criminal law, or in the management of a family, or in the running of a school or any other corporate enterprise?

I have the feeling that each of you has faced this problem. I doubt if any human being can live very long without either suffering punishment or inflicting it or asking himself its purpose or its reason. Any of us who have discussed the whole problem of capital punishment or the problem of such devices as probation and parole and the indeterminate sentence realizes that these problems raise the question of the justification of purpose, the objective of punishment.

RETRIBUTION OR PREVENTION?

Let me see if I can state the issue for you, the issue we want to discuss. Because here there are two extremes. At the one extreme there is the position of those who say that punishment is a matter of strict justice. It is a matter entirely of retribution, of retaliation, of punishing the criminal precisely because the criminal or the wrongdoer did wrong. At the other extreme is the position which I would say is entirely a position of expediency, where the punishment is justified entirely in terms of the good result it produces, a result like preventing more crimes, preventing the repetition of the wrongful act.

The two basic words here that more or less summarize these two opposed positions are the words *retribution* and *prevention*. One position says that punishment is entirely retributive. Its whole aim is to achieve retribution for the guilty person. The other position says that the aim of punishment is prevention, either by reforming the criminal or deterring other persons from committing crimes or similar offenses.

Now what I am going to do is try to state these two positions, first the retributive position, and then the preventive position. Having stated the two positions, I would then like to indicate what difficulties there are in each of these two extreme positions; and finally ask you whether or not the two positions can be in any way combined or reconciled. And in the course of doing that, I would like to see if you can make up your own mind as to which position you take or whether you try to combine them both somehow.

Let me begin by stating the retributive position, the position that the only purpose of punishment is to retaliate against the wrongdoer for his wrongdoing. This position holds that punishment simply rights a wrong, that justice requires that the wrongdoer be wronged in time, be punished in proportion to the gravity of the wrongdoer's offense. The sense of this position is that by punishing in proportion to the seriousness of the offense, the balance of justice is restored.

You all know, I'm sure, how old this view of punishment is. It goes back to the Old Testament where we find in the Mosaic Law, the famous lex talionis. I'm sure you all know the familiar statement of that rule, ". . . thou shalt give life for life, eye for eye, tooth for tooth, hand for hand, foot for foot, burning for burning, wound for wound, stripe for stripe." Now you will remember that in the gospels, Jesus Christ said, "You have heard that it hath been said, An eye for an eye, and a tooth for a tooth: But I say unto you, That you resist not evil: but whosoever shall smite thee on thy right cheek, turn to him the other also." This doesn't mean that punishment is completely removed. For in the New Testament, Saint Paul enjoins us as follows: ". . . avenge not yourselves," he says, ". . . for it is written, Vengeance is mine; . . .saith the Lord." And the ruler of the State, the government of society here is, according to Saint Paul, God's minister, the minister of God who carries the sword to execute justice upon those who do evil.

This view of retributive punishment is not exclusively to be found in the Old or the New Testament. One finds it also in the writings of the ancient Greeks in that great play or series of tragedies by Aeschylus, that dealt with the killing and the vengeance of one man in return for the killing of another, we find these extraordinary lines: Aeschylus says, "Justice claims allowed her debt, who in blood hath dipped the steel, deep in blood her meat shall feel." Whosoever shall take the sword shall perish by the sword.

Now this view is that it is immoral to punish for any ulterior purpose, that it is intrinsically immoral to punish in order to reform the criminal or to deter others from committing crimes or wrongs, that nothing except retaliatory justice justifies punishment.

Let me read you the two classic statements of this theory of punishment. They are to be found in the writings of the two great German philosophers Immanuel Kant and Georg Friedrich Hegel. The first passage is from Kant. Kant says, "Juridical punishment can never be administered merely as a means for promoting another good, either with regard to the criminal himself or to civil society but must in all cases be imposed only because the individual on whom it is inflicted has committed a crime. The penal law," says Kant, "is a categorical imperative." He means a strict rule of duty. You must do it because it is right to do. And woe to him who creeps through the serpent windings of utilitarianism to discover some advantage that may discharge him from the justice of punishment or even from the due measure of it.

And if we turn to the writings of Hegel, we find a similar statement of this basic point of view. "Crime is an evil," says Hegel, "but punishment is not an evil. Punishment is good because it rights a wrong. To regard punishment as an evil," Hegel says, "is the fundamental presupposition of those who regard it as preventive, as a deterrent, or as a reformative. What on these theories is supposed to result from punishment is characterized quite superficially," says Hegel, "as a good. But the precise point at issue is the wrong that was done and the righting of that wrong. If you adopt a superficial attitude toward punishment, you brush aside the objective treatment of the righting of a wrong." And he goes on to say that "when you are concerned with reforming the wrongdoer, making him better, or deterring others, you are treating the wrongdoer not as a man who deserves to be punished because he has done wrong, but as an animal you are trying to train. It is all right to punish animals for this reason, but men deserve to be punished strictly as a matter of justice."

I think these two statements I just read you, one from Kant and one from Hegel, indicate the extreme position that there is no ground, no reason for punishment except for retaliation or retribution. A wrong has been done and it must be righted by punishment. And no other end must be considered.

At the opposite extreme is a theory which says that the whole purpose of punishment is prevention, either by the reformation, the correction, the improvement of the wrongdoer, or by the deterrent of potential wrongdoers from committing wrong. Here this emphasis on reformation or deterrence as the sole purposes or justifications of punishment leads the person to go so far as to say that no one is to be punished simply because he did wrong. Wrongdoing itself is not the reason for punishment.

Now this is a hard thing to understand. But perhaps one can understand this extreme position by this comparison. If a man damages the property of another man and the person whose property is damaged goes to law, he gets compensation, he wins the case, he gets some kind of compensation or restitution. In the Old Testament it says that if you stole a man's pig, you had to return a pig to him. If you tore down his fence, you had to rebuild his fence. If a man breaches a contract and you suffer a certain amount of injury in business, the man who is guilty of the breach of contract must according to the law in some way compensate you for the financial injury you have suffered.

Now the point is that though this kind of balance, this kind of rectification happens in civil cases, you have this kind of compensatory or rectificatory justice, the utilitarian view of punishment says that punishment doesn't work this way. If someone is killed, you do not compensate the family of the person who was killed by killing the murderer. Nor if a person injures the State, is the State compensated by the punishment of the wrongdoer. So those who hold this theory say that justice does not require the punishment of the wrongdoer.

Oliver Wendell Holmes, who took this extreme view, said that retribution wasn't an expression of justice at all; it was mere vengeance, it was retaliation of a vengeful sort. Let me read you the passage in which he expresses himself on this subject. This is from his famous book on *The Common Law*. Holmes says, "I think it will be seen on self-inspection that this feeling of fitness, the fitness of punishment as something that is deserved by wrongdoing, is absolute and unconditional only in the case of our neighbors. It does not seem to me that anyone who has satisfied himself that an act of his was wrong and that he would never do it again would feel the least need or propriety as between himself and any earthly punishing power alone of his being made to suffer for what he had

done. Although when third persons were introduced he might as a philosopher admit the necessity of hurting himself to frighten others. But when our neighbors do wrong, we sometimes feel the fitness of making them smart-worth, whether they have repented or not. The feeling of fitness," says Holmes, "seems to me only vengeance in disguise."

According to this view that punishment should try to reform the criminal, change his character, or deter others from committing wrongs, punishment should be made to fit the criminal, not the crime. There should be no effort to proportion the severity of punishment to the gravity of the offense; rather, the punishment should be modeled or molded to do for the criminal the best that can be done for him insofar as making him a better man is concerned. You remember in Gilbert and Sullivan's *Mikado*, the Mikado sings, "My object all sublime, I shall achieve in time, to let the punishment fit the crime, the punishment fit the crime." But according to the view we're now considering, the punishment should not fit the crime; it should fit the criminal.

Now just as before, I read you a classic statement of the view that retribution is the end of punishment. Let me read you now a great statement of the utilitarian position that punishment is for the sake of prevention. We find this in *The Dialogues of Plato:* "No one punishes the evildoer for the reason that he has done wrong"—just the opposite of Kant and Hegel. "No one punishes the evildoer for the reason that he has done wrong. Only the unreasonable fury of the beast acts in that manner. He who desires to inflict rational punishment does not retaliate," says Plato, "for a past wrong which cannot be undone. He has regard only to the future and his desire is that the man who was punished and those who see him punished may be deterred from doing wrong again. He punishes entirely for the sake of prevention." That is Plato.

Let me read you a similar statement many centuries later from the English philosopher, Thomas Hobbes, so that you get a full sense of this position which says that punishment is solely with regard to the future, not with regard to the past wrong but the future, the reform of the criminal or the deterrence of other persons. Hobbes says, "The chief aim of punishment through reformation and deterrence is to maintain public peace. In punishing," he says, "we do not look at the evil which has been done in the past, but only at the greatness of the good we wish to achieve.

Whereby," he says, "we are forbidden to inflict punishment with any other designs than for the correction of the offender or the direction of others. Anything else is an act of hostility."

And then later Rousseau says that the wise statesman is one who knows how, by punishing crimes, to prevent them. And the most important thing is the reformation of the criminal himself. "There is not a single evildoer," according to Rousseau, "who could not be turned to some good. The State has no right to put to death, even for the sake of making an example, anyone whom it can leave alive without danger." Now this gives you the other extreme position which insists that punishment is solely for the sake of preventing future wrongdoing.

CHOOSING IN DIFFICULT CASES

I now want to ask you the hard question, which of these two positions do you take? Let me see if I can help you by giving you some examples and showing you how you would have to decide particular cases according as you took one position or the other. Suppose that you and you alone—no one else in the world—you alone knew that a man was guilty of murder; he had confessed his guilt to you; but suppose you also knew that he had completely repented of this crime and would never commit another crime or do anything wrong, would you punish him? If you take the retributive position, you certainly would. He is guilty and deserves to be punished. If you take the utilitarian position, you would not punish him because he is reformed, and no one knowing of his crime, there would be no deterrent value in punishing him.

Or let's take another case. Suppose you knew that if you punished a particular person publicly, you would deter a great deal of wrongdoing; yet you knew that this person was not guilty of any crime at all. He was an innocent person but you could make an example of him and deter others. Would you punish him? If you take the retributive position, you would say, "Not at all. He is guiltless and therefore does not deserve to be punished." But if you take the utilitarian position, you might say, "Since the end of punishment is the prevention of crime or wrongdoing, it makes no difference whether this person is guilty or not. If we punish him, we achieve some good by deterring others."

Or take some other examples, would you punish a man severely, even if the results made him a more hardened criminal than he was, instead of reforming him, simply because the severity of the punishment was proportionate to the offense he committed? If you take the retributive position, you will punish him in proportion to his crime regardless of whether or not you would harden him as a criminal. But if you take the utilitarian position, you would say, "No, the important thing here is to correct this man. I would treat him in such a manner that he is reformed, regardless of whether we have to treat him lightly or severely in order to do this."

Or to take one other case, here are two men; one has committed a very slight offense and one a serious offense. But suppose you knew that if you punished the man who committed the lighter offense severely and the man who committed the very serious offense lightly, you would improve them both, would you do that? If you took the utilitarian position, you would because your aim is to make punishment fit the criminal, not the crime. But if you take the retributive position, you would not. You would treat the man who committed the slight offense in a light manner and you would treat severely the man who committed the very grave offense.

This indicates the options you have. In view of this let me ask again, which position do you take, the extreme retributive position or the extreme utilitarian position?

Finding Middle Ground

Now you may say to me, "Do I have to take either of these extreme positions?" You may answer my question, the one I've just given you, by saying, "Why must I take either extreme? Is there no way of combining these positions, of reconciling some truth in the one with some truth in the other? Isn't there some middle ground which avoids what seems the difficulty of the two extremes?"

And I think I can show you that there appears to be middle ground, because some of the great thinkers and writers about punishment seem to have combined something from the utilitarian position with something from the retributive position. For example, Plato seems to combine both positions. He says, "The proper purpose of punishment is twofold. He who is rightly punished

ought either to become better and profit by it or he ought to be made an example to his fellows that they may see what he suffers and fear and become better." So far as he says that, he is emphasizing prevention, reform of the wrongdoer, or the deterrence of potential wrongdoer. But then he goes on to say, "But the law should aim at the right measure of punishment, and in all cases at the deserved punishment." Now those words, "the right measure of punishment," and "at the deserved punishment" indicates that Plato is also saying that a man must be guilty in order to be punished and the punishment should somehow still fit the guilt.

Or to take one other great thinker, Saint Thomas Aquinas in the *Summa Theologica,* who talks about punishment, both divine and human punishment. We find again the three things combined somehow. Aquinas says that retribution or just retribution is not the only reason for punishment. "Sometimes punishment is for the good of those who are punished, and sometimes for the correction of others who are deterred from wrongdoing." But notice what Aquinas is saying. "In addition to retribution," he is saying, "one can punish in order to reform the wrongdoer or to prevent others from wrongdoing." So he seems to say that there are three reasons for punishment: retribution or retaliation, reformation, and deterrence.

If you look at Aquinas carefully I think you will find that he does not think these three things are equal or coordinate, for in this passage where he deals with the matter—I'm not going to bother to read it to you—he says that retribution is not only the primary but the essential, the indispensable condition in punishment. And then over and above that as secondary purposes of punishment one can attempt to prevent wrongdoing by reforming criminals or deterring others from committing crimes.

If I were to attempt to state for you in principle how these two extreme views can be reconciled, I would say it somewhat as follows: On the one hand the truth in the retributive position is that only the guilty shall be punished. No one shall be punished who is innocent. This is why you and I recoil from the use of men as hostages, killing them or making an example of them in order to prevent others from doing certain things. They are innocent and should not be punished for any reason. Only the guilty shall be punished, but then we add something which the retributive theory doesn't say; though only the guilty shall be punished and all the

guilty should be punished, we should not try to proportion the punishment to their guilt but try to make the punishment fit the criminal or the wrongdoer rather than the crime.

Now on the utilitarian side, what is the truth we want to preserve? It is that guilt, though it is a condition of punishment, is not the justification of punishment or the purpose of it. Though we do not punish anyone who is not guilty, nevertheless when we do punish, our aim is not mere retribution; our aim is to reform the wrongdoer or prevent others from doing wrong.

Now are these two things consistent? Can we put these two positions together so that we can punish in a consistent and coherent manner? I'm not sure that I know the answer to the question. I think it is a hard one to think about and I urge you to think about it for yourself. It often seems to me that it is very difficult to punish consistently because sometimes if we try to punish retributively, we get in the way of punishing for other reasons. We impede ourselves from punishing effectively in a manner that deters criminals or that reforms them. And sometimes when we punish lightly in order to reform this particular criminal, we are failing to deter others who are impressed by the lightness of his punishment.

It is extremely difficult, I think, to punish with all these three ends in mind: retribution to the guilty person, reformation of his character, and the deterrence of others. Yet somehow in all our legal systems, and I am sure that it is true of your home and my home when we punish children, we somehow combine these things. We do not punish innocent persons; we punish them only because they are guilty. We do relate somehow the severity of the punishment to the gravity of the offense, and yet we do try to reform the wrongdoer and deter wrongdoing.

30 How to Think about Language

Today we shall deal with Language as a Great Idea. The special significance of language, the special importance of language as an idea, lies in the fact that it is related to all the other Great Ideas in a particular way insofar as ideas and thoughts are expressed by persons in words, in speech, in language. What people have thought about language and the uses or limitations of language has affected what they have thought about many other things.

I'm sure that all of you are acquainted with the word *semantics.* In recent times the science of semantics and the art of semantics have a great deal of currency and popularity. You hear people say, when a conversation is going on and someone starts to make a comment on the use of words or the difficulty of finding the right word, "Oh, now you're involved in semantics" or "That's just a semantic problem." And many people, I think, suppose because of the recent vogue of semantics that the interest and concern with language is a very modern or even contemporary thing.

There is a great contemporary interest in language, but man's concern with language as a vehicle for the expression of thought, for the communication of ideas and emotions, is perennial. It has existed in every age, in every century. It was as prominent in antiquity as in modern times.

If you read the dialogues of Plato, for example, you will find Socrates and the people he was talking to continually calling attention to the slipperiness of words and how words sometimes conceal thought as well as express it. Or take another example in the ancient world, the works of Aristotle. You will find that Aristotle was continually commenting on the three, the four, the five senses of a word like "justice" or a word like "government" or a word like

"substance" or "liberty." In fact, one of the books of Aristotle's *Metaphysics* is nothing but a commentary on twenty-five or twenty-six basic words, an attempt to clarify their meanings and to distinguish their senses, so important did Aristotle think the clarification of language as an instrument of thought was.

The same thing is true in the Middle Ages. The Middle Ages developed an elaborate grammar and an elaborate theory of signs and how words had to be used to convey different shades of meaning and to clarify our intentions in speech. And again, in modern times such philosophers as Hobbes and Locke included chapters in their works on the use and abuse of words, how language should be used to be effective and what pitfalls and errors should be avoided.

There is one important difference between the ancient and the modern attitude toward language. The ancients regarded the fault as ours when we misuse language. It is almost like saying that we had certain weaknesses, men have certain weaknesses, moral weaknesses. And the moral virtues are necessary to overcome the weaknesses of our desires or appetites or passions. The fault in ours when we misuse language. And if we succeed, the reward is ours when we master language and make it serve our purposes.

LANGUAGE IS PECULIARLY HUMAN

The modern attitude is quite different. The modern attitude almost looks at language as if it were a foreign thing, as if it were an enemy of ours. Such figures of speech as the tyranny of words, language as a source of deception, language as a barrier to communication, put upon language, as if it were not our own, the burden of the difficulty. And so moderns, as the ancients never did, have in mind the ideal of a perfect language, the construction of a language which unlike the language we ordinarily use, would have all the difficulties removed and be a perfectly lucid, clear medium of communication.

There is one point that was generally agreed upon until very recently, namely, that speech or language is a particularly human thing. Speech in some ways is one of the distinguishing characteristics of man. In the last fifty years there has been some disagreement with this point. Biologists have supposed that they have

discovered communication among other beings, among insects. The students of the higher apes have claimed that they have found in the chimpanzees a language, a vocabulary of a hundred and twenty or a hundred and twenty-five words. And so it is now thought that communication or language is not a special property belonging to man but one that is shared with other animals.

I think this is wrong, by the way. And I should like to tell you why. I still think it's true that language or speech is a peculiarly human characteristic, a property of man and man alone. And my reason for thinking so is that communication is one thing and language or speech is another. When one animal communicates to another animal it does so by an emotional cry, an expression of emotions the way a man might express his emotions of rage or fear or anger or hate. So the animals express their emotions. But this communication from one animal to another is not speech. Speech doesn't begin until thought is communicated. And thought is communicated by words which function as parts of speech in sentences, sentences that have syntax, in which the parts of speech go together in a certain way to form the structure of a sentence.

I say to you that the first time any animal utters a sentence, a sentence that has a syntactical structure in which the words function as parts of speech, then I am willing to admit that other animals than man have language or speech. Until then, I think we must only say that other animals may have means of communication, but they do not employ language or speech.

This last fact leads us to the problem which I should like to discuss with you first, the problem of the nature or the naturalness of human language. Let's consider that at once.

THERE IS NO SINGLE NATURAL LANGUAGE

I said a moment ago that language was a distinctive trait of human nature, that it was natural for man to be a user of words in the form of speech to communicate ideas and emotions. But though this is the case, though language is natural to man in this sense, as it is not natural to any other animal, it is also true that among human beings there is no natural language. There is no single, natural language.

Let me explain this point. If one takes the cries of other animals, the instinctive expressions of emotion in the case of the chimpanzees or the movements and sounds made by insects in the brushing of their wings by which biologists tell us they communicate to one another, we find that those means of communication are quite natural to each species of insect or animal. That is, all the animals of a certain species will have the same, exactly the same, means of communication. But although language is natural to men, we find in the human race a tremendous plurality and variety of languages. The tribes of men, the races of men, the different nationalities, all speak different tongues. In this sense there is no natural human language. All our languages are, as the saying goes, *conventional* modes of speech, languages which men themselves have made up as they have built different kinds of houses and have clothed themselves differently and have used at different times and different places different implements in the process of conquering nature or controlling the environment around them.

At the same time that there is a vast plurality of conventional languages among the races and nationalities of men, there is another fact of the greatest significance that has an opposite tendency. In general it could be supposed that whatever can be said by humans in one conventional language, such as French or English or Russian or Hottentot or Zulu or any of the Eskimo languages, can be translated into any other conventional language used by human beings.

The anthropologists who travel among the various tribes and races of men somehow can learn to communicate their thoughts in the language—translate from English or French or German, one of the European languages, into one of the tribal languages. And any of the European languages is of course capable of being translated into another. Now this fact, that each of the conventional languages like French and German and English and Russian and Italian, can be translated into any one of the others, seems to show that there must be something common to all these languages, and whatever this is, which we shall try to discover in a moment, whatever this is that is common to all these many, diverse, conventional languages, it suggests that it may be possible someday to construct a single, universal, common language in which all men could communicate to one another.

Suppose you were to ask me what a *natural* human language might be like. I've been saying that there is no natural human language, that at present we have not yet been able to construct a single, universal, common language, that we are separated, one group or nationality of human beings from another, by the diverse tongues we speak, even though we are able to translate our thoughts from one language into another. But suppose you were to ask me, What would a natural language be like? What does one mean by supposing a natural human language?

The only way I can answer this question imaginatively is to remind you of a passage in the Bible that I think most of you know though perhaps you do not remember as well as you should. It is really quite an extraordinary passage. It is the story of the Tower of Babel. And you all know that the meaning of the word "babel" is the confusion of tongues. But let me read you the exact passage and let's look at exactly what happened at that point in the story. The people, the human race at that time, said to one another, "Come, let us make a city and a tower, the top whereof may reach to heaven; and let us make our name famous, before we be scattered abroad in all lands. And the Lord, the Lord God, came down to see the city and the tower, which the children of Adam were building. And he said," that is, God said, "Behold, it is one people, and all have one tongue; and they have begun to do this: neither will they leave off from their designs until they accomplish them indeed. Come ye therefore, let us go down, and there confound their speech, that they may not understand one another's speech. And so the Lord scattered them from that place into all lands: and they ceased to build the city. And therefore the name thereof was called Babel; because there the language of the whole earth was confounded: and from thence the Lord scattered them abroad upon the face of all countries."

As I understand this story, what we are being told here in the Bible is that before God confused or confounded the speech of men, at this moment in history, all human beings talked one language as if it were a natural language. And only after this point when God confounded their speech were men separated from one another by diverse languages which prevented them from understanding one another until they were able to translate from one language to another.

You may still ask what I would mean by one, common, natural language, the kind of language that men had before God confounded human speech at the Tower of Babel. And I would turn to another passage in Genesis, the opening of the story of the garden of Eden when Adam is still there. And there is a passage in that story which reads as follows: "And the Lord God, having formed out of the ground all the beasts of the earth, and all the fowls of the air; brought them to Adam to see what he would call them: for whatsoever Adam called any living creature, the same is its name."

Notice that passage, for what we are being told here is that as the angel brought a different animal before Adam, a flower or an animal, Adam gave it its name and that was its name, that was its right name, the name that belonged to it as if that name were the natural and proper name of that thing. Now we, in English, we say *dog*, in German we say, *Hund*, in French we say, *chien*. None of those is the "right" name of the animal because there are three of them, and any one of them is as good as any other. But the name that Adam gave, according to the story, was the natural name for the animal. So a natural language would have only one name for each thing. And that would be the right name, the proper or natural name.

Words Mean Ideas

We know, so far as any actual history of mankind is concerned, that apart from the Bible there has never been such a natural language. But this idea of a natural language raises for us a problem about the conventional languages which we speak, the various languages such as French and German and English. The problem is, how in these conventional languages do such sounds as "dog" or "Hund" or "chien" get their meaning? They are just sounds. Or the marks on paper which we write are just physical marks. How do these, what at first are merely meaningless sounds or meaningless marks, get their meaning? That is one of the problems that we must face when we consider a purely conventional language in which we make up the sounds and marks that constitute the language.

The second problem is the problem about the ambiguity of the words that we use, the fact that these words we make up soon get

to have a large number of meanings. The fact that they have a variety of different meanings often tends to confuse us and make our use of language difficult and sometimes even treacherous.

I would like to deal with this problem now. That is, how do words—the problem of how words get their meaning first, and deal later with the problem of ambiguity. How do words get their meaning? Where do they get their meaning from? Let me correct that last wording just a little. One shouldn't speak of words as getting or changing meaning so much as the sounds or marks which become words when they get meaning and function differently as words when they change their meaning. A sound or mark, the mark one makes on a page, the sound one makes with one's voice when it is meaningless, is not a word. A meaningful sound or mark is a word. And the problem is, the problem I want to face is, how in the origin of language do these meaningless marks and sounds become words by becoming meaningful? How do sounds and marks become meaningful?

One problem about the origin of language is, I think, in general insoluble. And that is the history of the invention of the different sounds and marks that constitute our conventional languages like French or German or English. But the problem of how those sounds and marks when they are invented become meaningful is, I think, a soluble problem. Let me read you two or three texts from the Great Books on the question of how sounds or marks become meaningful and thus function as words.

The first text, in some ways one of the most striking texts, is from Aristotle. "Spoken words," writes Aristotle, "are the symbols of mental experience, our ideas or images or feelings. And written words are the symbols of spoken words." And Aristotle goes on to say, "Just as all men do not have the same writing," they don't all write in French or in English or in German or Spanish, "so all men do not have the same speech sounds, but the mental experiences," that is, our ideas or images or feelings, "which these are sounds or words directly symbolized are the same for all men, as also are those things of which our experiences are the images." What Aristotle was trying to say here is that our images or ideas directly symbolize the things of which they are the ideas and it is through these that our sounds and marks are words, signify, or point to, mean, things.

John Locke carries this same analysis forward by saying that words came to be used by men as the signs of their ideas, not by any natural connection between particular articulate sounds and certain ideas, for then there would be one language amongst all men, but by a voluntary imposition whereby such a word is made arbitrarily, the mark of such an idea.

And Aquinas summarizes what Locke and Aristotle are trying to say here when he says that words are the signs of ideas and ideas, because of their similitude, because they are the images of things, are the signs of things and therefore it is evident that words function in the signification of things through the ideas or images in the mind. In other words, it is through the content of the mind, our ideas and images, that words come to mean the things of the world. In one other passage Aquinas says we can give a name to anything only insofar as we can understand it.

How does the word "dog" mean that animal? According to this theory, only through the idea or image of dog that we have in our mind. That is, the word we use, the sound we use, signifies the idea of dog and the idea of dog because it is the idea of dog signifies the animal dog. The word does not mean the thing directly. The word cannot get meaning from the thing or cannot point to the thing except by going through this circuit. The word we use, the sound or mark we invent, must be attached to an idea we have and the idea, because it is the natural image of the thing of which it is the idea, signifies the idea and the word gets its meaning through that.

That is terribly important to understand. Because when you understand that, you see a distinction between, if I may use this way of saying it, a physical word and a mental word. The word itself or the word mark is a physical word. It is a physical mark on paper or a physical sound I utter. But my idea is a mental word. And the difference between a mental word and a physical word is that a mental word is a meaning, whereas a physical word, a sound or mark, gets its meaning from its attachment to or connection with a mental word.

In other words, if there were no mental words, if we didn't have ideas, there would be no meanings and we'd have no language either. The basis for the translatability of one conventional language into another is the fact that all these conventional languages express the same set of ideas and images that men have

concerning the world in which they live. It is this fact that makes it possible to translate from one conventional language into another. But let me repeat, the most important thing here is the fact that mind is the realm of meaning, that all the meanings that we have come from the fact that we have ideas and images in our mind, and it is these meanings that are attached to words and give them their significance.

THE AMBIGUITY OF LANGUAGE

In the time that's left I would like to deal briefly with one other problem in connection with language, and that is the problem of ambiguity which arises from the fact that we often have many meanings for one and the same word, and also from the fact that we often have many words to express one and the same idea. These two facts that we have too many words sometimes for a single idea, or on the other hand, too many meanings for a single word, really creates the problem of communication.

Think about what communication means. Communication has at the root of it unity, community. It involves two minds sharing the same idea. It isn't enough that they use the same word, because if two people use the same word, one having one meaning for it, another a quite different meaning, they aren't communicating. They are communicating only if, when one uses the word and the other uses the same word, they use it to express the same idea, the same emotion, the same thought, or the same intention. Only in that way do you have two minds getting together, coming to terms, sharing experiences of a mental or emotional sort.

One of the problems that people have always faced is how to overcome this difficulty about our conventional languages. Sometimes they think that the problem would be solved if we could invent an ideal language in which each word had only one meaning. But I don't think this would solve the problem because then we would have to find other words to express the relation, the connection, of the various meanings. For example, when we use the word "freedom" we often use it in a number of different senses, but those senses are connected. And the connection of those senses is part of the significance of the word "freedom." If we were to have a different word for each meaning of the word

"freedom," we wouldn't be able to express our sense of the connection of those different meanings.

I think the only solution—to the ambiguity of words as a barrier to communication or a difficulty with human speech—the only solution is not one of inventing an ideal or perfect language but rather using the language we have, using the words we have, to clarify the meanings of our words. We have to use speech in order to make speech itself more perfect or more useable or more effective. It is a hard job, one we must be continually at. And only by working at it can we bring our minds together through the medium of language.

31 | How to Think about Work

The most obvious questions which might arise in approaching the Great Idea of Work, or human labor, would be such issues as labor versus capital, or the organization of labor unions, or the division of labor, or the labor theory of value, or labor as the right to property. All of these are important aspects of the idea of labor but in these four programs we want to discuss the idea of labor from another point of view. We will be concerned with *the nature and necessity of work in human life*. We're interested in the relation of work to other kinds of activity. Above all, we want to understand the variety of different kinds of work and to see that variety in relation to the great and central problem of the fundamental dignity of all human labor.

THREE AGES OF MAN

I begin with a question about the parts of human life. What does the question itself mean? What does it mean to ask, What are the parts of a human life? In the first place, let's consider for a moment what one means by a human life. Normally one means a span of time in which there is a regular rhythm of activities, a clear pattern of development. And as one looks at a human life this way, one cannot help but recall Shakespeare's seven ages of man. Well, seven is too many for me this afternoon. I would like to deal with three ages of man, three great periods of human life: infancy or childhood at one end, senility or old age at the other, and in between that long period I shall simply call maturity, without distinguishing between youth and middle age.

Of these three periods only one is the working period of human life. We don't expect infants or children to work, we don't expect old people to work after they have worked the major part of their lives, and the middle part, the long middle period of human life, I want to call the working period. Men and women are expected to work during this period of their life.

How do we use our time, how should we use our time, during this long working period of our lives? To that question the average American citizen in the twentieth century has almost a standard answer. Here it is: he says: Take a twenty-four hour day, and then in about equal thirds the average American says, "I devote eight hours to sleep, eight hours to work, and I have eight hours approximately, day after day, left over for free time." And the word "free," here as applied to that last third of time, means time free from sleep and work. It's the unoccupied time.

The average American, when he gives this answer, if he were then asked, How do you fill that free time?, What do you do with that free time?, would say, "I play, I play, I amuse myself, I indulge in recreation, or I use it for leisure activities, or I use it for rest." And the average American today would use those three words, *play, leisure,* and *rest,* as if they meant the same thing, as filling for free time.

I want to comment on this standard answer. There are two things I want to say about this answer which the average American citizen gives to this question. In the first place, I want you to understand, it is terribly important for all of us to understand that this answer is an answer that belongs to an industrial, democratic society. It was never given by human beings before.

To make this point clear let me compare the life of an average American citizen in the industrial democracy of the United States today with all the preindustrial, aristocratic societies of the past, whether they be those of our own colonial times in this country or those of the feudal societies of Europe or the time of ancient antiquity in Greece and Rome. In all those preindustrial, aristocratic societies of the past, in the first place, men were divided into two classes. They were either slaves or artisans, they belonged to the working class; or they were free men, they belonged to the leisure class. And, of course, the working class were the many, and the leisure class were the few.

Each of these two classes of men had a two-part life, not a three-part life. The average American today has a three-part life: sleep, work, and free time. But the slaves of all the societies of the preindustrial past had only two parts. They worked and they slept. Work and sleep occupied their time in almost equal halves. And there is a little saving remnant there against which I am putting a question mark. Just a little time left over in the whole week from twelve or fourteen hours of work and twelve hours of sleep to get over that fatigue of toil. And perhaps there was a day off once in a while or an hour off once in a while. Let's hold that open. For the most part the slaves of the working class of all the preindustrial societies of the past had a two-part life: half work, half sleep.

And in those same societies there was another class of men, the free men, the class we call the leisure class. And they also had a two-part life. They slept, and they didn't need to sleep as much because they didn't work. They had some sleep and the rest of their time was free time. They had a two-part life. They didn't work. They had, by accumulated wealth or the work of slaves and others, freedom from labor. Their life divided into two parts, not equal parts: about a third of sleep, and two-thirds free time.

Now that doesn't tell the whole story. Because I must add one more thing to that. I must point out that in this leisure class there were two kinds of men. There were the useful citizens, the men, who though they were free from work, occupied their time well in activities that were contributed to human welfare and activities which ennobled and improved themselves. These men were virtuous. But in this same class of free men who had leisure there were in every society of the past the men that we would call the wasteful, the playboys, the prodigals, who spent this free time in play or diversion, often of a degrading kind.

In fact, the meaning of the word sloth, the cardinal sin or vice of *sloth*, means the misuse of this free time, not by sleeping but by playing it away, killing it, frittering it away. As a matter of fact, you could say it one other way, children have this kind of a life. They sleep and use their free time for play. And when an adult human being lives this kind of a life, sleep and uses the rest of his time for play, he is acting childishly.

So the average American citizen's three-part life of today combines the parts that were separate in all the preindustrial societies of the past when slaves worked and slept and free men were free

men because, apart from sleeping, their time was free. And so you see, if it is possible, which I'm not sure we can understand fully yet today, to distinguish between play, leisure, and rest, we may be able to see how a human life can have not just these three parts but five parts, comprising sleep, work, play, leisure, and rest. These are the possible five parts of a human life.

THE DIFFERENCE BETWEEN LEISURE AND PLAY

Lloyd Luckman: Now that we have the five things before us to consider, I think we are ready to take up one of the questions that we have received. It comes from Robert V. McPherson in Palo, Alto. It is a very simple and direct question. He says, "What importance in the scale of values should one assign to work?"

Mortimer Adler: There are several answers to that question, Lloyd. In all of the preindustrial, aristocratic societies of the past, Mr. McPherson, work was degrading. In all such societies the ideal of the free man, the ideal of life, was a life free from work.

In fact, the ideal of freedom from work, having no work to do, has been a persistent ideal throughout the whole of human history. Let me read you some passages from the Great Books that bear directly on that matter. Lucretius, an ancient Roman poet, pictured a golden age of abundance and plenty in which men could live well without any labor whatsoever. And a modern French political philosopher and economist, Jean-Jacques Rousseau, describes a golden age, a time when the products of the earth furnished humankind with all its needs. And instinct told human beings how to use their time, so that singing and dancing, the true offspring of love and leisure, became the amusement or rather the occupation of men and women assembled together with nothing else to do. Again, Virgil describes two ages of men, the age of Cronus, in which there was no need for work at all, and the age of Jupiter or Jove, when humans are care-ridden and burdened with toil.

And in the Christian tradition the story of Adam and Eve leaving the Garden of Eden is a story of the transition from the perfect paradise on earth in which Adam and Eve and all their descendants would have lived, *without any labor at all,* off the fruits of the tree, into the world where the angel who put Adam out says to

him, "In the sweat of thy face shalt thou eat. In toil shalt thou eat all the days of thy life."

So much for the answer to Mr. McPherson's question as it would have been given in the past. But in the America of today, it seems to me there are two possible other answers. In our industrial society, if the free third of our time is mainly play or amusement, then I think the answer should be that work is the most important part of human life because no adult can possibly say that he lives in order to play.

On the other hand if the free third of our three-part life is not play or amusement but leisure activity, then I would say the opposite, Lloyd and Mr. McPherson. I would say that work is subordinate to leisure and that in proportion as we understand the relation of work to leisure, we perceive a scale in the kind or types of work.

I don't think, Lloyd, that I can make all this clear today without much more clarification of the distinction between leisure and play than we have time for now. In fact, this becomes the most important part of our discussion next week, and very important indeed because it is my impression that in America today the notion of leisure is almost everywhere confused with that of play or amusement, recreation or diversion. I'm going to try to show next week that it is almost the very opposite.

The Meaning of Rest

But before I do that I want to discuss one very special notion that I think stands out from all the rest and which we should deal with quickly and put aside. And that is the notion, Lloyd, of *rest*. And to make the point about rest that I want to make clear, let me remind you of two biblical texts that I think you are all quite familiar with. One is the text from Genesis and the other is a text from Exodus.

Let me read you the text from Genesis first. The text from Genesis reads, "And on the seventh day God ended his work and he rested on the seventh day from all his work. And God blessed the seventh day, and sanctified it: because in it he had rested from all his work."

Now I'm sure we all understand that when it says in Genesis that God rested from all His work, it doesn't mean that God slept

or that God played. Now then, following that text there is a very closely related text in Exodus. It is the text that is in one of the Ten Commandments. It reads as follows: "Remember the sabbath day, to keep it holy. Six days shalt thou labour, and do all thy work: But the seventh day is the sabbath," and by the way, the word *sabbath* in Hebrew means simply "cessation," cessation from work. "But the seventh day is the sabbath of the Lord thy God: in it thou shalt do no work, nor thy son, nor thy daughter, they manservant, nor thy maidservant, nor thy cattle, nor thy stranger that is within thy gates: For in six days the Lord made heaven and earth, the sea, and all that in them is, and rested on the seventh day: wherefore the Lord blessed the sabbath day, and hallowed it."

Again, it is perfectly clear—is it not?—that what the Old Testament means by sabbatical rest, keeping this day holy, hallowing it, is not something that can be done by sleeping all the Sabbath or playing all the Sabbath. What does "rest" mean, as used in the Old Testament, when it talks about God resting or men resting on the seventh day?

I think, in the first place, it means not merely rest as against work in our sense but rest as against all other normal, natural, everyday, human activity, including sleep and play and leisure activities. For if resting on the Sabbath means keeping it holy, then the only thing it seems that the Old Testament could have in mind is religious worship on the Sabbath, the contemplation of God and the glorification of God. And this, I think, is the meaning of the phrase we all know and use, the phrase "heavenly rest." There is no work in heaven, there is no sleep in heaven, and the rest of the souls who are among the saints is a rest of the contemplation of God.

Now if this is what the word "rest" means, then rest divides human life into two planes: a religious plane and a secular plane, a supernatural plane and a natural plane. And any life can be on two planes. And our problem for the rest of these discussions of labor is a problem about the division of the time of the natural plane. And there it would seem as if there could be three or four parts to human life. On the natural plane it could be either just understood as sleep, work, and free time, confusing play and leisure; or sleep, work and play, and leisure quite distinct from play. The question we then face is, Should we live, or do we live, a three-part or a four-part life?

Lloyd Luckman: I have a question on that very point. It comes from Donald Mills who lives in San Francisco. I think Mr. Mills would admit that labor is distinct from sleep and play but he asks further, "Is it necessary to distinguish between labor and leisure? Isn't it possible that they are the same thing, provided that the general term *labor* includes different kinds of labor activity?"

Mortimer Adler: Well, Lloyd, I think that Mr. Mills in a sense himself gives part of the answer to the question that he asks. He admits, as you say, that sleep and play are different from work. And I think if we can see that sleep and play are different from work, we shall also be able to see that leisure is also different from work or labor.

How do sleep and work differ? Very simply, sleep is inactivity or if we include in sleep such things as eating and cleansing the body, all of the biological activities which, like sleep, sustain life then sleep is either inactivity or merely biological activity, whereas work is distinctly human activity.

How do play and work differ? Well, I think Mr. Mills would recognize and agree that the difference between play and work is— I'm not going to explain the whole difference—caught by one extraordinary sign: *we do not get paid for play.* No one expects to be compensated for play. And no one in his right mind would work without compensation. Just think of that for a moment. We do not get paid and don't expect to get paid salaries or wages or anything else for playing, but for work we certainly do expect it. Though both are human activities, play is uncompensated, work must be compensated in any fair or free society.

Now according to this distinction of all of our free time, whether we play or in distinction from play, use it for leisure which I should like to have quite separate from play, is a kind of human activity, not like sleep, inactivity or mere biological activity, a kind of human activity which we do without any sort of compensation. Hence with this preliminary distinction of work, play, and recreation, our problem remains mainly one of understanding how in the free part of our time play or recreation on the one hand is distinguished from leisure on the other. And as we make this distinction, as we solve this problem, the character and significance of work will be greatly affected.

Lloyd Luckman: Well, I hope we have time for one more question. It comes from Mr. Angus Babcock in Menlo Park. And it

reads: "There is one angle to the subject of labor, Dr. Adler, which I would enjoy hearing you discuss. I accept the theory that the conservation of human energy and the division of labor creates leisure. We have now reached a stage in which most of the manual tasks have been taken over by machines and specialization has been added to the division of labor, yet it seems to me that the family of fifty years ago knew more leisure than the push-button family of today. The half-hour of leisure time we Babcocks spend watching your TV show is most enjoyable, but another half hour of cracker-barrel chat among friends and relatives which should follow upon your show is just a utopian wish. I regret the lack of time to discuss, digest, assimilate the ideas that are born of such project."

Mortimer Adler: I'm most grateful to you, Mr. Babcock, for that question and for the kind words you have to say about this program. I'm glad that Mr. Babcock regards watching this program as a use of leisure not as either work or amusement, and I certainly hope not as sleep. And you know as a matter of fact, Lloyd, it would be a hard question for us to answer: When we're on this program, are we working or are we engaging in leisure activities? If we could keep quiet on anything in the way of compensation we get for this, I would like to say that Mr. Luckman and I regard this as not play, not work, but as a rather interesting and exciting form of leisure.

The other aspect of Mr. Babcock's question I would like to deal with briefly now and then come back to next time. The lack of time you complain about, Mr. Babcock, the lack of time must mean that play or recreation or amusements of some kind, not work, has swallowed up too much or all of our free time. The trouble with life in America today is not that we work too much but that our free time is too much engaged in play and amusement so that too little of it is left as you point out, Mr. Babcock, for the kind of leisure activities that really are the most profitable part of human life.

We will make that point quite clear in our next program.

32 Work, Play, and Leisure

Today as we go on with the discussion of work which we began last week, I would like to remind you of some of the things we said that have a bearing on our further discussion today. We asked about the parts of human life, how men occupied or used their time. And last week we thought of five different things that fill up or occupy the hours of a man's day or the days of his week. They were: sleep, work (or labor), play (or recreation), leisure activities, and rest.

We saw that "rest" had a very special meaning, that it was the kind of thing that belonged to the Sabbath or the day of rest. It was on a special part or plane of man's life and so for the time being we eliminated rest from our consideration. We were left with the other four and we asked ourselves again the question, Is a person's life divided into three or four parts?

And so our problem for today is our understanding of the difference between work and leisure, on the one hand, and leisure and play or recreation, on the other hand. The interest in this problem of work, play, and leisure is very great indeed, as Lloyd and I have found in the letters we've received. We have selected letters that we think will help pose this problem for us as we start today. This time, Lloyd, let's hear several of these letters before we talk about them.

Lloyd Luckman: The first letter is from Mrs. Prentice Goldstone, whose home is in Mill Valley. She writes, "For many of us much of our leisure time is spent in performing duties which because of their nature seem more like work. Is this time thus spent actually considered leisure?"

Mortimer Adler: That distinction that she makes there, between things we have a duty to do and things we don't have to do because there is no duty, suggests that work is dutiful. Yes. By the way, we've got another question in which someone, Mrs. Dane, said that all her time is divided into duty and sleep, as much duty as opposed to sleep.

Being Paid Is Not Essential to Work

Lloyd Luckman: A good emphasis. Then there's this question by Mrs. Helen Whitten, whose home is in Berkeley. She says, "Work as that activity for which there is monetary compensation is easily understood." "But," she asks, "are there not other activities which are called work for which there is no compensation, monetary or otherwise?" Now how would you describe these activities in her question?

Mortimer Adler: Yes, her point is that compensation is not sufficient as a mark or sign or definition of work. There are other activities that feel like work even if you aren't compensated for them.

Lloyd Luckman: That's her point. And then there are two more which seem to raise the same sort of problem for you to consider. I would gather from these questions that you still have a lot of explaining to do concerning labor and leisure. Now both of the questions that I'm going to read to you now have their bearing on domestic duties. And I'm glad to say that one is from a husband and the other is from a wife.

Mortimer Adler: Good, good.

Lloyd Luckman: And they want to know whether these duties are work or leisure. Mr. Gordon Culler here in San Francisco writes, "Is there not actually a fourth part of time involving the care and instruction of one's family? I assume that leisure, rest, and play presuppose a free exercise of one's will. Since the time devoted to family duties are obligatory does the average man, the average family man, have any time for leisure and rest?"

Mortimer Adler: The same point is coming back, the distinction between duties, domestic or otherwise, as opposed to the things we are free to choose to do or not to do as we please.

Lloyd Luckman: Plus the issue of compensation.

Mortimer Adler: Plus compensation.

Lloyd Luckman: And then Mrs. Broderson in Napa says, "Would you please make the meaning clear of leisure as opposed to labor when applied to housework? I prefer housework as a labor of love to working for compensation. Am I not correct in calling it leisure then, at least as it is applies to me?" That is Mrs. Broderson.

Mortimer Adler: I think those are all extremely good questions, Lloyd, because I think they advance the discussion. As I see it the main point each of these letters is making, somewhat differently each time, is that the distinction that everyone feels between work and that which is not work is that whether or not something is compensated, if it is necessary, that is compulsory, if it's something we have to do, we call it work, whereas if it is something we do or don't do, as we please, if we are free to choose to do it or not to do it, then it doesn't have the feeling of work. Hence, at least subjectively, the compulsory is a sign that something is work as opposed to the free. And that seems to go deeper into these questions than compensation.

Lloyd Luckman: Very good.

Mortimer Adler: Nevertheless as I look at this it seems to me we haven't caught the point completely. Because I don't think that duty or obligation by itself is a sign of work.

For example, I would say that everyone has a duty to pursue the truth. All persons have an obligation to improve their minds. We all have the obligations of citizenship and the obligations of friendship. These things are obligatory upon us and yet the fact that a duty is involved doesn't make them work and they certainly aren't play. Hence, we have to find something else that distinguishes leisure from work and leisure from play since duty seems to present perhaps in both work and leisure.

Now our whole aim today is to get clarity on this very question. And I should like to see if I can. It is a difficult one, and I hope you'll bear with me as I see if I can get some of these meanings a little clearer. It takes time and if you're patient, I hope you are, perhaps we can make some progress.

There is one general impression that I think is as wrong as it is widely prevalent that I would like to remove right away. That is the impression that pain or fatigue always goes along with work, that work is the hard or difficult thing we have to do. Now everyone knows this really isn't true. I mean we certainly accumulate fatigue

when we play any game very hard, in particular any physical sport. And sometimes sitting in the movies is quite fatiguing. And there are other things that are painful. I always regard *thinking* as a leisure activity and yet, I must assure you, I find thinking very painful indeed to do. It is a hard thing to do and yet I don't call that work. So pain and fatigue are not the signs of work.

Now the thing that provoked these questions was the remark I made last time that compensation is the clear sign of that which is labor. I would like to return to that point and pick it up just a little, see if I can carry it a little further forward.

Let me define work, for a moment, as that which we must do in order to obtain our subsistence, that which keeps us alive, the goods we have to consume. And so if it is that which we must do in order to obtain our subsistence, then for the work we do we must be compensated, either directly in the form of consumable goods or with the money by with which we buy consumable goods and the services we need.

Let me test this definition out for a moment. Imagine a person who has enough wealth stored up so that he is absolutely secure, secure for the whole of his life with regard to having a plentiful supply of the means of subsistence. Now think about this man a moment, would you say that he would work, could anything he would do be described as work? I say the answer is no. I don't mean that what he did might not be productive; he might do many things that were useful, produce useful goods, produce enjoyable things, works of art, but because he was secure in his supplies of the means of subsistence, I think that we should not say that that man worked or labored. And if there were a whole society thus secure in the possession of goods and services, that whole society, I say, would be freed from work. Such a society, of course, has never existed on earth. That is, except in the story belonging to Christian dogma—some people regard it as myth—the story of the Garden of Eden, in which Adam and Eve and all their children if they had stayed on in there, would have had all the needs of subsistence without ever working.

Do you remember the picture I think you have all seen, of the angel expelling Adam and Eve from the Garden of Eden and sending them out into the world? What is he saying to them at the moment when he is pointing the way out and they tearfully are leaving the Garden? He is saying to them, "By the sweat of thy brow

shalt thou eat, all the days of thy life." That is the condemnation we are under in the world. It is by the sweat of our brows that we have to eat and we must therefore be compensated for the work we do in order to obtain the means of subsistence.

If our four-part division is correct, then what is not sleep and what is not compulsory—something we have to do to obtain the means of subsistence—is not work. And so whatever is not compulsory in this sense must be either play or leisure.

Work, Leisure, and Chores

Lloyd Luckman: Are you really sure, Dr. Adler, that your four-part division is correct? I refer back to the questions that we opened our discussion with this afternoon. I think they throw some doubt particularly on your four-part division. There are certain activities which people have to do, we have this duty to perform, and there isn't any compensation for them, so that—well, I have a name I'd like to use for that type of activity that our viewers were describing, *chores*, the good, old, household chores that your sons do and children do, and we all do. And I would like to have you react to that then. What about chores? Is that labor or leisure?

Mortimer Adler: I'm terribly glad, Lloyd, that you introduced the word "chores," because I have a feeling that chores is what everybody has been looking for as the name for what is bothering you. Chores, farm chores, household chores, chores such as brushing your teeth, chores such as mailing a letter, the things you have to do. As a matter of fact, Lloyd, as I have thought about Mr. Babcock's question from last week, I believe I didn't answer it quite properly because I think Mr. Babcock was worried about the way in which chores occupy our time so we don't have enough leisure.

What is the characteristic of chores? What are chores? Are they like labor or leisure? They are much more like labor, or work, than they are like leisure. They have the following characteristics: chores are things we have to do, we don't get compensated for doing them but we have to do them; they are part of the necessities or our life. In the second place, very much like most of the things we call work, they are repetitive. And it is the repetitive quality of them that I think we find distasteful. And in addition to being uncompensated, things we are compelled to do, and repeti-

tive, they are for the most part intrinsically unrewarding. We wouldn't do them if we didn't have to. We ask our children to do our chores for us. If we can get anybody else to do them for us, we are usually relieved; we prefer to get rid of them for ourselves.

Hence if you put chores on the side of work, then we begin to see that leisure has two parts. It's not only—is not necessary for subsistence, it's not even biologically necessary. The leisure activities we perform are not compulsory for our biological maintenance or existence. And in the second place, our leisure activities are things we are not compelled to do, like chores. They are things we may or may not do as we please.

DEFINING LEISURE

Let me see if I can take the meaning of leisure as distinct from both chores and work, putting chores together with work and explain it a little more fully. I would like to do this in two steps before I come to a definition.

I'll begin by just listing some of the things which belong to leisure. Here are the things that people do by themselves, as part of their leisure: any form of learning; any form of thinking; reading, mainly for the improvement of one's mind not just to kill time; making things of any kind, from carpentry to the highest form of works of art: writing books, painting pictures, taking photographs, and enjoying works of art. These are parts of a person's private life which belong to leisure activity.

Then there is a person's social life. Conversation, not just chitchat but conversation whereby one learns something or helps others to learn something. That is leisure. And certainly writing letters, not business letters, but the kind of letters with which one communicates to one's friends is another form of leisure activity. All the activities of friendship I would call social active leisure. And certainly the things we do in rearing our children provides another form of leisure activity. And then there are the political aspects of leisure, all the duties of citizenship such as voting. Now there you have quickly before you a list of leisure activities.

My second preliminary step to explaining leisure involves going into the etymology of the word. The more I've thought about this the more I've been fascinated, just overcome really, by

how interesting the history of this word "leisure" is. And I want to show you the word "leisure" as it occurs in three languages before it gets into English.

The Greeks had a name for it and the Greek name for it is here, *schole*. That is the word which in Greek books we translate in English by the word *leisure*. But when you find the word *schole* being used in Greek, its first meaning is simply "free time." And then as the word gets used a little more sophisticatedly in the course of Plato and Aristotle's writing about leisure, the word *schole* stands for a certain use of free time, not just the time being free but a use of it in any form of learning. The first meaning of *schole* which we translate leisure is simply "free time." The second meaning is the use of that time for learning.

When the Romans translated this Greek work into Latin, they used two words to translate these two meanings. They used the word *otium*, which means "empty," "vacant," for the "free time" meaning of *schole*. And they used the word *schola* for the learning meaning of *schole*. And it is from the word *schola* that the English word *school* comes. Notice the Greek word for *leisure* becomes through the Latin the English word *school*. Now when you take the English word *leisure*, we have two meanings that we only have one word for. The meaning of *otium* or "free time," we translate when we say—by leisure we simply mean "leisure time," whereas the meaning of *schole* which is a certain kind of activity, learning, we have in mind when we say leisure is for certain kinds of activities that we call leisure activity.

That English word *leisure* comes from a French word *loisir*, which simply means "free." The things we are permitted to do, not compelled. The permissible as opposed—the permissible, free in the sense of permissible as opposed to the compulsory.

By the way, the Latin word for the opposite of *otium* which is "free time," is *negotium*, "not free time" which in Latin meant "business." And that is the word from which we get in English, *negotiation*.

What, in childhood, we call play really fills the role of leisure activities in adult life. Because often children are learning, are growing by playing. And therefore play in a child's life is the equivalent of leisure in adult life.

You know how children regard learning as work? Don't they speak of it as school work? Well, it's a sign of being a child that you

regard learning as work, not play. And the sign of growing up and becoming an adult is that you regard learning as the opposite of work. And when a boy says to himself, "Now shall I go to work after this year in school or go on with my schooling?" opposes going to work and going to school, he is on the very edge of becoming an adult.

I think this enables us to define leisure. I would like to define leisure as consisting in all those activities by which the individual grows morally, intellectually, and spiritually, through which he attains personal excellence and also performs his moral and his political duty. I want you to notice that the element of obligation or duty is not removed from leisure. The leisure activities I listed before consist of things we *ought* to do, but they are also things we may or may not do as we please, unlike chores or work. We are free to do them or not, as we are free to do many things or not do many things that we ought to do, whereas play as opposed to leisure consists of those activities we may or may not do as we please, but attached to which there is no "ought." There is no compulsion about play; there's no necessity to play.

We have play, work, and leisure. And play is of two sorts. There is the kind of playing which we do just for amusement. And sometimes we play not just for pleasure but as a form of recreation. And if you look at the word *recreation*, you will see that what it means is that we recreate our energies, we recuperate from fatigue. This kind of play is useful. It's like sleep, because by sleep we also recuperate our energy. Recreation is that sort of play. The other kind of play is just for pleasure.

In contrast, work is something necessary for subsistence and is intrinsically compensated. It consists of the useful things we do, the means to an end. And chores, as we talked about before, belong with work.

And in the third place, leisure consists of those things which are desirable for self-development and are intrinsically worthwhile.

LEISURE IS MORE IMPORTANT THAN WORK

We can see here an ascending scale of value. Play, which is merely the pleasant, is a less important activity than work, which is useful, serves an end. And work is finally less important than leisure

activities, which are intrinsically rewarding and virtuous, ennobling, making a man good as a man. Work is higher than play, and leisure is higher than work. It is the highest form of human activity.

Work comprises both chores and labor for compensation. Work consists of things we are morally obligated to do, and in addition we have no freedom about them; we must do them, we have no choice. And sometimes when they are labor as opposed to chores we are compensated.

If we look at play as amusement, not play as recreation, we see that we have no moral obligation to play and we are free to play or not to play. These are the things we may or may not do, as we please. And they are simply pleasant activities.

But leisure is something like work and something like play. Because all of the leisure activities I've talked about today are things which we have a moral obligation to do: learn, read, political duties, the duties of friendship. We have a moral obligation to do them, but unlike labor or chores we have freedom. Though we are morally obliged, we may or may not do them as we please.

And so you see how leisure sometimes looks like work and sometimes looks like play. No one, I think, ever confuses chores and work on the one hand and play on the other. But leisure which falls in between them is sometimes confused with the one and sometimes with the other.

There still remains a shadowy line between work and leisure, not merely for the reasons that I have pointed out but for another reason. Let me mention it as something we want to consider next time. There are many things that individuals do for which they get compensation, which they would do even if they were not compensated for doing it. They would feel morally obliged to do them and they would freely wish and freely choose to do them even if they had secured all the means of subsistence. It is this fact that causes the line between labor and leisure to be very shadowy indeed. And the only way we can get this clear is to consider, as I propose that we do consider next time, the distinction in the various kinds of work from what I am going to call, at the very lowest level, the forms of drudgery up to the highest forms of labor, which have the greatest dignity, the kinds of things that men would do even if they had all the wealth in the world.

That is our problem for next time. I think, Lloyd, that there is still time for a question or two.

Lloyd Luckman: That's fine. The first one I would choose would be by Mr. James D. Gabby in San Francisco. He asks, "Shouldn't there be a limit to the amount of leisure that the working man is asking for, since many of them have not have the opportunity to develop the type of leisure activities which promote mental growth?"

Mortimer Adler: My answer to Mr. Gabby is no. I think that the problem is one for liberal education to solve. It is in fact the chief problem in our day for liberal education. It is how to prepare people, the people who now have leisure, for the proper use of that time. It ought to give men more and more free time and also prepare them better and better to use their leisure. That is the problem of liberal education in America today.

Lloyd Luckman: Here's another angle on that same problem as you've answered it, Dr. Adler. This question is from John J. McGovern also from San Francisco. He asks, "Assuming that the average American uses his free time almost exclusively for play, as I think he does, is such a man any happier than the slave who spends the same time in work?"

Mortimer Adler: Yes, Mr. McGovern, I think he is. Because as you will recall from our discussion of happiness, play is a good that belongs in the happy life. Pleasure is a good that every person deserves and therefore the free person of today who has the pleasure of play is a happier man than the slave of the past.

33 The Dignity of All Kinds of Work

As I mentioned last time, leisure can be seen as being something in between or intermediate between work and play. Leisure activities, like play when play is amusement, involve freedom of choice; we can do or not do these things as we please. We have no obligation whatsoever to play. But leisure is also something like work. For though we have freedom with respect to the things we ought to do in matters of leisure activity, nevertheless we have some obligation to ourselves to perform these leisure activities in so far as they are the occasions by which we grow morally, spiritually, and intellectually.

And I raised the question last time about the shadowy line between work and leisure. The answer I gave last time is that leisure is something like work and something like play and so tends to be sometimes confused with work or labor. But there is a deeper answer to that question, an answer, by the way, one person who wrote us a letter saw right into.

Lloyd, do you remember the question from Mr. Thompson? An excellent question.

Lloyd Luckman: Here it is. Mr. Thompson lives in Walnut Creek and he wrote, "Since both leisure and work can be characterized by the element of obligation and since leisure activities are motivated by moral obligation, but work is motivated both by moral obligation and the need for physical subsistence, therefore cannot the desirability of work be assessed by the proportion of the compulsion that is moral?" Or as he says, "To put it more simply, is not work the more virtuous, the less it is simply a matter of biological survival? Cannot this standard be used to measure all the shades of work from drudgery to sheer paid leisure?"

Mortimer Adler: As I said, Lloyd, that is an extraordinarily good question. It is more than a question because what Mr. Thompson has done here is to give us the answer to the question and the answer contains a great deal of insight about work and leisure, particularly about the "shades of work," to use his phrase. They shade—let me repeat what he said—they shade from sheer drudgery at one extreme to what he calls "sheer paid leisure." That, by the way, Mr. Thompson, is a wonderful phrase you invented, "sheer paid leisure." And I take it what you mean by that phrase—I'd like to see if I explained it correctly—is that these activities you call "sheer paid leisure" are the kind of things that you and I would do, that people would do even if they didn't need to be paid, even if they didn't need the compensation. They are like leisure activities even though as a matter of fact someone gets paid for doing them.

There are two points, I think, in Mr. Thompson's insight. He says there are two kinds of obligation: moral obligation, to do the things that improve us, that make us grow; and the biological necessity we have of working for a living, to earn the things that keep us alive. And going along with moral obligation is the intrinsic reward of satisfaction, whereas the kind of activity that is biologically necessary we have to be extrinsically compensated for. And he says between these two extremes there are all the shades of work from drudgery at one extreme to what he calls "sheer paid leisure" at the other.

It seems to me that this is an extremely clear point and I hope that as we go on this afternoon we shall be able to develop it even more fully. But first, I would like to make one preliminary remark. One thing that occurred to me is that one and the same activity can be work or play or leisure. For example, consider dancing or football. For some men and women, dancing is recreation or play, but for professional dancers it is work. Take football. For many boys in school and college, I hope at least that football is play, not work. But there are some and there are certainly professional football teams for whom playing football is work. Or consider such things as gardening and carpentry. Many human beings do both of these things: gardening and carpentry as part of their leisure activities and yet, there are men who work at gardening and work at carpentry. Or consider teaching and music. These too are things that for some people are leisure activities and others earn their liv-

ing while engaged in the performance of these tasks. And finally, there is learning, which as I said last time is viewed by children as work, though for adults it should not be work but should be one of the highest uses of leisure.

Lloyd Luckman: This remark of yours about learning or study being work for children makes this, I think, an appropriate place to consider a question by Judith Poole of Jackson Street here in San Francisco. Her question reads: "Since children are incapable of true leisure activity, should the wise parent train a child for future leisure by presenting such pursuits, that is, learning, as play or as work? Since obligation to a child implies work and freedom implies play, which of these should receive the emphasis during the person's childhood in order to develop a better adult?"

Mortimer Adler: I think that my answer will run somewhat contrary to the intention of Mrs. Poole's question. In my judgment, learning in childhood should be work, not play. It should prepare the child for the kind of work that child has to do in adult life. Learning I think, Lloyd, is the most serious obligation of childhood and is the equivalent of the obligation to work in adult life. In childhood, play should be the prototype of leisure. And there, I think, is where we tend to make our great mistake. We think that the play of the child should be entirely fun or amusement. Some of it certainly should be that. But some of the play the child does should be like leisure, intrinsically beneficial and not merely fun or amusement.

We have received a lot of questions from boys and girls in college and school who keep asking about whether learning is work or play. And I think, at least I hope, that by now this answer is clear, that for children it is work and as one becomes more and more an adult, learning becomes less and less work and more and more a form of leisure. And anyone can decide for himself just how much of a child or how much of an adult he is by this test.

Lloyd Luckman: Well, I would agree that you've answered the questions that have come from the college students who have asked if the kind of studying they're doing is work or leisure, but I take it too that you think that students should be adult enough to regard their study as a leisure-time activity. But I am not so sure that you've fully answered yet this query we received from Fredrick Roff of San Mateo Junior College. Mr. Roff wants to know whether schools and teachers should always try to make learning fun,

"when," as he puts it, "students should realize that learning involves hard work, disagreeable work." And again he writes, "Difficulties to be overcome are the essence of learning."

Mortimer Adler: Mr. Roff, I think I said something last time that I would like to remind you of, that is partly an answer to your question. I said that work, the work we do for compensation, is not the only hard, difficult, painful, or disagreeable thing we do in life. Thinking is hard and painful and difficult. And much learning is difficult. And there is no reason to call something work simply because it involves pain or effort and some difficulty. I think it is wrong to regard learning or studying as work simply because of that fact; that tends to confuse the distinction that I hope we can keep clear between work and leisure.

DRUDGERY AND LABORS OF LOVE

I'm going to see if I can make the distinction a little clearer, as well as show you why there is a shadowy line between work and leisure. Let me go on with the discussion at this point, Lloyd, and I would like to begin getting into this further development of the insight that we have got from Mr. Thompson by making two distinctions. One that Adam Smith made in his great work on *The Wealth of Nations* between productive and unproductive labor. And then secondly, what I think is a deeper distinction, that between servile and liberal work.

Adam Smith's distinction is between the kind of work that produces economically valuable goods and services, whereas what he called unproductive labor or work produced only services: the services of the ministry, the services of the physician, the services of the teacher, the services of the government official. He called these types of work unproductive.

What interests me about this distinction here is something that may not have occurred to you. We have a lot of different names for the ways in which men get paid or compensated for what they do. We speak of wages and salary. Wages are the kind of pay one gets for a fairly low grade of work; salaries are paid to people who do work that may involve a little leisure. And as one gets to the kind of work that is even higher in the scale of work, we don't use the word *wages* or *salaries* at all. We talk of paying *fees* to a physician. We

talk of *honoraria* to artists and lecturers. As a matter of fact, we may talk about fees and honoraria to teachers, not salary. And finally, when we come to the priesthood or the ministry, we talk about the priest or the minister having a living or stipend, not even a fee or an honorarium. I think these words that suggest different kinds of payment also suggest something about the kinds of work. And so I turn to the second distinction which will make even clearer, I hope, the grades of work from one extreme to the other, from the extreme of servile work at one end to the extreme of liberal work at the other.

I would like to define for you the two extremes between which all human work falls. At one extreme I say we have the kind of work that should be called drudgery, completely servile work. It is like the thing we called last time "chores," except that in this case it is compensated. It is the kind of work that is repetitious day after day, that is stultifying to the human spirit and that no one would do except for the compensation; no one would choose to do these jobs if he could possibly avoid them and gain a living in some other way.

At the other extreme we have the kind of work, which—you recall last time Mrs. Broderson used the phrase "labor of love," Lloyd?

Lloyd Luckman: Yes.

Mortimer Adler: The kind of work I would like to call a labor of love. The kind of work which is completely liberal. It is varied from day to day. It is self-improving rather than stultifying, and it is the kind of activity that a human being would perform or engage in even if he did not get compensated. Even if he had a living from some other source, he would still do this kind of thing because it is exactly like leisure, self-rewarding, intrinsically satisfying.

All the shades of work fall between these two extremes of drudgery at the bottom and labors of love at the top. All work is on a scale between those two. As one goes up the scale, one gets work that is more and more liberal. As one comes down the scale, one gets work that is more and more servile. Everyone's job, everyone's way of earning a living involves some of the liberal, some of the servile, some aspect of leisure, some aspect of drudgery.

And if you were to ask me whether you could tell in your own life, in your own job, in your own working day what kind of a working job you had, how much of leisure was in it, how much of

drudgery; I can give you two criteria for answering your own question. Ask yourself about the importance of the compensation. Would you keep on doing it if you didn't need to earn a living? If you wouldn't—if you stopped tomorrow, if you had a living provided you, then I say it has a lot of drudgery in it, if you would go on doing it even though you had a fortune before you, then I say there's a great deal of leisure in it.

There is a second criteria, how much do you watch the clock? If the time of the working day is sharply divided from free time, the time left over for play and leisure, and you look at that clock and want the working day to come to an end, then it is full of drudgery. But if in your life the line between the working day and the leisure hours is a shadowy line, almost doesn't exist, then your work goes right into leisure. I would say, for example, if I may speak for you as well for me, Lloyd, that we are very fortunate being teachers, leading that kind of working life. Because I am sure, I really feel sure for both of us, were we freed from having to earn a living, we probably would go on doing very much the same thing. Now the hard part about it—and that is a good part—the hard part of it is I never know when my working day stops. My work goes right into my leisure activities so continuously that in some sense I have less free time. That's a silly thing to say because I have a great deal of free time; all my time would be free time if work and leisure are so inseparable, as I think they are when one gets up the ladder of work to work that is a labor of love.

Lloyd Luckman: I have a question I'd like you to answer. It is from Mr. Ketche in Berkley. And we discussed it I think in this connection, too. He writes, "In view of your statement that work is done only to secure a livelihood, is it wrong or fallacious to try to motivate workers by appeals to pride or to craftsmanship and to competition?"

Mortimer Adler: Not at all, Mr. Ketche. Those motivations are good motivations. But let me add a warning. Too many employers uses them in a hollow and superficial manner. The motivation of pride and competition, feeling of workmanship, can't be genuine, can't be made genuine unless the work itself is worth doing, unless the workman can really take pride in the work, can have the feeling described as the instinct of workmanship. It can't be faked; it has to be real. The work has to be good work, work worth doing.

And this leads me to one comment on the whole labor problem that this seems to me to be the appropriate time to make. There really is no solution, and there never will be a solution of the labor problem simply in terms of wages and hours. Workers will always want more money and less time at work so long as their work involves drudgery. And by the way, I'm sure we all agree this is so. There is nothing wrong with this either. If people have to do drudgery, then they want more money for it and they want to do less of it. The only real solution with the labor problem it seems to me is in other terms than hours and wages. The real solution for workers' happiness and their satisfaction is to make the work itself less drudgery and more intrinsically worthwhile so that more and more it becomes liberal and a labor of love.

THE DIGNITY OF LABOR

Now it is that last point about the labor problem and the relation of the character of the work to the satisfaction of the workman that brings me to one of the great notions that really is born in our own day. You may be surprised at the phrase we use all the time, "the dignity of labor." The "dignity" of all forms of "labor" would have been unheard of, unthought of, a hundred and fifty years ago. In all these previous societies, preindustrial and aristocratic, there could be no meaning to the dignity of labor. In fact, the only thing that could have dignity would be leisure because leisure was the occupation of free men. Labor could have no dignity because labor was the occupation of slaves.

In our society, an industrial democracy which is in that sense a classless society because all individuals are both workers and persons of leisure, labor for the first time has dignity. Because now for the first time free persons work. Individuals who are free in the sense of being persons of leisure, persons who are free in the sense of being citizens, are also persons who work and therefore work is dignified. And this is the social or external aspect of the dignity of labor, respectable now because free persons do it, not just slaves.

But there is also an inner and spiritual aspect to the dignity of labor that had to do with the character and the end of the work itself. Work has dignity internally, spiritually, if it is the kind of work that is worth doing, if it has liberal elements and aspects of

leisure in it. That is in terms of its character. It is worth doing for its own sake.

And secondly, work has dignity in the terms of the end or the goal of the work. To have intrinsic, spiritual dignity, the end or purpose of the work must ultimately be the good of the worker or the good of society and not merely the private profit of another person.

We say labor has dignity when it has freedom in it, the freedom of contract, of hiring—getting, taking a job at one's own will or giving it up at one's own will, the freedom of choosing one's own occupation, one's own way of earning a living; this a slave cannot do. Freedom of contract and choice of occupation are part of the dignity of labor. But the other part comes from the end of the work and its character. It must be work that is worth doing for its own sake and it must be work that is done ultimately for the good of the worker or the society in which he lives and not solely for the private profit of some other individual. This last point will help us as we go on next time to consider the moral, the political, and the economic consequences or our understanding of labor and leisure.

34 Work and Leisure Then and Now

I wonder whether you realize how much ideas are like seeds; if you plant them in good soil, take care of them, they will bloom and bear fruit. And I am hoping that we have planted well the ideas about labor and leisure we have been discussing in the last few weeks, and that this afternoon we can harvest some of the fruit in important consequences from our consideration of this basic idea.

There are two things that I should like to remind you of from last time. One is the insight that we gained about the distinctions between work, play, and leisure. We saw that as we got these three basic notions clear, there were difficulties about applying them to particular cases. We learned that the same task, for example, may be a different sort of thing to different persons. What to some is work, may be to others leisure; what to some persons is drudgery, may be to others a labor of love. And we saw that the line dividing work from leisure or drudgery from more liberal work is often shadowy and only sometimes is it sharp. And we saw that it may be very difficult, however clear we are about these ideas, to classify some particular task or job that we have to do.

I think this answers a great many of the questions that we received, Lloyd, in letters, questions that suggested that whether something was work or leisure, drudgery or a labor of love, depended largely on the attitude one took, on the state of mind of the person occupied with the task.

Lloyd Luckman: Well, I would agree in general. I have those questions here and yes, you've answered most of them. But this one, I think, puts particular emphasis on a person's capacities or talents and I'd like to put it to you. It is from Allen A. Cougan here in San Francisco. He asks, "Does not the classification of any par-

320

ticular task as drudgery, a labor of love, or leisure depend in part at least upon a person's capabilities?"

Mortimer Adler: Yes, I think that is another and an important factor. Mr. Cougan, I think I would say that a task becomes drudgery when it falls below the level of a person's ability. For work to be good work and have some aspect of leisure in it, it must make the right demands on a person's ability. It must have some proportion to what his capacities are and in fact it must call upon them in such a way that it develops those capacities to the fullest.

The second point that we considered last time of importance for us today is the point about the dignity of labor. We saw last time that the dignity of labor is established when free persons work, when work is not just the occupation of slaves, and when work has some intrinsic value for the worker. And the most important thing we saw, I think, about this is how recently in human history has the dignity of labor been established, have all forms of labor had dignity in people's eyes and in the eyes of society.

In terms of these two main points that we covered last time, I should like to project for you the two main points we want to consider today. First, in terms of such clarity as we have gained about the different parts of life: work, play and leisure, I would like to raise the question about how these parts of life should be ordered, how they should be related to one another. And second, in terms of our understanding of how recently in human history the dignity of all forms of human labor have been recognized, I would like to discuss with you the great revolution of our time, what in my view is the second great revolution in the history of mankind.

WORK IS NOT AN END IN ITSELF

Let me go back to the first point and deal with it now. As we discuss in another program, happiness seems to consist in the possession of all good things and in order to come into possession of all good things it is necessary to have a right ordering of the different goods. Now that ordering of the different goods is very closely related to a right ordering of the parts of life. So much is this the case that I think that happiness itself can be defined very concretely in terms of labor and leisure and play, as these are properly ordered in a good life.

I seem to recall, Lloyd, that we had a letter from a Mr. Culligan that puts the very question we want to answer.

Lloyd Luckman: The letter is from Private Culligan, U.S. Army. And he lives here in San Francisco. He puts his question as follows: "Does one work for the sake of having free time or does one have free time for the sake of work?"

Mortimer Adler: I think that if we did not distinguish between mere play and true leisure, the question could be answered either way. But suppose we do make the distinction that we've been trying to make between play and leisure, then it seems to me that we have to say the following: that play as recreation is like sleep; it is for work, and work in turn is for the sake of leisure. In other words, it seems to me that we have to live, we have to have the vitality of life itself, in order to earn a living. And the whole purpose of earning a living is for the sake of living well, of enjoying life.

Sleep and all other similar biological activity, along with play as useful recreation, are the conditions of our being alive and having vitality. And these two conditions are for the sake of our being able to work so that we can earn a living, labor for commodity or for compensation. And along with labor we again include uncompensated chores. And these two things, labor—compensated labor and the uncompensated chores we have to do—are for the sake of living well. And living well consists of the leisure pursuits in which we engage and the liberal work we do and some small amount of play itself as pleasant amusement.

We can see what the wrong order of the parts of life would be. Certainly it would be wrong to sleep for its own sake. It would be wrong to play for its own sake, just to kill time or to escape boredom. I think the psychiatrists will tell you that a man who slept for its own sake or played for its own sake was indulging not only in escapism, but perhaps even a kind of suicidal neurosis.

It is almost as wrong to regard work as an end in itself instead of as a means. It certainly is wrong to regard work as something we do for the sake of play. And the third error we could make would be to order the parts of our life in such a way that we omitted leisure activities from them entirely and used our free time simply for the sake of play.

Now I should like to summarize this with somebody else's terms in mind. These basic notions about the order of work and play and leisure in human life are very old in our Western civiliza-

tion. They were discovered and understood in the fifth and fourth centuries B.C. And I think perhaps better understood then, for some of us today have tended to forget them.

ARISTOTLE ON WORK AND LEISURE

I would like to read you some short passages from Aristotle's *Ethics* and *Politics,* where in the discussion of happiness, he makes these fundamental points very simply and very well. First, I would like to read you a passage from the *Ethics* in which he says, "Happiness does not lie in amusement. It would indeed be strange if the end of life were amusement and one were to take trouble and suffer hardship all one's life in order to amuse oneself. To exert oneself and work for the sake of amusement seems silly and utterly childish. But to amuse oneself that one may exert oneself seems right. For amusement is a sort of relaxation and we need relaxation because we cannot work continuously." "Work, in turn," he goes on to say, "is for the sake of leisure as war is for the sake of peace. And happiness depends upon leisure more than upon anything else."

And then in another work of his, *The Politics,* he returned to this basic theme. And let me read you the other passage which continues this thought and, I think, develops it. "Leisure and personal development," he says, "may be promoted not only by the virtues, which are themselves practiced in leisure, but also by some of the virtues which are useful to business or work. For many necessities of life have to be provided before we can have leisure." "Yet," he adds, "we need virtue not primarily in order to work well, but to use leisure well. For the first principle, the end, or the goal of all human activity is leisure. Leisure is properly the enjoyment of life; it consists in doing the things which make a life worth living."

Now to this there is one point I would like to add. If Aristotle is right, if happiness consists in a virtuous conduct of one's work and a virtuous use of one's free time in leisure, then the two most prevalent of all human ills, the two most prevalent causes of human misery are these: one, not having the right sort of work to do, work that calls upon one's abilities and develops one; and two, having time on one's hands to kill or burn. The happy man, I would define as one who enjoys the work he is doing and has no time to kill or burn.

Now let me turn then to the second main point of today's discussion. I turn from this ethical consideration of labor and leisure to social, political, and economic consideration, and to the great revolution which has taken place for the first time in our own day.

THE TWO REVOLUTIONS IN LIFE AND WORK

Lloyd Luckman: Dr. Adler? May I interrupt to ask you about something that has been bothering me? From your reading of Aristotle, I think you have demonstrated clearly that the Greeks twenty-five hundred years ago had a magnificent grasp of this concept of labor and leisure. Now what do you mean then when you say or at least imply as you just did that we have revolutionized the understanding of these two concepts?

Mortimer Adler: I'm glad you asked me that question, Lloyd. The revolution I am going to talk about is not so much a revolution in our understanding of labor and leisure, as it is a revolution in the social, economic, and political reality concerned with labor and leisure. And I am going to have to talk to you now about the facts, turn from ideas to facts. I hope that it is permissible for a philosopher to give up ideas for facts because that is what I have to do now.

The first of the two great revolutions that changed the whole course of human life in society took place about 750 B.C. And that revolution governed human life from 750 B.C to 1750 A.D., about the middle of the eighteenth century. That is the revolution that came about when the division of labor had reached a point where some few individuals had leisure, enough leisure to develop the arts and sciences, to create constitutions and republics, and to act politically as citizens. This great change in the mode of production had, as I just indicated, two extraordinary effects on human life, one good and one bad.

The good effect is the rise of cities. People left family life and tribal life or village life, and amalgamated in cities. And with the division of labor that existed in cities, they formed republics, became citizens, and had enough leisure to develop the arts and sciences.

Just one more passage from Aristotle on this that I think is extraordinary. In the opening book of his *Metaphysics*, he says,

"The arts and sciences which do not aim at giving pleasure or of the necessities of life were first discovered in the places where men began to have leisure. That is why the mathematical arts were first developed in Egypt; for there the priestly class was allowed to be at leisure."

But the bad effect of this first revolution was that it divided men or society into two classes: a large laboring working class and a small leisure class. And it brought about the necessities of slave labor or servile labor.

The second great revolution, and in my opinion a much greater revolution than the first, took place around 1750 and it is running its course into our own day. That is the Industrial Revolution. This great change in the mode of production from hand work to machine work, from manufacturing to machine-factoring, has revolutionized the conditions of labor and the distribution of leisure. And it had, in my view, greater and more far reaching results than the first revolution. But these results are both good and bad.

Let's consider some of the basic facts. First, let's consider the change in the sources of power in the last hundred years. In 1850, human and animal muscle produced 95 percent of the goods we use and machine power only 5 percent; whereas in 1950, a hundred years later, machines produced 84 percent of the goods we use and human and animal muscle only 16 percent. Yet, in that same time as measured by 1940 prices, human productivity produced only seventeen cents worth of goods per man-hour in 1850, and produced eighty-seven cents worth of goods per man-hour of work in 1950.

Consider the effect of this change upon the work week. The facts are that in 1850, men worked 70 or more hours a week. In 1890, the work week had dropped to 63 hours a week. In 1920, it had dropped to 51 hours a week. In 1950, it had dropped to 40. Though this happened, it was accompanied by an increasing productivity as you have seen, per man-hour of work, and this indicates the extraordinary change in both production and in leisure.

Now consider the effects upon education. For instance, in 1890, only 6.7 percent of 14-to-17 year-olds were in high school. In 1920, 37.9 percent, and in 1950, 70 percent were in high school.

Then consider the political effect of this extraordinary change. In 1850, 16 percent of the population voted. In 1920, 25 percent

of the population voted. In 1950, 39 percent of the population voted. And even more striking are the figures that in 1890, only 29 percent of the population were registered to vote. In 1920, 51 percent of the population were registered to vote. And in 1950, 65 percent of the population were registered to vote.

Now let's turn from these extraordinarily significant facts and figures to the basic results of the Industrial Revolution. In all the pre-industrial societies of the past, society was divided into a laboring and leisure class, whereas with the industrial economy of our own day, we have a classless society of free persons who are both workers and persons of leisure. All the pre-industrial economies of the past were "aristocratic" in political form; the rule was in the hands of the few. Only with an industrial economy do we have democracy and universal suffrage. In all the pre-industrial economies of the past, only leisure and a few learned professions had dignity; whereas in the industrial democracy of the present, all forms of human labor have dignity.

In all the pre-industrial aristocracies of the past, most people, being slaves and hirelings, had only a two-part life of sleep and work; whereas in the industrial democracy of the present, all individuals who are citizens, workers, and people with leisure, have a four-part life. A possibility, but yet only a possibility because unfortunately the Industrial Revolution, which has these good consequences, carries with it some bad effects also. And I would now like to have you consider with me what the bad effects of the revolution is so that we can see the balance of good and bad together.

The Bad Results of Industrialization

Finally let's consider the bad consequences of the Industrial Revolution. The first is the routinization and trivialization of productive tasks, the elimination from the labor of many workers on the assembly lines, the elimination from their life of pleasure and the value of individual craftsmanship.

The second great evil of industrialization is the widespread fallacy, particularly in America today that productivity is the end of life, that the producing of more and more goods is the end of all of our efforts; whereas, in fact, we ought to regard the increase in productivity only as a means and not as an end.

And when as a consequence, when men look upon productivity as an end, there is a further, third, consequence because this has the effect of making many people think that free time should be used only for play and recreation, in order to get back to work and produce more. And those who take part in leisure properly are often looked upon as dilettantes. There is a tendency on the part of workers with leisure to use their free time for play or recreation because of the emphasis on productivity.

Finally, as a consequence of the Industrial Revolution and the industrialization of our society in every way, there has come about what I have indicated here in this last line, the deterioration or disappearance of liberal education. And this is the greatest misfortune of all because it is only through liberal education that we can hope to correct or overcome the other evil consequences of industrialization and realize the good possibilities of the Industrial Revolution.

Lloyd Luckman: I've got to interrupt you once more, Dr. Adler. And this time as an educator because to me there is an apparent paradox here. And if I see it, I think perhaps it might disturb some of our viewers as well. On the one hand, just a few moments ago, you pointed out very clearly the effects of the Industrial Revolution, which was to make possible the increase of schooling, more schooling for more children and more time for the individual child.

Mortimer Adler: Yes.

Lloyd Luckman: And now you're pointing out that industrialization has ruined education. Now, it would seem to me that it has done the very opposite to ruining education. And I think then that you must have either something more in mind or there is this paradox.

Mortimer Adler: Well, I think there is this paradox, Lloyd, but I think it is only apparent. On the one hand, industrialization, the basic changes in labor and leisure, have made it possible for the first time to give liberal education to all children and all adults. On the other hand, while the quantity of education has increased for all and for each, the quality of education has diminished; it has become less and less liberal.

And this, Lloyd, is my basic point: that education for all must become more and more liberal if we are going to realize the good possibilities inherent in the Industrial Revolution, the political

possibilities for democratic citizenship, and the ethical possibilities for the best use of leisure and the good or happy life.

Now that is our subject for the next time. Next time we want to deal with the problem of liberal education in an industrial democracy in which all men are citizens and all men have leisure to use well or waste. And whether they use it well or waste it is finally up to liberal education. That is the problem of liberal education in an industrial democracy.

35 Work, Leisure, and Liberal Education

Our last discussion, when we looked at the Industrial Revolution and its effects on the organization of labor and the distribution of leisure, prepares for our consideration of education this afternoon.

Let me remind you of the main conclusions we reached. We saw the great advantages that accrued to individuals and to societies from the Industrial Revolution that took place largely in the last two hundred years. We saw how the industrial mode of production broke down, almost abolished, the sharp distinction between a working class and a leisure class. We saw the effect it had on establishing for the first time the dignity of all forms of labor. And we saw the political effect, how as individuals became emancipated from grinding toil they now had the leisure to participate in the rights of political suffrage and the duties of citizenship.

But we also saw the evil consequences of the Industrial Revolution. We saw how as free time increased, people tended to misuse this free time by using it for recreational play instead of for genuinely leisure activities. And we also saw, or at least I made the statement, that with these changes there was a progressive deterioration in liberal education.

SCHOOLING HAS RISEN, EDUCATION HAS DECLINED

Mr. Luckman challenged that last statement of mine by pointing to the obvious fact that in the last fifty years, with the rapidly increasing Industrial Revolution, education was on the increase; it seemed to be improving, not deteriorating.

I mentioned last time that in the United States there has been a great expansion of the proportion of 14–17-year-olds in high school. Another indication is that at the time of World War I, 75 percent or more of the draftees had had eight years or less than eight years of schooling; whereas at the time of World War II, twenty years later, 68 percent of the draftees had had nine years of schooling or more. And 39 percent had had twelve years of schooling or more as compared with only 9.5 percent twenty years earlier.

Now, Lloyd, it seems to me that what these facts show is that schooling has been on the increase. But if you look at the facts, it is clear that this is a quantitative improvement, not a qualitative improvement. If we ask ourselves, what about the quality of education in the last fifty years, has that improved? It seems to me there, Lloyd, the sad fact is that as schooling has increased more and more, education has deteriorated, for it has become less and less liberal.

And if we put the emphasis on the word *liberal*, then we understand, I think, the point about the deterioration of education in the last fifty years. Now that brings us to the main point of this afternoon's discussion. And I think we can start, Lloyd, with two questions we received: one from Mrs. Cavanaugh, I think, and one from Mr. Starkey.

Lloyd Luckman: Yes, that's right. Here's the one from Mrs. Cavanaugh. She is a resident of Livermore. She says, "Since so many connotations attach themselves to the term 'liberal', will you please preface your discussion with an explanation of the term as applied to education?"

Mortimer Adler: I certainly am glad you restricted your question, Mrs. Cavanaugh, to "liberal" as applied to education; for to define liberal in a political sense as a name for one of the great parties or positions contrasted with the conservative position or the radical position is very difficult indeed. You probably have heard the definition for "liberal" that is given either by the conservative or by the radical who doesn't like the liberal. He says the liberal is a man with both feet squarely planted in midair.

But to explain what "liberal" means as applied to education is not so difficult. In fact, one catches the meaning immediately one recognizes the word "liberal" has the same root that the word "liberty" has. And that root means in Latin, "free." And so, you can

define liberal education by saying it is education for free human beings. It is the education of free people and for their use of freedom, the freedom they have to use because they belong to the ruling class of society and because they belong to the leisure class of society. I think that is a perfectly clear definition of what liberal means as applied to education.

The Meaning of Liberal Education

Lloyd Luckman: Well, with that in mind then we can go on to the second question which follows quite hard on Mrs. Cavanaugh's question, Dr. Adler. And I think it may be harder for you to answer it so briefly. It comes from Mr. Elmer Starkey of Petaluma. It is very short and sweet. He says, "Just what does a liberal education consist in?" And that is all Mr. Starkey wants to know.

Mortimer Adler: That question, Mr. Starkey, calls for a book, not a sentence or two. And because it calls for a book, I'm going to recommend some books which you and others may be interested in to read on the subject of what liberal education consists in. I have here a long list of books about liberal education from the fifth century B.C. down to our own day. I'm only going to recommend four, written by three Americans, that I think are excellent on the subject. One is the book by John Dewey, the great book at the beginning of the century, *Democracy in Education,* published in 1916. And then a book by Mark Van Doren in 1943, called simply, *Liberal Education.* Then, two books by my friend Robert M. Hutchins. One in 1943, called *Education for Freedom* and one published in 1951 called *The Conflict in Education.*

Now that doesn't answer your question, Mr. Starkey, but let me see if I can, in two sentences that will be brief and inadequate, say what liberal education consists in. I would say, first, in school, liberal education consists in acquiring the disciplines of learning, learning how to learn; and then in becoming acquainted for the first time with the ideas that one must spend a lifetime in trying to understand. And then I would say, second, that in adult life liberal education consists in using the liberal arts which are the disciplines of learning, the disciplines acquired in school, to carry on the process of learning and the lifelong pursuit of understanding, insight, and wisdom.

Now with these two questions answered, Lloyd, I think I can
state my main propositions, the ones I should like to explain and
perhaps even defend against objection. They are that the universal
distribution of leisure and suffrage that accompanies industrial-
ization requires an industrial democracy to give liberal schooling
to all the children who are going to grow into free men and
women, free in the sense of having leisure time, free in the sense
of being citizens. The purpose of this liberal schooling is to pre-
pare these children for the use of the leisure they will have when
they grow up, and one of the main uses of leisure itself is to con-
tinue learning throughout an adult life.

In all the pre-industrial aristocracies of the past, education was
only for the few, that few being a leisure class and a ruling class.
And that education for the few consisted of liberal schooling and
adult, liberal learning. There was no education for the many at all.
There was no need to educate unfranchised slaves and workers.
They had no freedom, they had no leisure, they were not citizens;
they needed no education. All that they received was training on
the job. And, of course, there was no learning, no time for learn-
ing in their adult life.

I want to stress the fact that in all the pre-industrial aristocra-
cies of the past, education was liberal education. One didn't talk
about some education being liberal and some being vocational.
Education was liberal education. One didn't talk of vocational
training as education at all; it was the training of workers or slaves.
And when one saw education itself as essentially liberal, one saw
that it could not be accomplished in school, that it could only be
begun in school, that the main points and purposes of liberal edu-
cation had to be fully accomplished in adult life.

In an industrial democracy—in which all persons are citizens,
and as citizens, citizen rulers, and in which they are all not merely
workers but free workers, workers with dignity of labor and there-
fore with leisure—in such a society one would expect that there be
liberal schooling for all and that there be opportunities and pro-
visions for liberal learning in adult life for all.

THE FAILURE OF AMERICAN EDUCATION

But is this the situation in America today, the most advanced,
industrial democracy in the world? I'm sorry to say the answer to

that question is no. What we find instead is this: we find that in the United States of America, what we have achieved is approximately eight years of common schooling, ordinary elementary schooling for all children, which by itself is, I think, woefully insufficient as preparation for citizenship and leisure. And past the eighth grade we divide our children. We give liberal schooling, and I'm sorry to say it isn't too good at that, but liberal schooling, to a minority in the liberal arts high schools and colleges, many of which are not liberal enough. But for the majority, for most of the children, after they leave elementary school, we give them vocational training in school instead of on the job. And we certainly have, I think, clearly inadequate provisions for the liberal education of adults in a country where most adults have an enormous amount of leisure.

I think one can understand why that failure of American education took place. The problem of giving liberal education to all the children, which is required in an industrial democracy, is a very difficult problem, much more difficult than any problem that educators have faced in the history of mankind. And that problem hit American education with a suddenness for which they were unprepared, so that they hardly saw the problem as it overtook them and in some sense swamped them. This, I think, excuses American educators for the first twenty-five or thirty years of the century from not doing what should have been done. But what is inexcusable in my judgment is the fact that American educators are still not facing the problem. They are still permitting this division between liberal schooling for the few and vocational training for the many to be widely prevalent in our school system. They are still not facing the problem; they are running away from it when in fact this problem cannot be solved unless it is faced and dwelt upon.

I do not mean to imply that I know the solution to the problem. In fact, I would say there is no American educator who at the moment knows how to solve this problem. All that can be said is what is required for its solution. We must discover, somehow discover by hard thought and patient effort, the ways and means of giving all the children the same kind of education, the liberal education that was given to the select few in all the pre-industrial aristocracies of the past.

Lloyd Luckman: Dr. Adler? I agree with you about the problem we must solve and also what is required to solve it, but I know a

great many educators and many teachers too who wouldn't agree with you. And I'm just wondering how you would answer their objection?

Mortimer Adler: What is their objection? They only have one objection, Lloyd?

Lloyd Luckman: No, No. I'm sure that you know very well that they have many objections. But there is one that goes to the very heart of this particular matter. It is simply that the facts are against you. We have this problem that most of the children, at least half of them, just haven't the capability of profiting by a liberal education and therefore we are faced with the choice of providing vocational training for those children who do not profit by the liberal education.

Mortimer Adler: Lloyd, I think that that is a basic mistake, that people who say that are misunderstanding the democratic maxim of equal educational opportunity. They think the maxim is correctly stated when they say we give equal educational opportunity to all the children because we give them equal amounts of schooling. That is an incorrect understanding of the maxim, I think. The correct interpretation of that maxim is that equal educational opportunity means the opportunity for all the children not merely to have the same amount of schooling, but to enjoy receiving the same kind or quality of schooling, and that quality must be liberal.

And I say, Lloyd, that all the facts, which I am willing to admit, certainly must admit, all the facts of individual differences, do not change one bit, or in one particular, the principle I've just stated.

Let me show you that. I have here two containers. Here is a quart container; here is a pint container. Let the quart container represent the quart-sized child, the child with a quart-sized capacity for receiving liberal education. Let the pint-sized container represent the pint-sized child, the child with a pint-sized capacity for receiving liberal education. Now what does the democratic maxim of equal educational opportunity for all the children mean? Does it mean putting merely the quantity of liquid these two containers can receive into them, putting cream into the large container and milk or skim milk or, worse, water into the small container? As compared with liberal education, vocational training is mere water. No. It does not mean that. What we are required to do with these two unequal containers, representing the unequal gifts of natural endowment, is to put the same kind of liquid in both: a

quart of cream if we can manufacture the cream of liberal educa-
tion, a quart of cream into the quart container and a pint of cream
into the pint container. That is treating the two children equally.

Now I say that American education today is as wrong in princi-
ple as Thomas Jefferson was in 1817, as undemocratic in principle
as Thomas Jefferson was, when he proposed that the Virginia leg-
islature availed to give all the children of Virginia three years of
common schooling and no more than that. And then beyond the
third year he suggested dividing them into those who were des-
tined for labor. They would be sent out of school to the farms, to
the shops as apprentices; and those destined for leisure and for
politics, they would go on to college. Are we much better than that
today? Yes. In one sense we are; we get eight years of common
schooling, but that merely is the result of the Industrial
Revolution. We give eight years of common schooling, but after
that we divide the children just as Thomas Jefferson would have us
divide them: into those destined for labor and those destined for
leisure and for rule, whereas, in fact, they are all destined for
leisure and for political life.

ALL CAN BENEFIT BY LIBERAL EDUCATION

The ideal we must embrace is to give all the children not merely
eight years of common schooling, but adequate liberal training,
liberal schooling through high school, and I would go further and
say through college—all the children up to and through a
Bachelor of Arts degree, which is the training, the education they
should receive in preparation for their role in the life of freedom,
the use of their own leisure and the performance of their political
duty.

Now I have to face the facts. If that ideal cannot be realized,
then we ought to give democracy up, give it up entirely and return
to the aristocratic forms of society in which the free were separated
from the slaves, the men with leisure and the ruling classes were
separated from the disfranchised many who were slaves or workers.

Because, I say to you, to give suffrage and leisure to those who
are incapable of liberal education is dangerous to society and dan-
gerous to the individuals themselves who have this leisure and
are not educated to use it. I don't think that is the case. I think all

persons can receive liberal education. But if they can't, then we
ought to give democracy up.

Lloyd Luckman: Well, Dr. Adler, again, let's suppose that this
ideal that you're stating can be realized, however far off that real-
ization might be. But there is still another difficult problem to
solve here, and it's in a question that I have about the relationship
of liberal education to labor this time, not to leisure.

Mortimer Adler: I'm glad we make that shift, as a matter of
fact, Lloyd.

Lloyd Luckman: Mr. Nelson, I think, points it out very well, Dr.
Adler, when he asked you, "If everyone is liberally educated," he
says, "what are we going to do about the menial and disagreeable
tasks that no one with a liberal education would then want to work
at?"

Mortimer Adler: Lloyd, I think that the question is a very good
one. Mr. Nelson asks the question that is always asked. I've talked
to many audiences about liberal education over the years and it is
interesting how when you propose the possibility, the ideal that all
the children will go to college some day, that they all will get a lib-
eral schooling in which there is no vocational training whatsoever,
they'll all be prepared for a life of leisure and of citizenship, some-
one in the audience always asks the question, Mr. Nelson, "And
what are you going to do then about the lower tasks, the less pleas-
ant tasks, the more menial tasks in the hierarchy of tasks that con-
stitutes the division of labor in a complex, industrial society?"

Now there are two answers. The first answer is suggested to us,
Lloyd, by one of our correspondents, Mr. Edward C. Keetche, who
teaches industrial engineering at Berkeley, at the University of
California. And Mr. Keetche in his letter suggests that the auto-
matic or the push-button factory of the future will do away with a
great many repetitive manual jobs, and so eliminate a great deal of
drudgery from the labor men have to do. But that's only part of
the answer, Mr. Nelson.

The other part is that the scale of individual differences will
remain unchanged after all individuals are liberally educated up to
their capacity: whether the quart-size capacity or the pint-sized
capacity. So there always will be human inequality and that human
inequality will always fit the hierarchy of tasks, even when many
menial tasks will be removed by the push-button factory and labor
has been liberalized and all workers are liberally educated. I don't

think there's any problem about the fitting of men into the complex hierarchy of tasks that a society requires.

Lloyd, I think we have time for one more question.

Lloyd Luckman: Very well. Mr. Asturias of Oakland wants you to tell him whether women should have the same sort of liberal education as men in our industrial age.

Mortimer Adler: Mr. Asturias, that again is a question I think very good and familiar. It is a question asked again and again, is it not?

One thing we should face at once, are women citizens? Do women have leisure? Even when they work, even when they have housework to do or when they are office workers? If they are citizens and if they have leisure, then they need liberal education just as much as men do.

But I always like to say one more thing here. If women don't work, and I suppose, Lloyd, there are some women who don't work, either housework or any other kind of work, they have more leisure than any man in an industrial society has, and therefore women who don't work need liberal education even more than men do. For liberal education is an indispensable condition of their being saved from the misuse of their free time and their having ways of using it well.

36 How to Think about Law

Today we begin the discussion of lore. Preventing any misunderstanding, let me say at once that though a moment ago you may have thought that you heard me say "lore," I said *law*. The subject for discussion today is law, not lore.

I was born in Manhattan, which is unfortunately very close to Brooklyn. When I first came to the University of Chicago and started to teach the philosophy of law, I noticed a puzzled look on the faces of my students for the first few months. Many of them thought they were in the wrong class. They gradually understood that it was simply a mistake of pronunciation on my part, that I really was teaching the philosophy of law, not the philosophy of lore.

Let me begin this discussion of law by calling your attention quickly to some obvious facts about the meaning and significance of law in our thinking and in our actual life. In our thinking the idea of law is closely connected with other basic notions, with those of justice and liberty and government and peace. For example, on the Supreme Court building there is the phrase that we all we know so well: "Equal justice under law." With respect to liberty we all know that the basic opposition is either freedom from law or the development of liberty under law. And as you may remember from our discussion of government, the three great functions of government are connected with law: the making of laws, the application of laws to particular cases, and the enforcement of laws.

Perhaps the one connection that may not be immediately clear here is the connection between law and peace. Let me make this connection clear by reading you two statements about law,

one by the great Italian political philosopher Niccolò Machiavelli, the other by the English political philosopher John Locke. Machiavelli says, "There are two ways of contesting: the one by law, the other by force. The first method is proper to men, the second to beasts." And a century or more later, John Locke, repeating the first phrase, said, "There are two sorts of contesting among men: the one managed by law, the other by force." And he comments on this by saying that "when we manage our contests or differences by law, the thing we call 'peace' reigns. But when we have to manage our differences or our contesting by force, then we have war." And he goes on to say, "Where the one settling things by law ends, the other settling them by force always begins. The reign of law is the reign of peace; the absence of law is war."

Now another way of catching quickly the importance of law in human life is to remember that one of the three great learned professions is the profession of law. Law, medicine, and the ministry of God represent the three most ancient and most important of the professions in which men engage.

There's a third way of remembering or holding before our mind the importance and the meaning of law in our lives. Here is our general sense of what we mean whenever we think of anything as being lawful on the one hand or lawless on the other.

Let me show you this quickly. The opposition in our minds between the lawful and the lawless is an opposition between order on the one hand and chaos on the other. Whatever is lawful is in order; the lawless is the chaotic. It is an opposition between the right on the one hand and the wrong on the other. The lawful is the right; the lawless is the wrong. And in general we have the deep sense that the lawful represents reason in our lives, the rule of reason, whereas the lawless represents the uncontrolled reign or rule of force.

Now if I turn from these lofty considerations to your own everyday sense or consciousness of the law, its impact on your life as its impact on my life from day to day, I think I would say that the most prevalent sense we have of the law is the image of the law in the shape and color of a policeman. We often call a policeman walking down the street "the law." We say, "There goes the law." And along with that image of a policeman as the symbol of the law is the image or the other images we have in our minds of the consequences that follow upon our being on the wrong side of the law.

It's unfortunate if we allow the criminal law to occupy the central place in our minds. We ought not to identify the law with the criminal law and with the apprehension, trial, and conviction, and punishment of criminals. However important that criminal law is, it is actually only a small part of the law's contribution to our daily lives, the conduct of our businesses, the regulation of our domestic and corporate affairs, the protection of our property, our rights, and liberties. Alongside the criminal law there is the civil law.

What Is Law?

Lloyd Luckman: Dr. Adler, one of our correspondents, Mr. Charles J. Croddy, of San Francisco, agrees with you about the importance of law in our everyday lives. He says, as you do, that the law seems to enter into every aspect of our lives. But he has a number of questions which he would like for you to answer. For instance, he asks first, "What is law? Is everything that exists governed by law? Must every law be obeyed?" And his final question, "Can some human beings obey or disobey laws as they choose?"

Mortimer Adler: That's quite enough, Lloyd, to start us off. In fact, that very first question, Mr. Croddy, "What is law?" will hold us for a while, though in the course of answering it, I hope to be able to throw some light on the other questions which you have asked. I hope that, as I go on now, all these three very basic questions that you have asked can be answered.

Let me begin with the first question, "What is law?" I think there are three things in our basic understanding of law. The three things are that the law is always a general statement, that it is a rule, and that it's the sort of rule which is an instrument for the government of a community of men. A particular decision is not a law because it is not general. A scientific "law" or generalization is not a law because it is not a rule of conduct. And rules are not laws if they are rules of art. For rules are laws in our sense only when they are instrumental in the governing of a community of men.

Let me explain these three points a little more fully. Let's take generality first. For example, the statement "This matchbox is here and now falling to the desk," is not a law. It is a statement about this particular event. A law must be a general statement. It must

apply to all things of a certain kind and to every possible action of a certain sort. For example, in contrast with the statement I just made, the statement "that all bodies within the earth's atmosphere tend to fall to the earth at all times and places," that is a scientific law. It is the familiar law that you know as the law of gravitation. But the law of gravitation, though it is called a law by scientists, is not a law in the sense in which we are talking about it this afternoon. It is not a rule of law.

In all of the thousands of laws contained in the books on the shelves of a law library, there is not a single law like the law of gravitation. The laws in law books are all rules of conduct. Let me explain this distinction between a law like the law of gravitation, which is a scientific generalization, and the laws that exist in law books, which are rules of conduct.

The word "law" divides into two kinds of general statements: descriptive general statements and prescriptive general statements. Descriptive general statements which are called laws are scientific generalizations. They are statements which describe how things do in fact behave. And such statements cannot be disobeyed; they are the inviolable laws of nature. Here as Immanuel Kant said, "We have law in the sphere of physical nature, in the sphere of things bound by necessity." But if we turn to law in the other sense, law as prescriptive, we then come to something quite different from scientific statements. These are legal rules when they are prescriptive laws. They state not how things do behave but how men should behave. And such rules can be disobeyed; they are violable, capable of being violated, rules of conduct. And here we have law not in the sphere of necessity but in the sphere of freedom, of human freedom. This is a fundamental distinction between laws in two basic senses and we are concerned in this discussion only with law as rules.

You see, Mr. Croddy, that there is a sense in which law does govern all things, but the laws which govern all things are of two kinds. All things other than men are governed by the kind of laws which are the descriptive, scientific generalizations the physicists and the chemists and others discover; whereas men in addition to being governed by those laws are governed by the rules of law which are made in society.

But are all the rules that guide or direct human beings, are all these laws? The answer to that is no. There are many rules in

human life which are not laws. For example, all the rules of art, the rules of cooking, the rules of driving a car, the many rules that govern the particular operations of our daily lives, these are not laws. Why are they not laws? Because they are not rules involved in the government of a community of men. What we mean by a legal rule as opposed to rules of art or other rules of operation are rules that are instrumentalities in the government of a community.

That explains, I think, why we use the phrase "law and order." Because law is the principle of order in a society. And what do we mean by that? We mean that it actually brings a one, a community, a single unit out of the many. You all know the phrase on all the coins we use, *e pluribus unum,* making a one out of a many. Well, a one cannot be made out of a many without law; for law is what regulates the conduct of individuals in such a way that they can live together and act together. Law can produce the concerted action of a multitude of men for a common good rather than for their individual interests.

Two Views of Law

So far, so good. We understand that laws are general rules governing communities of men. On this much all students of law, all philosophers of law, tend to agree. But once we go beyond this point, we get into deep water. We meet one of the most fundamental differences in the philosophy of law, in human thinking about law.

Let me present this fundamental difference, this fundamental conflict about law to you in the shape of two theories, two radically different and opposed theories of what the law is. I'll begin with the view of law taken by Thomas Aquinas in the thirteenth century. It was held by Aristotle in the fifth century B.C. It was held in the eighteenth century by John Locke, the great English political philosopher, and by our own founding fathers.

This view can be stated in the following way: "Law is a rule made for the common good of a community, grounded in reason, instituted by the will of a duly constituted authority and having coercive force." Let me comment on that statement. A law is not a law if it is not for the common good but is only something to serve the interests of a private person. A law cannot be made by anyone,

not even by someone with the power to enforce it; it must be made by a duly constituted authority, either by the whole people or by their representatives and with their consent. Without such authority law is law in name only, for otherwise it is merely an expression of force. But law, though it must not be merely an expression of force, cannot lack force either. Because without coercive force a rule of law would be merely advice or counsel, because to be effective as law in the governing of a community of men, the law must bind bad men as well as good men. And the law binds good men through its authority and reason in conscience. But bad men it must bind by the application of its coercive force and by their fear of punishment. Remember that now, in the case of good men the law has its binding power by binding them in conscience because of its authority and its being grounded in reason. In the case of bad men, they are bound only by fear of punishment.

The opposite theory of law was first stated by a great Roman jurist Ulpian, at the time when the Roman emperors were at their tyrannical worst. And according to Ulpian, the statement of the nature of law is as follows, a magnificent statement of the opposite view: "That which pleases the prince has the force of law." You can substitute for "prince," "government," or "party" and "power." That which pleases the prince has the force of law. It need not be for the common good. It can serve the interests of the most powerful man, of the prince, the dictator, or the party in power. It need not be grounded in reason. It can be a rule imposed by the will of a prince or by anyone who has the power to enforce a rule. The prince need not have authority by consent or as a representative of the people. He can seize power as a tyrant does. The law then is merely an expression of his power, an expression of force. And hence, such laws bind all people in one way and one way only, by their coercive force, by the fear of punishment they arouse. And so far as their attitude towards law is concerned, it obliterates the distinction between good and bad individuals subject to law.

Now this view of the law is not held only by Ulpian. It was held later by the celebrated English philosopher Thomas Hobbes, the great defender of absolute monarchy in England. And it was held recently in the United States by Oliver Wendell Holmes.

Let me read you two statements to show this, one from Hobbes and the other from Holmes. Hobbes, for whom law is a command—and a command is an expression of will, not of

reason—says, "All laws written and unwritten have their authority and force from the will of the sovereign. No law can be unjust then, for the law is made by the sovereign power and all that is done by such a power is warranted."

Mr. Justice Holmes in a famous speech that he made for the Harvard law school said, "What constitutes the law? You will find some writers telling you that it is a system of a reason, that it is a deduction from the principles of ethics or whatnot, but if we take the view of our friend the bad man, we shall find that he does not care two straws for axioms of deduction. All he wants to know is what the courts are likely to do in fact." Then Holmes goes on to say for himself, "Not merely for the bad man, the prophecies of what the courts will do in fact, and nothing more pretentious, are what I mean by the law."

To summarize the view of law taken by Aristotle, by Aquinas, by Locke, by our Founding Fathers, and by many others throughout the whole history of human thinking about the nature of law, thinking we call *jurisprudence:* law is regarded as something grounded in reason and instituted by will. Because it is grounded in reason and instituted by will, it is something which combines authority and coercive force. And because it combines authority and coercive force, it binds human beings both in their consciences to obey it and through fear of punishment. It binds good men in their conscience and bad men through fear. Such law is certainly what we regard as a reasonable thing. It is law looked upon as reasonable law.

The opposite picture of law is the view taken in the ancient world by men like Ulpian, in our time, in the modern world, by the great English philosopher Thomas Hobbes or by Mr. Justice Holmes. The law is something imposed by the will, not grounded in reason, strictly imposed by the will. Since it is imposed by the will and the will alone, it is something which has force alone and no authority except the authority of force itself. And it binds through fear alone, not in conscience. Such law is what we mean by arbitrary law.

Let me emphasize this. When law has authority it is reasonable law; when law is imposed by the will it is arbitrary. The very meaning of imposed by the will is the meaning arbitrary law.

Lloyd Luckman: Your summary, Dr. Adler, I think leads quite directly to the question that I think you'll remember we received from Allen J. Flores.

Mortimer Adler: Yes, I do remember the question. It's a very good question.

Lloyd Luckman: He's in Richmond and he writes to you as follows. He refers first of all to the age-old argument that law is made in the interest of the strong. And this was first stated, or at least was stated very early, by Thrasymachus in Plato's *Republic.*

Mortimer Adler: Right.

Lloyd Luckman: Mr. Flores goes on to say, "If this is so, that law is made in the interest of the strong, what validity would people of a democracy have in saying that their form of government is superior to any other form of government?"

Mortimer Adler: That is precisely the point, Mr. Flores, of the basic conflict about the nature of law between the two theories I have just stated for you. The position of Thrasymachus in Plato's *Republic* is the same in essence as the position of Ulpian or of Thomas Hobbes or of Mr. Justice Holmes, or of anyone that holds that law is an expression of might, not right. On that position, on that view, democratic laws as you indicated in your question are no better than tyrannical laws or the laws of a tyrant. And democracy as a form of government is no better than tyranny. In fact, Mr. Flores, on that view, all government is tyrannical.

But if we take the opposite view, which I describe as coming from Aristotle, Aquinas, Locke, our Founding Fathers, and many others, law is then something not made in the interest of the stronger, but for the common good. And moreover, it must either be made as John Locke said, "with the consent of the governed" or as Aquinas said, "by their representatives." On this view, democracy is much better than tyranny. On this view, I think I could show you why democracy is the best form of government, a supremely just form of government.

Now, Lloyd, this basic issue about law which we have been considering this afternoon leads to a great many other basic issues, such as the issue about the justice of laws or the distinction between good and bad laws. And it leads to such questions as the question I think raised at the beginning by Mr. Croddy as to whether disobedience to law is ever justifiable and under what circumstances disobedience to law is justified.

Those who hold these opposite views about the nature of law tend to give opposite answers to these issues and questions. For example, according to the view that whatever pleases the prince

has the force of law, there is no standard for measuring the justice of laws. As Thomas Hobbes, from the passage I read to you said, "If law comes from the sheer power of the prince, then you can't talk about an unjust law; law is the standard of justice and justice cannot measure good and distinguish between good and bad laws."

Now to deal with these issues, not only this issue this afternoon about the nature of law in which we find such radically opposed views, but these other issues about the justice or goodness and badness of laws and the very difficult question whether disobedience to law is or is not ever justifiable, I think we must consider a number of things. We must consider the different kinds of law. Is the kind of law we've been talking about this afternoon, the law of the state, the law of California, the law of the federal government, is that the only kind of law that governs men, that is a rule of conduct, that is instrumental in the governing of a community of men or are there other kinds?

And in addition to considering the different kinds of law, we want to ask ourselves questions about how law is made. What is involved in the making of laws? And then, we ought to be able to go from that to the last and what must be for us—for anybody, I suppose—the most ultimate of all questions, the question about the justice of law. By what standard are laws good or bad, just or unjust, expedient or inexpedient? Or, can it ever be said, as some people seem to think, that one can't talk about the justice of laws, for law is the source of justice and not justice the measure of the goodness and badness of law?

Now these are the issues we expect to take and discuss in the next few weeks. In fact, the order of our discussion will be, next week, the kinds of law, and then a discussion of the making of laws, and finally in the fourth of our discussions, a consideration of the justice of laws.

37 The Kinds of Law

We continue this afternoon thinking about the Great Idea of Law. I would like to remind you of what we learned last week concerning the elements in our everyday conception of law. We saw that law consists of rules of conduct which men may obey or disobey. We saw that laws are generally understood to be made by those who are charged with governing the community, that government is in some sense the source of law. And we saw that as we understood law in general we thought of laws as being good or bad, just or unjust laws. And we even considered the possibility that there is sometimes justification for disobeying the law.

The familiar image of the law that all of us carry around in our minds is something like the law of San Francisco or the law of California or the law of New York or of the United States or of England. And when we have this image of the law before us we come to two other considerations. We think of the law as changing from time to time. We think of it as being different in different countries, in different places of the world.

Now I should like to project for you the main points of our discussion today by posing three or four questions. First, are there different kinds of law? And when I say different kinds of law I don't mean different in content as, for example, traffic laws different from licensing laws or civil law is different from criminal law; I mean more fundamentally different in the way in which they are made or in the way in which they rule man's conduct. My second question is, if there are different kinds of laws, how are these different kinds of law alike as law and how do they differ? And what kind of law is the familiar kind of law, such as the law of California? Finally, are these different kinds of law

related in any way? Do they ever come into conflict with one another?

Now, Lloyd, it occurs to me that it may help us to make these problems that I've just stated a little more concrete, a little clearer, if you would read some of the questions we have received about the kinds of law. As I recall, Lloyd, words or phrases were used which indicated that the writers had in mind different kinds of law. Why don't you read all of these questions and let me make notes while you do, so I can answer them all at once?

Lloyd Luckman: You're quite right, Dr. Adler, and I have the questions set aside right here precisely because they call attention to the fact that there are different kinds of law. They are rather direct, short and sweet questions, right to the point.

Mortimer Adler: Good.

Lloyd Luckman: My first one is from Mrs. M.F. Pritchard who lives in San Francisco and she asks, "What is meant by the unwritten law? Is the unwritten law law in the same sense as the statutes of California? And the next question from Mr. Peter Raven in San Francisco, and he reminds you that you said last week that laws are made by a government or a governing body and therefore are enforced by that same body. And he asks you, Who then makes international law and who enforces it? And my third question is from Mr. Samuel Ziglar in West Lake. It's a little longer and states first, "The Declaration of Independence speaks of the laws of nature and of nature's God. Does this mean," says Mr. Ziglar, "that the laws of nature and the divine law are the same thing? I would also like to know whether the laws of nature which a scientist discovers, for example, Newton's laws of motion, are all that is meant when the lawyers speak of the natural law?"

Mortimer Adler: Those are very good questions, Lloyd. Let me see if I can answer them now with the utmost brevity, in the hope that the rest of our discussion will explain them more fully.

Lloyd Luckman: Right.

Mortimer Adler: No, Mrs. Pritchard, the unwritten law is not the same as the law of California. What most people mean when they say the unwritten law is the natural law, though sometimes they understand by the unwritten law the customs which have the force of law; and then the unwritten law is very much like the law of California.

International law, Mr. Raven, is divided into two parts: general and special. What we mean by special international law consists of the contracts, compacts, or treaties between sovereign states. And when these laws are broken they are usually enforced by war and war alone. On the other hand, what is meant by general international law consists of the very general principles and precepts of natural law. No governing body makes these laws and none enforces them. Again when these are breached, war is the only remedy.

HUMAN AND DIVINE LAW

Finally, Mr. Ziglar, the laws of nature are not identical with the divine law in every sense. In one sense they are the same, in another sense they are distinct. We shall see this presently, the sense in which divine law is not always the same as the law of nature, the kind that is referred to in the Declaration when the Founders speak of the law of nature's God. Moreover, what the lawyer means by natural law, Mr. Ziglar, is different from what the scientist means by natural law. For example, when the lawyer talks about natural law, he doesn't mean Newton's laws of motion.

Now I hope that these three points which I have just made very briefly in answer to your questions will become clearer as we go on now with the discussion of the kinds of law. And I would like to present two ways of distinguishing different kinds of law. The first way is in terms of the source of law and the subject of law. Who makes the law and who obeys it? Who is subject to its rules? Here the principal, the primary distinction is between God and man as the source of law.

Moses receiving the Law, the divine law, the Ten Commandments, on Mount Sinai is a symbol of the divinely revealed law. The Senate of the United States, a body of lawmakers, exemplifies manmade law, quite different from divine law. One body of law, divine law, is made by God. The other body of law, human law, is made by man. But I said a moment ago that law, the kinds of law, can be distinguished according to their source or according to their subject, who obeys them.

Let's first look at divine law; and there I think we will see that there is a threefold distinction in the subjects of divine law. Divine

law, or one part of it at least, is that which is divinely revealed to man. Man is the only subject of this law, only man receives a law like the Ten Commandments from God.

A second part of the divine law is, as the theologians tell us, that part which exists in the very natures of things. As God created things, the very laws of their nature He created. And this is the sense in which we speak of the laws of nature's God and these laws, the laws in all other things outside of man, other than man, which are in them by their very creation, are the laws the scientist discovers when he discovers the laws of their properties or the laws of their action.

And there is a third part of divine law, that part which is specially present in man in his creation because God created man, the theologian tells us, as a creature with free will and with moral sensibility. This is the moral law of human nature. It is often called the natural moral law and it is different from the law of inanimate things or the law of other living things.

As I say these are the three parts of divine law and of these three parts, two are alike and one is different from the other two, for the laws which inanimate things, bodies, are subject to they cannot disobey; whereas human beings can disobey the divine law that is revealed to them and the divine law that is implanted in their nature.

Let us look now at human law, the laws which humans make, and ask who is subject to them. Here again we can think of a threefold division. The most obvious parallel to the threefold division of the divine law is that humans are subject to human law. Men make laws for men even as God makes laws for man.

Do human beings make laws for anything else in the universe other than human beings? When you think of this, you think of two other things. You think of domesticated animals. In a sense don't humans put their laws, their rules into the domesticated animals that are used for labor or for pleasure, by training the animals, by instilling human rules into them as matters of habit and punishing them when they disobey? In this sense there is a way in which humans do rule animals by laws. And when humans create things, invent things like machines, don't they build right into these artifacts the rules of human art, so that the machines obey without violation, without disobedience the rules of art which himans have built into their very structure?

We first distinguish law according to its source, God and humankind as lawmakers. And we speak of divine law and human law. And then looking at divine law, but now in terms of who is subject to it, we see a threefold division. Humans are subject to divine law as receiving the revealed law of God. Humans are also subject to divine law as having moral precepts instilled into their very nature. And humans as well as all other earthly creatures are subject to divine law as having created natures in which that law is present.

Now let's look at human law and see and ask who is subject to human law. Again humans are subject to human law as receiving that law when it is promulgated by a legislature or a government. And domesticated animals are subject to human law as having human rules drilled right into them. And in the third place, the machines which people have themselves constructed are subject to human law as having the rules of human art built right into them.

Now let's turn to the second distinction. And this time we are going to be concerned only with the laws to which humans are subject, not human laws in the sense of what their origin is, but human laws in the sense that these are the laws to which humans are subject everywhere. And these laws we are going to be concerned with are all of the same kind in this sense for we are going to ask, Are there different kinds of humans laws? Of all the laws to which men are subject can we make any further distinction?

Go back to the question raised by Mrs. Pritchard, Lloyd. It seems to me that the usual distinction among human laws as to whether they are written or unwritten is unsatisfactory because the unwritten law, as I think I said in talking with Mrs. Pritchard before, the unwritten law stands for a number of things. Sometimes it means the customary law of the land, the things which have the force of law because they are well-established customs; these are not written. In another time, in another sense judge-made law in the Anglo-American tradition of law, the common law as opposed to statue law is called the unwritten law. And there is the third sense of unwritten law in which the unwritten law means the higher law, not made by men or human communities at all, neither made by judges or customary in any sense.

Positive and Natural Law

A much deeper distinction among all human laws is the one I'm going to state for you in these terms: The principle distinction is, are the laws to which humans are subject made by humans or discovered by humans? I'm going to make three preliminary remarks before I develop this distinction. In the first place, whether the laws we are talking about are made or discovered, they are rules of conduct which people can either obey or disobey. In the second place, though I may speak of some of these laws as discovered, not made, I am not begging the question at this point whether they are made by God or not made at all. One can talk about these laws that are discovered without any reference to who makes them. Maybe they are not made at all. Maybe they simply exist in the very nature of things, so that at this point we need not be theological in our discussion. And in the third place, I have to face the consideration of how they are discovered. Are these laws which are rules of conduct discovered in the same way in which Newton, a great scientist, discovers the laws of motion? And there we will see that partly the answer is yes and partly the answer is no.

Now I want to give you two names that carry this distinction between laws which are discovered by men and laws which are made by men. I want to use the two phrases "natural" and "positive." I want to call the laws which humans discover "natural laws" and the laws which humans make, "positive laws." And the word *positive* simply means that humans institute these laws. They don't merely think them up; they have to with some authority establish them or institute them. And the best example of what you mean by a positive law are the laws of California or the ordinances of San Francisco. And it makes no difference here whether these laws are statutory, judge-made, or customary.

And when one comes to the natural law, on the other hand, one must be very careful not to misunderstood the natural law. By the natural law I do not mean the scientist's natural law. For the scientist, natural laws, the laws of motion such as those of Newton, are not laws that anyone can disobey. I am talking about the lawyer's sense of natural law. And the lawyer's sense of natural law, the natural laws we discover,refers to laws that can be disobeyed, laws which are violable. Because they are rules of conduct and are capable of being disobeyed, we ordinarily speak of this natural law

as the natural moral law so that we don't confuse this meaning of natural law with the laws of nature in the sense in which scientists talk about laws of nature when they discover the great controlling principles of natural action or behavior.

Lloyd Luckman: Dr. Adler?

Mortimer Adler: Yes, Lloyd?

Lloyd Luckman: Your use of the phrase "the natural moral law" connects immediately in my mind with a question we have. It's one that came from Mrs. Lucille McGovern, who lives in south San Francisco. Very simply, Will you explain the relationship of law and ethics? That is her question.

Mortimer Adler: It's a simple question and a very good one. I cannot answer it now, Mrs. McGovern, except to say that if and when we understand the relation between the natural moral law and the positive law, I think we will have the answer to the relation of law to ethics. For what I think you mean by the question is, Are there any principles or criteria for telling whether laws are good or bad, just or unjust? And I think you will see before we get finished this afternoon that the answer is in terms of the relation of the positive law, the laws we make in our states, our governing bodies or legislatures, and the natural moral law. So I will answer it a little later, perhaps even more clearly in the discussion next week.

Now let me go back if I may to the natural moral law that is one of the two main branches of rules or laws to which men are subject and ask the really difficult question. How do we discover the natural moral law? How do we discover the basic "oughts" which control our behavior which are somehow, we think, implanted in our nature? I said a little while ago that we do not discover these basic "oughts," these basic rules of conduct, in the same way that Newton discovered the laws of motion. And yet, we do use our reason, we do observe in a sense to do it, but we observe ourselves. It is by reason's self-examination of itself or of our self-examination of ourselves that we discover the basic "oughts."

Everyone understands this; you look inside yourself, you make your own conscience active, you activate your own sense of right and wrong. And what do you come up with when you examine yourself in this way, when you make your conscience active or feel your sense of right and wrong? You come up with such general rules as the golden rule: Do unto others as you would have them do unto you. Or what is sometimes described as the first principle

of all natural moral law, namely: Do good, harm no one, and render unto each man what is his own, what is his due. And if you held these two rules in front of you, you would soon, simply by thinking, be able to discover a whole series of other basic rules of conduct.

What does it mean to say that one shall not steal, except that by stealing you are taking what is not your own? What does it mean to say you shall not murder, except that by murdering you harm someone? And the rule is: Thou shalt not harm anyone. So that one simply looks inside oneself and finds in one's sense of right and wrong and one's conscience the basic rules that somehow are implanted in one's heart or in one's nature.

If we compare positive law, like the laws of California, and the natural moral law, we find a number of things. The positive law is formulated by reason and instituted by the will of the lawmaker. It is made and promulgated by a duly constituted authority, such as the legislature or a governing body. It is learnable only by memory. There is no other way of learning what the law is except by memorizing it, committing it to memory. And it binds by coercive force, by the threat of punishment; as well as binding people in conscience, it binds some people only by coercive force and not in conscience at all.

If we turn to the natural moral law and compare it on these four points, what do we see? We see that the natural moral law is discovered by reason, no element of will in it at all. And by self-examination it is discoverable and teachable by any person, not by a duly constituted authority. Any person can learn it by rational inquiry, and it binds in conscience only and not by coercive force.

POSITIVE LAW MAY CONFLICT WITH THE HIGHER LAW

Much of the content of the positive law is morally indifferent, by which I mean that there are many rules of positive law like traffic ordinances, like licensing rules, like many of the rules of contract or of property, which are neither good nor bad, but are merely laws for convenience, stating how the things should be done and are not themselves intrinsically right or wrong. And the rules of positive law can be good or bad rules, just or unjust, expedient or inexpedient. And they certainly can be changed and improved

and that is why they so often vary from time to time and place to place.

In contrast, there could not be in the case of the natural moral law any part of its content which is morally indifferent. For if truly stated, all the precepts of the moral law are right or just. No part of the natural moral law is purely expedient. And though the knowledge and understanding of the moral law, the natural moral law, can be improved in itself apart from our knowledge and understanding of it, it is universal and immutable; it doesn't change from time to time or place to place because it is in the very nature of man. And wherever man is the same, the natural moral law is the same.

Now, Lloyd, I posed at the beginning, as I recall, four questions. Have I answered them now, do you suppose, howsoever briefly?

Lloyd Luckman: Well, my answer would be yes to at least three of them, that you've answered those in some fashion, but I think you yet have to give an answer to one of your four questions. Let me just recapitulate. For example, you've shown us that there are different kinds of laws such as divine law and human law and under human law, positive and natural law. Now that distinction is clear and I think we are also clear on the fact that human law is the kind of law, which as positive law is legislated and enacted and enforced, such as the State of California would enforce laws.

Mortimer Adler: Right.

Lloyd Luckman: And then you've also brought out very clearly that the one thing that law would have in common is that there is a rule of conduct which all persons are forced to obey.

Mortimer Adler: I've tried to show how all those kinds of law differ from one another as to their source or as to the persons or things which are subject to them. But what is the question I've failed to answer, Lloyd?

Lloyd Luckman: Well, my notes show me that you didn't bring out how these laws are related to one another, particularly these different kinds of law and whether or not they come into contact.

Mortimer Adler: Oh, yes. Let me see if I can spend the few closing moments on that point. They do come into conflict. In fact, the classic cases are cases in which men disobey the law because the law of the state conflicts with the higher law. In the ancient world there was a tragedy, *The Tragedy of Antigone*. Let me read you

a short speech from it. Antigone has disobeyed the law of the king, Creon. She has buried her brother who was a traitor. And Creon, the king, has issued an edict that traitors are not to be buried. And she says, "Not to have done so, not to have buried my brother would have been to violate the unwritten statutes of heaven which are not of today or of yesterday but from all time."

All the great religious martyrs of history, all the great political reformers, men like Thoreau in our country or Gandhi in India, or people who disobeyed the law of the state because they were obeying some higher law, they appealed to a higher law, the law of their conscience or the law of God.

This raises a problem about good and bad laws, just and unjust laws. Listen to this statement I'm going to make now. If man-made laws are bad when they violate the higher law, the law of God or the law of nature, then does it not follow that man-made laws are good when they are in agreement with, based upon, somehow derived from the higher law, the law of God or the law of nature? Does this statement I've just made solve the problem? It does solve the problem of good and bad laws, just and unjust laws for those who accept the existence of a higher law and think that the positive law of the state should somehow be related to it and derived from it. But for those who deny a higher law, for those who say there is no divine law or no natural moral law, it doesn't solve the problem. And for them there still remains the problem of what makes a law good and bad, what makes a law just or unjust. Now this is the central issue in the philosophy of law, the issue about natural law, the natural moral law as against the positive law of the state.

And I hope we shall be able to deal with this central issue in the next two weeks when in succession we consider the making of law and the justice of law.

38 The Making of Law

Today we shall think about the problem of how human laws are made. And, of course, we can only deal in discussion of how laws are made by man with those laws which are within the power of human beings to make or not to make. As we saw last week, not all laws to which people are subject are of this sort. Some laws are not made by human beings but *discovered* by them: the natural law, discovered by persons as they examine their own nature. Some laws are *received* by human beings, as the divine law is received from the revelation of God.

Our two preceding discussions of law have direct bearing on today's problem. Our consideration of how human laws are made is certainly affected by the two deeply opposed views of what the human law is, whether it is, on the one hand, something grounded in reason or, on the other hand, something that is merely imposed by the will of those who have the power to enforce law. Our investigation is also affected by the two views about how human law, the positive law, is related to the natural law—the view that the positive law is derived somehow from the natural law as against the view that the positive law has no relation to the natural law (the standpoint of those who either deny that there is a natural law or maintain that if there is a natural law it has no bearing on the making of positive law).

The questions we have received as a result of these two preceding discussions may be very useful in starting off today's discussion. Lloyd, would you read one or two of the questions we have selected for that purpose?

WHY WE NEED LAWS

Lloyd Luckman: Well, in view of the fact that you are going to consider the making of human laws, I think the most pertinent question is one that we have from Frank Milligan who lives on Baker Street here in San Francisco. And he writes, "This is pure theory, of course, but if the Ten Commandments were adhered to and obeyed by all, would there be any need for additional laws?" Now as I see it Mr. Milligan is simply asking you to tell us why human beings make laws, before you tell us how laws are made.

Mortimer Adler: The "why" question, Mr. Milligan, certainly comes before the "how" question. But as I see it, Mr. Milligan, your very question contains part of the answer. It is all contained in that word "if" that you used. *If* all men adhered to and obeyed the divine law. That's like saying *if* all men were saints. It's like saying, as we saw when we discussed government, *if* all men were angels, no government would be necessary. But Alexander Hamilton knew that all men were not angels and I'm sure you know, Mr. Milligan, that the supposition that all men are saints, that all men obey the divine law perfectly, is a supposition contrary to fact. And because it's a supposition contrary to fact you have one reason for human law: human law is needed because all humans do not adhere to or obey the divine law.

That, by the way, is the answer that a great theologian gave when he himself asked the question why it was useful for human beings to frame laws in view of the fact that God had given the Ten Commandments to human beings. In a question which is worded that very way, whether it was useful for laws to be framed by man, Aquinas says, "Since some men are found to be depraved and prone to vice and not easily amenable to words, it was necessary for such men to be restrained from evil by force and fear in order that at least they might desist from evil doing and leave others in peace. And that they themselves, by being habituated in this way, might be brought to do willingly what hitherto they did from fear and thus become virtuous."

But that is not the only reason. In fact, it is not the deeper or deepest reason for the need for human laws. There is a deeper reason. Even if you could suppose that all men were to obey perfectly the Ten Commandments of the divine law, there would be a need for human laws. Let me see if I can show you that in two ways, Mr.

Milligan. First, let's take the commandment "Thou shalt not steal." There are many ways in which individuals steal. There are many forms of stealing. Are they all equally stealing? Are there more serious stealings and less serious stealings? Should they all be punished in the same way? Questions of this sort are answered by the human law, not by the divine law.

And then think of this fact, Mr. Milligan: the divine law—and, as a matter of fact, the natural law—contains no traffic ordinances, no traffic regulations. And I'm sure whether you're a pedestrian or an automobile driver you recognize the deep need for traffic ordinances. This is another reason for the utility of human laws over and above the divine law or the natural law, even if all men were to obey them both.

Lloyd Luckman: Now, Dr. Adler, if you would go back from your discussion of Mr. Milligan's question to a discussion you had two weeks ago when you said that Mr. Justice Holmes held a view of the nature of law which agreed with Ulpian's view, namely, that whatever pleases the prince has the force of law. Or in other words, that law is the expression of power rather than of reason. I think that argument or that discussion probably elicited this question from Mr. Pat Frane. Mr. Frane is a special representative of the California Department of Justice at the office here in San Francisco. And Pat Frane asks you to comment on the remark of Oliver Wendell Holmes that law is not logic but experience.

Mortimer Adler: Mr. Frane, as I remember the exact words Mr. Justice Holmes said, "The life of the law has not been logic; it has been experience," that reminds me of another statement by Mr. Justice Holmes which is that in the study of law, a page of history is worth a volume of logic.

Both these remarks are true in part, for certainly the growth of the law is not a pure work of the reason. It does develop out of our social experience, it is perfected by our efforts to live together successfully and effectively, and it's certainly true that to understand the concrete details of the law as it is today, we must look to history; pure logic will not explain the law. So far Mr. Justice Holmes is correct. But I would think he would be wrong if he were taken to mean or that logic, the rational aspect of the law, is totally irrelevant to its substance.

Now both these two questions, the one from Mr. Milligan and the one from Mr. Frane, lead us into the very heart of today's

discussion. And I think they will be answered more fully as we examine the making of human law. Hence, Lloyd, would you postpone the other questions until we go a little further?

Now let's just review the background for today's discussion, by reminding ourselves of the two views of what human law is and of the two views about how the positive law is related to the natural law. There is, first of all, the natural moral law itself. And then there are two views of the positive law: the view of the positive law as rationally grounded in the natural law and the view of the positive law as having no relation to the natural moral law, but as being simply willed and enforced.

The natural law is to be regarded as nothing but an expression of reason itself. At the other extreme the positive law, viewed from the positivist point of view, is simply something imposed by the will and has no relation to reason. Still, the positive law, when it is seen as rationally grounded in the natural law, is seen as something which, though grounded in reason, must be instituted by will.

The natural moral law consists of the principles or standards of justice. At the opposite extreme the positive law—viewed, as a positivist views it, as something simply willed and enforced—is to be regarded not as just or unjust but merely as more or less expedient. Whereas the positive law, viewed from the naturalist point of view as something grounded in the natural law, is both more or less just *and* more or less expedient.

How Laws Induce Obedience

Finally, let's look at these three things in terms of how they bind or demand human obedience. The natural moral law binds man in conscience only. At the opposite extreme the positive law taken from a purely positivist view binds by coercive force alone. But if you look at the positive law not in that extreme way but as something rationally grounded in the natural law, you see that it binds in conscience as well as by coercive force.

Now I'd like to make three further comments. First of all, you can see that the "naturalist" view of the positive law as something distinct from the natural law, though something grounded in it, puts it in between the natural law at one extreme and the positive law, looked at purely as positive law, at the other extreme. The nat-

ural law alone, viewed in a "naturalist" way, binds in conscience only. The positive law, viewed from the positivist angle, binds by coercive force alone. The positive law, viewed as somehow derived from the natural law, binds in both ways. As the natural law binds, it binds in conscience. And it also binds as positive law binds, by coercive force alone.

My second comment is that I may have given you a misimpression last week when I compared the positive law with the natural law. For in that comparison I used a conception of the positive law which sees it as something derived from the natural law. A much sharper contrast between positive law and natural law is made from the positivist point of view, which looks at the positive law as something unrelated to, unconnected with the natural law.

Lloyd Luckman: Now what you've just said, Dr. Adler, I think explains then this question we had from Father Frank J. Buckley, SJ, of the Bellerman College Preparatory in San Jose. Father Buckley asks you, "How can the state enact positive laws which do not bind in conscience? If the very nature of law involves the common good, it seems to me that from its connection with the common good each law then binds in conscience."

Mortimer Adler: It depends on which view of the positive law you take, Father Buckley. My guess is that you take the view which I call the middle position, that view of the positive law which regards it as derived somehow from the natural law. And if you take that view, then you think of the positive law as being made for the common good and as binding both in conscience and by coercive force. But on the opposite view which is the one you are disregarding for the moment, the view of the positive law as unconnected with natural law, the laws bind by their coercive force alone for they have the force of law whether or not they are for the common good, whether or not they are just.

My third comment on the background we have just covered is this: on the extreme positivistic view of the positive law there is no problem about how human laws are made; the only condition needed for the making of human laws is the power to enforce them. It is only on the other view which regards the positive law, man-made law, as somehow derived from the natural law that we have to face the question, How is it derived from the natural law? How in the making of human laws are these rules derived from the

principles of the natural law? That is the question I am now going to attempt to answer.

How Is Positive Law Derived from Natural Law?

And as I start to answer this question, I would like to feel that you all share with me at least for the purposes of this discussion a certain supposition. I would like you all to share with me the supposition that the traditional statement of the first principle of the natural law, the first precept of the practical reason is a correct statement of it. It is sometimes stated as "Seek the good and avoid evil." It is sometimes stated, "Do good, harm no one, render to each man what is his due, what belongs to him, what is his own."

The question is, from this first principle, this most general rule of conduct, how are further rules of conduct derived? The answer seems to be: in two ways. First, by deduction; second, by determination. Let me illustrate these two ways. Any thinking man, considering the command, "Harm no one," can certainly conclude that he should not steal what belongs to somebody else or that he should not kill another man, take his life. The conclusion that killing is wrong or that stealing is wrong is a conclusion that any man can reach for himself. It is a simple deduction of the reason from this first principle, "Harm no one or leave each man in the possession of what belongs to him." And these rules, "Kill no one, steal from no one," are often called therefore the secondary precepts of the natural law.

How do we go further than that? How do we go beyond these secondary precepts? Not by deduction. In this sense Oliver Wendell Holmes was right; logic will not do it, but by determination, by making those secondary precepts like "Thou shalt not kill, thou shalt not steal," much more determinate.

To explain this further I am going to go to the penal code of California. In the penal code of California we find a whole series of sections dealing with various kinds of stealing. For example, robbery is one kind of stealing. It is not the same as burglary or housebreaking. That is not the same as forgery and counterfeiting. Nor are any of those the same as simple theft or larceny, either petty larceny or grand larceny. And those are still different from

embezzlement and from extortion and from fraudulent transactions or cheats. There is a whole series of particular different kinds of stealing which the penal code of California defines. And by defining these different kinds of stealing, it adds determinations to the rule of the natural law which says "Thou shalt not steal."

Let's look at one section of the code together. Let's look at the section which deals with robbery. Here as you look at this, let me read to you the definition of robbery given in the penal code. It says, "Robbery defined. Robbery is the felonious taking of personal property in the possession of another, from his person or immediate presence and against his will accomplished by means of force or favor."

That's something which man-made law adds to the natural law. And if you were now to look at the rest of the section—let's go back to that code for a moment and look at the rest of the section on robbery; it includes that small type there which I'm going to read to you. The first section is robbery defined and then it goes on to talk about degrees of robbery, the kind of fear which may be an element in robbery, and the punishment for robbery. In fact, if I now go to the code and read those sections to you, you'll see that the degrees of robbery are first and second degree robbery according to whether or not a deadly weapon is used in the attempt to rob or commit the theft. If it is not used, you have second degree. And the punishment is defined or determined. "Robbery," it says, "is punishable by imprisonment in the state prison as follows: robbery in the first degree for not less than five years, in the second degree for not less than one year."

In other words, what you see from this example is the determination of the kinds of stealing on the one hand and the determination of the particular modes of punishment for these different kinds of stealing. These two kinds of determinations are the way in which the human law adds something to the natural law and the way in which the human law is derived from the natural law.

Natural Law Commands, Positive Law Defines

Notice one other thing. The penal code does not say to anyone, "Do not steal." It merely defines the kinds of stealing and attaches

to each kind of stealing a particular degree or grade of punishment. Now that is very important because it is almost as if the penal code left to a man's conscience the knowledge of the fact that he should not steal. The natural law says, "Do not steal." The penal code merely defines the kinds of stealing and determines the particular kinds of punishment for each of the different kinds of stealing.

What I've just showed you in terms of stealing is equally true of all other aspects of the positive law. If I turn now—and I don't have the time to do it in detail—if I turn now to the law of homicide, you would see that the natural law commandment, "Thou shalt not kill," is broken down into a series of definitions of murder in the first degree, murder in the second degree, and the various kinds of homicide, and all of these are distinguished from lawful killing or excusable killing, killing under extenuating circumstances.

It isn't only the criminal law that does this. For example, take the vast body of the civil law which is the law of contracts. That whole body of civil law dealing with contracts between persons and corporations consists of determinations of one principle of the natural law, a principle which you understand to be "Keep your promises, for if you fail to keep your promises, people who rely upon them, others who rely upon them, will be injured." The civil law of contracts consists of the determination of under what conditions contracts are to be relied upon. How are they to be made? What are the penalties for breaking contracts? All of that is a set of determinations of the simple principle "Keep your promises," which is a principle of the natural law.

I think you can see in terms of these examples that the principles of the natural law are like the invariant universal principles underlying all the particular determinations of various codes of civil law; for the law of California is different in some respects from the law of the forty-seven other jurisdictions in the United States and from jurisdictions abroad. And I think also that you can see how this answers a question raised—I think it was last week, Lloyd, by Mrs. Lucille McGovern, when she asked about the relation of ethics to law. She was asking, "What is the moral content of the law?"

And the answer to that question, Mrs. McGovern, I think I can make more clear now than I did last week; for the moral content of the law comes from these principles of natural law that lie under the determinations that are made by the positive law. The deter-

minations made by the positive law are things that are themselves indifferent. Different states can determine what burglary is, what robbery is, what counterfeiting is, what embezzlement is, and assign different amounts of punishment to it. That is not moral; that is practical or expedient to be judged in terms of how it works. But that robbery or stealing should be prohibited and that stealing should be punished and that different degrees of stealing should be punished in proportion to the severity of the offense or the gravity of the offense, this is part of justice, this is the moral aspect of the positive law.

Lloyd Luckman: I have a question right here, Dr. Adler. What about such things, for example, as traffic laws? What in the world is intrinsically right or wrong about driving on the right-hand side of the street or on the left-hand side of the street? How are such rules then as traffic laws determinations of basic moral principles, I guess is my question?

Mortimer Adler: True, Lloyd, there is nothing practically, intrinsically right or wrong about traffic rules. Moreover, there certainly have been and there are right now primitive societies which don't have any traffic regulations at all. That's important to remember because though there are primitive societies which have no traffic regulations at all, there probably are no societies in the world today, primitive or civilized, and never have been, which do not have some regulations against killing, some regulations against stealing.

So you see the traffic rules are of a different sort. They aren't necessary. Yet, under certain contingent circumstances such as a complicated society which has automotive traffic and vast municipalities, traffic regulations under these circumstances are grounded in reason and have some relation to the common good. Because certainly the first precept of the natural law commands us to do whatever it is necessary to do for the safety and security and the welfare and the peace of the community. And in a society such as ours, traffic regulations are indispensable to the safety and security of the community as a whole. Hence I would answer, Lloyd, by saying that while it makes no difference whether the traffic is required by law to keep to the right or to the left, that's indifferent, it does make a great difference to all of us that traffic be regulated in one way or the other and that there be some determinate manner in which traffic is organized and regulated.

THE SOURCE OF LEGAL AUTHORITY

Lloyd Luckman: With that I agree.

Mortimer Adler: Finally I'd like to turn to one remaining problem that we have time to discuss in regard to the making of law. It has to do with the source of the lawmaking power or authority. Anyone, as I pointed out before, can conclude that murder is wrong or that stealing is wrong by his own reasoning from the first principle of the natural law. But not everyone can make these determinations as to what robbery and what burglary is or what the traffic regulations should be. Whence comes the authority and power to make such regulations, such determinate rules of law? The answer is that either it comes from the whole people or from the people's delegates or representatives.

Now there are two sorts of law that are made by the people as a whole. The first sort are customs, the established customs of the people which have the force of law and even sometimes can abolish law or bring about changes in law. And the second kind of law made by the people as a whole is what we call constitutional law, the primary law of the land which in fact sets up, creates, and circumscribes the lawmaking and law-enforcing power.

You all, I'm sure, remember the two great episodes in our English and American history. The barons of England, the highest nobles of England, elicited from King John a charter of their fundamental rights concerned with trials and punishments and how law shall be made. That was Magna Carta, promulgated in 1215. Centuries later in Philadelphia the delegates assembled at our own Constitutional Convention drew up the United States Constitution in 1787, which was then submitted to the people for their ratification. Such law as you can see is made by the people as a whole. They must ratify these laws. They are the constituents. And such primary laws underly the lawmaking power of legislators, the law-applying power of judges, and the law-enforcing power of police officers.

According to this understanding of how law is made, a law is a law in name only, if it fails to satisfy two conditions. First, it is a law in name only if it is not properly derived from the natural law in one of two ways, either as the law of homicide or larceny is derived from the natural law or as the traffic regulations are. And second, it is a law in name only if it is not made in the right way either by

the whole people or by their representatives, having duly consti-
tuted authority.

The most important point I can make is that the second con-
dition by itself does not ensure the justice of the laws, for the will
of the majority can often be as wrong as the will of a despot or a
tyrant. Hence we must face the question which we will deal with
next week, What is the ultimate standing of justice in the law?
What determines when the law is not only rightly made but just in
content? And this is the problem I hope we can spend our last ses-
sion on law discussing next week. We shall deal not only with the
main questions of the justice of law, but also with the connection
of justice and equity and how laws can be improved, how there can
be a progressive perfection of the law in the direction of more and
more justice.

39 The Justice of Law

Today we're going to consider justice in relation to law. I'm sure you realize that we cannot cover the whole subject of justice. Nevertheless, even though we're going to consider justice only in relation to law, the application of laws, the making of laws, and justice in the very substance of law, it may be useful to try to answer the general question, What is justice?

Now most people run away from that question, just as they run away from the question, What is truth? Like Pontius Pilate, they think they don't have time to wait for the answer. But Pilate was wrong and so are all those others wrong who think that it's difficult to answer the questions, What is justice? or What is truth? Neither of those questions is the hard one; the hard question is, What is true in this particular case? Is this statement true or false? Is this law just or unjust? Those are the hard questions. But the question, What is justice?, I think we can answer quickly.

The most famous answer to the question, What is justice?, has been given by a Roman emperor or by those who wrote a book for him. The emperor is Justinian. Now I have here *The Institutes of Justinian,* the book that Justinian caused to be compiled by the great jurists of Rome. It supposedly is a compilation of all the Roman law. A well-known translation of the opening sentence of Book I reads: "Justice is the earnest and constant will to render every man his due." I like this translation a little better: "Justice is the constant and perpetual will to render to each man what is his own."

Is that the definition of what justice is? Only in part; the other part of the definition of justice is in terms of the principle of equality. Justice consists in treating equals equally and treating unequals in proportion to their inequality.

Everyone understands this, I think, certainly most parents do in relation to their children and most children in relation to their parents in the family. For example, in a family in which there are two children, it is perfectly clear—is it not?—that if one child does something and gets punished in a certain way, justice requires that if another child does the same thing, the other child should be punished in exactly the same way. And if the parent doesn't do that, the child at once cries out against injustice. Or the other kind of justice in the family is allowing one child to stay up later than another if that child is older than the other, or if two children of unequal age, giving one a smaller allowance, the younger a smaller allowance and the older a greater allowance. This is justice rendering two unequals something in proportion to their inequality. You see what I mean when I say that in this basic sense everyone knows what justice is? Certainly, all children know what justice is.

Lloyd Luckman: Now I'll agree that children know what justice is just as you've explained it. And I'm sure that some adults do too, particularly those adults who haven't been to college and told by their professors that it's impossible to know what justice is or to define it. But nevertheless, I think you'll agree with me that this relationship of justice to law is not a simple matter. It's a very difficult question and it brings to my mind here and your attention the question you may remember we received from Mrs. Nino Gutadarro.

Mortimer Adler: Yes, I do remember, Lloyd.

Lloyd Luckman: She lives in Palo Alto and wrote you this question: "How can anyone say that law is justice? To my way of thinking, bad or unfair laws can be and are made, therefore I maintain that law should be measured by justice. What is your viewpoint on this question?"

Mortimer Adler: My viewpoint, Mrs. Gutadarro, is the same as yours, namely, that law should be measured by justice, not that law is justice. But I am compelled to tell you that others disagree with this. There is an opposite viewpoint, one quite opposed to this view that you and I share.

So let's begin by facing this basic issue about the relation of law and justice. Let's first of all consider the point of view which says that law is justice or that law is the measure of justice. This is the view held by those who regard law as the expression of the sover-

eign will or as that which pleases the prince or ruler and as having
no relation to natural law.

According to this view, laws are the measure of justice in
human acts. Human acts are just or unjust according as they con-
form to what the laws in the particular land are. And according to
this view the things which men do that are wrong are all called, as
the lawyers say, *mala*—using the Latin here, *mala prohibita,* or
wrongs which are wrong only because the law prohibits them.
According to this view, then, murder is just like driving on the left
side of the street. Murder is wrong because there is a law against
murder. Driving on the left side of the street is wrong because
there is a law against driving on the left side of the street. And if
there were no law against murder and no law against driving on
the left side of the street, neither would be wrong. Both are wrongs
on the same plane, wrongs made by the fact that some states pro-
hibit that as a matter of law.

Now the opposite point of view is the one that I hold and the
one that I gather you hold, Mrs. Gutadarro, and others, all those,
for example, who think that the law is grounded in reason and that
it's ultimately derived from the natural law. Those who hold this
view think that justice is above law and is the measure of law and
that as justice measures laws, the laws in turn become just or
unjust. Some laws conform to the principles of justice and some
laws do not and they are the unjust laws.

In other words, this second point of view adds something to
the picture. It says that there is justice above laws and it is the prin-
ciple of justice which determines which laws are just and which are
unjust. And in consequence of that addition something is changed
in the picture. Let me add the words here the Latin words *mala per
se,* meaning, not wrongs merely prohibited by laws, but wrongs in
themselves. According to this second point of view, there are two
kinds of wrongs. Wrongs like driving on the left side of the street,
which is a wrong act because the law prohibits it and things like
murder which are not wrong merely due to the prohibition of the
law, but wrong intrinsically, wrong according to the very nature of
justice.

Moreover, according to these two points of view about law in
relation to justice, the first one denies natural rights. All human
rights are legal rights, granted by the States and capable of being

taken away by the State. But according to the second view, the view that justice is the measure of law, there are over and above legal rights inherent and unalienable natural rights.

Now I should like to proceed this afternoon on the second point of view, the point of view which says that justice is the standard or measure of law and determines which laws are just and which are unjust. And as I proceed, I would like to proceed in three different connections. I would like first to consider justice in the application of law, the administration of laws by courts of justice; second, to consider justice in the making of laws; and third, to consider justice in the very substance, the very content, of laws themselves.

JUSTICE IN THE APPLICATION OF LAWS

Let me begin by considering justice in the application of law, as courts decide cases and apply laws to particular cases. What is justice? I think we all know what justice is in this connection; justice consists in fairness and equality, treating all individuals alike, respecting no persons over other persons, no favoritism, acknowledging no privileged classes before the law. You all remember the words that are engraved in stone on the top of the United States Supreme Court. It says, "Equal justice under law." That means that all men come before the law as equals, to be treated equally. This is justice in the administration of law.

Another way of remembering this is to remember the statue of justice, of blind justice holding the sword and the scales. This famous statue shows the scales, the sword, and the blindfold on the eyes of Justice. Let me talk briefly about those three symbols. The scales in the hands of Justice represents or symbolizes the principle of equality or the balance. The sword represents the coercive force of the law in the application of justice. And the blindfold over the eyes of Justice is most important of all; for the blindfold represents the impartiality of legal justice, the treating of all men alike. It is this fact of the impartiality of justice which gives us the principle that no person shall be a judge in his own case; for no one can be impartial in his own case, no one can be "blind" in his own case in the application of justice.

JUSTICE IN THE MAKING OF LAWS

Now let me go to the second point we want to take up, justice in the making of laws. And here the principle is that the law is justly made if it is made by the right person in the right way and for the right end. What is the right end of making laws? The common good, not the private interest of any person. Who is the right maker of the laws? We've answered that before: either the whole people or their dually constituted representatives. In other words, for the law to be rightly made, it must be made by duly constituted authority. And how shall the law be rightly made? It is that it be done by due process of law or within the authority and power granted the lawmaker by the Constitution. In this sense you can see that in our government at least, and any government that is constitutional, the constitutionality of a law is almost the same as saying the justice of a law. It is rightly made if it is constitutionally made. If it is unconstitutional, it is an almost illegal law or an unjust law.

By the way, Lloyd, this reminds me of a very good question on this very point, I think, that we received from Mr. Willard Knott, did we not?

Lloyd Luckman: Yes, indeed we did. But it is a very long question. Would you like me just to read the parts that I think are relevant to the point you're making?

Mortimer Adler: Please do. I think that will help us considerably.

Lloyd Luckman: Well, Mr. Willard M. Knott writes you. He begins by saying, "As I understand what you've said, law is a code of human behavior, having coercive force which is established for the common good by the majority of the people or by their duly qualified representatives." And I think that is your definition.

Mortimer Adler: Yes, indeed.

Lloyd Luckman: "Rather it would appear to me," Mr. Knott continues, "that under this definition without qualification, the Jim Crow Laws of the southern states are then entirely in order. The whites are in the majority and these laws are a direct expression of what they feel serves the common good." And before you answer that, Mr. Knott goes on to suggest that something else must be considered, namely, man's natural and unalienable rights. And he says, "There are rights in an absolute sense which cannot be

subrogated by vote or by force. If a law originating in any fashion attempts to cancel these rights or infringe on them, then that law itself becomes unjust even though it may have been passed by a majority vote." To which comment he adds, "I feel that the concept of absolute human rights imposing limitations on man-made law is one of the fundamental secrets of the success of our American experiment even though we have not always followed this principle as well as we should."

And that is what I would like you to consider at this point.

Mortimer Adler: Let me correct you just on one point, Mr. Knott. In our definition of law, we spoke of law as being made by the whole people or by their representatives. There was no reference as such to majority rule. Apart from that, however, it seems to me, Mr. Knott, you are on very solid ground. A law can be rightly made, made by the right persons and in the right manner even. If majority rule happens to be the way in which the delegates or the representatives act, then that is the right manner; it is the constitutional manner. And such a law, though constitutionally made, can still be, as you point out, unjust in substance because it violates some intrinsic, as you say, inherent or unalienable natural right. Of course, in that case, Mr. Knott, if it violates a natural right, the law will not be for the common good. When it is against the natural rights of man, when it is not in conformity with natural justice, law will also be against the common good.

JUSTICE IN THE SUBSTANCE OF LAWS

Mr. Knott's question seems to me, Lloyd, to lead us to our last point about the justice of laws, the standards by which we determine whether they are just or unjust in substance. Before I go on to that last point, however, I want to go back to something I said earlier, when I was talking about the application of law. We said that laws had to be applied justly and fairly to cases. But there is one problem in the application of law that I meant to talk about, that I forgot a moment ago.

There is the problem of equity. It is often said that strict justice in the application of law, applying the law strictly to the case, can work greater injustice than not applying it at all. The point is that sometimes laws being general don't apply to all cases equally. And

it is important to distinguish this case from that. And sometimes as the saying goes, to dispense justice by not applying the law to the case.

The most famous statement on this, by the way, one that all lawyers know and that all students of the subject studies is in Aristotle's *Ethics*, in the book on justice, the famous chapter on equity in which Aristotle says, "The equitable is just, but not legally just but rather a correction of legal justice. The reason," he says, "is that all law is universal. But about some things it is not possible to make a universal statement which shall be correct. In those cases then in which it is necessary to speak universally but not possible to do so correctly, the law takes the usual case, though it is not ignorant of the possibility of error. So that when the law speaks universally and cases arise on that which is not covered by the universal statement, then," says Aristotle, "it is right, where the legislator has failed us and has made an error by being over-simple, to correct the omission, that is, to say what the legislator himself would have said had he been present in the face of this very case. He would have put the law that way if he had known it. Hence," says Aristotle, "the equitable is just and better than one-kind justice, not better than absolute justice, but better than the error which would arise from the absoluteness of applying justice in this case. This is the nature of the equitable, a correction of the law where it is defective because of its generality."

Now let me pick up once more where Mr. Knott took us, the problem of justice in the very substance of laws. Here the standard is twofold. First of all, there is a standard of fairness in the very wording of the law and the very formulation of the law. And secondly, the standard of natural rights that the law should conform to natural rights.

Let me illustrate the first of these two standards. Suppose for a moment that our penal laws punished lighter crimes more severely and more serious crimes in a lighter manner. Or suppose that two crimes, one of which was a slight crime and one which was a very grave and serious offense, but both punished in the same way. Everyone, I think, would recognize the injustice of such a law in content. It is just only if proportionate punishments are given to the unequal gravity of the offenses.

Or consider for a moment the matter of taxation, the income tax law. The graduated income tax law we regard as more just than

the flat income tax because we tend to think that those of greater wealth are in a better position and should be in the position to pay proportionately higher taxes than those of smaller incomes. So the progressive proportioning of taxation, of the amount of taxation to the amount of wealth we regard as a just, legal regulation. Or consider the matter of military service. Here we regard equality, simple equality, that all young men of a certain age shall be treated alike with respect to the demands that the country make upon them so far as military service is concerned.

These are examples of a proportionate distribution for rewards and punishments or an equal or proportionate distribution of burdens. This kind of distribution of burdens, equal or proportionate, is required if the laws are to be just in their very substance.

Now the other principle here, the other standard for measuring the justice of laws, is that provided by natural rights. When laws violate inherent natural rights, they are unjust. For example, the laws mentioned by Mr. Knott, the Jim Crow Law in the South, violates the natural right of every person to equality of treatment as far as public conveyances are concerned. It violates every person's natural right to be treated as a human being, as a human person, having the same dignity as every other person. So at times when laws permitted slavery, they were unjust because they violated the natural rights that every man had to be treated as a free man. And before certain amendments were made on suffrage in this country, when there was a restricted franchise, when women, for example, were disfranchised, that legal regulation was unjust. At times in the past when labor unions were prohibited by law or collective bargaining was regarded as illegal, those laws were unjust because workers have the right, the natural right. to associate in the pursuit of the activities of labor and to bargain collectively. These natural rights are what determine the injustice of earlier regulations against such acts on the part of working people.

THE IMPROVEMENT OF LAWS

Now in so far as our Constitution accepts almost as its foundation the existence of natural rights, in so far as our Constitution in its Bill of Rights actually declares certain of these natural rights, it

would be true to say that a law which violated natural rights would be an unconstitutional law. In this case the unconstitutionality of a law would be almost equivalent to its injustice. But it would be an error to let that lead you to suppose that the constitutionality of a law and its justice are one and the same thing. The reason why that would be an error is that constitutions themselves can be unjust. They are, after all, human law too. And constitutions themselves can be unjust, as our Constitution, the Constitution of the United States, was unjust before the Civil War amendments. Or up until the time of the women's suffrage amendment when half the population, who deserved to be treated as citizens, were then for the first time given the franchise and their just status as full citizens in the democracy.

This, of course, raises the whole question about the change and improvement in law. It raises the question about how human laws, constitutions, or other positives laws progressively become better and better expressions of justice by conforming more and more to the whole body of natural rights and to the principles of natural justice.

Lloyd Luckman: Now this question that you're raising, pointing out the progress of laws and their greater conformity to justice gives me another question in turn which was raised for you by Mr. Ernest Slauge of Burlingame. And Mr. Slauge asks you, first, whether there exist human rights which are really universal, inherent, and natural in terms of which a just and consistent body of positive laws can be developed or whether rights must always be arbitrary and merely expedient in the society which acknowledges them.

Mortimer Adler: I am compelled to say again, Mr. Slauge, that there are two points of view here, two absolutely conflicting points of view. Some men suppose that all rights are legal rights, that all the rights that human beings have are granted to them by the state under its laws. And the state is in the position to take these rights away; just as it grants them, it can take them away. The opposite point of view affirms that there are natural rights, rights that are unalienable, that are neither granted by the state initially nor able to be taken away by the state. According to this point of view, that state is most just whose laws do acknowledge all the natural rights. And that state is unjust whose laws violate natural rights.

But it must not be supposed that at any given time we have perfect knowledge of what the natural rights are. At one time, for

example, it was not thought that slavery violated natural rights. Now we know that slavery does violate natural rights. At one time the rights of labor were unknown. Now we know that labor has certain natural rights which laws must not violate.

I say this *raises* the whole question which we can't go any further this afternoon into the growth of our understanding of what natural rights are, a process of growth which will probably go on until the end of time.

This afternoon, as I see it, we have raised many difficult questions that we have not been able to answer fully, and we have not had time to even touch on a number of important and difficult questions, like the one I have here from Mr. Mooney. Mr Mooney asks what we should do with respect to obeying a law that is justly made in the sense that it is made by constituted authorities, but unjust in substance, violating a natural right. Is a citizen justified in disobeying it or should the citizen obey it?

This leaves me to say something that I've been wanting to say to all of you for many weeks, I hope that no one supposes these brief, half-hour discussions of The Great Ideas do more than skim the surface. I must confess to you that I always feel somewhat dissatisfied at the end of the half-hour. And frankly, I hope you feel dissatisfied too because that is the right way to feel. It is the kind of feeling that calls for more and more discussion of The Great Ideas, of these fundamentals that can't be dealt with fully in a short space of time.

Today, for instance, we've had to touch on two Great Ideas in addition to the Great Idea of Law: the Idea of Justice and the Idea of Rights, particularly natural rights. And both of these ideas really deserve a whole series of discussions by themselves.

40 How to Think about Government

Our problem today is whether government is necessary. Is government necessary? Now, is that a silly question? You remember the question by Will Rogers, "Is sex necessary?" He said, "No, not necessary, just ninety-nine and two-thirds percent of life." Well, is the question, "Is government necessary?" like that? You may think so.

You may think, for example, that no one in the world would say it isn't necessary. Who says that government isn't necessary? And if I were to say, "Well, anarchists say that government is not necessary," you may reply, "Well, who bothers with anarchists? They are un-American." As a matter of fact, if you start to think about anarchists, you may have the image before you of a man with long whiskers and a smoking bomb in his hand, muttering gutturally in a Russian accent.

But that isn't quite the whole truth. There are, of course, bomb-throwing anarchists. But there are also philosophical anarchists. And our own Thomas Jefferson was one of them. I'm sure you've all heard a statement of his that has been quoted again and again which is, "That government is best which governs least." And he goes further than that as a matter of fact, comparing the American Indians, whose society he thought existed without any law or government and the highly civilized Europeans who lived under, in his view, too much law and government; he thought it was much better to live as the Indians did without any government at all than as the highly civilized Europeans did.

CAN WE EVER SCRAP GOVERNMENT?

By the way, Lloyd, don't we have a question on that very point?

Lloyd Luckman: Very much so, Dr. Adler. It's from Marjory Glover.

Mortimer Adler: Let's have it.

Lloyd Luckman: She lives here in San Francisco. She says, "Following the theory that the best government is the least government, will you say that the best government at all might be no government at all? That is, if humans ever improve to the point where they govern themselves perfectly as individuals, might it not be possible to dispense with organized group government except for possibly a few routine technicalities? And if so, how long do you think it will take us to reach this happy state of anarchy?"

Mortimer Adler: Well, that's an interesting question.

Lloyd Luckman: Right on the point.

Mortimer Adler: Because Mrs. Glover in some sense is saying what Thoreau said when he thought about Jefferson's remark that that government governs best which governs least. You remember Henry David Thoreau, another American anarchist—not a bomb-throwing one, just a philosophical anarchist. Let me read you what Thoreau said. "I heartily accept the motto, 'That government is best which governs least', and I should like to see it acted up on more rapidly and systematically. I would like to see it more systematically carried out. And when more systematically carried out, it finally amounts to this which also I believe: 'That government is best which governs not at all.'"

Lloyd Luckman: This is what Mrs. Glover says.

Mortimer Adler: This is what Mrs. Glover says. Now, the other part of Mrs. Glover's question is, Will men ever get so much more perfect that they can dispense with government? To that part of Mrs. Glover's question, Alexander Hamilton has an answer.

Hamilton, in *The Federalist Papers,* raising the question, What is government itself but the greatest of all reflections on human nature? answers by saying, "If men were angels, no government would be necessary." And he goes on to say something that we shall refer to again next week and the week after, if angels were to govern men, neither external nor internal controls on government would be necessary.

Let's consider Hamilton's answer for a moment. Is he saying, or is the answer that he wants us to think about, to be stated as follows, that government is necessary because men are imperfect, simply because they are not as perfect as angels would be? I don't think that that is the whole answer to the question because I think we have to state the question a little more fully and then find a more complete answer than simply the imperfection of men taking men by themselves.

GOVERNMENT IS NECESSARY FOR CIVIL PEACE

Suppose we ask the question this way, Necessary for what? What is government necessary for? And the answer that I would give, or at least subject to debate, is that government is necessary for the existence of society and for its peace, for what we call civil peace. Well, having said that, you may then ask another question. You may say, Why is it necessary? Why is government necessary for the existence of society and for its civil peace?

And I think I can give you at least two reasons, two very good reasons why government is necessary if society is to endure and to exist peacefully. The first is that in order for people to live together and act together they need some way of reaching agreement about the rules and decisions which will guide them in their common enterprise. And secondly, since even when people do agree to the rules and decisions, not all voluntarily comply with them or obey them, there is some need for the use of force to compel compliance or obedience.

Consider an individual person, Jones, concerned with trying to reach his own goal in life. I don't care what that goal is; Jones reaches that goal by acting according to his own rules and decisions. He may take advice from other individuals, he may seek the direction of other persons, but whether or not he takes advice or seeks direction he acts toward or for his own goal, according to his own rules or decisions. No government is necessary in that case.

Now let's take the case of Jones not by himself but in a group. Jones along with Smith and Brown—in fact, in order to make this case a little more striking, let's take this little group of Jones, Smith, and Brown, and consider them as an exploring team. These three persons have associated themselves with one another; they

have formed a group to look for the headwaters of the Amazon. Now before they go off on this perilous, long expedition through the Brazilian jungle, what must they do in order to ensure that the three of them together as a group are going to achieve their common goal, which in this particular case is finding the headwaters of the Amazon? They've got to find some way of acting together, all three of them as a group, for that common goal. But according to whose rules and decisions? Jones? Jones wants to go that way. Smith? Smith wants to go that way. Brown? Brown wants to go a different way. If you let each individual rule, the group falls apart at once. Hence the question is, How do they stick together? How do they remain a peaceful, effective social group trying to act together to reach a common goal? According to whose rules and decisions?

The answer to that question, I think, can be found in only one of two ways. There are only two ways these three human beings can possibly preserve their group as a group acting together for a common goal. As they start out in the jungle they must decide that Jones is going to be the leader and the other two will have to agree to abide by his decisions and rules of operation as they go on their perilous expedition. That is what we have come to learn in the modern world as the *Führerprinzip*, the leader principle, the principle of the chief. And many societies—most primitive societies and many modern societies—still have that single ruler as a way of government to keep the group together.

But another principle is one where they could decide to take a majority vote. They could decide unanimously, all agreeing before they start to take a majority vote on every question and let the majority decide. That will work just as well for they will always be able to reach a decision by a vote of two against one. And since they have agreed to abide by that decision they can act together under it to reach their common goal. According to whose rules and decisions then? According to the rules and decisions made by the form of government they have decided on, the government of one person or the government of majority rule—it makes no difference. But here you see that government, something which is a principle of decision and of action other than the opinion or decision of one person is necessary, quite necessary, to keep the group together and make them function together in concord, in harmony, and in efficiency for the achievement, of whatever their common purpose is.

I think this tells us in essence why government is necessary. What I've just said, Saint Thomas Aquinas, I think, says better than I in a famous passage in which, in a single sentence, he sums up this point. He says, "A social life cannot exist among a number of men unless government is set up to look after the common good." Notice, the common good, the common goal. It is because a number are together in trying to reach a common goal that you have to have government or a principle of decision and a way of enforcing it. And Charles Darwin, many centuries after Aquinas, also said, "Man being what he is, any form of government is better than none."

This solution that I've just stated applies to every form of society, from this simple group of three to the whole state, to the society in which we live, the largest in which we live, to any business corporation, to any club, to any association of human beings, even of course to the human family.

But when you come to the human family you really have a difficulty. I wonder if you have ever thought about this. Leaving the children out, as I would leave the children out, because while they are children they should have no voice in their own government, you have the husband and wife, and when you only have two members of a society—let that be husband and wife for a moment—then what principle can you use? Can you have majority rule? Not when you have two. In the family, this thing of husband of wife, the only principle of government can be the rule of one. And, of course, you know the answer I think is the right one. I'm afraid that some of you will not like my answer, but I tend to agree with Saint Paul's injunction to wives that they should obey their husbands. This is one way of keeping peace in the family.

Lloyd Luckman: Dr. Adler?

Mortimer Adler: Yes, Lloyd?

IS GOVERNMENT A NECESSARY EVIL?

Lloyd Luckman: Before you get tangled up in domestic relations with your own life in this particular problem, I have a question here from one of our—

Mortimer Adler: Why don't you pull your chair up so we can sit down together on that one?

Lloyd Luckman: I'll do that. You haven't answered this question which comes to us from Dominic Cortese who lives on McKey Road in San Jose, California. Now in his letter he refers to the political philosophies of Hobbes, Rousseau, and Locke, and their view that society is not natural. He points out that as the Declaration of Independence says, government may be necessary to secure the rights of men in society. But he goes on, "If society itself is not natural, then it may not be necessary for men to live in society. And if that is the case, that men don't have to live in society, then maybe government isn't necessary either."

Mortimer Adler: The argument Mr. Cortese states, I think, advances the analysis and one to follow. Mr. Cortese is right. If society is not necessary, then government is not necessary since all we have been able to say about government is that it is necessary to preserve society and have men live together socially, effectively, and peacefully. But Mr. Cortese, I think, is wrong in saying even of the writers that he quotes, Locke, Rousseau, and Hobbes, that they held that society is not necessary. Even they who thought that men were not by nature instinctively social—as the bees are or the ants or the social wasps and other insects—nevertheless even they thought that society was necessary for good human life and that government was necessary to keep the peace in society.

So I think Mr. Cortese goes further than these writers. Why, as a matter of fact, Lloyd, even the anarchists hold that society is necessary, even when they think that government is not necessary for society. And I have here a quotation from a Russian anarchist this time—but believe me, not a bomb-throwing anarchist, but a great philosophical anarchist, the great Prince Peter Kropotkin—who says, let me quote this to you, "The anarchists conceive a society in which all the mutual relations of its members are regulated not by law, not by authorities whether self-imposed or elected, but by mutual agreements between the members." There, you see, is an anarchist who is saying that society is good and men can live together socially, but without law, without government, without the imposition of any external force, by mutual agreement of the members. Doesn't that answer the question, Lloyd?

Lloyd Luckman: Not to my satisfaction. And the reason I am differing with you is that while government may be necessary as you are pointing out, may it not be a necessary evil? Your quoting the anarchist Kropotkin brings to mind Bakunin.

Mortimer Adler: He's another philosophical anarchist, isn't he?

Lloyd Luckman: Yes, Mikhail Bakunin is a philosophical anarchist. He points out that the ruling classes have long made us feel that government is a necessary evil. And he goes on to say that it may be a necessary evil for them, all right, but not for the people they are governing. To them it is not only a necessary but a tragic evil, a fatal evil.

Mortimer Adler: Well, that is a position we do have to face because as I see it, if we agree that government is necessary, we then have to face the question whether, as necessary, it is good or evil.

Lloyd Luckman: Yes.

Mortimer Adler: Let me see if I can answer that question by stating three views of the matter. Two of them, I think, are extreme. And I am going to try to consider both today and then carry on with the moderate view next week.

One extreme view is, as Mr. Luckman just represented it, that government is a necessary evil and therefore we should have as little of it as possible. This view is based upon the notion that the end of government is merely the protection of one person from another and that government, while doing this good to us, is evil because it fundamentally destroys our liberty, the liberty the individual has when acting according to his own rules and decisions. We must give up this liberty when we live under society and government. The evil of government destroys our liberty, though it does the little good of protecting us.

At the opposite extreme is the view that government is an unlimited good and we should have as much government as possible, because this view of government, first of all, holds that government destroys no liberty whatsoever. And second, it looks upon government as being the means for helping men to achieve their happiness and their salvation. It's as if government were the direction of man and the whole end of his life. I think that goes too far to the opposite extreme. I think government is not as good as that, nor do I think government is as evil as the anarchists or Thomas Jefferson thinks it is.

My middle position is based upon the view that government is a limited good, neither a necessary evil nor an unlimited good, but a limited good which has as its objective not the whole welfare of

man, not the ultimate happiness of mankind, and certainly not his eternal salvation, but that it has as its only objective the peace of a civil society, a peace achieved by justice and good order. And that with this definite limited objective of social or civil peace through justice, government performs its function for human welfare, and in this respect and only in this respect, is good as a means to that end.

Let me summarize this quickly by saying that in the first place we see the necessity of government for the very existence of society. Even this social group—let me put Brown back in there again, this small social group of a team of explorers going into the jungle can't stick together and achieve their goal without some principle of government, whether it be majority rule or the rule of a leader they themselves have chosen. And that principle of government they have set up for themselves is necessary and good. It is good as a means for achieving this goal. In this particular case, the goal is discovering the headwaters of the Amazon. So when men associate for any purpose—I don't care what the purpose is; it may be the purpose of making money as in a corporation for profit, it may be for the purpose of advancing learning as in the university, it may be the purpose of some activity together as in a social club, or it may be the purpose of a good human life itself as is the purpose when they associate in a state, but whatever the purpose—government is necessary to achieve that purpose of association so that people can act together and act also in peace.

If as a result of today's discussion we understand the necessity of government, and that it is not just a necessary evil, but a necessary limited good, then the problem we want to go on to next time, a very interesting problem indeed, is the problem of how government serves this purpose. How, being necessary, does it help mankind? How does it actually work to help people live together peacefully in such a way that they can achieve whatever is the common purpose of their association, of their coming together for a common life and acting together, or trying to act together, in concord?

41 The Nature of Government

Last week we gained some understanding of the necessity of government. This week I hope we can use that understanding to see if we can explore and examine the nature of government. But before we do that, my associate Lloyd Luckman thinks that there are some questions that we ought to answer first. Lloyd?

Lloyd Luckman: Dr. Adler, your remarks about the anarchists last week provoked a question which I think you ought to answer before you go on with your discussion. This question is from Meyer Kahn who lives here in San Francisco. And he says, "Communists and anarchists are both revolutionists." And he asks then, "Are the Communists carrying on the same revolution which the anarchists began is Russia?"

Mortimer Adler: No, Lloyd. It seems to me it is exactly the opposite. The anarchists wanted no government at all. The Communists in their revolution have set up perhaps the most totalitarian of all forms of government. In fact, I would guess that the anarchists who are against the absolute rule of a czar would be even more revolutionary if there were any left in Russia, which I think is probably not the case, and would be even more revolutionary against the present one-party regime of the Communists, so they are exactly opposite in their character, and not the same at all.

Lloyd Luckman: So that certainly should clear that point up not only for Mr. Kahn, but for many other listeners. You know, it seems awfully hard for the American people today, Mortimer, to think about this topic of government without thinking about Communism. And when they think about Communism, according to the mail we received, they think about McCarthy. So I have a

question here on the subject of McCarthyism. I don't know whether you are going to want to answer it or not but, well here goes. Shall I read it?

Mortimer Adler: Yes, please.

Lloyd Luckman: It comes from Mrs. Betty Meyer who lives in Richmond, California, and reads as follows: "Perhaps this is more a political issue than a governmental one but would you say that Senator McCarthy is sincere in his spy hunt and does he have a moral right to accuse men without proof?"

Mortimer Adler: No, that certainly is not a question about government. It is not even primarily, in my view, a political issue. As a matter of fact, as Mrs. Meyer suggests, it really is basically a moral question.

Lloyd Luckman: Yes, I see that.

Mortimer Adler: She asks in her own words, Lloyd, she says, "Has Senator McCarthy"—I would make it anyone else: has Senator McCarthy or anyone else—"a moral right to accuse men without proof?"

The answer to that question, I think, Lloyd, is given to us by God Himself. It is found in the Ninth Commandment: "Thou shalt not bear false witness." And there are three things I would like to say about the Ninth Commandment. First, that the Ninth Commandment, though most people I think tend to forget it, is just as important a prohibition as the prohibitions, Thou shalt not commit murder, Thou shalt not steal, and Thou shalt not commit adultery. And secondly, it is an injunction against much more than committing perjury in court; it is an injunction against libel, slander, defamation of character, detraction, and anything that would do anybody an injury either in name or reputation. And still more important it seems to me, Lloyd, I think that this is something a great many people, even if they thought of the Ninth Commandment, would misunderstand: it is not only an injunction against saying what one knows *is not* true; it is also an injunction against saying what one does not know *to be* true.

For example, if I were to say what I might think, though certainly I do not know, that Senator McCarthy is not sincere, that he is only masquerading as a patriot but in reality is a self-serving politician who would not stop at any lie or any deceit to serve his own personal ambition; if I were to say that, I would be violating the Ninth Commandment. Don't you agree, Lloyd, that I would be

violating it as much as those who charge others without evidence or proof of being Communist?

Lloyd Luckman: Yes, that's a very serious sin against—

Mortimer Adler: Then that's why I can't answer Mrs. Meyer's question as to whether Senator McCarthy is sincere. Nevertheless I am glad you asked the question because it is an important one, but it certainly has taken us away from our subject. Let us get back to the subject.

Lloyd Luckman: Yes, and though it has taken away from our subject, Mrs. Meyer is not the only one who asked a similar question.

Mortimer Adler: I'm sure that's the case.

Lloyd Luckman: Well, I have a question I think will bring you right back on the subject then, Dr. Adler. And this is from Mrs. Eleanor George who lives on Jackson Street here in San Francisco. She says that Lincoln stated in his Gettysburg Address that our government was established as a government "of the people, by the people, and for the people." Now do you think that this can be true as "of, by, and for" in a country as large and as complex as ours?

Mortimer Adler: Yes, Mrs. George, I think it can be true. In fact, even though our country today is much larger and more complex than it was in Lincoln's time, I think Lincoln's principle is truer today than when he first uttered it. In fact, I think it is much truer even than at the time when our forefathers brought forth upon this continent a nation dedicated to that proposition.

To understand this, to understand why our nation, our government today, is more than it was in Lincoln's time a government of the people and for the people and by the people, I think we have to understand the nature of government. And that takes us right to the problem we want to discuss today. So if there are any other questions, Lloyd, let's hold them until we go on with this discussion and then pick them up at the end.

Lloyd Luckman: All right.

Mortimer Adler: In order to go on and discuss the nature of government in terms of the necessity of government, let me take you back to the discussion we had of those three individuals, Jones, Smith, and Brown, who organized an expedition to go into the Brazilian jungle and find the headwaters of the Amazon.

We saw that the only way that these three could stick together and act together to reach their common goal, which was finding

the headwaters of the Amazon, was by means of some form of government which they could work together under and accept, either the rule of the leadership of one man, Jones, or majority rule. And we saw, as we understood this, that this principle of government, of making men able to work together for a common goal, applied to *any* form of social group: the small social group, like a family, any organization or association, and, of course, the state itself, our political community.

CIVIL PEACE THROUGH JUSTICE

We're not interested here in any form of government, like the government of a small club or team; we're mainly interested in political government, the government of our civil society or what is sometimes called *civil government*. And to ask ourselves what the nature of civil government is, we have to be concerned first of all with the common goal folk have in mind when they associate in that form of community we call a state. What is the common goal of the political community? What is the end of civil government?

Now there are three answers to that question that I would like to suggest to you. One is given by Lincoln in the phrase that Mrs. George quoted in her letter. It must be government for the people; the goal of government or the end is the good of the people governed, not the good of those who govern or those who exercise or use the powers of government.

Another answer to the question is given to us, as you recall, in the Declaration of Independence, in those words in which it says, "That to secure these Rights, Governments are instituted among Men." The rights referred to are such rights as life, liberty, and the pursuit of happiness. But not only those rights, because they are referred to merely as examples of the rights which men have naturally and unalienably. In other words, the end of government is to secure for human beings all their natural and unalienable rights.

And the third answer which doesn't disagree with those, but says it another way is that the end of government is the common good of the society, the general welfare, the common good of humankind associated in a political society. Now when you say the common good or the general welfare is the end of civil

government, you could have in mind two different things. You could have in mind, for example, that a common good and welfare consists of the happiness of all men, their material and spiritual welfare in every respect. I think that is too much to ask government to do. I think that is too large an objective. I would like to suggest that the common good or the general welfare is a more limited objective than that. And precisely because it is a more limited objective, it sets certain limits to the powers of government. I say that that limited objective of civil government aiming at the good of the ruled, the good of the people who live under the government, is civil peace, the peace of the civil community or the civil society, through justice, through the administration of justice.

Let me see if I can explain what I mean by civil peace through justice before we go further into the nature of civil government. In the first place, by peace we ought not to understand complete harmony of all men, the total absence of disagreement or differences of opinion or policy or conflict. No human society from now until the end of time will have such harmony. No, what we mean by civil peace is the ability of men to live together, differing in many ways, having conflicting interests, having many differences of opinion about what should be done, but able to settle their differences without resort to violence. And not settle their differences in any way, but settle them justly. For if the settlement is not just, you do not really have peace.

If you think you have peace merely because no one is in fact fighting anyone else, and there is no justice, you have, below the surface of that apparent peace, rebellion or war seething. John Locke, one of the English political philosophers who greatly influenced our own Founding Fathers, pointed out that men cannot long stand oppression, nor will they long suffer abuses and injustices. And when injustices thrive in a society they would rather return to a state of war than put up with a peace that is not really a peace at all because they do not have justice. As Locke himself pointed out, the word "rebel" comes from the Latin word "rebellare" which means "return to war," because the peace is not a good peace.

Aquinas before him said exactly the same thing. Men always fight and always will fight to get the justice they think they deserve. And so you don't have peace in a real sense unless it is maintained through the administration of justice.

THE TWO ASPECTS OF GOVERNMENT

Now then, supposing that you understand the end of government to be the maintenance of civil peace through the administration of justice, what is the very nature of civil government? There are two factors which constitute every civil government. Government does two things. It makes rules and decisions and gets agreement on them, and it enforces these decisions. So every government must have two properties: it must have the authority to make laws and decisions that ought to be obeyed, and it must also have the power to compel obedience to those laws and decisions.

There is the aspect of government which is right, the right to be obeyed. And there is also the aspect of government which is might, the might to compel obedience. And if you look at these two factors, I think, and think about them for a moment, you will see that a government that consisted simply of might without right would be a mere organization of force, sheer tyranny. And a government that consisted only of right, the right to be heard because it was speaking good sense, but no might to enforce its rules or decisions, wouldn't be government at all. It would merely be friendly advice or good counsel. It would be totally ineffective as government. Hence if you see this, you will see that these two factors, might and right, or authority and power, go together and constitute all government.

GOVERNMENT IS A MONOPOLY OF AUTHORIZED FORCE

That makes it possible, I think, for us to grasp the very nature of government in a simple, clear definition. Put authority and force together in the single phrase authorized force, and you can say that government consists of *authorized force*. But you have to add one more thing. You have to add a word. You have to say government is a *monopoly* of authorized force.

Why must we say "monopoly"? Imagine for a moment the city of San Francisco having two mayors, two police commissioners, and two police forces. Now the robbers who don't like cops might like that much better than one police force. But the rest of us who look upon the police as safeguarding our law and order by

enforcing law would find two police forces a nightmare, a grue-
some nightmare. You cannot have peace nor can you administer
justice unless the government has a monopoly of authorized force.
And that is the meaning of that very special word which we apply
to governments. We say of governments, they are sovereign gov-
ernments—they have sovereignty. To say that a government has
sovereignty is simply to say that some institution in the society has
a monopoly of authorized force.

Now then, the 64-thousand-dollar question that anyone ought
to ask themselves when they understand that government is a
monopoly of authorized force is, How does it get that way? Where
does it get the authorization to use force? Where does it get the
monopoly of the force which it can use with authority? To that very
important question there are two answers. It either gets it by
seizure, by conquest, by usurpation, in which case you've got ille-
gitimate government again, or tyranny. The other way that a gov-
ernment can have a monopoly of authorized force is by consent
and constitution. I think some of us tend to forget how important
that word is we often use of ourselves. We are not only citizens but
we are constituents. This means that we have in ourselves the
power to constitute the government under which we live. This is
the meaning of popular sovereignty, that "We, the People" are the
source of the sovereignty the government exercises.

Here again the Declaration of Independence gives us the
answer. What the Declaration says if you recall, "Governments are
instituted among Men, deriving their just Powers from the
Consent of the Governed." And here again, if I can return to Mrs.
George's quotation of Lincoln. Lincoln gave us the answer. This is
what he meant by saying government "of the people" first. I know
some political scientists who think that Lincoln didn't mean any-
thing by the word "of," that they can explain his meaning for the
words "by the people and for the people," and that Lincoln put "of
the people" in there with his wonderful sense of rhythm, to fill out
the sentence. I don't think so. I think the primary thing is govern-
ment "of the people," meaning that the people are the source of
the government's authority, that it comes from them. That is why
it is "of them," derived from them.

With this understanding of the nature of government let's take
one step further forward and understand how government works
to keep the peace or maintain the peace through the administra-

tion of justice. Many centuries ago a great Roman lawyer and senator, Cicero, made the extremely wise observation that people can settle their differences in two ways, whereas the beasts of the jungle can settle theirs in only one. Cicero said, "Men can settle their differences either by fighting as the beasts do or by talking. And the human way to settle differences is by talking."

It is the very nature of government in the administration of justice for the sake of peace, by the exercise of a monopoly of authorized force, to settle all human differences by talking instead of by fighting. In fact, my second definition of government would be that it is the machinery, the vast machinery for keeping the conversation going, to prevent individuals from stopping in the business of talking and starting to fight.

Let's consider Jones and Smith once more. Suppose we think of Jones and Smith and think of them as two persons living in a society. Now then, Jones and Smith differ about who is to hold a particular office. Do they fight it out? No. The institutions of government permit them to go to the polls and according to their acceptance of majority rule, decide that issue between them, who is to hold a certain office, by an act that is an act of "talking," communicating not fighting, which is voting. Or suppose they just disagree about what kind of law is to be made on a given subject. Again, they may vote on this at an election or they may elect a representative who will debate the matter, talk it out in a deliberative assembly, and when the law is passed their issue will be settled.

Or take the case in which Jones and Smith disagree about the boundary line between their farms. If there were no government, they might, because of the seriousness of the matter, settle this difference by stones and blows. But what they do in a civil society where governments administer justice and keep peace is to hire lawyers, go to court, talk it out, accept the decision of the court, or even if not accepting it, have the decision, if it is justly reached, enforced upon one of them. Thus you see how government keeps the peace by making the conversation go on and preventing the individuals from fighting.

And when you see this you begin to see what the basic powers of government are. They are the traditional powers which even children learn about from civics books: legislative, judicial, and executive. The legislative power is the power of making laws or rules; the judicial power is that of applying those laws or rules justly

to particular cases, and the executive power is the power of carrying out the laws or rules, enforcing the law, or enforcing the decision of the court.

But contemporary government, if you and I think about what is going on in the United States today, appear to do much more than this. It takes care of public education, public health, security, economic security, the conservation of natural resources, economic planning, all of these things and many others, in the name of the general welfare. This is the problem we shall face next time, a difficult problem because it looks as if, in our day, the powers of government are going beyond the end of maintaining peace through justice. Government is concerned with the general welfare in a much wider sense than governments were thought to be intended to do when our Founding Fathers conceived this government under which we live.

Now Lloyd, I think we have time for one more question before we close today.

The Moral Basis of Government

Lloyd Luckman: I've been following you very closely and I've selected from my file this question by Andrew L. Parovich. He lives in Jackson, California. He says, "Dear Dr. Adler, Are the achieving of internal peace and the maintenance of a society the only factors which make a government a good one? Or should its moral basis, such as its intrinsic worth and the qualifications of its rulers, be considered as prior and more basic causes?"

Mortimer Adler: That's a very interesting question. One thing it shows is that it's very important for us to recognize that our interests, your interests and my interests, are not simply in government but in good government. More than good government, it is in what the best government is, our attempt to discover the best government. We want to know what makes government good and what makes one government better than another. And I think Mr. Parovich is right to say, "on moral grounds," morally better.

Now we have the answer to that question so far in very general terms. Justice is the answer. A good government must be a just government, and one government is better than another if it is more just than the other. And I think we've discovered in part what

makes one government more just than another. In the first place, a government to be just must be government *for* the people. It must secure to each person his natural and unalienable rights. In the second place, to be just a government must be *of* the people. It must derive its just powers in every case from the consent of the governed.

But now two important questions are left. What are the just powers of government? Not only must the powers be just, derived from the consent of the governed, but the powers themselves must be the just powers of government. And our question is, what are the just powers of government? This is the very important question which we shall deal with next Sunday when we consider the powers of government and face the issues that I mentioned a few minutes ago.

And then finally the last question of all is, Who shall exercise the powers of government and how shall they be exercised? This is the third point in Lincoln's magnificent statement. It is the question about government *by* the people, the problem of how the people themselves carry on or handle the powers of government. And that is the question or the problem I should like to deal with next time.

42 The Powers of Government

You will recall that some of the great documents we have dealt with in discussing government in the last few weeks are the documents of American history, like the Declaration of Independence or the Constitution of the United States. Some viewers may not think it's very appropriate to discuss this subject at Christmas time, so I would like to recall a few of the key events in the founding of our country, events that occurred around this time of year.

You all remember don't you, Gilbert Stuart's painting of *Washington Crossing the Delaware?* That took place on December 25th, on the night of Christmas, in 1776. The next day George Washington, with a very small force, won the Battle of Trenton.

A year later George Washington was with his men at Valley Forge. On December 23rd, 1777, George Washington wrote the following words: "We have this day no less than 2,873 men out of 11,000; 2,873 men unfit for duty because they are barefoot or otherwise naked. Numbers are still obliged to sit all night by the fire."

And then on December 23rd of 1783, after having won a great Revolution, George Washington, unlike other Revolutionary leaders with an army behind him and a sword in his hand, turned that sword in to the Continental Congress assembled in Annapolis, Maryland. He got up the next morning, on the 24th, and rode hard all day. He was back at Mount Vernon late on Christmas Eve.

I think these facts indicate the kind of actions our forefathers took in this Christmas week for a government whose blessings we enjoy. I myself think it is a lot easier to think about good government than to fight for it. That's probably the peculiarity of a philosopher. There may be some of you who think it's easier to fight for it than to think about it.

As a matter of fact, there is another peculiarity that I fear I have as a philosopher. I take great pleasure in the simple truths about government that we have been learning in the last few weeks. Let me remind you of just four of them before we go on with today's problem.

First, government is necessary so that men can live together and act together in society. Second, the end of government is the peace of civil society and the general welfare. Third—this is one of my favorites as a matter of fact—government must combine right and might or authority and force, and therefore it is aptly defined as a monopoly of authorized force. Fourth, the sovereignty of government derives from the people, who constitute the government. It's a government, then, of the people, or as the Declaration says, it derives its "just Powers from the Consent of the Governed."

HOW MUCH POWER SHOULD GOVERNMENT HAVE?

And it is this last proposition that brings us to today's problem. It is not so simple as these truths I've just stated. It's a very difficult problem, and to understand it I think you are going to have to stay with me carefully as I attempt to state the problem so that you can accurately appraise it in all of its difficulty. The problem is, What are the powers of government? How much power should government have?

I warn you this is not easy. The problem as I see it is the problem of power in the hands of men. Power that almost anyone feels can be an enemy to the liberty which other men wish to enjoy, men who don't have that power. Woodrow Wilson, in a speech he made in New York in 1912, siad, "The history of liberty is a history of limitations of governmental power not the increase of it. When we resist the concentration of power, we are resisting the powers of death because the concentration of power is what always precedes the destruction of human liberty."

And you will recall—you will recall that Lord Acton, before Woodrow Wilson, said, "All power tends to corrupt; absolute power corrupts absolutely." In fact, it was against just such absolute power, the absolute power of George III, that our Founding Fathers, men like George Washington and his ragged soldiers at Valley Forge, fought that Revolution, because they wished to be emancipated from such absolute power.

Lloyd Luckman: Dr. Adler?

Mortimer Adler: Yes, Lloyd?

Lloyd Luckman: We have a question that I think is particularly pertinent at this point. It is from Elizabeth Cronin. She lives in Oakland, and she asks, "If the people are the source of the government's sovereignty, where does an absolute monarch get his?"

Mortimer Adler: The answer, almost in a word, is: he doesn't get it, he *takes* it. And this, Lloyd, really is the whole problem.

Let me see if I can state the problem for you. Our whole problem of power, and that is our problem today, is a problem that can be divided into two parts. One is the problem of the power of men in government and the other is the problem of the power of government itself. Now I think this first problem we can solve. It is the second one that I think is difficult. The one that I am going to ask you to watch carefully as we deal with it is the second problem, the problem of the power of government itself.

The reason why I'm confident this problem can be solved is that largely it has been solved. It has been solved in two ways. First of all, that very question that was just considered, the question about the absolute power of an absolute monarch who does not get that power from the popular sovereignty of the people connects in your mind, I'm sure, and in mine, with a famous statement of a basic division in kinds of government. Government is either *government by laws* or it is *government by men.* And when a government is government by laws, its power is limited, or the power of men in government is limited. But when the government is government by men, by particular individuals, the power of those individuals in power is unlimited. That's why we say that limited government, or government by laws, is constitutional government and unlimited government, or government by men, is absolute government.

The Greeks, way, way back at the beginning of our civilization, the Greek city-states, really gave us the first great invention of free government. I often like to think about this as an invention as important to human society and human happiness, human freedom, as the invention of the wheel is to mechanical progress. The Greeks *invented*—I can't use that word any more seriously, the Greeks invented a constitution. And what is a constitution or a constitutional form of government? It consists in having all the citizens and the magistrates or office holders share in the sover-

eignty. It divides the sovereignty or the power into shares. And all the citizens share in the sovereignty.

And what this means is, in a word, that individuals don't have power vested in themselves as persons; they have the power, they exercise the power that is vested in offices. They have a power that is authorized to the temporary office and they can exercise that power so long as they hold a political office. That is the meaning of constitutional government, a government by office holders, each office having some authority and power invested in it and the man having that power and authority just so long as he holds the office, and no longer.

That is the way the ancients solved the problem, but they didn't solve it completely. It was in the eighteenth century that the second stage in the solution took place. Our ancestors saw that the problem was not solved if office-holders could misuse the power of public office or if persons holding offices could exceed their power, the power they had from the office they held. And so the question was, How do you control the individuals who hold the power of office?

I think it was a couple of weeks ago that I quoted that famous sentence, "If men were angels, no government would be necessary." Do you remember the next sentence? The next sentence right after that reads as follows: "And if angels were to govern men, neither external nor internal control on government would be necessary." Now there is the answer. Because since angels don't govern human beings, since it's not angels who hold public office but human beings, we do have to have external and internal controls. External controls are the kinds of things that our constitution has when we have rules of impeachment. When individuals misuse political power or exceed the power of their office, we impeach them.

But there is a deeper answer to the question. Let me turn to the Great Books for a moment, and read to you from *The Federalist Papers* Madison's statement. You all know, I'm sure, that our system of government supposedly is one of a division of the powers of government into three departments: executive, legislative, and judicial; with, as we say, a system of checks and balances. Now that system of checks and balances our founding fathers, men like Madison, learned from the great French political philosopher Montesquieu. Montesquieu had said, "Power should be a check to

power." He had said, "There can be no liberty where the legislative and the executive powers are united in the same person or body of magistrates."

And Madison, James Madison, following him said, "This is the sacred maxim of free government. The preservation of liberty requires that the three great departments of government should be kept separate and distinct." And he went on to say that in our constitution, "The Constitution of the United States so contrived the interior structure of the government that its several constituent parts may by their mutual relations be the means of keeping each other in their proper places."

The Loophole in the U.S. Constitution

Is the problem solved? Our Founding Fathers thought it was. They thought the constitution with its system of checks and balances solved the problem. But they left a loophole, a loophole through which power can pour and has poured more and more into the hands of individuals so that in the twentieth century we are faced with a more difficult problem, the second problem we want to consider, the problem of the power of government itself. How does that problem arise? It arises through a loophole that the system of checks and balances does not close up. Why is this?

Let me remind you of something for a moment. In absolute monarchy or even in constitutional monarchy, the king is said to have certain prerogatives of government. In our system of government the executive exercises certain prerogatives. What are the prerogatives of the executive branch? They are to do, when it is necessary to do so, the things that the general welfare of the country require, things on which the law may be silent. They are to exercise emergency powers with or without emergency grants of power from the Congress. Hence it is on the side of governing, beyond the law and outside the law, that there is a loophole which increases the power of government itself.

The problem is, How shall we limit, not the power of persons in government but the power of government itself? And the general answer to that problem, so far as I know, is that the only way you can limit the power of government itself is by considering the purpose of government.

What is the purpose of government? Let's illustrate this for a moment by going to the Constitution of the United States and looking at the Preamble. What purposes are there stated? "To establish Justice, to ensure domestic Tranquility." These two together are the "end" or purpose of government that I have been talking about for two weeks, peace through justice. "To provide for the common Defense." That again is another aspect of peace, external peace now. "To secure the Blessings of Liberty." This is justice again. This is that same thought that is contained in the other words of the Declaration. Governments are instituted to secure these rights, all of man's natural and unalienable rights and liberty.

So far all of these purposes stated in the Preamble to the Constitution, I think, set a limited end to government, the one I've been calling the maintenance of civil peace through the administration of justice. But there is one more clause in the Preamble. And that is the clause which throughout the history of the United States, and more so in recent years than earlier, has been the source of a change in our government. It is the so-called general welfare clause. The Preamble lists, among the purposes of the new constitution, "to promote the general Welfare."

The general welfare is an unlimited kind of purpose, as opposed to the very limited and well-defined purpose which consists in administering justice. And Alexander Hamilton calls our attention to what happens when a government has an unlimited purpose. Listen to Hamilton's words on the subject. Because Hamilton's point is that the power of a government must be proportionate to its responsibilities. His words are extraordinary. Let me read them to you carefully. "Every power," he says, "ought to be commensurate with its object. There ought to be no limitation of power destined to affect a purpose which is itself incapable of limitation."

GOVERNMENT AND THE GENERAL WELFARE

Now think about that for a moment. Is the general welfare capable of limitation? No. It is an almost infinite purpose or end. And if to promote the general welfare or the promotion of general welfare is one of the great purposes of government, then how can you

limit the power of government? If Hamilton is right, that when you give a government responsibility for an almost indefinitely large, unlimited end, you must also give it power as large, power proportionate.

By the way, Lloyd, don't we have some questions on this problem of the general welfare that will help us along at this point.

Lloyd Luckman: Yes, I think there are two. Suppose I read them both. The first one I have chosen is from Mrs. William C. Smith who lives in Los Altos. She asks you, "How far should government go in promoting the general welfare? Because the trend in government today seems to be almost a parent-child relationship, with the parent taking more and more responsibility for the child and the child expecting more, of course, of the parent. And so is not this trend in government making children of us rather than mature people?"

And the second question is from Natalie Soznick in San Jose. And she asks, "Dr. Adler, when there is a conflict between two sovereignties, that is, the state's sovereignty and the federal government's, under which Americans live, should the general welfare of the whole, that is, the United States, the forty-eight states, supersede the general welfare of the parts, the individual states if that of the part is predominantly concerned?"

Mortimer Adler: Thank you, Lloyd. Those two questions are right on the problem we've been discussing, because Mrs. Smith's question calls attention to the fact that even when a democratic republic with a very good constitution, such as our is, starts to pay primary attention to the general welfare, one result is a kind of paternalism on the part of government, which she says tends to make children of us all. And the other question?

Lloyd Luckman: Mrs. Soznick calls our attention to the fact that we are a federal republic with some division of problems between the federal government and the states. And she raises the question as to what powers the federal government should have as opposed to the inferior corporations or the inferior units of government.

Mortimer Adler: Let me take these two questions to see if I can state the two sides of the issues they represent. When the purpose of government is to serve only some of the ends for which persons associate in society, government doesn't do the whole job. You have what is called the principle of political pluralism. In fact, this principle of political pluralism is Jefferson's principle that a gov-

ernment should do as little as possible, meaning that thereby other parts of society—private corporations, private associations, subordinate governments, local governments—should take some of the load of satisfying the purposes for which men associate and live together. Hamilton tends, on the other hand, towards strong government, taking as the end of government, promotion of the general welfare, letting government have that unlimited purpose.

Now it seems to me that Jefferson's principle here of "That government governs best which governs least" and which therefore allows other parts of society to serve the needs of individuals when they associate together is perhaps the sounder principle.

Haven't we a question on this point? I recall Lloyd there is question that someone asked us about the relation of Jefferson's principle to government?

Lloyd Luckman: I think you have in mind Nick Diamond.

Mortimer Adler: That's right.

Lloyd Luckman: He asks you, "Isn't it true that the Republican Party supports the idea of 'that government rules least rules best' as far our national government is concerned, by giving more responsibility to the states and to the local government?"

Mortimer Adler: Well, as a matter of fact, Mr. Diamond is, I think, just a little bit wrong about the two parties, at least if you take the whole of American history. Jefferson was a Democrat of his day and yet the Jeffersonian principle of political pluralism tends to be in our day expressed by Herbert Hoover in the form of a rugged individualism, which his opponents often call a ragged individualism, whereas Hamilton's principle—Hamilton was the Republican of his day—Hamilton's principle of strong government, serving all the interests of society, particularly for the general welfare, tends to be espoused by a man like Franklin Roosevelt who is a Democrat.

I should like to say to you in closing that there is no satisfactory solution to this problem. I think that Jefferson's principle of a partial use of government to solve the problems of men is the right principle. On the other hand, even though that is the right principle, it is opposed by sound prudence sometimes, for when the other organs of society aren't doing what must be done for the welfare of people, in education, in the handling of natural resources, in public health, in countless things that people need to have done for them, if private corporations or other human bodies or

organizations don't do this, then doesn't prudence require government to do what it has to do, even though that is more than it ought to do by the right principle that government should do nothing more than administer justice and keep the peace?

So in this problem we see a serious conflict between a sound principle on the one hand and sound prudence on the other. This is a very difficult problem to solve and I doubt if we will ever solve it, but let me just say one more thing, going back to the blackboard. When justice is the end of government, the main end, we tend toward political pluralism and even individualism. But when welfare is the end, we necessarily tend toward totalitarianism. And since in our day government has these two ends, both the administration of justice and the general welfare, we are in a continual tension between these two sides of the problem.

Next week we will go on to the problem of the most just form of government, the best government. Thank you very much and a Merry Christmas to all of you.

43 The Best Form of Government

One morning last week I met a friend who had been following these discussions on government and he said he had a solution to the problem about the power of government that we discussed last week. He said that as between Jefferson and Hamilton, he was on Jefferson's side; he preferred as little government as possible. But for everybody else he wanted as much government as they needed. I met him again the next morning and he said he had been thinking it over. He thought that wasn't really the right solution. That wouldn't satisfy everybody. The only solution, in his judgment, that would satisfy everybody was theocracy, or the kingdom of God on earth, God governing all men; then they would all be satisfied.

Unfortunately, I don't think theocracy is the solution. For if man was created by God as a rational animal, then I think God would not rule man as a Governor or as a Prince. For that would put men in the position of children and defeat the development of their rational, political nature.

That problem, the problem of the best form of government, is one which I think can be solved. In fact, I shall try to indicate the solution this afternoon and show you why my friend's suggestion of theocracy is not the right solution. But the other problem, the problem of how much power government should have, the problem we discussed last week, that is a problem which I don't think can be solved, certainly not in practice though perhaps it can be solved in theory. In theory I think Jefferson is right, that government should carry only some of the burdens of society and that other organizations should do the rest. Government should perform the main job of administering justice.

405

But in practice I think Lincoln has a point we have to face. Lincoln said that government must do for human beings what they cannot or perhaps will not do for themselves. The trouble is, I think, that people use government as a drastic remedy, when they fail to prevent certain social ills, and then they complain about the remedy itself. That problem probably will never be solved. But problems about the forms of government, and which is the best form of government, can be solved in both theory and in practice.

THE FORMS OF GOVERNMENT

Let me introduce you to that problem by explaining a phrase that is used throughout the whole history of political theory, the phrase, "the forms of government." It is always associated with the question, which is the best form of government or what is the form of ideal government? In fact, this problem has two questions in it. One is the descriptive question, how does one government differ in fact from another? The second is the evaluative question, Can governments be ranked, one better than another, and one form of government put at the top of a list as the best of all?

Now there is a traditional answer to these questions. The Greeks first gave us the answer. In fact, you know the expression, "The Greeks had a name for it." Well, in this case the Greeks had all the names for it. Watch now the names I am going to use. They invented the names for all the forms of government.

I said this was a traditional answer. By that I mean it is the answer that has appeared in textbooks and schoolbooks generation after generation. And like most answers of this sort it is over-simplified. It is partly true and partly false. Let me state this answer and show you what the Greeks did, or at least what the schoolbooks say the Greeks did, and then let's consider whether it is a good analysis or not.

There are two criteria for characterizing the form of government. The first is the descriptive criterion: the number of men who hold power, one man, the few, or the many. And the other criterion is what the government is for, the end or purpose of the government, for the common good of the whole community or for the self-interest of the rulers. And when you use these two criteria

together, whether government is by one, few, or many, and the criterion of whether government is for the common good or the self-interest of the rulers, you will get, according to the traditional statement, six possible forms of government.

Monarchy, the government of one man for the common good or sometimes it might be called the government of a benevolent despot. And when the one man who is a dictator governs for his own interest not for the common good, you get tyranny. And so *tyranny* is the perversion of monarchy.

Aristocracy is government by the few, the elite, the best men in the society for the common good. And when the few are not the elite or the best men but the rich governing in their own interests, you get a form of government called *oligarchy*. And that is a perversion of aristocracy. Oligarchy is the perversion of aristocracy.

Democracy or polity is the government of the middle class, a predominant middle class for the common good. But when democracy is government by the poor for their own interests, you get *extreme democracy*, a perversion of democracy, a bad form of government. And democracy in the bad sense is the perversion of democracy or polity in the good sense.

Before I go on with this, Lloyd, didn't we have a question on this?

Lloyd Luckman: Yes, you're thinking of the question that James J. Barece sent in. He says, "Aristotle said, 'Governments are bad or good according as the common welfare is or is not their aim. A bad government, two or three: tyranny, oligarchy, and extreme democracy.'" So Mr. Barece of Cabillo Street in San Francisco asks, "What did Aristotle mean by extreme democracy and how does this apply to our form of democracy?"

Mortimer Adler: Mr. Barece, Aristotle meant by extreme democracy not merely government by the poor in their own interests, the poorer classes in the community, but also mob rule, lawless government by the masses. And he had the feeling that that was a very bad form of government indeed.

This distinction I have just made between bad democracy and good democracy is, as Aristotle and Plato discuss it, not merely a distinction between whether government is for the common good or for the self-interests of the rulers but whether it is lawful government or lawless government, mob rule.

THREE ERRORS OF THE GREEKS ON GOVERNMENT

The classical or traditional Greek conception has three serious errors. In the first place, in my judgment it is wrong to say, as the ancients said and as has been said many times since then in schoolbooks, that of the three good forms of government, democracy is the least good. And of the bad forms, democracy is the most tolerable and tyranny the worst. That is an error I think I shall try to show you. In the second place, I think it is equally in error to say that of the three good forms, monarchy, the government of a benevolent despot is the best.

The three "good" forms of government are all for the common good and the only reason why monarchy is said to be better than aristocracy and democracy is that it is more efficient. It is more efficient government. But then, that doesn't make it better morally. It doesn't make it more just and we want a classification of the forms of government that shows one good form to be more just than another, not three which are equally just with one simply more efficient than the other.

There is a third serious error that comes out of this. It is the illusion that the government by the one best or wisest man would be the best government for mankind. That, by the way, is, I think, the error that my friend made when he proposed theocracy or the government by God on earth. It is an error which John Stuart Mill in his book on *Representative Government* in 1863 described as follows: he said, "It has long been a common saying that if a good despot could be ensured, despotic monarchy would be the best form of government." Mill is right. It had been said for twenty-five hundred years before him. And then he says, and I agree with Mill, "I look upon this as a radical and most pernicious misconception of what good government is."

Thomas Jefferson explained what is pernicious and wrong about this misconception of government. And the same thing would be wrong with divine government on earth; it would make children of us all. To be governed by the one best or wisest man for our own good would leave us with no voice in our own government. No self-government, we would live and act as children, not as adults who are exercising our rational and political natures.

What Jefferson said, he said in a letter to his aristocratic friend, Viscount Dunmore in the beginning of the nineteenth century.

He said, "We both consider the people as our children and love them with parental affection. But you love them as infants whom you are afraid to trust without nurturing. And I love them as adults whom I freely lead to self-government." And that is the answer. That is the reason why, as Mill points out, the notion of having a benevolent despot or even God-rule of men on earth is a wrong conception of the best government for men who are rational, political animals.

And I say that, even though I am a philosopher, and even though Plato who was for this kind of government said that the ideal human society would be one in which philosophers were kings or kings, philosophers. I don't think so. I don't think philosophers should be kings.

LAWFUL AND LAWLESS GOVERNMENT

Let me see if I can correct the error by taking you to another classification of the forms of government. The basic distinction in the forms of government is between lawless government and lawful government, absolute government or constitutional and limited government. And these two are the most deeply opposed principles of government.

Lawless government we also call despotic government, whether it is government by the one or by the few. And this despotic form of government takes two subordinate forms. Either tyranny or benevolent despotism, according as the despotic power is used for the good of the ruler, in which case it is tyranny, or is used benevolently for the good of the people ruled, in which case you have benevolent despotism.

Tyranny is the lowest or worst of all forms of government. It has no justice whatsoever. Benevolent despotism has only one principle of justice, namely, the principle of benevolence, the use of power for the common good, which is the right or just use of power.

When we talk about republican government, we are not only talking about government *for* the people and *of* the people, but government *by* the people. And as soon as we mention government *by* the people, the question at once arises, who are the people? Does the word *people* mean the same thing as population? Is the

population of a country identical with the people who are a political class? The answer is no.

The whole problem now when we get to this point in the analysis of the forms of government is, Who are the people? And when you say government *by* the people, do you mean by some of the people or all? And as you answer that question, you get the distinction between two more forms of government, aristocracy or oligarchy—either of those terms is all right;I think they mean the same thing finally—which means government by some of the population, or democracy, which means government *of* the people, *for* the people, *by* all. By all. Here you have the principle of universal suffrage, all men being treated equally as citizens.

Lloyd Luckman: Dr. Adler, as a political scientist, I think you have made quite a contribution. Though I think one of our correspondents would still have difficulty with your analysis. This is Joseph Gatchel. He is from Oakland and he asks as follows: "Our form of government is often referred to as 'this great democracy.'" "I would be inclined to doubt that," says Mr. Gatchel, "to doubt that it is a democracy at all." For he was taught that a democracy is a government in which the supreme power is retained by the people and in which the governed direct what laws shall be passed, and that a republic is a government in which the supreme power resides in those elected by the people.

Mortimer Adler: Yes, this suggestion of Mr. Gatchel's, Lloyd, is one that began with our Founding Fathers. For Hamilton and Tom Paine and Jefferson and Adams all made the distinction between a democracy and a republic. I think they are using the words in a slightly different sense. And I think there is a misconception here that has run through the whole of American history. The word *republic* as Rousseau points out, and I think the ancients understood, is any form of constitutional government or government by laws. What they wanted to distinguish, Lloyd, is between two forms of democracy: *direct democracy*, where the people directly govern themselves in deliberate assembly and *representative democracy*.

What Mr. Gatchel thinks a republic is is a representative democracy as opposed to what the Greeks had, a direct democracy. Now you may ask me: "Of these two forms of democracy, which is better?" Is it better to have the kind of direct democracy that the New Englanders had in what they called the town meeting, or the representative democracy that we have in the nation as a whole?

Direct democracy, in the first place, only fits a small community. The very small, Greek city-states of the ancient world or our New England towns where the whole population could meet in a town meeting. But there is a deeper advantage to representative democracy than the fact that it fits the needs of a larger country. Because in representative government, the people can choose the most able men for the offices of government. Representative democracy contains, as well as its own fundamental principles of justice, the best features of aristocracy. Because it permits the people to choose the best men for public office.

THE DEMOCRATIC REVOLUTION

The nineteenth-century revolutions in this country and abroad and mainly in this country and England, beginning with Jackson and running through the Civil War, coming right down into our own day, these amounted to a revolution taking place within "republican" government between those who want government in the hands of the few, the rich, the property owner, the noble classes; and those who want government in the hands of all men, the whole population, to be treated as the people, all men shall be granted suffrage. Democracy is distinguished from aristocracy or oligarchy by the principle of justice which is universal suffrage.

This nineteenth-century revolution of democracy against oligarchy has gone on in our own day in the twentieth century. Only it has broadened out even further. In the twentieth century we have proceeded not only to fight for political rights, but for social and economic rights. Where in the nineteenth century men were concerned only with political justice, in the twentieth they want economic and social justice. And the fight in our own day for civil rights is a fight for the democratic principle of equal political, social, and economic opportunity for all men. And when that fight is won, I think we shall have the best form of government that man could ever have on earth.

Lloyd Luckman: Dr. Adler?

Mortimer Adler: Yes, Lloyd?

Lloyd Luckman: Your distinction between republican and democratic in these remarks about revolution cause me to interrupt you for these two excellent questions. The first one is from

Richard Johnson of San Francisco. He says, "Now at what point do the people who are the source of the government's authority have the right to attempt to overthrow that government? And is the only justification for such an attempt a denial by the government of the natural rights of man? So when can you revolt?"

Mortimer Adler: Well, a revolution is going on all the time as a matter of fact. And it is going on in a variety of ways.

Let me go back to the Declaration of Independence on this question. Because the Declaration gives us an answer to the question, Lloyd. The Declaration says if you will recall, "whenever any Form of Government becomes destructive of these Ends," the one Mr. Johnson mentioned, the natural rights of men, "it is the Right of the People to alter or abolish it and to institute new Government, laying its Foundation on such Principles and organizing its Powers in such Form, as to them shall seem most likely to affect their Safety and Happiness."

Now notice the Declaration says they have the right to alter or abolish it. And when a government, Lloyd, doesn't give the people any due process of law to alter or amend the government, they can do nothing but overthrow it. The wonderful thing about our form of constitutional government is that it provides due process of law for the gradual improvement, alteration, or amendment of our constitution and our form of government. In fact, these revolutions that have been going on since we won the first revolution against Great Britain have for the most part, with the one exception of the Civil War, been bloodless revolutions, revolutions by legal or constitutional change, the use of due process of law to carry the social, political, and economic revolution forward. And as long as we have that in the United States, there is never any need for bloody revolutions.

Lloyd Luckman: The next question follows quite hard on that explanation. Donald Brandon of San Francisco asks, "In the United States, government by the people means in practice the government by one of the two major political parties. Now what can the citizen do to further the purpose of government in the service of the common good when both parties are partial to particular interests rather than servicing the interests of all the people?"

Mortimer Adler: Well, I once agreed with Mr. Brandon that parties cannot serve the common good. I have changed my mind since then. If Mr. Brandon would like a copy of an article I wrote

on parties and the common good, if he'll write me, I'll send it to him.

In addition, I think, the parties themselves have changed in the history of our country. At one time one of the two parties, the Republican Party, was for the few and the Democratic Party was for the masses. Or at least the parties were took on those names. At one time the parties were opposed on the principle of democracy itself. But now that the democratic revolution has taken place, the two parties are both democratic parties really. And they only differ on the ways and means to bring about the best forms, the best state of democratic government; they differ only about the rate of change. And that, I think, is a great blessing under which we live.

And for Mr. Luckman and myself I would like to say to all of you, A very Happy New Year.

44 How to Think about Democracy

Today we're going to consider the Great Idea of Democracy. Few ideas are of more lively current interest than democracy, and none perhaps is more in need of clarification because all of us use the word *democracy* in our daily speech and use it quite loosely. We use it with many different meanings. And unfortunately we too often use it with almost no definite meaning at all. That is why there is a need for precision in our understanding of this idea and our use of this basic term in our political life.

Let me say at once what "democracy" does not mean or what will not give us a sharp enough conception of it. It is not simply popular sovereignty, though popular sovereignty is involved in democracy and democratic institutions, nor is it simply majority rule, though again majority rule is involved in our democratic institutions, but both of these things, popular sovereignty and majority rule, would occur in republics that are not democratic.

EQUALITY IS THE ESSENCE OF DEMOCRACY

The essence of democracy is simply equality, the equality of all human beings. And therefore the definition of a democratic government is this, that it consists in constitutional government, that it consists in a republican form of government but with one thing added, namely *universal suffrage*. Because democracy is this, it has two opponents. In so far as democracy consists in constitutional government or government by law, it is opposed to despotism. And in so far as the democratic constitution insists upon universal

suffrage, it is opposed to all forms of oligarchy by which we understand those forms of government in which there are privileged classes. There are no privileged classes in a democracy.

Two Live Issues about Democracy

We currently tend to think of democracy—and this view is reflected largely in the newspapers—as opposed to despotism or dictatorship. This is the great conflict today in the world of action. It is perhaps the best way of describing the conflict between the East and the West. But this conflict between despotism and democracy is no longer, at least for us in the West, a live issue in the world of ideas. In the West we know both in our bones and in our understanding that democracy is the right form of government and that despotism or dictatorship is intrinsically unjust.

But do not be mistaken about this, there are some live issues about democracy. In fact there are two intensely living issues, and both of them are raised by aristocracy or aristocratic notions. One of these issues attacks the very essence of democracy itself. It challenges democracy on the fact of equality. And it insists that democracy is wrong in treating all men as equals, and through that, giving them all the equal status of citizenship.

The second issue raised by aristocratic notions is not an attack upon the idea of democracy itself or the democratic constitution so much as it poses the question as to what is a sound as opposed to an unsound conception of democracy. And here the issue is between an extreme egalitarian version or conception of democracy which carries the notion of equality to the letter, and a notion of democracy which is more moderate and which mixes with the democratic principles, what I'm going to call in this discussion the leaven of aristocracy.

Now I should like to take both of these issues up in that order, first, the issue concerning the justice of the democratic constitution as opposed to the aristocratic challenge to it, and second, the issue concerning what is a sound conception of democracy itself. First, the issue concerning the justice of the democratic constitution and second, the issue concerning a sound conception of democratic government.

THE JUSTICE OF DEMOCRACY

I said a moment ago that the conflict between democracy and despotism, while a live conflict in the world of action today, is a dead issue in the world of ideas. But to be sure that we all understand the same thing here, let me go through the argument quickly which I think shows conclusively that democracy is just and despotism, like tyranny, essentially unjust.

Let's consider the three different sorts of things or objects that men can rule. Let's consider man as a ruler and then put down the word *thing* to cover all inanimate things or brute animals, *child* for the young of the human species, and the word *man* to stand for another adult man. Now men manage or govern things, adult men manage or govern children, and men rule men.

A man, or an adult human being, in governing a thing, managing it, governs it for the human good. He doesn't govern it for the thing's good and that's quite proper; he uses the thing and rules it for his use. Parents, in governing children, govern them for the good of the child but without the child having a voice in its own government; this is a kind of absolute rule of the child. But a human being governing another human being who is his equal treats him not only as something to be governed for his own good, but with his consent and with his having some voice in his own government.

Now when men rule other men as if they were things, you have the injustice of tyranny. And men who are governed as if they were things are enslaved. And when men rule other men as if they were children, you have the injustice of despotism. And even when it is benevolent despotism, even when this absolute rule is for the good of the other man, it is still unjust because the other man is not a child and is being treated as an unequal when in fact as an adult person he is equal to his ruler. Hence the only just relationship between one adult human being and another, in the relationship of ruler and ruled, is when the ruler and the ruled have equal status and the ruled is treated as an equal by his ruler. This kind of rule, the rule of man over man when both are equals, is what we understand constitutional government to be, a government in which the fundamental office is that of citizenship and in which all men are equal as citizens, and this is our way of understanding that constitutional government is just, and despotism, the rule of man

over man as if the man ruled were a child, and tyranny, the rule of man over man as though the man ruled were a thing, are both essentially unjust.

Yet even though we understand that constitutional government is just and the things that are not constitutional government, the absolute rule of despotism or tyranny, are unjust, we face a serious question, a question of justice also, when we ask, Who in a republic, which persons under constitutional government, shall be treated as citizens? Now you can already guess the democratic answer to this question because the democratic position is that all men are equal as human beings in their dignity as persons; the democratic answer is that all men should have the equal status, the equal political status, which consists in citizenship.

And from the democratic point of view, insisting upon the equal status of citizenship, any privileged class represents an injustice. To restrict citizenship to those who have certain advantages of birth, who have certain advantages of wealth, or to those who have the accidents of sex or race or creed, all these accidental qualifications, according to the democratic view, would amount to unjust discrimination, an unjust giving of privileges to those who have not deserved these privileges.

There was a time, by the way, when the privileged classes looked as if they were the superior classes, when those who had the advantages of birth and wealth—because they had the opportunities for leisure and education as the large masses of people did not—it looked as if these privileged classes also had the special competence to be the ruling class. But now, with the remarkable social changes resulting from industrialization, with everyone having an opportunity for leisure and everyone having the opportunity for education, the picture has changed. It can no longer be said that these special accidents of birth or wealth or position really distinguish one man from another in terms of any competence for being a ruler or having the status of citizenship.

THE ARISTOCRATIC CHALLENGE TO DEMOCRACY

Nevertheless, even though this is democracy's answer to all special pleading for privileged classes, democracy still must meet what is its only real challenge—the challenge that comes from aristocracy.

Aristocracy questions the fact of human equality. It asserts against democracy that all human beings are not equal; in fact, that they are fundamentally unequal with respect to the capacity for government, that only some individuals, and perhaps relatively few individuals, have by talent or training a capacity to govern themselves and that the others should be treated as children, governed for their own good, but not allowed to participate actively in government.

Now democracy has an answer to this challenge. Democracy answers the challenge on the level of fact. It is a challenge with respect to fact and the democratic answer is in terms of fact. Democracy doesn't deny what the aristocrat says, namely that men are unequal, that some men have superior talent or virtue or native ability of one kind or another, but what the democrat says is that in addition to this inequality among men there is a fundamental equality among men, the equality that insists in their all being human, having the dignity of personality, reason, and free will. And because they have this fundamental equality they should all have the equal status of citizenship which their dignity deserves, which their reason deserves. It is in terms of this fact, the fact of the equality of men, not denying their inequality, that it can be said that the democrats have answered or criticized the fallacy of supposing that government by a few superior people would be a just form of government.

Let me read you what John Stuart Mill, who is in a sense a great exponent of democracy, has to say on this point. Mill, in a great passage in his *Essay on Representative Government* says, "The ideally best form of government is that in which the sovereignty or supreme controlling power in the last resort is vested in the entire aggregate of the community, every citizen having a voice in the exercise of the ultimate sovereignty." And what does Mill mean by every citizen? He says there ought to be no pariahs in a full-grown and civilized nation. There ought to be no persons disqualified except through their own default. And why does he say this? Because it is an essential point of justice. "It is," he says, "a personal injustice to withhold from anyone the ordinary privilege of having his voice reckoned in the disposal of affairs in which he has the same interest as other people."

In addition to what I have just said, it can also I think be added that aristocracy in the past when it has been a form of government

has seldom worked out as aristocracy was intended to. The government by the few virtuous men, usually tends to degenerate into oligarchy, not the government by the few really virtuous men but again the government by those who from the accident of birth or wealth or race or creed have special privileges.

The Error of Egalitarian Democracy

Now let me add that though aristocracy is, I think, wrong as a constitution of government as compared with democracy, nevertheless I think that the aristocratic challenge has deep significance for the formation of a sound conception of democracy. And it is to that issue that I wish now to turn.

I said a moment ago that aristocracy as a form of government is wrong because it denies the fundamental fact of human equality. But the unsound conception of democracy on the other hand is equally wrong because it makes the exactly opposite error. It denies the inequality of man. It insists that human beings who are fundamentally equal are equal in all respects and should be treated as equal in all respects. That is why this extreme form of democracy should be called egalitarian democracy. But you may ask, Who? Who takes this extreme view of democracy? Who takes the view that I have been describing as an egalitarian democracy?

My answer to that question is twofold. If we go back to the ancient world to the democracy, for example, of Athens, we find this egalitarian conception taking the following form. In Athens though only a few men were citizens, the citizens were treated as equal in all respects. This we know from the fact that the Athenians practiced the lottery. That is, they used a lottery, an ordinary lottery to select from among the citizens those who would hold most of the public offices. This shows—does it not?—that they thought of all of their citizens as equal, that they made no effort to select the best men for certain offices, but they allowed a mere lottery to select from among them those men who for a time would hold this or that public office.

Of course, we have nothing like the lottery in our day. So you may say, "Well, we don't, unlike the Athenians of old, have this wrong, egalitarian conception of democracy." I know that is true; we don't have a lottery, but just think about certain aspects of our

political life. We do have and have taken great stock in public opin-
ion polls. We do have many pressure groups that exercise their
effect upon government. And the whole tendency of American
political life in the twentieth century through public opinion polls,
through sending telegrams to one's congressman, through the use
of lobbies and pressure groups, is to have the whole electorate get
involved in the very business of government and have the elec-
torate try to govern directly, almost, and regard the people in
Washington or in the posts of government, whether they be exec-
utive, judicial, or legislative, as mere puppets, to be pushed around
by public opinion and public pressure.

Now this is so serious a change in the character of democratic
life that recently Walter Lippmann has written a book called *The
Public Philosophy,* in which he argues that as we come from the eigh-
teenth century to the twentieth century there is a real decline in
the very nature of democracy, that democracy today is a perversion
of its true self, that it is not what a democracy should be. And his
chief complaint is that today our chief administrative officers, the
people who should be governing, are not governing according to
their own judgment but are paying too much attention to the
opinions of different factions or groups in the electorate as a
whole. They are watching public opinion polls. They are allowing
themselves to be controlled by the electorate instead of having
been elected by them, governing for them.

This criticism which Lippmann brings to bear on the contem-
porary confusion, if you will, or decline of democracy, is decline
from a true conception to an unsound conception of itself. It was
expressed before Lippmann by such great political writers as
Montesquieu in France and John Stuart Mill in England.

Let me read you a passage from Montesquieu and paraphrase or
summarize a passage from Mill that make the very point I think that
Lippmann is calling attention to. Montesquieu said, "As most citizens
have sufficient ability to choose, though they are unqualified to be
chosen, so the people, though capable of calling others to account
for their administration, are incapable of conducting administration
themselves." And John Stuart Mill would preserve some measure of
independent judgment for the representative and make him both
responsive and responsible to his constituents, yet without directing
or restraining him by the checks of initiative, referendum, or recall.
Mill seeks a leaven for the democratic mass in the leadership of men

of talent or training. He would qualify the common sense of the many by the expertness or the wisdom of the few.

ARISTOCRATIC ELEMENTS IN A SOUND DEMOCRACY

Now in terms of this criticism of the mistake of the egalitarian democrat, what is a sound conception of democracy? I think the answer is nearly indicated by everything I have said. It is a democratic constitution based upon the equality of men expressing itself in the principle of universal suffrage but leavened by admixtures of aristocratic elements so that two facts, not one fact, two facts are taken account of: the equality of men as represented in universal suffrage and the inequality of men in so far as some men are more fit to execute, the powers of government than others. The whole problem here then is how to combine universal suffrage and the popular sovereignty it represents with leadership by the best men.

The democratic principle is simply that the citizens are the ruling class. But though they are the ruling class this does not mean that they actually are engaged in the day-to-day business of government. What does it mean to say that the citizens are the ruling class? I think it means three things. It means, first, that the ultimate sovereignty, ultimate power, is vested in the total electorate, the total body of enfranchised persons who have the office of citizenship.

Secondly, it means that all the particular offices of government, whether executive, judicial, or legislative, are chosen directly or indirectly by the electorate, by the citizens—and not only chosen by them, but that the actions of government as represented by fundamental decisions and fundamental policies ultimately must win the approval of the electorate or, being disapproved of by them, shall have no ascendancy and shall not go into action. In other words this is the *principle of consent,* that the electorate not only shall have the power to choose the offices of government, but they can give or withhold their consent to the actions of government.

And finally, the notion of the citizens as a ruling class involves their being participants in government, not participants by actually engaging in the day-to-day business of government, but by participating through the public debate of public issues and by what

they have to do when they go to the ballot box at the time of an election. This is the democratic aspect of a sound democracy.

What then is the aristocratic aspect? Where does the aristocratic leaven come in, that prevents this from being the merely egalitarian democracy that is wrong because it fails to face the fact that men are both unequal and equal? The aristocratic leaven comes from the fact that representatives chosen by the people should be competent to govern for them. They should be competent to conduct the business of government, and that is the reason they have been elected or selected or delegated to their post in the government. But not only must they be competent to conduct the business of government, they must be allowed by the electorate to do so; they must not be interfered with in the process of government itself.

Let me now read you the statement from Madison, because Madison, one of our Founding Fathers in *The Federalist Papers* makes an excellent statement of this principle of representation. Madison said, "The delegation of the government to a small number of citizens elected by the rest tends to refine and enlarge the public views by passing them through the medium of a chosen body of citizens whose wisdom may best discern the true interests of their country. It may well happen," he says, "it may well happen that the public voice pronounced by the representatives of the people will be more consonant with the public good than if pronounced by the people themselves, if they will convene to that purpose."

And Thomas Jefferson enlarges on this point of Madison's by making the distinction between an artificial and a natural aristocracy. He says, "There is a natural aristocracy among men. The grounds of this are virtue and talent. There is also an artificial aristocracy started on wealth and birth without either virtue or talent. The natural aristocracy I consider as the most precious gift of nature for the instruction that trusts the government of society. And the meaning of this is that a democracy functions well when it manages somehow to take account of its own natural aristocracy and puts men of virtue and talent into public office."

OBSTACLES TO EFFECTIVE DEMOCRACY

This requires two things which are not now operative and which are very difficult to obtain. It requires, first, that the electorate

have the good sense to choose the best individuals they can find for public office. And second, what is almost more important, having chosen the best candidates and put them in public office, *they must let them govern.* They must let them be leaders and not make them followers by trying to make the people whom they have elected to these offices do their bidding, as we do when we send telegrams to our congressman or by various pressures or the use of public opinion polls try to conduct the government ourselves. It doesn't work. There is no point in having selected the best individuals for public office unless we allow them, once they are elected, to exercise their own judgment on the day-to-day affairs of government, only requiring them to come back to us for consent on fundamental issues or policy.

What is needed to make democracy work as it is not now working—to bring into existence in reality a sound conception of democracy? The mass liberal education of the mass electorate. Not just schooling, but an education that involves moral training as well as the training of the mind. For the mass electorate cannot make democracy real unless they regard their political duty as thinking about what is for the common good and acting for the common good, not just acting in terms of their individual interests or the interest of some small faction or group.

But there is one other obstacle to the proper development of democracy in which I would like to touch in the few remaining minutes. It is something that has weakened democracy twice in this century and now threatens it once again. That is the effect of war or the threat of war upon democratic processes and democratic institutions.

Let me read you some prophetic words of Alexander Hamilton on this point. He said two centuries ago, "The violent destruction of life and property incident to war, the continual effort and alarm attendant on a state of continual danger, will compel nations, the most attached to liberty, to resort for repose in security to institutions which have a tendency to destroy their civil and political rights. To be more safe they at length become willing to run the risk of being less free."

I can think of few statements that are more applicable to American life today than this warning of Hamilton.

45 How to Think about Change

Today we are going to think about the Great Idea of Change. There are other English words that connote this idea. Let me mention a few of them: motion, alteration, coming to be, and passing away. And all these words have opposites which suggest what the idea of change does not signify: rest, permanence, stability, fixity, immutability.

There is one other way of thinking about the subject we are going to consider, because closely connected with the opposition between change and permanence or motion and rest is the opposition or pair of terms we know as *time* and *eternity*. For everything that changes is in time; every changing existence is a temporal thing and only that which is unchanging, absolutely unchanging, deserves to be called eternal.

Let me call your attention to the fact that the word *eternal* has two meanings in English. Sometimes it means "endless time, time without beginning or end." But more strictly it means "the timeless," and the unchanging as the timeless is the eternal.

Time is much more closely related to change than space is. Only one kind of change involves both time and space, that is local motion, motion from here to here or here to here. But other changes which are not local motions all involve time even if they don't involve space—so much so that one great classic definition of time is that it is the measure of befores and afters. It is the number of befores and afters in any process of change.

As I said a moment ago, the temporal is the mutable. Anything which is temporal or exists in time is subject to change. There is nothing absolutely immutable in time. But this does not mean that everything which exists in time is always changing in all

respects. On the contrary, things endure in time. The word *endure* is an interesting word. It suggests something that lasts unchanging, at least for a while. If we say something endures during a certain period, we mean it goes on without changing, so that endurance, as well as change, is possible in time.

The philosophical problem of change runs through the whole history of Western thought, from the beginning down to our own day. The earliest Greek philosophers were concerned with change. The students of change were called physicists. And that is the primary meaning of physics, the study of motion, of the world of things in motion or change.

At the very beginning of this concern with or study of change there was a great conflict between two extraordinary philosophers, Heraclitus and Parmenides. Heraclitus took the extreme position that everything was in flux; everything was changing, and Parmenides took the equally extreme position that nothing changed at all; everything was permanent.

Now this issue continues right down to our own day, though no one in our own day, I think, takes either position as extremely as these two early Greek philosophers. There have been eminent thinkers like the Frenchman, Henri Bergson, or the American, John Dewey, or the Englishman, Alfred North Whitehead, who have thought that change or flux or process lies at the very heart of reality and existence. And on the opposite side there are those who think, not that everything is permanent, that nothing changes, but rather who hold that there are some things which are eternal, and that even in the realm of change there is a certain degree of permanence.

Let's turn to this basic issue at once. As I said a moment ago, at the very beginning of European thought two extreme positions were taken by Heraclitus and Parmenides. Heraclitus's view was that everything is in flux. One statement of his that has been quoted many times over the centuries is that "No man can step into the same river twice," for new waters are always flowing in. Heraclitus had a disciple by the name of Cratylus who went so far as to say that you couldn't even use words because the meanings of words changed from moment to moment. So Cratylus said that all we could do was wiggle our little finger to indicate that everything was changing. This, of course, goes to the extreme of absurdity. But it shows what happens, I think, when one takes the extreme

position that everything is in flux at every moment. Everything then becomes quite unintelligible. That extreme position is no longer taken by anybody. But such philosophers as Dewey, Whitehead, and Bergson, go in the direction of that extreme in their emphasis upon change or flux.

In the beginning of European thought, the opposite extreme position was taken by Parmenides, who held that change is unintelligible and that therefore, since being intelligible is the sign of reality, that change is fundamentally unreal. He is quoted as saying that nothing changes. Everything which is, is permanently what it is and is unchanging.

Zeno's Paradoxes

Parmenides had a disciple by the name of Zeno, who tried to support his view that change was unreal and unintelligible by showing how one could think of the changing world we seem to experience as merely an illusion of the senses. And Zeno did this by what are called *paradoxes*. In the history of European thought the four paradoxes of Zeno are very famous. Let me tell you about two of them.

The first one is the paradox of the man who is standing at the position A, and who wants to go to B. "But," said Zeno, "in order for the man to go to B, he has to go through half the distance first, doesn't he? But in order to get to the halfway mark he has to go through a quarter of the distance first. But in order to get to the quarter mark he has to go through one-eighth of the distance first. And if you keep on dividing the distances, the man never gets started; change can't happen."

Then there is the famous paradox of the tortoise and the hare. You know the fable of the tortoise and the hare, how the hare, who is much faster than the tortoise, gives the tortoise a head start. Well, in this paradox Zeno proves that the hare can never overtake the tortoise. Because if the tortoise has a head start—this represents the tortoise and this figure here represents the hare. If the tortoise has a head start, then the hare in order to pass the tortoise must first overtake the tortoise. But when the hare gets to the position at which the tortoise was, the tortoise has moved on. And again, though the distance may be diminishing, the hare in order to overtake the tortoise and pass him must first get to the position

the tortoise is at. But as soon as the hare gets there, the tortoise has passed on a little further. So the tortoise is never passed by the hare and the tortoise wins the race.

These paradoxes were Zeno's way of supporting his master, Parmenides, and showing that change is unintelligible or unreal. In our day we have learned what is wrong with these paradoxes. I'm not going to take the time to tell you but modern mathematics, particularly the analysis of the infinitesimal units of time and space, has exploded the paradoxes of Zeno. And so no one nowadays takes the extreme position that change is absolutely unintelligible and unreal.

PLATO'S TWO REALMS

Nevertheless, in the history of thought there is a view that is somewhat like this extreme position and that is very popular and has persisted to our day. This is the view taken by Plato, which somehow combines both what Parmenides and what Heraclitus had to say. For Plato there are two realms: the realm of being and the realm of becoming. The realm of being is the world of things which are purely intelligible. And the realm of becoming or change is the world of things which are merely sensible. The realm of being, which is intelligible, is immaterial. It consists of the ideas or the essences or the forms, whereas the realm of becoming, which is sensible, is the physical world. The realm of being is the realm of unchanging reality. And the realm of becoming is the realm of the flux of appearances. Now this Platonic view, dividing everything into the things which are and the things which change, persists right down to our own day.

THE ATOMISTS

In the history of European thought, particularly in the very beginning in the Greeks, there were attempts, other than Plato, to mediate, attempts to find a middle ground between the two extreme positions of Heraclitus and Parmenides. I am going to report to you two of these attempts. The first attempt is made by the Atomists, the Greek philosophers who analyzed change and the

physical world in terms of atomic particles, these little, hard, solid units of matter that were uncuttable. That is why they were called atoms, indivisible and therefore unchangeable.

According to the Atomists, physical nature, the world of physical change, the physical world, contains elements of change and of permanence both. The atoms themselves are immutable because they are "atomic" or uncuttable. They can't be divided, they neither come into being nor pass away. "They are," as Lucretius the great poet of atomism says, "eternal units of matter." But all the large bodies in the world, all the bodies made up of atoms, do come into being and pass away by the joining together and the separation of the atoms. As the atoms move locally in space and congregate or separate, their very motions create the large, complex bodies which are mutable. Large bodies are mutable because, being made up of atoms, they can be broken into parts and divided and disappear or come into being again.

The significance of this atomic solution is that it combines elements of permanence and of change. The atoms are permanent; their arrangement into larger bodies, clusters of atoms, are impermanent. And the atomic solution shows that change is intelligible. Change is made intelligible by reference to the atoms which are themselves immutable, enduring particles of matter.

ARISTOTLE'S ACCOUNT OF CHANGE

Now the other middle ground, the other attempt to mediate between the two extremes, is that found in the physical treatises of Aristotle. Let me begin to convey to you Aristotle's account of change and how Aristotle found permanence at the very heart of change. Let me show you how Aristotle looked at two changes.

Here is a billiard table. And here is a billiard ball at position 1. Now if we are going to hit this billiard ball and make it move to position 2, it must be true, says Aristotle, that while the billiard ball is at position 1 it is possible for it to be at position 2. It has, says Aristotle, the *potentiality* of being at position 2. And the change, when it moves, when it goes through local motion, is the actualization of this potentiality. It then becomes actually at position 2, and is no longer actually at position 1. It gives up the actuality of being at position 1., and takes on the actuality of being at position

2. When it's at position 1, it's only potentially at position 2.

Or consider another kind of change, alteration. Let's look at a white circle. It is white. Can it change? Yes. We know, don't we, that it can be black? It can change in color. It has the potentiality of being black. And when I make it black, it undergoes an alteration or a change in color. And that change, too, is the actualization of a potentiality. The white circle can be black and it changes by becoming black.

In both these changes something, the billiard ball or the circle, endured. That billiard ball was at 1, and comes to be at 2. The circle was white and comes to be black. The circle must continue to be, the billiard ball must continue to be, if they are going to change. So according to Aristotle, in all change there is an enduring subject, an enduring something which undergoes the process of change, which is the subject of change. And also in all change there must be potentiality. That which changes must have the capacity for being something other than it was, being at a different place, or having a different color. For Aristotle, potentiality is the very matter of things. Matter is nothing but potentiality, the capacity for taking on some other form or characteristic. So that with this theory of change, anything which is really immaterial as Plato suggested, is immutable or unchangeable. Only material things are mutable or changeable.

Let me summarize this then by giving you Aristotle's definition of change. It is the actualization of that which is in potentiality while it still remains to a certain degree in potentiality. For only so long as this can be potentially here and is not actually there can it be moving toward there. Once it gets actually there and stops, change is stopping. It is only while it is in process that it is more and more becoming there, less and less being here, that change is going on. And so, as you look at it this way, change is only partly intelligible. While something is in process of change it is not completely actual. Because if it were completely actual, it couldn't be changing. It must be in a process of actualizing what it can be. And that is why, according to Aristotle and many of the ancients, change is not a fully intelligible thing.

For the Atomists, those who explain change in terms of the mechanics, of the motions of atomic particles, change was fully intelligible. It was only regarded as less than fully intelligible by such philosophers as Plato and particularly Aristotle. Now this

issue about the intelligibility of change is between the Atomists on the one hand and a philosopher like Aristotle on the other comes right down into modern times. It occurs in modern physics.

ARISTOTLE'S FOUR KINDS OF CHANGE

To explore it a little further, let us turn to another problem, the problem about the kinds of change, whether change is all of one kind or there are different kinds of change. To begin with, let me state Aristotle's view. Aristotle held that there were many different kinds of change and that these different kinds of change were irreducible to one another. You couldn't reduce one kind of change to another kind of change.

In the realm of physical change he distinguished these four kinds of change. First, local motion, the kind of thing we talked about here. Local motion is the change of a body from place to place. Secondly, alteration, the change of something in quality as in the ripening of an apple when it changes from being green to being red. That change in quality Aristotle called alteration. Or another kind of physical change, increase and decrease, something getting larger or smaller in size or quantity. And finally, the most fundamental of all changes, the coming to be or passing away of something as when a living organism is born, it comes to be and then passes away and dies.

In addition to these four kinds of physical change, Aristotle distinguished between all physical change and the kinds of change which took place in living organisms, such changes as growth or learning. These changes, Aristotle thought, were not of the same sort at all as the kinds of change which took place in the locomotion or alteration or increase and decrease of inert bodies.

Now there is an opposite view to this pluralistic view of Aristotle, this view that there are many kinds of change not reducible to one another. The opposite view is *monistic*. It says that all change is of one kind. There is only one kind of change. For example, in the seventeenth century the French philosopher René Descartes looked at the material world and found there only bodies in motion. And by bodies in motion he meant bodies changing place, moving locally from one place to another. This is the only kind of change which bodies as such undergo. And for Descartes,

a universal mechanics, the mechanics of the motion of bodies changing position in space, accounted for all the phenomena of the physical universe. This mechanics Descartes applied even to living things. He regarded all living things except man, as being like automata, like machines. And he even regarded man's body in this way, but not man's mind. One of the great followers of Descartes, the French philosopher La Mettrie wrote a book called *Man the Machine* in which all the motions of the human body were explained as movements of the parts of a very complex machine.

NEWTON: THE UNIVERSE AS A MACHINE

This tendency toward mechanism, toward explaining all the phenomena of change in terms of one kind of motion, the motion of bodies in space, reaches its great climax with the work of the English physicist Isaac Newton. For Newton the laws of motion are the laws of nature. And the whole universe, the celestial universe as well as the terrestrial universe, is to be explained as one vast, complex machine.

Let me read to you Newton's three laws of motion. They sound very simple but by these laws of motion Newton thought to explain the whole universe that we experience. The first law of motion according to Newton is that every body (every solid object) continues in its state of rest or of uniform motion in a straight line, unless it is compelled to change that state by forces impressed upon it. That is the law of *inertia.* The second law of motion is that the change of motion is proportional to the motive force impressed upon it and is made in the direction of the straight line in which that force is impressed. Finally—and there are only these three laws, no others—the third law of motion is that to every action there is always an opposed and equal reaction, or the mutual actions of two bodies upon each other are always equal and directed to contrary parts.

Newton's triumph was great. Until the end of the seventeenth century and beginning of the eighteenth century, Newton was looked upon as the man who made the whole world intelligible to us. Alexander Pope, the English poet, praised Newton for this in the following couplet. He said, "Nature and nature's laws lay hid in night. God said, 'Let Newton be,' and all was light." Newton

dominated the thought of Europe for three centuries. At the end of the nineteenth century the mechanics of Newton, which came later to be called later "classical mechanics," was the dominant view of the world throughout all of the West. And mechanics was triumphant in the sense that the machine was the ideal model by which everything in nature was to be explained. Everything was reduced to mechanical laws, to the machine-like operation.

In our day Arthur Eddington, a great English physicist who just recently died, looking back at the Victorian period said, "It was the boast of the Victorian scientist that he would not claim to understand a thing until he could make a model of it." And by a model he meant something constructed of levers, geared wheels, works, and other appliances familiar to the engineer. Nature, in building the universe, was supposed to be dependent on just the same kind of resources as any human mechanic.

That triumph of classical, Newtonian mechanics, which was at its high point at the end of the nineteenth century, was not to last long after that. As Eddington pointed out, "One of the greatest changes in physics between the nineteenth century and the present day has been the change in our ideal of scientific explanation. The most characteristic thing about twentieth-century physics is its attack upon the classical mechanics of Newton which lasted from the seventeenth until the end of the nineteenth century."

I think I can best give you the sense of that attack on classical mechanics by reading you the words of Einstein. Einstein said, considering the assumptions which physicists had to make, for example, as the assumption of the ether, "The assumptions which physicists had to make in order to construct a mechanical theory of light, gravitation, and electricity," Einstein said, "the artificial character of all these assumptions and the necessity for introducing so many of them, all quite independent of each other, was enough to shatter the belief in the mechanical point of view." And that is why contemporary physics, beginning with Einstein, turns to a field theory explanation of the phenomena of change rather than a mechanical explanation, where the laws are not the laws of bodies in motion but the laws representing the structure of fields, the gravitational field and the field of electromagnetic attraction.

In addition to this attack on classical mechanics, we have seen the atom exploded. Atomic fission not only exploded the atom but exploded atomism in the original sense. For it removed for ever

the possibility of atoms as simple building blocks out of the motion of which the whole world could be explained. Moreover physics now teaches us that the subatomic particles, the electrons and the protons and the ions, do not obey the laws of classical mechanics in their motion. This is one great challenge to mechanism. A second challenge is that philosophers have often doubted that the mechanical approach can really explain how one body causes another to move.

And there is still a third important challenge to mechanism: the challenge that comes from the phenomena of life itself. Because there are philosophers who think that you cannot explain the phenomena of living processes, be it the change that takes place when an animal grows or when a man learns in terms of mechanical laws or in fact of any laws that describe physical change and nothing but physical change. Hence the issue about whether or not all change is of one kind and is subject to the same laws is still an issue in our day as it was an issue at the beginning of the study of change in Greek physics and philosophy.

WILL CHANGE COME TO AN END?

Let me mention one other problem about change. It is the problem whether change itself ever had a beginning and will ever end. Is change everlasting? Has it always been going on? Has the world of changing things always been in existence without beginning or end? Well, to this question there are two answers. One is the answer of the Greek physicist and the modern physicist, namely that the world is endless in time, has neither beginning nor end; change couldn't get started, change will never come to a stop, change is always going on. The other answer to this question is the Christian answer, the answer that is based upon the opening words of Genesis: "In the beginning God created heaven and earth." The Christian theologian interprets this to mean that God made things begin in time and begin to change.

This statement that God created things as having a beginning, that time started and that change started, that time started when things started to change, raises a very puzzling question, the question about what was happening before time started. That is the question we naturally try to ask. But it's an impossible question to

ask because there is no "before time." If time is the place where there are befores and afters, then there can't be a "before time."

Saint Augustine commented on this by his answer to the person who asked him, "What was God doing before He created the world?" Saint Augustine said, "Thinking up punishments in hell for fools who ask questions like that."

46 How to Think about Progress

The idea of progress raises difficult questions of fact as well as theory. It is a modern idea and it is one of the few distinctively modern ideas. Perhaps I should say that the idea of progress and the idea of evolution are the only two among all The Great Ideas that really have their rise and vitality in modern times.

The idea of progress makes its first appearance in European thought in the eighteenth century and it becomes a dominant idea in the nineteenth century. Evolution is a nineteenth-century idea. But in such works as the great historical writings of the Italian historian, Giambattista Vico, or in the writings of the French sociologists Pierre-Joseph Proudhon and Auguste Comte, and the German philosophers Immanuel Kant and Georg Wilhelm Friedrich Hegel, this idea plays a very important part.

And then when, in the nineteenth century, the idea of evolution becomes so important in the work of Charles Darwin, the earlier idea, the idea of progress, is very influential in developing the theory of evolution. One finds the notion of progress in Darwin's work and in the work of his great disciples Huxley and Spencer. In fact, towards the end of the nineteenth century in the collection of works by Herbert Spencer, one finds the idea of progress and evolution wedded in all fields as progress and evolution—in society, in astronomy, in the physical world, and in the biological world. It is a kind of cosmic evolution and cosmic progress. But it is primarily in the philosophy of history, not in biology, not in cosmology, that progress is a central idea and raises a central issue.

435

History and Philosophy of History

You may ask, What is the philosophy of history? How does the philosophy of history differ from history itself? Let me see if I can answer that question since it is so important to know the answer to it in order to understand the significance of the idea of progress. Let me show you the difference between the philosophy of history and history.

Imagine someone standing on a watchtower, looking at the past. A person who is concerned only with the past, with knowing what the past contained, in this sense recording what could be remembered of the past, is merely an historian. The philosopher of history stands to the mere historian as imagination stands to memory, as the sense of the future stands to knowledge of the past. The philosopher of history is someone who, knowing something about the past and observing its trends and tendencies, then turns around, to face in the opposite direction on that watchtower, and projects his knowledge of the past into the future, predicting how history will go on.

If this is what one means by philosophy of history, two things are required for a philosophy of history. There must be sufficient knowledge of the past on which to base predictions, on which to give one a chance to observe the trends or tendencies of past or recorded history. And the second thing is that the philosopher of history must have a perception, a keen perception of the pattern of change, the way in which change has taken place in the past so that he can project that pattern into the future.

It is for this reason that the philosophy of history is itself a modern subject. Along with progress it is a modern thing. And the reason for that perhaps is that until modern times there wasn't enough recorded knowledge of the past to provide a basis for prediction, to provide a basis for an observation of trends and tendencies which would enable one to foresee the future and see the whole sweep of history.

It's obvious, I think, that progress gives us one answer to the central question in the philosophy of history. That question is, What is the pattern of change? What is the pattern of change that takes place in time? What is the picture of the changing state of things, either in the physical world or in the world of human affairs?

Progress versus Cycles

If the individual on the watchtower looking back at the past sees events as following a line upward, if as he looks at the past it seems to him that the past is a series of steps upward, stages of advance, each century or each period of time being an advance of a previous time, then he may very likely project the future in this way, as a continuation of that line of progress and see the future as getting ever better, reaching higher qualities, reaching elevations that the past does not reach or increasing in quantity in some way. That is the answer which the philosophy of history based on progress gives. It sees a gradual ascending as one goes through the ages of the past and projects that into the future. But progress is not the only answer. There is another answer that is given in the philosophy of history.

If the person on the watchtower looking at the past sees that the past, the pattern of change in the past, has consisted of cycles in which things have risen only to decline, that there is a continual rise and fall in human affairs, there is always a tendency to rise, but it never reaches more than a temporary peak and from which it comes down, in which there is a decline almost to a point at which things perish, that person will project the future as a repetition of ups and downs. He will say that in all human change, in all history, there will be these cycles, cycles of rise and decline. And his view of history will be cyclical as opposed to progressive.

Now these two fundamental ideas are opposed in the philosophy of history: the idea of progress and the idea of cycles. And that is the first thing I want to do in this discussion, consider the opposition of these two fundamental views of history: the progressive view and the cyclical view. Having done that, I would like then to consider the facts of history, the facts of recorded history, and ask of them the question: What evidence of progress do they show? Is there in history evidence that progress has taken place in the past and provides us with some basis for projecting the future as a progressive development in time? And in the light of this consideration of the facts I would like to conclude with some of the difficult questions raised by the facts themselves.

THINGS KEEP GETTING BETTER AND BETTER

In considering these conflicting theories, let's begin with the optimistic view that progress is the pattern of history. Let's first consider the extreme form of this view, that progress is the very law of history, as gravity, for example, or gravitation as a law of nature, that progress is therefore inevitable, that it happens whether we like it or not, that things are so constituted that in human affairs, human society, and the succession of civilizations, men are always advancing.

Let me give you some examples of this extreme view that progress is inevitable, a necessary law of history. We find this in the work of the great German philosopher of history Hegel, who looked at world history in the following way: he saw it as consisting of three stages; a first stage which he called the Oriental stage in which only one man, the single despot was free—actually in Hegel's view no man was free because the despot himself did not have real freedom but only arbitrary caprice—necessarily followed by a second stage, the Greco-Roman stage of classic antiquity in which some people were free as citizens and others were slaves; and that led in Hegel's mind to a third and almost final stage of history, the Germanic-Christian stage in which everyone has freedom. And he sees that as a progress in freedom that happens inevitably in the course of human events.

Or take a follower of Hegel, Karl Marx, who looked upon history as the succession of class struggles. For him there are four stages in history, one following another in inevitable succession, necessarily one coming from another. The first stage is the slave economy of ancient times. And that is followed in the Middle Ages by the economy of feudal serfdom. And that inevitably leads to modern capitalist production and the class war of capital and labor. And that in Marx's view inevitably leads to the fourth and final stage of history, the communistic or classless society.

Herbert Spencer is another of these philosophers of history who sees everything as a necessary progress. For him the law of progress is a law of change in which one goes from something, a less complex, less differentiated state of affairs, to a more complicated and more differentiated state of affairs.

There are more moderate versions of this philosophy of progress; as, for example, the version we find in Immanuel Kant.

Kant does not think that progress is necessary or inevitable; he thinks it can happen, that it is possible, that in human beings there are potentialities for development. But whether or not these potentialities will be developed depends upon humans themselves. It depends upon the human race and the use that human beings make of their freedom to realize the ideals that are in some sense the projection of their potentiality.

There are some fundamental questions raised by this theory of progress as a philosophy of history: Is progress necessary and inevitable or is it the result of people exercising their freedom? Is progress interminable? Will it go on forever? Will there be no end to progress or is it getting better and better or higher and higher? Or does the line of progress reach some goal, some final goal which is its terminus or end? And if there is a goal of progress, is that goal attainable in time? Is it reached in time or is the goal only at the end of time when the world is done?

RISE AND FALL, RISE AND FALL

Now let's look at the other view, the opposed view, the view that I would call the pessimistic view, that there is no progress in history, no real advance at all, everything is cyclical. Things do improve for a time only to decline after they have improved. This is an ancient view of history. And in its ancient form it was quite extreme.

Let me read you from some ancient writers some indications of this extreme view that history is completely cyclical, that everything that is happening now, happened once before, and will happen again almost in the same way. One finds that in the writings of Herodotus, the great early Greek historian, Herodotus says, "The cities which were formerly great have most of them become insignificant. And such as are at present powerful were weak in olden times. I shall therefore discourse equally of both, convinced that prosperity never continues long in one's day." Rise and fall, rise and fall, almost like the waves of the ocean. History doesn't move on; it just goes up and down.

Or an extraordinary statement by Aristotle, talking now about the arts and sciences. Aristotle says, "Probably each art and science has often been developed as far as possible and has again perished," as if the arts and sciences, the products of civilization were

once developed and lost, only to be developed again and lost, to be developed again and lost.

Or we find in Lucretius the picture of the birth and growth and decline of worlds in one succession after another. And some of the rise of civilizations to be followed by their fall and the rise of new civilizations to be followed by their fall. All of this, perhaps, is most pointedly summed up in the words of the preacher in Ecclesiastes, when he says, "There is no new thing under the sun; all is vanity and vexation of spirit."

What you notice about this cyclical view of history is, I think, this: that it applies to history the kind of pattern of change one finds in the biological world of living things. For plants and animals are born, grow to maturity, develop to their prime as it were, and start to decline and end in weakness and death. And what the thinkers who take the cyclical view are doing is finding in this analogy the pattern of historical change: history, society, and civilizations are almost like living organisms.

One modern philosopher of history, Oswald Spengler, wrote a book that was very influential in my youth, *The Decline of the West*. It took exactly this view, that civilizations were like organisms and were born and had their infancy and grew to manhood and the prime of life, only to decline and decay. And he predicted that just as past civilizations had arisen and grown to maturity and declined, so Western civilization, our society, was doomed, necessarily doomed, by the same cyclical motion of history.

The greatest philosopher of history in the world today, Arnold Toynbee, takes a more moderate view than that. He reports to us that twenty-two or twenty-six civilizations in the last six thousand years have arisen and have reached a kind of prime, grown to their maturity, only to decline and disappear, to pass away. But he does not think the West is doomed, that the two or three civilizations in the world today that are alive and flourishing need to pass away. It is possible for Toynbee to think that if people exercise their intelligence and their freedom, they can produce a different state of affairs, that a civilization can go on and not necessarily pass away. In a sense, Toynbee is opposing both extreme positions, either that there is necessary progress or necessary alternation of rise and decline. Neither progress nor decline is necessary. Which happens will depend upon the way in which people exercise their intelligence and freedom.

And this, you see, really raises the crucial question in this conflict of the two theories, the theory of progress and of cycles. It is the question whether or not what happens in history obeys necessary laws, laws like the laws of physical nature, or whether, in the processes of history, men are at work bringing about changes by the exercise of their freedom. Those who give the answer that freedom is an important factor in history, those who affirm freedom tend, I think, to take the optimistic view that the future can be better than the past if men, having ideals to realize, manage by the use of their freedom to so control events that to some extent they realize the ideals that they strive toward.

What Do the Facts Tell Us about Progress?

Now with this conflict of theories before us, let's look at the record of the facts themselves and see what the facts of progress are. Let's see how much progress we can find in the actual events of past history. Let's consider, first, those spheres of human activity in which the evidence of progress is most obvious. And then, second, let's consider those other spheres of human activity where we have the greatest doubts about whether or not human beings have made progress or not.

The clearest evidence of progress is, I think, in the field of science and technology. The history of science is a history of advancing knowledge, an advancing conquest of nature as it were, by knowing it from century to century. And along with that progressive accumulation of better, more accurate, more comprehensive knowledge, man has through this knowledge a greater command over the physical forces of the earth in which he lives. He has by invention, the application of knowledge through invention, century after century made more and more progress in techniques. Let's call this technological progress.

All one has to do is to think of the progress from the wheel to atomic energy. The wheel you pull by animal power, by human power, muscle first, by animal power, by steam power, and now by nuclear energy. That is a progress in speed of transport and in efficiency in production which is perfectly clear as one goes across the centuries of human history. Or to think of another example in the sphere of our economic life, think of the progress we have made

over the centuries as we have passed from a society in which the production of goods and services requires immense slavery to that society which is just around the corner, when most of our production will be automatic, to what we now look forward to as "automation." This is progressive emancipation of mankind from grinding toil. As one comes down through the centuries men have to work less and less, less in time and less laboriously, less painfully, to produce the goods, the things they need to live by and on.

You may ask, Is it only in this economic sphere, this sphere of transport or productive power that we have made progressive advances as one goes from century to century? No, I would say no. It was also in the sphere of our social and political arrangements that there is a real advance across the centuries.

About five thousand years ago the first advance was made when humans passed from a nomadic or primitive tribal existence to life in cities. The rise of the first cities was a great step upward in human social life. And then in the succession of centuries one sees the development of higher and higher forms of government. One sees the transition from merely despotic rule by a kind of tribal chieftain to constitutional rule. The invention of the constitution by the Greeks some three thousand years ago was a great progressive step upward, the beginning of citizenship. And as one comes down from the Greeks to our own day, one makes a steady progress to what is happening in our own day for the first time, the democratic constitution. And if one projects this line of progress into the future, one has a right, I think, to predict or to foresee or to hope from the past that the future holds the promise of a world federal government with a democratic constitution with world citizenship, more or less a common fact for all men.

These are the evidences of progress in history: the rise of higher forms of government, the expansion of the human community into a larger and larger society so that in the end one can see that the whole tendency of history is toward a world society, the advances in technology, and in the conditions of human work.

DOUBTS ABOUT MORAL PROGRESS

If one looks at other spheres of human activity, one has, I think, serious doubts about progress in human affairs. If instead of con-

sidering science, one considers wisdom, man's wisdom, it is much more questionable whether as one comes down the centuries from ancient to modern times there has been a great advance in human wisdom. One is entitled to doubt that there has been any advance at all over the ages. Or if there has been any advance, it certainly is not the same rapidly accelerated rate; it happens very slowly, if it happens at all. And this perhaps is the most serious problem we face today. We are in grave peril as the gap widens between the increase in our power through progress in the arts and sciences and in technology with a gap between the amount of power we have and the amount of wisdom we have increasing. Our wisdom does not increase nearly at the same rate or proportion to the increase in our power.

Or if one looks at another field, one has serious doubts about progress. Consider man's moral character as opposed to the way in which he has improved his economic arrangements or his social and political institutions. There is some evidence, I suppose, of moral progress in the fact that over the centuries we have one way or another tended to abolish, eliminate, or attenuate human slavery. Yet it is not entirely clear that this is due to man's moral improvement. It may be due simply to the fact that technological progress has made it unnecessary to have slaves. We may not be able to take the credit for the progress in the emancipation of slaves or the abolition of slaves, for it may not be entirely an exercise of wisdom on our part or good character, but something that happened as the facts of technological change provided the occasion for another mode of production.

And the most serious doubts about man's moral progress come from the fact that in the twentieth century human beings seem to be just as inhumane toward other human beings as they were twenty-five centuries ago. Not only in two great world wars, but in concentration camps and enforced labor camps and in a variety of ways, one seems to see man's inhumanity toward man unchanged. This is disheartening, and it seems to argue that there is no progress in man's moral character, that as he improves his institutions, as he improves his command over nature, he does not improve in his heart and soul, that man is as much the beast and brute today, only with more power than he had twenty-five hundred years ago or five thousand years ago. These are the most serious reasons for doubt that progress happens always and in all spheres of human activity.

Now these reasonable doubts about progress combined with the obvious fact of progress, the clear evidence of progress in certain fields, I think, raises for us the ultimate questions about progress that we want to consider in the little time that remains to us today.

One of these ultimate question is, What factors or conditions are indispensable to progress? I think we can give the answer to this question at least in part. I think it is clear, for example, that progress depends upon tradition. If we did not conserve what has been accomplished in the past, we could not advance from it into the future. It is necessary for each generation to conserve the accomplishments of the past as a basis for making any advance to higher levels in the future. Hence tradition or conservation is an indispensable condition of progress.

But there is a second, perhaps even more important condition of progress. And that is that we overcome in all human affairs the inertia of custom. Custom is the great enemy of progress.

Let me quote you, I think, a very good statement on this point by John Stuart Mill. Mill said, "The despotism of custom is everywhere the standing hindrance to human advancement, being unceasingly antagonistic to that disposition to aim at something better than the customary which is called according to the circumstances the spirit of liberty or the spirit of progress." And Mill says, "The progressive principle is antagonistic to the sway of custom. The contest between these two principles, custom and progress, constitutes the chief interest of the history of mankind."

Finally, if you think as I do that progress is not inevitable, not a law of history, that it need not occur, then the human race makes progress only on one further condition, namely, that people set for themselves ideals, high ideals to realize, and setting these ideas before themselves, then exercise their freedom, their intelligence, and all their powers to do what they can against chance and circumstance, to realize the ideals progressively. The use of freedom intelligently is an indispensable condition of progress if, as I think, progress is not a simple, inevitable law of history.

HUMAN NATURE DOES NOT CHANGE

There is a second ultimate question that I should like to talk about very briefly, what is for me the most interesting question of all. It

is the question, Does progress in human affairs occur only in the outward conditions of human life in the institutions, the arrangements, all the things outside of man that man contrives, designs or arranges? Or is there progress in human nature itself? Do men as men in their very nature get better from century to century, age to age, epoch to epoch?

One answer to this question is given by those who call themselves the perfectibilists, who believe in the endless perfectibility of man, who think that man is in his very nature improvable. The biologists do not give us complete warrant for thinking this. It is true that the anatomical records of the human body, as it has been born generation after generation, over the centuries, show some improvement, some change and perhaps improvement in the physique of man. There is no clear evidence that man's intelligence has increased in the record of human life on earth, leaving out now those questionable prehistoric men, and talking only about historic men. And it is certainly doubtful in the facts of history whether there is improvement in man's moral nature century after century.

Nevertheless the moralist tends to think that there can be an improvement in the long course of time in the very nature of man himself. I must confess that I take the opposite point of view. It seems to me that man as man is a constant in history. Or there may be slight accidental changes in minor things. But the essence of human nature, what man is, his moral and mental limitations, I think, will be the same at the end of time, at the end of human time as they were at the beginning.

All the progress that is made, in my judgment, is progress in human institutions, what men are able to do with their environment, how they are able to change their society, how they are able to arrange their laws and customs. Men can change other things, but not men themselves.

This, I fear, must conclude our discussion of Progress.

47 How to Think about War and Peace

Today we shall consider the twin ideas, the inseparable ideas, of War and Peace. These two words, *war* and *peace*, are day in and day out on everyone's lips. It may even be that the ideas they represent are in everyone's minds. Whether or not they are clearly understood is, of course, another matter. I am hoping that in the course of today's discussion we can get some clarity on the meaning of these two fundamental ideas.

The problem of war and peace, how to avoid war, how to secure peace, is perhaps the most important and the most urgent problem of our time. It is, of course, a practical problem, a problem that can be solved only by right action, not simply by right thought. Nevertheless, the right action cannot be taken by human beings unless they can think straight and do think straight about the causes and the nature of peace. Right thinking about this subject is indispensable to right action.

A sound understanding of war and peace exists and has existed for centuries in the tradition of The Great Books. It has been available to men for centuries. And yet century after century this sound understanding of war and peace has not been taught to the young in schools and it has not been possessed by men in general.

I think that in our time people have begun to understand more than ever before the meaning of war and peace. The reason is the general currency, in the twentieth century, of such phrases as "the Cold War" or "the War of Nerves." The use of these phrases shows that people understand that war exists even when the nations are not shooting at one another. And this may lead them to understand that peace, real peace, is positive, not negative. It is

not just the absence of shooting.

There is one other great advance that we have made in the twentieth century. The twentieth century is the first century when there have been world wars. It has been the first century in which the world has been made—by way of communication, by way of transport—physically small enough for a worldwide war to take place. It's also the first century in which the economic interdependence of all peoples has been such that there could be a conflict of interests worldwide.

As a consequence of this, the twentieth century has been the first century when human beings have been able to think practically about world peace, the first century when the vision of the whole world at peace, almost a vision of the brotherhood of man, begins to look like a practical ideal, not a utopian dream.

What I would like to do in the course of our discussion today is first to clarify the meaning of war and peace, especially the meaning of these terms in the light of our understanding of the meaning of the Cold War, and the understanding that the Cold War is not peace. Second, I would like to consider with you the conditions necessary for peace. And then finally, I would like to ask myself and you the 64-thousand-dollar question whether world peace is possible, or whether peace could even in a sense be inevitable in our time.

WAR IS NOT CONFINED TO FIGHTING

I said that we would try first to get at the meanings of war and peace. Let's begin with the meaning of the idea of war. The usual definition of war that people give themselves is that it is "the use of force or violence to obtain the objectives men seek or to resolve their differences and conflicts." And this definition of war applies equally to civil war or wars of rebellion within states as it does to international war, war between states. But let me suggest to you a much deeper and I think sounder conception of war. War consists of hostile acts, hostile acts involving the threat of force, or the use of fraud sometimes without military action, and sometimes these things leading to and accompanied by overt military action.

Now on this conception of war there are two different ways in which war exists. Let me show you. There is actual warfare which

is the warfare in which shooting takes place battles are fought, and men are killed. And there is war which is not actual warfare but merely a state of war. This distinction between actual warfare and a state of war has been made through the tradition of Western thought. Let me call your attention to this deep insight into these two modes of war that has come down to us from the fifth century B.C. and has been echoed century after century from the fifth century B.C. until our own day.

Let me begin by reading you a passage from Plato in which he says, "What men in general term peace is only a name. In reality," he says, "every city is in a natural state of war with every other whether or not they are actually fighting with one another." But a clearer and better statement of this, I think, very important insight, we find in the English political philosopher Thomas Hobbes, to my mind one of the greatest statements on the subject ever made. Hobbes said, "War consisteth not in battle only or in the act of fighting but in a tract of time wherein the will to contend by battle is sufficiently known. As the nature of foul weather lieth not in a shower or two of rain but in an inclination thereto of many days together. So the nature of war consisteth not in actual fighting but in the known disposition thereto." And Hobbes goes on to say, "In all times, kings or sovereigns," and he might have said sovereign nations, "because of their independency are in continual jealousy and in a state and posture of gladiators, having their weapons pointing and their eyes fixed upon one another, that is, their forts, garrisons, and guns upon their frontiers and continual spies upon their neighbors which is the posture of war."

Or to come two centuries later to the great German philosopher Immanuel Kant who says, "In their external relations to one another, states like lawless savages are naturally in a nonjuridical condition. This is a state of war in which the right of the stronger prevails, although it may not in fact always be found as a state of actual warfare or incessant hostility."

And finally in our own time the claim has been made, "The state of war is the natural relation of one power to another." Now what these writers call the state of war is what more recently has been called the Cold War or the War of Nerves. And this Cold War, this state of war exists between nations when they have no way of settling their disputes without recourse to violence and when, because they are hostile toward one another, they are willing to

resort to violence if that is necessary. Furthermore, when hostile nations leave all actual fighting, it is a mistake to suppose that they return to peace. I don't think it is true. Hostile nations are not at peace when they are not actually fighting. In the intervals between war it would be much more accurate to say that they existed in a state of armed truce or that in armistice obtained between them.

A great ancient historian calls our attention to this point. And I would like to take this quotation from him and apply it to the twentieth century. Thucydides wrote *The History of the Peloponnesian War.* The Peloponnesian War usually is said to have lasted thirty years. But there was a very long period in the middle of the war, almost seven or eight years, when there was no fighting going on, when fighting stopped and then after this long interval, fighting was resumed. Although the war is called thirty years long, Thucydides says, "Only a mistake in judgment can object to including the interval of a treaty," this short period when there was a treaty between the Peloponnesians, the Spartans and the Athenians, "Only a mistake in judgment," he says, "can object to including the interval of a treaty in the war. Looked at in light of the facts," Thucydides says, "it cannot be rationally considered a state of real peace where neither party gave or got back all they had agreed upon." In other words, you have here what we have had in the twentieth century. In 1914 a World War begins. It is fought until 1918. And then you have a 21-year period when it looks as if you have peace. Why isn't it accurate to say with Thucydides that that wasn't really a peace but an armistice, an armed truce when war breaks out again and this armed truce becomes an actual fighting war in 1939 and 1940? The modern writer on this subject says that peace established by the state is necessarily of the nature of an armistice, in effect terminable at will and on short notice.

Perhaps the easiest way of making this point is to look at the remark made by the German military strategist, a writer on war, General von Clausewitz, who says that war is nothing but the continuation of the activity of the diplomats, the activity of the foreign offices, by other means, by the means of the military. But you can reverse Clausewitz's statement. You can say that the activity of the diplomats, the activity of the foreign offices is nothing but the continuation during the time of no fighting, no shooting, of the activ-

ity performed on the battlefields by the generals and on the seas by the admirals in the navy.

If one turns from this understanding of war and its two modes, the active fighting, the shooting, the hot war, and the state of war which is not a fighting war but a cold war, a war of nerves; one can, I think, shed some light on the nature of peace. The vulgar misconception of peace follows upon the usual definition of war. It is just a negative conception of peace. It is the conception that peace is merely nothing but the absence of fighting. But such peace, the absence of fighting between really hostile nations is not peace. In fact, it is exactly the same as a cold war. It doesn't really add anything to the notion of a cold war.

And what I just said about the relation between states is equally true within a state. For when people are conquered or ruled unjustly, underneath the enforced order of the conqueror there is always rebellion seething, waiting to break out. You have a state of war there too.

Peace Requires Law

What then is genuine peace? What then is positive peace? Something which is peace and not the equivalent of the state of war. A peace which is not only distinct from the Cold War but distinct from actual warfare. I think that to understand peace positively, we must say that men are at peace when they do not have to resort to violence, when they can settle their disputes and obtain their objectives without the use of force or violence.

How then do they settle their disputes or obtain their objective if they have no recourse to violence or the use of force? The answer: by the appeal to law and by the practices of law, and by the practices of conversation. This it seems to me is a very important set of notions, that the use of law and of conversation constitutes the making of peace positively.

Let me mention two writers, one the ancient Roman Cicero, and the other the modern Englishman John Locke, who called attention to the fact that human beings can settle their differences either in peaceful or in belligerent ways. Cicero says, "There are two ways of settling disputed questions: one by discussion, the other by force; the first being characteristic of man, the second of

brutes. We should have recourse to the latter only if the former fails." And Locke makes the same kind of point when he says, "There are two sorts of contests among men: the one managed by law, the other by force. And these are of such a nature that where the one ends, the other begins."

Let's think about this concretely for a moment in terms of the United States. Here we are in the United States, many millions of people living at peace. What is the peace that we enjoy in the United States today? Does it consist in the absence of conflicts? Does it consist in the absence of quarrels among our citizens? Not at all. We do have conflicts of interest and quarrels. But we can always settle without resort to violence by the appeal to law or to conversation, by using talk instead of force. Nor does it mean that all of our institutions are perfectly just. On the contrary, our constitution, our form of government can still be improved. But we can get greater justice in this country, we can improve our constitution and improve our form of government by due process of law; we do not have to resort to rebellion. This is the reason why we have civil peace in the United States of America today.

KEEPING THE CONVERSATION GOING

With that understood, let's ask, What conditions are indispensable to the existence and maintenance of such peace? First, in terms of the understanding of war and peace we have just achieved, let us observe a widely prevalent misunderstanding of history. As history is taught to children in school, and as it is believed by most of us, it looks like a succession of wars, each followed by a peace between the nations which were are war, which were fighting against one another, a peace concluded by something called a peace treaty. We talk about declarations of war, the conduct of war, the end of a war, the conclusion of a war, the making of peace by a peace treaty.

Or we sometimes understand history as involving peace through the conquest of a great power, the subduing by a great power of its enemies so that that hostility is put an end to and peace is made by conquest. This is a great mistake. As history should be taught us, and as we ought to understand the facts of history, we should never think of treaties as making peace, for between hostile nations there is only a state of war, even when they

have made a treaty of peace. And we should never think of conquest as making peace. For when the conqueror puts down the enemy, all he has done is allowed the subjugated to exist under his heal, waiting to rebel, and a state of war exists there as well.

If I just remind you of what we said a moment ago, you will see that positive peace consists of men living together in such a way that they have means of resolving their difficulties, means of resolving their conflicts without the resort to force or violence. And to have such means two things must be available to them: they must live under law, a law that is enforced equally and justly; and they must be able to settle their differences by conversation, by talking instead of fighting.

I have used the words "talking" and "conversation" several times in the course of our discussion. And you may think that I have overemphasized this notion of conversation in relation to peace. But to show you that this is not the case, let me remind you of the language of diplomacy. The diplomats, when an international crisis is brewing, often say, and the press in its headlines reports it this way, that conversations are rapidly deteriorating. When a conference is called between leading powers and things aren't going well, they say that conversations are rapidly deteriorating. And then in the eleventh hour, in the last moment before war is declared, the headlines of our great metropolitan dailies will carry the words "Conversations Have Completely Broken Down." And when conversations have completely broken down there is nothing left for the nations who have real differences, real conflicts, and real interests at stake but to resort to force. When conversations have completely broken down, then the armies march, the navies sail, and bombs begin to drop.

If you understand the importance of law and law enforcement and conversation as the elements, the sinews of peace, you will see that the one indispensable condition for the existence of peace is government. For government in the society provides the reign of law, it provides the enforcement of law, and it provides the machinery for keeping the conversation going. What do I mean when I say this last thing, that government provides the machinery for keeping the conversation going? I mean all of the apparatus of courts and the kind of legal formalities that take place in courts when things come to trial and things are contested by law rather than by force, all of the machinery of debate in and outside deliberative

assemblies, and even such matters as voting on men and issues. Even that is a way of deciding important things by talk rather than by force. That is how government is fundamentally the machinery for keeping the conversation going. Ambassador Jessup in a recent book said, "When government provides the processes for correcting abuses by nonviolent means or for settling differences by nonviolent means, then" he says, "there is no need to exercise the right of revolution."

THE NECESSITY OF WORLD GOVERNMENT

On this view of what real or what positive peace is, let's look at history again and see how peace has grown, how peace has developed over the century. What we find is that there is an enlargement of the areas of peace. There is an enlargement of the units of peace. Consider each society, each political community where men live together under government as a unit or area of peace. Over fifty centuries of man's life on earth, the peace units, the areas of peace have grown larger and larger and larger in size, so that now in our world hundreds of millions of men can live together in peace; whereas in antiquity the peace units seldom numbered more than fifty or a hundred thousand. What has happened is that the size of the community had grown from tribal village to the small city, to the city-state, to the nation, to the large nation, to the great federal nations of the modern world.

This is the sense in which there has been progress in peace. Peace has been spread over the earth. But if this is true, it is also true that in the whole history of the past all we have made is not peace but peaces—you hear me say it in the plural—peaces, not peace. There have been as many local peaces as there have been peaces in this city or this state, this nation or wherever there has been a local unit of government, wherever there has been a political community living under government, there there has been peace. And so peaces have existed on earth in the plural, local, city-wide peaces or nationwide peaces. But nowhere on earth, not in the past and not in the present, has there been one, single, universal peace. That is the problem. That is the problem we face finally.

Can we make one peace out of all these peaces? Can we make a world peace? Human beings have succeeded in making these

smaller units of peace and making them grow so that the units of peace in the modern world are very much larger than they were in antiquity. The problem is, can we have world peace, one universal and indivisible? The answer to that question can be given in what looks like an axiom, a political axiom or self-evident truth. It is that if government is necessary for local peace, that is, if government in the United States is necessary for peace in the United States, the government of England for the peace of the people of England, the government of France for the peace of the people of France, if government is necessary for each of these local units of peace, then it would seem to follow without any doubt that world government is necessary for world peace.

But the question remains, Is world government possible? Is world peace possible, if it requires or depends upon world government? That is a difficult question and yet I think we must answer it by saying that world peace and world government are very difficult things to achieve and yet not impossible. All the lessons of history, the lessons of history which have taught us how men have made and enlarged the units of peace from the smallest tribal unit to the great modern state, teach us also that it is possible, difficult but possible, to make the whole world a single unit of peace. Yet the price may be too high. For what the price is is the surrender of certain aspects of national sovereignty and subordination of other aspects of national sovereignty to the higher sovereignty, the higher lawful sovereignty of a world government. I would say in the first instance a world *federal* government. Will we pay that price? That all depends, I'm afraid, on how much people want peace.

Clemenceau, who was prime minister of France during the first World War, said, "Men say they want peace but they do not want the things that make the peace." So far in this century men and nations do not seem to have been willing to pay the price for peace. But atomic warfare may change their minds on that subject. And atomic power, making the world smaller as well as making the threat of the next war more terrible, also changes the whole aspect of the question of war and peace.

Perhaps the most incisive remark which we have on the subject has been made by the great English historian and philosopher of history, Arnold Toynbee. He said, "It is no longer a question of whether world peace is possible in our day, for we must now face

the fact that world peace is inevitable in the near future." And the only question, the only practical question we face is how it is going to come, either by force and conquest and war on the one hand or by law and consent on the other. That is our only choice.

48 How to Think about Philosophy

The difficulty about philosophy is that people take quite opposite attitudes toward it. Some honor it as the pursuit of wisdom or the love of wisdom and by others it is despised or even held in contempt as useless inquiry or idle speculation or merely their opinion.

Philosophy means different things to different persons so that perhaps if we look at the kinds of questions that people have sent in to us, we may get some guidance about the points we ought to consider first that may need most of all to be clarified. I am going to ask Mr. Luckman to read a sampling of the questions that we've received. This may get us started in the right way.

Lloyd Luckman: Well, Dr. Adler, it's a very interesting collection of questions, though I was surprised that one question which I thought would be asked just didn't appear in our letters.

We had four letters, for example, asking about the relation of philosophy and religion. And I selected two that I think are slightly different. The first one is from Mrs. Frank England from Petaluma. She writes, "It seems to me that a man's religion is his philosophy, and that religion and philosophy are indistinguishable." And then some of those questions simply ask how closely philosophy and religion are related. But one of them from Mrs. Carol Terry in Santa Rosa tends somewhat in the opposite direction and she asks you to *distinguish* between philosophy and religion.

Mortimer Adler: There is no doubt, Lloyd, that the relation of philosophy and religion troubles a great many people, and it is certainly a problem that we shall have to deal with, but let's have the other question—but first, Lloyd, I'd like to know what the

question was that you expected we would receive that we didn't get. What was that question?

Lloyd Luckman: Well, I thought there would be just as many questions, for example, on the relationship of philosophy and science, and the distinction between philosophy and science.

Mortimer Adler: Now that is very surprising, as a matter of fact, because living in an age of science such as this you would think the people would ask as much about how science and philosophy differ as about philosophy and religion.

Lloyd Luckman: That's how I felt.

Mortimer Adler: Let's consider that question asked and added to the rest of the list. Would you go on with the others now?

WHAT USE IS PHILOSOPHY?

Lloyd Luckman: Surely. Mr. Harley Crawford in Stockton wrote, "Does every person need a philosophy of life? Is an individual aimless if he lacks a philosophy of life?" And then closely connected with that question is one from a seminarian, Mr. Eugenio Fontana of Menlo Park. And he asks, "When you speak of a philosophy of life, are you speaking to a branch of philosophy or to philosophy as a whole?"

Mortimer Adler: My guess is that most people who use the word *philosophy*, use it in the sense of a philosophy of life. And that may be the very reason why they tend to confuse or identify so closely philosophy and religion. Because for a religious person it certainly is true that his religion is a way of life. Hence if philosophy is a way of life; it would appear to be very much like religion.

Lloyd Luckman: Well now, there is just one more question I think should be considered and that is the one from Mrs. Dunne in Napa. Mrs. Dunne says, "Most people think of philosophers as living in ivory towers, whereas, in my opinion, they are the most realistic individuals."

Mortimer Adler: Thank you, Mrs. Dunne.

Lloyd Luckman: Ah but, Dr. Adler, Mrs. Dunne continues. She goes on to ask you how you would go about proving to the skeptical person that philosophy is practical or useful.

Mortimer Adler: Maybe I said thank you, Mrs. Dunne, too soon. Proving that philosophy is useful to the person who is skep-

tical about philosophy is a large order. But it is certainly one of the things that we must try to discuss in the course of these programs on the meaning of philosophy.

Now as I see it there are two main questions, two main points that we have to consider that I draw from all these questions. The first is the desire to have us distinguish and relate philosophy, science, and religion. And the second is that we must consider philosophy in relation to life and explain how it is useful; or more than that, prove that it is useful.

I think it is quite reasonable that people should be concerned with these two matters. In fact, I think I can give an historical reason why they should be and a contemporary reason why they are. The historical reason why they should be concerned with this is that in the history of Western culture, philosophy is the most primitive, the most basic of all the forms of inquiry and thought. I beg your pardon, I should have said religion as a matter of fact; our culture begins with religion and out of religion, philosophical inquiry develops. And then much later all of the special sciences that we know, that we call sciences in the world today, have broken off from the main front, the main branch of philosophy.

PHILOSOPHY, SCIENCE, AND RELIGION

The contemporary reason why we are concerned with the relation of philosophy, science, and religion is, I think, a very striking one. All of us are aware of the ways in which both science and religion make themselves visibly manifest in the world about us in their institutions, in their practices, and their uses. We know what a scientific laboratory looks like. We know what a house of God looks like, a church. We know what goes on in a house of God or a church. We know that people go there to pray and worship and that on the solemn occasions of life, weddings and funerals, they seek God's help. We know that in a scientific laboratory there is apparatus, instrumentation, and that research is going on. And we know the uses of the things that are produced in scientific laboratories. But I feel quite sure that the many persons who walk by the Hanson building at 2090 Jackson Street in San Francisco and see the sign on it, "Institute of Philosophical Research," wonder what is going on there. Because philosophy is not institutionalized and

people do not have any visible manifestation of what philosophers do or what use philosophy is. This, I think, is one of the reasons why everybody wants to know what philosophy is, what philosophers do, and the use of philosophy to human beings in the course of their living.

Now there are several ways of meeting this demand. I think each of them that I am going to propose at first is somewhat unsatisfactory. But let me try them one after another until I build up what may be a satisfactory answer to this primary and, I think, quite right question.

The first thing that one is told is that philosophy is everybody's business. Everyone should have a philosophy of life in order not to be aimless, in order to guide and direct the conduct of his affairs. This is extremely well said by Gilbert Chesterton. I am going to read you a passage. from the opening chapter of William James's *Pragmatism*. This happens to be, by the way, the first philosophical book I ever bought. I bought it before I entered Columbia College at a fairly young age. In the opening chapter, William James quotes Chesterton as saying the following: "There are some people," Chesterton says, "and I am one of them, who think that the most practical and important thing about a man is his view of the universe. We think that for a landlady, considering a lodger, it is important to know his income, but still more important to know his philosophy. We think that for a general, about to fight an enemy, it is important to know an enemy's numbers, but still more important to know the enemy's philosophy. We think the question is not whether the theory of the cosmos affects matters, but whether in the long run anything else affects them." William James goes on to say, "I agree with Mr. Chesterton. I know that all human beings have a philosophy and that the most interesting thing about you and about me is the way in which that philosophy determines the perspectives in our several worlds."

What is unsatisfactory about that answer is that while it distinguishes philosophy from science, it doesn't distinguish it from religion. Philosophy is a way of life and philosophy is something that guides a man's life, and science in that sense does not. The trouble with this answer is that religion also can be looked upon as something that directs a man in the conduct of his life.

The second answer is one that in a sense is given, first of all, by Socrates. And Socrates is, for all of us I think, almost the perfect

image of a philosopher. In the *Apology*, in which Socrates is on trial for his life, he says, "God orders me to fulfill the philosopher's mission of searching into himself and other men. While I have life and strength," he says, "I shall never cease from the practice and teaching of philosophy, which is cross-examining the pretenders to wisdom, exhorting them to care first and chiefly about the improvement of their soul. Therefore," he says to his judges who ask him to give it up, "I can't hold my tongue daily to discourse about virtues. And to those other things about which you hear me examining myself and others is the greatest good of man." And then that magnificent sentence of Socrates, "For the unexamined life is not worth living." And he might have added, "The unexamined thought is not worth thinking."

There is another exemplification of this in another group of philosophers in the ancient world, the Roman Stoics. For them philosophy also was a way of life. Marcus Aurelius, who was a Roman emperor, says this to himself: "What is that which is able to direct a man's life?" And he answers, "One thing and only one: philosophy, for it enables him to accept all that has happened and to wait for death with a cheerful mind." And then he says to himself, thinking of the cares of state and the duties of the court, "Return to philosophy frequently and repose in her."

And at the other end of the social scale there is Epictetus, the slave, who says, "Philosophy does not promise to procure the man anything outside himself. It provides only peace of mind. You must busy yourself with your inner man or with things outside. That is, you must choose between being a philosopher and an ordinary man."

That also is an answer about philosophy which distinguishes it from science, but I think fails to distinguish it from religion. Because certainly any religious person would also say that he lives his religion. And in this sense there is very little distinction yet that we've seen between philosophy and religion.

Now let me try to give you the third answer to the question. This third answer is an answer that might be called the academic answer, the professorial answer; professors of philosophy have been giving it, from the Greeks right down to the end of the nineteenth century, in fact, even later than that. It was the answer I first learned when I went to college in around 1920. Philosophy, this answer says, consists of a whole series of sciences, very special,

highly technical sciences, what we might call the philosophical sciences.

This is not exhaustive but these are the main philosophical sciences. There is, first of all, *logic*, which is the science of thought; then a science called *metaphysics*, which is the science of being or existence; and the science of *physics*, sometimes called the philosophy of nature, which is the science of becoming or change; the science of *epistemology*, sometimes called the theory of knowledge, which is the science of how we know and what knowledge is, or the science of the true; and *ethics*, which is the science of conduct or of the good; *aesthetics*, which is the science of art or of the beautiful; and *politics* which is the science of society and of government.

Now this answer clearly separates philosophy from religion on one hand, but it doesn't now successfully separate philosophy from science; for anyone who should ask the question, "How do these philosophical sciences differ from the scientific sciences we all know in the alphabetical order from astronomy to zoology?" The trouble with philosophy is that it seems to be like religion on the one hand and like science on the other.

THE SPECIAL FUNCTION OF PHILOSOPHY

In the ancient world, philosophy was considered to be science. It was science. The sciences had not separated from philosophy yet. And philosophy as science was opposed to both religion and poetry, which were not scientific. In the modern world when all the special sciences have arisen and we regard the experimental sciences, the natural sciences, and the social sciences as knowledge, we tend to put philosophy along with poetry and religion as not scientific.

As I say, the trouble is that philosophy resembles both science and religion. How shall we distinguish it from them both? I think there is an answer to this question. And I think the answer finally most clearly turns on the special function of philosophy, its special use.

Let me see if I can explain this. There may not be time enough for me to complete the explanation today, but let me at least make a beginning. And I have some help in making a beginning, in doing this, from the fact that we have an exemplification of

philosophy doing its work right before us, in these programs on The Great Ideas. The discussions on this program exemplify philosophy doing its work. And what is that work? That work is the rational discussion of basic ideas.

You all know, I think, that it is philosophy, not science or religion, that is taking place on this program. How do you know it? You know it because you do not see the marks of either science or religion. There is no evidence in this program of any need for experimental research, of apparatus, of laboratory work; that is the mark of science. And in the course of our discussions there was certainly no appeal to faith or the dogmas of religion. That is the mark of the religionist. What is the mark then, the distinguishing mark of the philosopher at work? I say it is nothing but the evidence of rational talk, of men thinking together.

In all the years that I taught young men philosophy in the university there was seldom a time when after a course in philosophy had begun some student or more than one student didn't come to me and say, "Professor, this is all very interesting but tell me, 'What use is it?'" And I learned as I grew older always to answer that question by looking the students straight in the eye and saying, "No use at all." Because I knew that what the student meant by use was a meaning he derived from the utility of science, and that in a sense in which science is useful, philosophy is of no use.

Now what is the use of science? Science gives us power over nature. It gives us a mastery of all the external conditions, the external aspects of human life. But does science tell us how we should control the power we have, how we should use all the machinery and the utilities that science with its technological applications gives us? Clearly not. In fact, we live in a world in which, made dangerous by this fact, science has given us the untold power of atomic energy. But does science tell us how to use atomic energy, either in peacetime or in war, how to use it for the benefit of mankind instead of the destruction of mankind? In fact, the same scientific skills in medicine or engineering that help us to cure and benefit can also help us or enable men to kill and destroy.

It is this fact, I think, which enables anyone to understand the special function or use of philosophy. If the use of science through technology is to give us power over nature, is to give us the means to our end or goal, then the use of philosophy consists in giving us

not the means, but the direction to the end, pointing out the goal, the things we should see, the things we ought to do, giving us the standards by which we can control our use of the means. And for this very reason in a world which has more and more science and more and more of the applications of science through technology, it becomes more and more important to have philosophy and the use of philosophy properly respected. For power without wisdom, the possession of instrumentalities without the understanding of how to apply them and direct them, is, of course, extremely dangerous. But you may say quite properly at this point, this may distinguish the use of philosophy from the use of science, the use of science being a technical use, the use of philosophy a moral or directive use, but how does this still distinguish philosophy from religion, because does not religion direct us too to the goal of our life and tell us how to live?

Well, as I think about this question I am reminded of the story that is told of Cardinal Barbarini, at a time when Galileo was fighting the church or was in trouble with the church. Cardinal Barbarini said to Galileo, "There should be no conflict in this case between science and the church because you, the scientist, the astronomer, teaches men how the heavens go; but we, the church, teach men how to go to heaven." That is not the whole answer because the church does more than teach men how to go to heaven; the church claims to give men, through God's revelation, God's direction to mankind. And beyond that, through the offices of religion, the church enables people to avail themselves of God's grace or help in the direction of their lives. Here is how religion differs from philosophy. Philosophy offers people some guidance and direction in the conduct of their lives by reason alone; whereas the church offers people God's direction of their lives and God's help in following that direction.

HUMAN BEINGS THINKING TOGETHER

Now if these three different uses are clear, then one thing should not be surprising; that this difference in use sharply distinguishes philosophy from science and religion. Let me give you one example of this point. Everyone recognizes how different are the three professions of medicine, engineering, and let's say, law. No man

would go to a physician to build a bridge or to build machinery. No man would go to an engineer and ask him to sit at the bedside of an ill person to cure him. No man would go to a lawyer and ask him to do what a physician or an engineer might be expected to do. We regard each of these three professions as having a special skill, able to do one thing for us, and not the other things that other professions can do. And we understand this in the following manner: We suppose that the reason why the engineer and the physician and the lawyer are able to help us in different ways, do different things for us, is because each of them knows something different, has a special kind of knowledge.

Well, let's apply this example of the engineer, the lawyer, and the physician to the three other, greater, larger divisions of human effort: science, philosophy, and religion. Each of them, I suggest to you, does something different for us. And if it is true that each of them does something different for us, must we not ask ourselves, Is this because each of them; the scientist, the philosopher, and the religionist, knows something different, has a different sort or kind of knowledge or because of some other reason?

Lloyd Luckman: That is the question indeed, Dr. Adler. And I think we were asked just about that question. It came from Mrs. Edward B. McGuinness whose home is in Walnut Creek. She would like to know if philosophy can be considered to contain the truth in the same way as the natural sciences contain the truth?

Mortimer Adler: That certainly is the question that we have to consider because the whole problem seems to me to turn on the point of how there are, or whether there are, different kinds of knowledge that we can describe as scientific knowledge, philosophical knowledge, and religious knowledge; and if there are different kinds of knowledge, where the truth and the conditions of truth, not only the kind of truth but the way in which men judge truth, the way in which men decide something is true in the whole scientific enterprise, the philosophical enterprise, and the enterprise of religion are the same or different.

This, I think, is the problem we shall spend most of our discussion next time on. But today I would like to summarize what we have learned. I may go back to this last question by calling your attention to what I think is the principal point. It consists in seeing that just as we don't expect a man who is an engineer to solve the kind of problems we go to a lawyer or a physician to solve, just as

we don't expect the lawyer to solve the kind of problems we would go to an engineer or a physician to solve, or the physician to solve those of the engineer or the lawyer, so we ought to look to the philosopher for certain kinds of solutions, for certain kinds of help in the conduct of life and in general the handling of human affairs. We ought to look to the scientist for a different kind of help and to the theologian or to the religionist for a third. And the thing we are most concerned to understand is if these three great professions of science, philosophy, and religion can give us different kinds of help, is the fact that they can do so based upon their having different methods of inquiry and different kinds of knowledge? Are science, philosophy, and religion three different kinds of knowledge? And if so, what is the mark of each of them?

We know one thing, that philosophy has one distinctive mark. It is not signified by the use of apparatus, research, or investigation. Nor like religion is it signified by the appeals to faith. We at least tentatively today have begun our understanding of philosophy by thinking of it as rational talk about the basic problems of mankind. It consists in human beings thinking together.

49 How Philosophy Differs from Science and Religion

When we decided to discuss the Great Idea of Philosophy, I had some concerns that it might not be of as much general interest as the more concrete ideas, such as Love, Work, and Art. But I was just looking over the letters we received last week, and the volume of the questions that we received indicates, I'm glad to say, that I was wrong. Moreover, the content of these questions indicates, I think, a great interest in the particular problem we considered last week and are going to push a little further in our discussion this week: the relation of philosophy to religion and to science.

Reflecting about the problem we discussed last week, I recalled a debate that I had in Chicago, I think it was in the mid-1940s, with Bertrand Russell, the eminent British philosopher and a noble lord and earl of the realm. This debate had as its question the following problem—I have here a stenographic report of the debate as it took place. The question that Lord Russell and I argued was this: Is science enough for the good life and the good society? The noble lord said it was. I, on the negative side of that debate, said it was not. And I took the negative side because I felt as I felt when I talked to you last week that science clearly is not enough to enable men to lead the good life or to construct and maintain the good society. If what I said last week was true, then my answer to Lord Russell was true, for science gives us at best the means and the power to use, but does not tell us how to use those means or that power well. It does not give us direction on the *end* of life.

Remembering this debate and looking at some of the things I said in it, I can recall to you also what we learned last time. You recall that we discussed the way in which engineering, medicine, and law do different things for men. And just as those three pro-

fessions do different things for men practically, so the three great departments of human culture, science, religion, and philosophy, do different things for men.

Perhaps the easiest way in which I can summarize this is to tell you the practical questions, the practical problems that science cannot solve, similarly the questions, the practical problems that philosophy cannot solve. Let me do it negatively. What kind of questions can the scientist not answer? Practical, concrete questions. The scientist, I say to you, cannot tell us what happiness is and how happiness is to be attained, what men must do in order to be happy. The scientist cannot tell us how to constitute a society justly, how to make it a just political organization or a just economy. The scientist cannot tell us what man's duties are, what is right and what is wrong. The scientist cannot tell us why all forms of labor should have dignity or why there should be no slavery, why all men should be free. In short, science cannot solve a single basic moral or political problem. And these basic moral and political problems are precisely the problems which both the philosopher and the theologian, both philosophy and both religion claim to be able to solve.

What are the questions, what are the limitations of philosophy in this respect? What questions can it not answer? Here I think the questions it must give up and leave to religion are questions about what precepts God gives human beings, what Providence has in store for people, and above all how persons can get help from God in achieving their ends in leading a good life and conducting a good society.

One other thing that we saw last week I should like to repeat. We saw that engineering and medicine, for example, can do quite different things for human beings, build bridges, cure diseases, because the engineer and the physician know different things. And so that raises a question for us. If it is true, as I think it is true, that the philosopher and the scientist and the theologian, the man of religion, can do different things practically for human beings, is this because each of them knows something different, that each of these three great branches of culture is a different kind of knowledge? Now that is the question I hope we can address ourselves to today. And, Lloyd, as we proceed with this discussion I hope you will bring into the discussion the questions we have received where they are appropriate.

THE SCIENCES ARE INDEPENDENT

Now I propose to begin today's discussion by giving you an example that I want to use later on. I would like to give you an example of three distinct bodies of knowledge. I am going to choose for this purpose history, chemistry, and astronomy. For everyone knows that these are three quite distinct, separate bodies of knowledge. And everyone understands in some sense the difference between being an historian and the kind of research an historian does, as opposed to the kind of research a chemist does or the kind of research an astronomer does.

But let's look at that a little more closely. How precisely do these three bodies of knowledge: history, chemistry, and astronomy; differ? I think for our purposes, at least today I want to call your attention to two ways in which they differ. They differ in their objects, what they study; and in their methods, the way they inquire, the way they learn the truth about the objects of their inquiry.

The things that are characteristic of the method of history are: the use of testimony, the use of documents, the use of archaeological remains or monuments from the past, and the kind of research the historian does. Using these materials enables him to know the object, which is the object of history, the past, the events which have taken place in the past.

The chemist uses experiments in his method, experiments that may involve very complicated apparatus, test tubes, and retorts and very elaborate instrumentation. And by experiment, using apparatus of this sort, the chemist is able to investigate the structure of matter, its elements and the compounds and fusions of these elements.

Then the turn of the astronomer. The astronomer doesn't perform experiments. The astronomer is an observer mainly, though an observer with very elaborate apparatus too, typically the great telescopes in our observatories. And observing by means of telescopes, the astronomer inquires into another kind of object, the great celestial bodies and their motions.

So we see how these three bodies of knowledge are distinct both in the methods they pursue or use and the objects they investigate. And there is a consequence of this. As a result of their being separate in this way, they are also to a large extent *independent* of one another.

Lloyd, it seems to me that I recall a question about the independence of one science from another. Is there a question on that subject?

Lloyd Luckman: Well, there is if you mean the one from Mr. Richard E. Hecht.

Mortimer Adler: Yes, that's the one.

Lloyd Luckman: He lives here in San Francisco on 39th Avenue. Mr. Hecht says, "I would like to know if one science can ever lawfully encroach upon the domain of another." Can once science encroach upon the domain of another?

Mortimer Adler: Well, there are really two answers to that question, Lloyd. To whatever extent two sciences are rightly independent of one another, Mr. Hecht, they should not properly encroach upon each other's domains. But, of course, Mr. Hecht, there are interdependent sciences. For example, biology and physics are at certain points interdependent to form the mixed science of biophysics. So are astronomy and physics to form the mixed science of astrophysics. But where two sciences are really independent or where two bodies of knowledge are really independent, as I think history and chemistry are or chemistry and astronomy, then they should not encroach upon one another.

If two independent sciences do their own work properly, mind their own business, answering the questions about the subjects they can ask about and criticize the answers of those subjects, then they will not come into any conflict. This is, I think, true of the chemist and the astronomer or the historian and the chemist. Those are independent bodies of knowledge and as a result they need not come into conflict.

DIFFERENT METHODS, DIFFERENT OBJECTS

Now let me apply what we have just learned about chemistry, astronomy, and history to the three great branches of our culture: science, philosophy, and religion. And here I would like to proceed in the following way: I would like first to consider their difference in method, I would like next to consider their difference in object, and third I would like to consider whether or not they are independent.

But again, Lloyd, it seems to me I recall a question I think from Mrs. Ryan this time, a question that was about at least the methods of philosophy and religion and science. Would you read us that question?

Lloyd Luckman: Yes, I have it here now. That is from Mrs. Peggy Ryan from San Francisco.

Mortimer Adler: Let's ask the question I mean.

Lloyd Luckman: "We accept many of our religious beliefs," she says, "as divine mysteries. But in the field of science we accept nothing without experimentation or investigation. In the field of philosophy then, what processes or devices are employed to establish the philosophical truths which we accept?"

Mortimer Adler: Lloyd, Mrs. Ryan gives us at least some of the answers as well as asks the questions. She points out something about the objects of religion, the divine mysteries. And she says something about the method of science which she says is experimentation.

Let's picture the chemist in the laboratory, performing an experiment with test tubes and retorts. That illustrates the kind of method of the chemist, that he is investigating by an experimental means. Then let's turn to another kind of scientist who also investigates. Let's picture an astronomer, inside a great observatory with a giant telescope. Consider the difference between the chemist and the astronomer. The astronomer is an investigator by means of sheer observation in an observatory; whereas the chemist is an investigator by means of experiment in a laboratory. So we oughtn't to say with Mrs. Ryan that the method of science is experimental. We ought to say the method of science is investigative, either by experiment or observation.

Now let's think about the method of religion. The method of religion involves the receiving of revelation from God. Picture Moses receiving the Law, receiving the Ten Commandments with fire on the top of Mount Sinai, one of the great episodes in the religion of Judaism, the revelation of the Law by God to Moses. Then consider Jesus delivering to His disciples and followers the Sermon on the Mount, again revealing the Word of God to man. In these two episodes we see what is common to religion, the element of revelation; and the reception by man of divine revelation.

How do we picture the method of philosophy? The armchair is the principal piece of apparatus of a philosopher; for the

philosopher is strictly an armchair thinker. Any philosopher worth his salt knows better than to ever get out of the armchair. Oh, he needs one other piece of apparatus perhaps. He needs a pad and a pencil; and that is about all the apparatus he needs. Of course, this does not quite distinguish the philosopher from the mathematician. The mathematician can work also in an armchair with a pad and pencil. But the mathematician is a solitary-armchair thinker. The philosopher needs conversation. He needs to carry on disputes with his fellow philosophers. He needs to discuss with them. And so the further apparatus the philosopher may need is a collection of armchairs around a table; for he is a social-armchair thinker.

Lloyd Luckman: I have a question just on that very point from Mr. Leiberman whose home is in Oakland, Mr. Jay Leiberman. And he wrote, "You said last week that philosophy was rational talk and stressed the fact that it is best exemplified by human beings thinking *together*." And with the accent on together.

Mortimer Adler: Yes.

Lloyd Luckman: "Now can a person be a philosopher alone?" is what Mr. Leiberman wants to know.

Mortimer Adler: Can a person be a philosopher alone? Yes, Mr. Leiberman, of course, he can be. The great geniuses in philosophy did a great deal or part of their work in solitary reflection. But it is still true that the philosopher profits much more by conversation with philosophers, by carrying on the great philosophical controversies with his colleagues, than the mathematician does. In fact, I would almost say that it is indispensable to the advancement of philosophical truth that philosophers do not think alone, but think with one another.

Now let me then go to my second main point which is the objects of philosophy in contrast to the objects of science and religion as well as the methods of philosophy, science, and religion. How do the three great branches of our culture differ in method? Science we understand is investigative. It must investigate, it must observe, by experiment or otherwise, new phenomena, get new data. And here reason serves the senses by making rational constructions or formulations based upon the data of observation. Philosophy is reflective. It is the kind of thing a person does in sitting down and contemplating or thinking hard, analytically, reflectively about the common experiences of mankind. Here the senses

in ordinary experience serve reason. And religion as compared to both of those is receptive. It is the attitude of receiving the revelation of God, and here reason is in the service of revelation.

As these three differ in method, so necessarily they differ in object, because the methods a body of knowledge uses to acquire what it knows will largely limit it to the kind of thing it is able to know. The objects of science, because science is investigative, are all phenomena, the world of appearances. The object of philosophy, because philosophy is reflective, is what lies behind the phenomena, what lies behind the appearances, the reality of things and their ultimate causes. And the object of religion, because religion is receptive of divine revelation, the object of religion is what Mrs. Ryan called the ultimate mysteries, the divine mysteries.

Philosophy Is Independent of Science and Religion

Science is investigative. This means it is able to describe the facts. It gives us knowledge of the facts.

Philosophy is reflective and does more than describe. It goes to the underlying reality and to the causes. It tries to do more than describe; it tries to explain the facts and therefore beyond giving us a basic knowledge of the facts of nature and of life, it gives us some understanding of them.

Religion accepts and believes. And in accepting and believing, it often goes beyond what is simply knowable and understandable by men. Perhaps the best illustration of this is to give you three questions, one that the scientist can answer, one that the philosopher can answer, one that the theologian or religionist can answer.

Here is a typical scientific question: How is matter transformed into energy in atomic explosions? This is the question that Einstein answered in his extraordinary formula for the quantitative relation between matter and energy in atomic fission or explosion.

A typical religious or theological question is the question whether God created the universe in the beginning of time. This is the question which the divine revelation in the first sentence of Genesis answers. God created heaven and earth, it says, in the beginning.

And what is the kind of question the philosopher answers? A question like, Why does all the world of change involve some permanent thing? Why must change be based upon permanence? Or this very question we've been discussing, the very question, How does philosophy differ from science and religion, is itself a question for the philosopher, not for the scientist or for the religionist or theologian.

Now we've got these three questions clear. Perhaps then I can talk, quickly, about the independence of science, philosophy, and religion. I recall, Lloyd, there were many questions we received about the conflict of science and religion. Did we receive any about the conflict of science and philosophy or of philosophy and religion?

Lloyd Luckman: Not any question that asked about all three possible conflicts, Dr. Adler. But I have one here that somewhat tends in that direction. It is from Mrs. John Ward Babcock in Berkeley, California. And she asks, "Would you agree with the definition that between theology and science there is a no man's land, exposed to attack from both sides? This no man's land is philosophy."

Mortimer Adler: I think I would in great measure agree, Mrs. Babcock. Certainly it is historically the case that philosophy has come between science and religion. But I would like to make two points in clarification of what you just said.

The first is that when conflicts occur among the three great branches of our culture, science, philosophy, or religion, it's usually due to the fact that one of them has become imperialistic, has exceeded its own domains and become an aggressor, invaded the territory of another. And philosophy, you are quite right, Mrs. Babcock, is like a buffer state, a buffer state needed to keep science and religion apart, in fact, to keep them in good order.

AN ASCENDING HIERARCHY

Now let me see if I can carry that one step further and explain what I mean by good order as between the three great departments of our culture: science, philosophy, and religion. What is a good order of these three? There are two answers to this. Either they should be equal and coordinate with one another or they should be a hierarchy from lower to higher.

On this question of what the right order is of science, philosophy, and religion, there are a number of opinions, quite a great diversity of opinions, as a matter of fact. One answer, for example, is that all three; science, philosophy, and religion; are equal and coordinate. Another answer is that science is primary and religion and philosophy are subordinate. A French philosopher, Auguste Comte, who called himself a positivist held that science was the primary form of human knowledge and that religion was superstition and philosophy mere speculation. Both of these answers, I think, lead to conflicts among science, philosophy, and religion.

I would like to give an alternative answer, that there is a hierarchy, an ascending hierarchy from science to philosophy to religion. And I would like to explain that hierarchy in practical terms by saying that the kind of help that philosophy gives men is a more important help than what science gives, and the kind of help that religion gives is more important than philosophy. And in the theoretical order as you ascend from science to philosophy to religion, you get the answers to more and more ultimate questions.

Lloyd Luckman: Now, Dr. Adler, I wonder if what you have just said isn't the answer then to a question we received from Mrs. Patricia Dell who lives in San Francisco. She asks, "If you were forced to choose between religion and philosophy, would you choose philosophy? Why?"

Mortimer Adler: That, Mrs. Dell, is a very hard question. You've put me on the spot. It is the kind of choice no one would like to make, yet I must answer it honestly. It is a hard and unhappy choice but if I were forced, you say forced, to choose between religion and philosophy, what I have just said a moment ago indicates how I would have to make that choice. If I am right that religion answers more ultimate questions and gives man a more important kind of help, then religion is more important than philosophy and if one had to make the choice, one would choose religion rather than philosophy.

Now, on the other hand, I hope one doesn't have to make this choice. I hope you see from what I have said that there need be no conflict between religion, science, and philosophy. This does not mean there is no conflict within philosophy itself. This does not mean there is not conflict about philosophy. On the contrary, philosophy is a hotbed of controversy, it is full of dispute, full of schools of thought. What does one make of the fact that there are

no conclusions on which philosophers agree? Why are there so many schools of philosophy?

This is our problem for next time: Why are there perennial, unsolved problems of philosophy? Can these perennial problems be resolved? Is there a way of achieving progress in philosophy?

50 Unsolved Problems of Philosophy

Lloyd Luckman: Isn't that nice?

Mortimer Adler: Yes, it is, Lloyd.

Lloyd Luckman: Ladies and gentlemen, Dr. Adler and I have been sitting here reviewing the citation which was awarded to him last evening by the Northern California Academy of Television. This award was for special achievement in honor of The Great Ideas program. And I would like to add my congratulations, Dr. Adler, to you for this achievement.

Mortimer Adler: Thank you very much, Lloyd.

This afternoon we go on with the discussion of the Great Idea of Philosophy. And I should like to make a thumbnail summary of the three points that we covered last time. We saw, I think, that there were three great branches of human culture, each with its own method, each limited to certain questions which by that method it could answer; and in view of this limitation by method to certain questions we also saw that if each of the three great branches of culture did not become imperialistic, did not invade the territory of another, there would be no need for conflict among the three.

But, Lloyd, in the course of the week I think we discovered both from the letters that we received and from the conversations of you, me, and other people that some of the points that I thought were particularly clear were simply not so clear. And so I should like to begin this afternoon by going back to two or three of those points and see if I can make them just a little clearer than they were. And, Lloyd, if there are any others that I forget, would you mention them when I've taken care of these three?

First, I have a sense from the letters I received and conversations I had that you were not quite clear as to the definition of philosophy since the definition was given in a purely negative way. As to method it was said that philosophy does not investigate. The philosopher is an armchair thinker who does not go out and make new observations. Nor does philosophy, like theology or religion, rely upon revelation or the dogmas of a church.

Now positively then, what is the method of philosophy? My answer to that, very briefly at the beginning of this program, is that it consists in rational reflection, not in a vacuum but about the common experiences of mankind, the experience all of us, each of us has every day of our lives.

Then I gather that the point I wanted to make about the independence of philosophy both from science and religion was not too clearly understood. In fact, some of these letters that came in indicated that people supposed that the philosopher would be better off if he had a religious faith. Or on the other hand, some people supposed that the philosopher would be better off if he were an atheist and were completely free from religious faith. Let me just say one thing here, that the work the philosopher does, as a person using his reason to reflect about the basic problems of mankind in the light of man's common experience, is independent both of scientific method and religious faith, and that there are opposite views here. Some persons, I think, hold the view that the philosopher would do better if he were guided by religious faith and others hold the view that he would do better if he were not trammeled by religious faith.

And then the third point I would like to clear up in advance is a point about the hierarchy, the order of these three great branches of culture. In regard to religion there are opposite views. On the one hand some of these letters suggest that religion is not superior to science and philosophy, in fact, it is inferior to them, that science is the top element in our culture and that both philosophy and religion are inferior to science. On the other hand there are letters here which suggest exactly the opposite, that the hierarchy is a hierarchy in which science is at the base and that one mounts to more important and more ultimate questions when one goes from science to philosophy and from philosophy to religion.

These two points of view, putting science at the top with philosophy looked at as mere speculation and religion as superstition, or the opposite point of view, putting religion at the top with philosophy subordinate to it and science subordinate to both; these two points of view represent basic opposition in our culture as to the importance and value of these three great branches of our culture. The one thing that's clear is that no one on either side of this opposition says that they are equal, that these three things are to be regarded as of all having the same value.

There was a conference in New York some years ago, still going on as a matter of fact, dealing with science, philosophy, and religion, which I think has been failing, has failed, and is continuing to fail because it tries to treat these three branches of our culture as if they were coordinate or equal.

SCIENCE CAN'T EXPLAIN EVERYTHING

Lloyd Luckman: I have a few more points, Dr. Adler, which I think could stand some comment from you. The first one comes to us—well, the first two in letters, one by Dr. Edward Shafer, who is in San Francisco, and Mr. Rupert Kemp, in Sausalito. Dr. Shafer asks, "Why should not science be able in the distant future to explain everything?" Now I suppose here he means answer all questions including what now belongs to the area of philosophy and religion. And the second question by Mr. Kemp is, "Why cannot the methods of science be used to solve some of the controversial problems of philosophy?" And he gives in his letter some examples, like the problem of justice and the problem of happiness.

Mortimer Adler: Well, it seems to me, Dr. Shafer and Mr. Kemp, that if one understands what one means by the methods of science, methods of investigating, gaining knowledge by more and better observations of the world of physical or psychological phenomena, that these methods cannot be used to penetrate the ultimate realities or the ultimate causes of things. The scientific method not only now, but probably never, will be able to discover the ultimate causes, nor will it be able to answer ultimate questions of value.

You will recall that I mentioned the debate I had in Chicago in the middle 1940s with Lord Bertrand Russell. And though he took

the opposite side to me in this debate, he conceded very early in the debate that by the methods of science—not only as they are now constituted, but as they will always be constituted so long as science remains science—by the methods of science we cannot solve a single, basic, moral question, or as he said, a question of value.

Interestingly enough, Lloyd, one of our correspondents, Mr. S.M. Wilson, sent me a clipping from the *Reader's Digest* which makes this point. It tells the story of an argument that was going on in an officers' club during the war. And a major who said that he was raised on the scientific method turned to the chaplain and said, "How can anyone scientifically prove the existence of God?" And the chaplain turned back to the scientific major and said, "That is a difficult question. In fact, it is a question I would like to put back to you in another way, 'How can anyone theologically prove the existence of an atom?'" And the major replied, "But whoever heard of trying to prove an atom theologically?" The chaplain said, "That is exactly what I meant, whoever heard of trying to prove God scientifically?" And that does indicate the sharpness and the separation of methods and the kinds of questions they can answer.

ACCUSATIONS AGAINST PHILOSOPHY

Lloyd Luckman: Well, my second point was raised by Mrs. M.H. Laucer, who lives in Oakland. She said, "You used chemistry and astronomy last week as examples of independent sciences." And then she sent us a very interesting newspaper clipping on astronomy. And if you read it, you will note it says, "U.C. Astronomer Scans Stars for Chemical Element Clue." And she obviously wants to know whether in view of this you were right in regarding astronomy and chemistry as independent.

Mortimer Adler: Well, Mrs. Laucer, until very recently astronomy consisted almost entirely of celestial mechanics. And celestial mechanics is concerned with the motion and position of the heavenly bodies. But in our own time a new branch of astronomy has come into existence, a branch we call astrophysics, concerned with the physical constitution of the heavenly bodies. Now the old part of astronomy, celestial mechanics is quite independent of

chemistry. But this new branch of astronomy, astrophysics, is clearly concerned with the physical or chemical constitution of the celestial bodies and is not independent of chemistry.

Mortimer Adler: Is that all, Lloyd?

Lloyd Luckman: I have some new business here, another question. And you may remember this question as the one which poses the problem for this week's discussion.

Mortimer Adler: Let's have that.

Lloyd Luckman: It comes from Mr. James J. Telorico, Jr., who lives in San Jose. He says, "Since you consider science, religion, and philosophy as the three great branches of our culture, attacks on philosophy must have been made by men in these other fields. If you could give a few of the major objections to philosophy by these other fields and then refute them, philosophy's right to existence as well as the worth of it might be on more solid ground in the eyes of the viewer of your program."

Mortimer Adler: That certainly is the task for today. And I hope I can fulfill your request in a satisfactory manner, Mr. Telorico. You are right, you are quite right that what I have so far stated presents only one side of the matter. I presented only the view held by the exponents of philosophy which can be summarized in these three propositions: First, that philosophy is a kind of knowledge; second, that philosophy as knowledge is independent of science; and third, that as knowledge solving more ultimate problems, philosophy is superior to science both theoretically and practically.

Now the opponents of philosophy, mainly from the side of science, seldom if ever from the side of religion, take a diametrically opposite view which can be stated in these three propositions: they hold that philosophy is mere opinion or guesswork; or that if it is not that, philosophy is a commentary and nothing more than a commentary on the sciences and so cannot be independent of the sciences; in either case it is clearly inferior to science in every way. Now this being so, because of this opposition, I shall try to proceed as you suggest, Mr. Telorico. First, to state the charges against philosophy on which the opponents rest their case, then to try to defend philosophy by answering these charges.

Now let me go at once to the charges against philosophy. They are two. The first charge is based upon the fact that there is such tremendous disagreement among philosophy. There are so many

schools of thought, so many isms that are in conflict with one another, such a great diversity of philosophical points of view or such a great plurality of philosophies. The force of this charge comes from a comparison of philosophy with science. The scientist says that we don't disagree as the philosophers disagree. There is a great deal of agreement among scientists. There are no schools of thought in science. Science looks like one common enterprise of inquiry and research.

This charge against philosophy, by the way, is not just made by the experts or the scholars; it is made by ordinary men and women. In fact, Lloyd, all the questions we've received in the last few weeks indicate that laymen, people in general, are greatly disturbed by the diversity of philosophical points of view, by the conflict of philosophical doctrines. They say, "Which shall we choose? Which is true? Why should the philosophers always disagree this way?"

The factual charge is true. There is no question about it. There is a diversity of philosophy. There is a great conflict among schools of thought in philosophy. Moreover, I have to confess that there always will be a plurality of philosophies; not merely do they have to have existed in the past and do they exist now, but it is in the very nature of philosophy itself for there to be many philosophies in conflict or in argument, in controversy with one another.

The second charge is that philosophy doesn't make any progress, that it keeps on going around in a circle, as it were, chasing itself. But it is dealing with the same old issues century after century. And this charge, like the first charge, gets its force again by contrast and comparison with science. The history of science is always an inspiration to the scientist. But the history of philosophy, I am sorry to say, is often an embarrassment to philosophers. At least it has been an embarrassment to me for a great part of my life.

This charge, like the first charge, is also one shared by ordinary people. It is not only confined to experts or scholars. And I must admit that the factual charge here is also true. It cannot be denied. These are two important charges that can be brought against philosophy and that are brought against philosophy in the contemporary world with great force.

Now what shall our answer be to these charges? How shall we reply? For Mr. Telorico not only asks us to state the attack on

philosophy, but to see if we can also represent the opposite side of the opinion of the issue so that all of you are acquainted with what the issue is.

Before I state my reply to each of these two charges, let me make one very important preliminary remark. I said the facts upon which the charges rest are true. But the facts are not new. The facts I just admitted have always been the case. Yet the charges which are made on the basis of these facts are new. They are characteristically modern charges: though the facts existed in the medieval world, the facts I'm talking about existed in the ancient world, the charges against philosophy are only made in the modern world.

Science Is Not the Model for Philosophy

Now why have these charges been made in the modern world for the first time if the facts are not new? I think the answer to that question is because science as the dominant feature of our culture is peculiarly modern. It is only as we come to modern times that science dominates our imagination as the great cultural enterprise. This being so, science becomes the model. And if science is the model, certainly philosophy looks bad by comparison. Philosophers should be ashamed of themselves for failing to imitate science.

But how about the opposite hypothesis, a contrary hypothesis? Suppose it was wrong to regard science as the model. Suppose science is not the model which philosophy should imitate and that philosophy should not be judged by comparison with science but in its own terms. Then how would philosophy look to us? It is on that contrary hypothesis, it is by asking you to think for a moment of philosophy in its own terms and not by contrast with science that I want to answer these two charges that I've just made.

Let me go to the first charge. The charge was that philosophers disagree, whereas the scientists tend to agree. This charge, if one looks at it now, can be answered in the following way: There is agreement and disagreement in both science and philosophy, probably as much disagreement in science as in philosophy, but the difference is in the way in which the agreement or the disagreement occurs. The pattern of the agreement and of the disagreement does not occur in the same way in science and philosophy.

If one considers science, one sees that for the most part contemporary scientists working at the same time, competent men in the field of science at one and the same time, tend to agree, but that scientists of a later generation or century tend to disagree with scientists of an earlier century or generation. Whereas if you look at philosophy, you see that there is a great deal of agreement among philosophers across the centuries; later philosophers agreeing with earlier ones, but that for the most part contemporary philosophers tend to disagree with one another.

Let me illustrate this with a few simple examples. Let's consider first, two great scientists, Isaac Newton living in the seventeenth century and in our own day the great Albert Einstein. Now in his own day, the work of Newton, the great formulations of Newton were generally accepted by other scientists alive at the same time. And in our day, the great formulations of Einstein, the general and special relativity theories, are for the most part accepted by competent scientists in our day. But Newton and Einstein do not agree. Einstein disagrees with Newton. Einstein is correct and I think has gone beyond Newton. This is a typical example of disagreement among scientists, a later one disagreeing with an earlier one.

Now then, let's consider two philosophers. Let's consider David Hume, living at the end of the eighteenth century. After we consider David Hume, let's turn to a contemporary philosopher whom I've mentioned several times, Lord Bertrand Russell. Bertrand Russell, coming two centuries after Hume, for the most part agrees with most of Hume's principal points. There is agreement among philosophers from one century to another, a later philosopher agreeing with an earlier one. But if one were to take a contemporary of Bertrand Russell, the great French Catholic philosopher, Jacques Maritain, one would find in the contemporary world a deep and important disagreement going on between Maritain and Bertrand Russell.

Let me now go to the second charge which has to do with philosophy and science. As in the first case, the thing I want you to see is that the way in which progress is made in science is different from the way in which it is made in philosophy; and that philosophy is misjudged if it must measure up to the kind of progress science makes, whereas it should be judged in terms of the kind of progress it can make in its own terms.

One of our correspondents, Mrs. J. Burnley, reminded me of a passage I had written in a book some time ago now in which I described the difference between progress in science and in philosophy. I would like to read you this brief statement of what kind of progress is made in science in order to have you look at the difference from that of progress in philosophy. I am quoting from my book written about 1935. This book is called *What Man Has Made of Man*. "The line of progress in science," I wrote, "is undeviating in each successive period. The state of scientific knowledge is an improvement on what went before. There is both more and better knowledge. The history of science can be reported as a correction of errors and inadequacies. But once the correction is made, the advance is consolidated. There is no backsliding. A scientific error always occurs at an earlier time than the scientific knowledge which corrects it. This is not true of the history of philosophy which moves forward in a spiral path rather than in a straight line. The same errors often recur again and again, and are corrected again and again. There is not on the whole more error in philosophy than in science, but the way in which it occurs and the way in which it recurs is different."

PROGRESS IN PHILOSOPHY

How does progress occur in philosophy and what is the difference between the pattern of progress in philosophy and in science?

First, consider the characteristics of progress in science and in philosophy. In science, progress is made by experimental corrections which produce new data or better observations. And these combined with theoretical advances in terms of new or more comprehensive hypotheses gives you the onward motion of science from generation to generation. If one goes to philosophy, there is nothing like that. We have something quite different. In philosophy the first and basic point of progress comes about through dialectical clarification which give us an improved understanding of old issues. And combined with this improved understanding of all issues there are theoretical advances which come with new insights involving restatement of old insights.

Now as a result of these differences in the character of progress in science and philosophy, one gets a difference in the

direction and rate of progress in science and philosophy. In science, you get more knowledge from generation to generation. And the motion forward is a straight-line motion with uniform acceleration. More and more and more, and the progress is more rapid in each generation. Whereas in philosophy it is not more knowledge you get, but more understanding, and not from generation to generation but from epoch to epoch, as you go from the ancient world to the medieval world, from the medieval world to the modern world. Those great epochs see more understanding in philosophy. And the motion forward is not a straight-line motion but a spiral motion, a slow, forward motion with intermittent retardation, slipping back before it takes another step forward.

In view of this comparison between progress in science and in philosophy, I would like to read you two maxims written many centuries ago by Aristotle. They are almost, so I say, directions to the philosopher as to how to make progress in the difficult field of philosophical learning. The first of his maxims comes from his *Metaphysics*, and it reads as follows: "The investigation of the truth is in one way hard, in another easy. An indication of this is found in the fact that no one is able to attain the truth adequately, while on the other hand we do not collectively fail. Everyone says something true about the nature of things, while individually we contribute little or nothing to the truth. So by the union of all, a considerable amount is amassed." And then a little later in his book on *The Soul,* he says, "Therefore it is necessary to call into council the views of our predecessors in order that we may profit by whatever is sound in their thought and avoid their errors."

Now all this being true, all this being so, it must be admitted, I think, that in recent centuries and even more so today, philosophy has not made the progress it can and should make in its own terms. I am very sympathetic to the question raised by Mr. Burnley in the letter he wrote us last week. He asks, "How can anyone be optimistic about the possibility of philosophical progress in the world today? Why has philosophy failed in the recent past? Why is it failing so much today?"

I think there is a two-fold answer here. One part of the answer is given by Mr. Burnley in the letter that I mentioned before. He points out the opponents of philosophy. "Antiphilosophy always exists and exists with special intensity in the contemporary world because this is a world in which we have a cultural predominance

of science." But I think there is a much deeper reason. In the modern world and especially today, philosophers have failed in regard to the first condition of progress. The first condition of progress is that dialectic clarification that gives us a deeper understanding of the basic issues. As a result of that failure we have more and more confusion, less and less communication among philosophers. They understand one another less and the issues less. And in consequence, the contributions of the philosophical genius making an advance with a new insight cannot be achieved.

Can this failure be remedied? Those of us who are at work at the Institute for Philosophical Research think that it can be. That is precisely what we are trying to do. We think the first step toward philosophical progress in the next century can be made in this one by a better understanding of the basic issues.

I will try to explain this more fully next week.

51 How Can Philosophy Progress?

Today we conclude the discussion of Philosophy as a Great Idea. From the letters we've received I would judge that the two things of greatest concern and interest to you are, first, the disagreement among philosophers. What should be done about this disagreement of philosophers? And secondly, the progress or lack of progress in philosophy.

Lloyd, does this accurately represent your sense of the questions we have received?

Lloyd Luckman: Exactly. Would you like me to give some samples?

Mortimer Adler: I wish you would.

Lloyd Luckman: My first is a letter from Mr. Desmond J. Fitzgerald in San Francisco. His question is, "How do you account for such a diversity among philosophers?" And he goes on to ask whether you think, as some suggest, that an established solution of the basic questions would be the death of philosophy.

Mortimer Adler: I do not. I don't think so. And I shall try to explain why I don't think so more fully in a moment.

Lloyd Luckman: Very well. Another one was from Mr. Lawrence Webber in San Francisco. "Dr. Adler, would you tell us whether progress in philosophy means that the philosophers today can or should be able to give better answers to the basic questions than the philosophers of antiquity?"

Mortimer Adler: The answer to that question is yes, Lloyd.

Lloyd Luckman: Well, then if that is yes, does it mean that John Dewey was a greater philosopher than Plato?

Mortimer Adler: No, Lloyd, it does not mean that. It doesn't mean that at all. But it does mean that John Dewey was in a

position to make a great contribution toward the advance of philosophy, living as he did in the twentieth century.

Lloyd Luckman: Then there's the question from Mr. Thomas K. Lay in Berkley. He says, "Would not group participation of five philosophers, a pooling of ideas, an exchange in discussion of viewpoints, contribute toward progress in philosophy? This procedure," he says, "has long been followed by many branches of science." And he wants to know then whether it might not prove useful in philosophy also.

Mortimer Adler: Indeed it would, Lloyd. What Mr. Lay suggests is precisely what we at the Institute for Philosophical Research are trying to do. For the first time in history there is the collaboration of philosophers doing teamwork, just as scientist do teamwork in laboratories.

Lloyd Luckman: Well, now the parallel with scientific research, Dr. Adler, occurred to many others who have been asking about the work of the Institute. And I have as an example here a question from Mr. Maurice O. Nordstrom, Jr., who lives in Berkeley, and wants to know whether when you use the word "research" in the title of your institute, does it mean that you employ something like the methods of science?

Mortimer Adler: As I hope to be able to show you, Mr. Nordstrom, the answer is yes. What we are doing at the Institute is very much like scientific research involving data, inductive generalizations, hypotheses, prediction, and verification.

Lloyd, are there any other questions about the methods of the Institute?

Lloyd Luckman: Oh, very many, Dr. Adler. But I think there is one that you will want to answer right away. It comes from someone who signs his name just J.H. And he asks like many others about the goal of your Institute, but particularly he wants to know whether you and your staff stick to your armchair.

Mortimer Adler: For the most part, we stick to our armchairs. But every now and then someone may get excited and get out of his armchair, trying to argue a certain point.

When the Institute began its work, there was some misunderstanding about its nature and function. You know the word *philosophy* has some queer meaning out here in California. In the early days we received a great many phone calls asking when we were going to begin to conduct services or when we would be

ready to receive patients. In fact, the title of the Institute caused a good deal of trouble. I have here two items that I would like to read you. One is a bill from R.H. Macy's addressed to us as follows: "The Institute for Philharmonic Research." And here is a telegram from Chicago reading: "The Institute for Philanthropical Research."

One afternoon as I came out of the Institute, a cable car was going by on Jackson Street and the conductor leaned over the rear platform and said, "Hi, Dr. Adler, How's philosophical research coming along?" And that is the question I am going to try to answer for all of you, I couldn't answer to him that afternoon.

PHILOSOPHERS WILL ALWAYS DISAGREE

I would like to begin this answer by going to the first point which you are all deeply interested, the problem of the disagreement of philosophers, which is the point of departure of the Institute's work. Now if we avoid the false inference from an improper comparison of science and philosophy with respect to disagreement and agreement, I think we see that disagreement is the very essence of philosophy, that there will always be disagreement in philosophy. This is not regrettable. On the contrary. Imagine the opposite. Imagine all philosophers agreeing. That would be, to answer the question you asked earlier, Lloyd, that would be the death of philosophy. In fact, the absence of disagreement in philosophy would be as much the death of philosophy as the absence of experimentation would be the death of science.

But there are two bad extremes here, not one. One of these bad extremes is the unity of agreement which would be the death of the philosophy, but at the opposite end of the scale, as bad a condition, is the chaos of disagreement which exists today. And in between is what should exist, a disagreement that is based upon understanding of the diversity and of the issue. Disagreement in philosophy is profitable only in proportion as those who are disagreeing really join issue, really communicate with one another and understand the whole diversity of opinion and the reason for this diversity. Moreover, disagreement in philosophy is profitable only in proportion as all sides of the issue or of the issues are taken into account.

On both these counts disagreement has become less and less profitable in our time. For today, philosophers are not meeting squarely in issue with one another. And they are not succeeding in communicating with one another. And I think the general state of affairs is that we do not understand, we haven't gotten an intelligible conception of, the diversity of opinions on basic issues. Moreover, the contemporary discussion tends to be shallow and constricted, only contemporary voices are heard in it. It lacks the wide variety of points of view that are relevant to it.

You would agree, I think, that a man does not understand an argument if he understands only one side of the argument. So a man doesn't really understand an argument if he understands only some of the sides to it when there are many more sides which he has not, or is not hearing.

Now on both these counts the Institute is trying to provide a remedy. We are engaged in an effort to see if we can formulate the issues on which philosophers will meet and argue against one another. We are trying to find the conditions which will produce communication among them. And we are certainly trying to describe the diversity of opinion and to explain why that diversity exists. Furthermore, we are trying to expand rather than diminish the disagreement. We are trying to increase the disagreement and bring all voices in, all the viewpoints from the whole tradition of Western thought, many of which are either ignored now or not even known.

What we are not doing is trying to solve the problems. We are not trying to establish the final truth on these basic issues. On the contrary, our aim is to achieve with as much dialectical objectivity as we can master and understanding and clarification of the great philosophical controversy. And we think if we do this, we shall provide philosophy with the first condition of progress.

You recall last week I discussed the two conditions of progress in philosophy and compared the progress of philosophy with the progress of science. Let me remind you what the two conditions of the progress of philosophy were by looking at this chart with me. The first condition of progress in philosophy is dialectical clarification, which brings about a progressively enlightened controversy through a better understanding of the issues and a more adequate statement of the alternatives. And this dialectical clarification is the basis for making theoretical advances in which new theories or

insights produce a more coherent and comprehensive restatement of old truths.

Now I think the title of the Institute for Philosophical Research is sometimes misunderstood, because people think that the philosophical research of the sort we are doing is an effort to bring about these theoretical advances. In fact, our whole aim is here, it is an aim to bring about the dialectical clarification, which is the basis of making those theoretical advances.

MAKING SENSE OF PHILOSOPHICAL DISPUTES

Mr. Luckman: I can see that what the Institute is doing is of great value to philosophers and to philosophy itself but I'm not a philosopher, at least not professionally. I am an educator concerned with the problems of liberal education. And I'm quite sure that there are many others like myself who are concerned about this particular problem, that supposing that the Institute is successful in its technical efforts, what will the value be of that success specifically and generally to the layman and to liberal education and the humanities in general?

Mortimer Adler: Thank you, Lloyd. Let me say at once that a direct result of the Institute's work must be the improvement of philosophy in this generation and then in the next. In this respect I would say the Institute is exactly like another Ford Foundation supported project, the Center for Advanced Study in the Behavioral Sciences, which is as you know now trying to locate here in the Bay Area. I'm sure that the Center for Advanced Study in the Behavioral Sciences hopes that its work will also indirectly benefit mankind and human society. But I'm sure that in its direct efforts, the Center is trying to improve the work of the behavioral sciences, research and method in those sciences. So, too, the Institute, after it does its primary work of bringing about the conditions of better work and progress in philosophy, hopes that its work will be of great value especially to the whole sphere of liberal education as well as to the layman who is faced with fundamental problems.

Let me see if I can talk about the value of both of these things, the value of the Institute to the layman and the value to liberal education, in that order. You know you had that question, Lloyd,

from Mr. Fitzgerald. Let me read the first paragraph of Mr. Fitzgerald's question because it leads right into the question of the value of the Institute's work to the layman. Mr. Fitzgerald writes, "The conflict among philosophers is such a scandal for laymen that seeing the disagreement among the great thinkers he despairs of the possibility of even attempting to find answers to the fundamental questions for himself." That states what the problem is. But, Mr. Fitzgerald, it is not the conflict among philosophers, but the unintelligibility of the conflict which makes the layman despair.

On a recent occasion, Mr. Fitzgerald, I said, commenting on the very point you have just raised in this letter, that if the layman supposed he could understand the issues of basic importance to him by somehow comprehending the conflicting views of the adversary, he might be willing then to examine them and to pursue intellectual inquiries into the sphere of his own basic problems. But he is deterred from doing this by his feelings that he cannot possibly make sense of the controversies as they are currently carried on. And he is quite right in that feeling. So the Institute hopes to make the basic controversies intelligible, and thereby restore the layman's confidence in his ability to deal with the conflict of ideas, as that affects his own life.

And I went on finally to say that in this way the layman may be cured of what is the most current disease in America, a deep anti-intellectualism; because he will be cured of this when he no longer despairs of the possibility of understanding fundamental issues or of taking sides on them.

Now I would like to illustrate this from some current work we are doing on freedom. Let's suppose that an intelligent layman or even a philosopher, if I may make the distinction, were to sit down and read through in succession all the great literature on the subject of human freedom, a hundred or more basic documents. I think if he were to do this, the result would be that he would get the impression very much of the sort that William James says the baby has when the baby first looks at the world; that it is "a great, booming, buzzing confusion." Or to use another comparison, the literature on freedom if he just went at it that way, with no preparation, would look to him as the world of nature, the world of living things, plants and animals must have looked to a primitive, untutored savage in a primeval forest or jungle. Consider how dif-

ferent that world looks to us, the world of living things, when you and I walk through a zoo or a botanical garden or a museum in which the whole of biological science is made visible to us; and we see the world of nature not as a disorderly jungle, not as an unintelligible variety, but as an orderly, intelligible pattern.

Let's consider the world of living organisms, of plants and animals, as I said a moment ago. To the untutored savage before he had the benefits of scientific discovery, it was a disorderly, unintelligible pattern, an amazing, bewildering disorder. But to those of us living in the twentieth century, fortunate enough to be instructed by biological classification, genetics, and the theory of evolution, the world of living things is an orderly and intelligible scene.

Now let me make the comparison by then going to the world of philosophical thought. In the world of philosophical thought the conceptions and the opinions of the philosophers are here like the plants and animals in the world of nature. And the conceptions and opinions of the philosophers to the layman or to the philosopher, before the kind of philosophical research we are doing at the Institute is done, is the same kind of bewildering jungle of conflicting, confused opinion in which one can't find one's way around, where one doesn't see the pattern of the diversity. But if the work of the Institute is done and if we will ever be enlightened by a dialectical ordering, an explanation of the intellectual diversity, that jungle world of philosophical thought will become as orderly to our eye and to our senses as the world of nature, the world of living things, is when we see it set forth in the exhibits at a museum or in a zoological garden.

So let me come to the second point which has to do with the value of the Institute's work for liberal education. Now I forgot one thing. Before I come back to that, there is one thing I want to add. In that comparison I just made, the work the Institute is doing—I remember Mr. Nordstrom's question—is very much like the work of scientific research. Just as the biologist looks at the specimens of nature, analyzes them, classifies them, draws up great classificatory charts and then, with something like genetics and the theory of evolution, explains how that diversity arose in the development of things in time, so the work of the Institute follows a similar pattern of research very much like that of science. We too are looking not at plants and animals but at thoughts, at the world of conceptions

and opinions. And we must see if we can classify them. We must see if we can develop hypotheses that give us charts of comparison and enable us to develop hypotheses explaining how this tremendous diversity has arisen. And in doing this, we, working with ideas, with conceptions and opinions, just as the biologist works with plants and animals, working with the materials in front of us, we develop hypotheses that we can put to the test in exactly the same way. In that sense our work is very much like scientific research except it is at the level of ideas instead of the level of things.

Philosophy and Liberal Education

Now let me talk to the second point we raised, the value of the Institute's work in relation to the whole of liberal education. The basic fact here is that liberal education and philosophy rise and fall together. The decay of liberal education in our time results, I think, from two things: the decline of philosophy in our time and also the loss of faith and the lack of skills in the basic disciplines of discussion. Both of these things must be restored, both philosophy and skill and faith in discussion must be restored if liberal education is to be restored to the vigor it once had.

Why is this so? I think the answer is twofold. First, because the very substance of liberal education is The Great Ideas, The Great Ideas understood in terms of the widest diversity of conceptions and opinions about them and also in terms of the deepest grasp of the issues to which they give rise. But how can this be communicated? How can this understanding of The Great Ideas be communicated to the generation of students? I say it can only be done by discussion carried on with the utmost dialectical objectivity and clarity, and by discussion in which all sides of the issue are fairly represented, represented impartially and with a sense of their contribution.

Now it is at this point that one might ask, How does The Institute for Philosophical Research and its work makes its peculiar contribution to the advancement, more than the advancement, I would say in this case, Lloyd, the *restoration* of liberal education in this country? My answer is that every college concerned with liberal education, or perhaps I should say, the students and faculty of every college that is concerned with liberal

education, should be doing all the time the kind of work that the staff of the Institute is doing, should be engaged in the study of The Great Ideas and in developing the methods of communication, the methods of discussion which are involved in the study of The Great Ideas, indispensable for their communication among many. If this is what every college faculty and student body should be doing if it is pursuing liberal education, then I think the peculiar function of the Institute, doing this more intensively, is to actually function as a pilot plant to discover and to perfect the methods for such discussion and analysis of The Great Ideas, to find the procedures by which men can think collaboratively about them, and above all, to put these methods and procedures to work in such a way that we produce some results that not only exemplify the goodness of the procedures and the methods, but also themselves are useful to schools and colleges engaged in liberal education.

Now I hope, Lloyd, that that begins to answer, answers a little, explains a little, if not fully the work of the institute in relation both to the layman and to liberal education.

Lloyd Luckman: Well, answering your question now, Dr. Adler, both as a layman concerned with his own position on philosophical issues and as an educator concerned as well with liberal education, I must say that I do think I see and understand more clearly, though perhaps not as completely as I would like to, the program and work that is being conducted at the Institute. And it is also clear to me that this indirect objective of the Institute which I asked you about is also going be particularly dependent upon the attainment of your immediate aims and objectives. And, of course, that is in the main field of philosophy.

Mortimer Adler: Right.

Lloyd Luckman: Now speaking about the main field of philosophy, I think I have learned a very important thing with you this afternoon. And that is that the Institute is not undertaking to find the ultimate answers to all questions, rather it is addressing itself to the more modest task, though at the very same time a very difficult task, of creating a condition whereby the philosophers of the future, the next generation, will be able to do better work and to come up with the results that our questioners are asking us for and demanding of philosophy today. And if that is the case and you are that way enabling philosophy in the future to come up with the

answers of ultimate truth, I am then, I think, required to ask you one more question.

Mortimer Adler: Sure.

Lloyd Luckman: And I think others who are in the same position as myself are vitally concerned in that question. And that is simply this, that considering the progress you've made thus far at the Institute, what do you estimate now are the chances for your ultimate success in the main issue?

Mortimer Adler: Well, Lloyd, if you'll let me knock on wood while I answer that question. I think I am willing to say that the chances look very good to all of us at the Institute. We think that we have licked the toughest part of the job, which is to find the right method for doing this kind of work which has never been done before, a kind of scientific work at the level of ideas, like the scientific work done in the classification and explanation of variety of living things. We have learned moreover how to do philosophy by teamwork in intensive collaboration with one another. And we have made great headway, I think, in applying these methods and these procedures which we have only recently invented in our present efforts to clarify and understand the difficult and basic controversy concerning human freedom.

52 How to Think about God

Welcome to another discussion of The Great Ideas. Today we're going to consider the Idea of God. It should not surprise you to learn that the idea of a Supreme Being is itself supreme among The Great Ideas. In the Syntopicon, where we were working on the 102 Great Ideas of Western Thought we found this out as we went through all of the 102 ideas; we found that the idea of God was the idea to which there were more references than to any of the others in Western literature—in poetry, philosophy, theology, and science—and references by more diverse authors, more different kinds of authors than occurred in the case of any other idea. Both in the quantity of the references and the variety of the references, the discussion of God is the largest single discussion that has gone on in the intellectual tradition of the West.

THE FOUR KEY QUESTIONS ABOUT GOD

In this extraordinary discussion over twenty-five centuries there are four main questions that have been raised and debated. The first is, Does God exist? The second is, What is God's nature? What is God like? The third is, Can we know God's existence and nature? Can we know God's existence and nature independent of revelation and religious faith by the operation of reason, by the natural processes of knowing? And finally the fourth question is, What is God's relation to the world and to man?

Now to these four principle questions there are a number of answers, the names of which I think you are acquainted with. Let me do this very quickly to just remind you of the fundamental

positions that men have taken on these four questions. To the first question, does God exist? The basic issue is between the atheist who says that God does not exist and all forms of affirmation. There are many varieties and many different ways in which men affirm the existence of God. All of these are opposed to the atheist.

Next to the question, what is God's nature? What is God like? Some of the fundamental oppositions, though not all, between the polytheist who thinks of the divinity as a plurality of forms and the monotheist who says that God is one. And among monotheists as we know in the West, there are those who are Unitarian, holding that the divine nature is absolutely simple; and Trinitarian, who find in the divine nature three persons in the Godhead, as in the case of the Christian doctrine of the Trinity. And then there are those who think of God as an impersonal force in the universe and those who talk of a personal God. A God which is a spiritual being and a spiritual being having an intellect and will in whose image man is made.

Next, to the question, Can we know God? Can we know God's existence and nature by the natural processes of our minds? There is the answer given by the agnostic who denies not that God exists but who denies that we can know that God exists or what God is like. And he is opposed by all those who in various ways claim to have knowledge, natural knowledge, of God.

And finally, to the question, How is God related to the world and to man?, there is the double opposition here first between the deist and the theist. Deism holds that God, having created the world, set laws for it to obey and no longer governs it, is not concerned with it by His providence. His eye is not on every sparrow. The theist, by contrast, holds that God not only created the world but governs it from moment to moment and that the divine providence is concerned with every aspect of the world in which we live.

Then there is the issue between the theist and the pantheist. According to the theist, God is in the world but also transcends it. He's in it by His power but He's not identified with it. He transcends the world. There is God and the world. Whereas according to the pantheist, the world and God are coextensive, in a sense; God's whole being is in the world, the world is itself the body of the Divine Being.

We must ask about God's nature before we ask about God's existence. We must have some meaning for the term *God*. We must use thatword "God" with some definite significance before there's any way we can reasonably inquire whether the thing we are naming and signifying by the word "God" actually exists. For certainly, if what God is is unknown to us and unknowable to us, then the word "God" can have no meaning and there could be no sense to the question, "Does God exist?"

THE THREE POSSIBLE CONCEPTIONS OF GOD

I want you to note something here. It is possible to give the word "God" a very definite meaning in our minds without begging the question whether God exists. No matter how we conceive of God, how definite our conception is, that still leaves quite open the question whether the thing we are conceiving, the object of our conception, really actually exists outside our minds and independently of our thinking.

When we ask the question, "What does the word 'God' mean?" how do we think of God? What is our conception of God? Three basic possibilities occur. And I think that these three possibilities are quite exhaustive.

First, it's possible for us to think of God as totally, I emphasize the word "totally," as totally unlike anything else we know, *totally* unlike *anything* else we know. But if we think of God this way then we can have no definite conception of God. For if God is totally unlike anything else we know, we have no way of going to the things we know to our understanding of God. That is, we can have no carry-over from our knowledge to God. Hence, if we take this possibility, we eliminate any further inquiry into the existence of God.

Now we can go to the opposite extreme. We can think of God as essentially like everything else we know. Most of the things we know in the world, most of the things in our experience are corporeal, finite, mutable, sensible, imperfect, changing in time. Now if we say that God is essentially like all the things we know from our experience, we must be saying of God that God too is finite and corporeal and mutable and imperfect.

What are the consequences of thinking of God this way? Well, if we think of God this way, then first of all, God's existence should

be as knowable to us as any of the other things we know that are finite and corporeal and mutable and physical and sensible. But clearly this is not the case. Everyone, everyone understands, no matter what else he knows or what else he thinks, that God's existence is not as known to us or as knowable to us as all the things in the world that are experienced.

Moreover, this attribution to God of finiteness and corporeality and mutability, these characteristics that are common with all the things of our experience violates, I think, anyone's sense of the notion of divinity. And it certainly violates the conception of divinity that is to be found in any of the western religions.

Now there is a third possibility, a middle ground between these extremes. I started out by saying at one extreme you could take the position that God is totally unlike any of the things in our experience. At the other extreme you could take the position that God is essentially like all the things in our experience. Now then, the middle ground would be to say that God is both like and unlike, both like and unlike the things we know, the things of our ordinary, everyday experience.

When you say this you've got to ask two further questions. How is God unlike the things in our experience and how is God like the things of our experience? The answers are, first, that God is unlike the things of our experience, the things we know in our daily experience in those respects in which we recognize them to be the very opposite of divine. That is, the things we must say negatively of God are these: we must say that God is not finite as the things of our experience are, that God is not corporeal as the things of our experience are, that God is not mutable as the things of our experience are, that God is not imperfect as the things of our experience are. In other words, all of these negative attributions must be made if this is the way in which we must understand God as being unlike the things of our experience.

And, second, we must say that God is like the things of our experience only in that respect which must be common to whatever is, which must be common to whatever is. Now whatever is has being. And therefore we must say of God, if we're going to say that God is like the things of our experience in any respect, that God at least has being and whatever properties belong to a thing in so far as it has being, only in this respect are we entitled to say that God is like the things of our experience.

SAINT ANSELM'S ARGUMENT

This leads us, I think, to a profound understanding of how we must conceive God. We must not only conceive God as a being—I don't yet mean an existent one, because all I've talked about is a being, possible being or actual being, either way—if we conceive God as a being, we are only conceiving *God* if we conceive of God as a supreme being. And when we say that we conceive of God as a supreme being or as the Supreme Being, some things follow almost at once from this.

A very famous argument arises at this point called the ontological argument of Saint Anselm. Let me state it for you. Saint Anselm asks us to start thinking about God as a Supreme Being. And when we think of God as a Supreme Being, Saint Anselm says what we are doing is thinking of *that than which nothing greater can be conceived.* If we're thinking of the greatest being, then the being of which we're thinking cannot be less great than any other being If we really are conceiving a Supreme Being, we must be conceiving a being than which nothing greater can be conceived. Because if something greater can be conceived then it is not a Supreme Being we are conceiving. Hence if we conceive of a Supreme Being, we must be conceiving of that than which nothing greater can be conceived. Is that clear?

All right now. Then there are two alternatives. As we conceive of this Supreme Being as that than which nothing greater can be conceived, either we conceive it as not existing or we conceive it as existing. Let's take the first alternative. If we conceive it as not existing, then it is not that than which nothing greater can be conceived because we could conceive of another being who had all the attributes of this one and also existence. And if it has this additional attribute of existence, this additional perfection, it is a greater being than this one. Hence in order to really conceive a being truly supreme, a being which is *that than which nothing greater could be conceived,* we must conceive that being as existing. In other words, it is necessary to conceive God as an existing being.

Notice now I did not say this proves God's existence. Far from it. It only shows us how we must conceive God. It is not possible to conceive God in an accurate sense and conceive God as not existing. If we conceive God as a Supreme Being, a being that than which nothing greater can be conceived, we must conceive God as

an existing being. This does not prove that the being we have thus conceived exists. That is the question we must come back to now.

As we do so, let me remind you of the alternatives on this fundamental question. There is the position taken by the atheist who says that from the very nature of things we can see that God, conceived as a supreme and perfect being, does not exist. The atheist usually argues from the existence of evil in the world and tries to infer, tries to reason, that the existence of the evil in the world about us tends to show or prove that a perfect or benevolent God, a good God does not exist. I want to call your attention to the fact that the atheist never shows or tries to show that a Supreme Being cannot exist. He never tries to show that it's impossible for a Supreme Being conceived as a necessary being to exist.

Then there is the position of the agnostic who says that from the very nature of God as conceived, in the manner in which I've suggested He be conceived, we cannot possibly know whether God does exist or not. The very nature of God being transcendent, infinite, beyond our range of apprehension, is such a being that even as we conceive it we could tell that we couldn't know whether it's a being that exists or not.

And finally the third alternative is a position of the philosophical theist, the person who says that looking both at the nature of things and at the nature of God it is possible to infer from the nature of things that a God thus conceived as having the nature of a necessary being does exist.

AN ARGUMENT FOR THE EXISTENCE OF GOD

How is such an inference made? How do philosophical theists reason in this way? I would like to try to show you that now. And I'm going to try to show it to you by explaining an argument or expounding an argument which runs, to put it to you very quickly and briefly in the following manner, that we can infer that a necessary being exists because the existence of a necessary being is required as the cause of the existence of the finite, corporeal, mutable beings we know to exist all around us.

In order to follow this clearly, you have to bear in mind the distinction between two fundamental terms in the argument. The first is the meaning of the term "necessary being." And I'm going

to use a circle as the symbol of a necessary being. Now what we mean by a necessary being is a being which cannot not exist. A being of which it is impossible for it not to exist. A being whose very nature is to exist so that its existence follows immediately from its nature.

To talk about the opposite of a necessary being, I'm going to use the phrase "contingent being." A contingent being is a being which may or may not exist. There is nothing about it which requires that it exist. Sometimes it does exist; sometimes it does not exist. It comes to be and passes away.

You and I, for example, are quite aware that we are contingent beings, not necessary beings. We're aware that we are on the edge of nothingness. In fact, it's only by holding onto our existence that we don't fall away into nothingness. And that sense of being surrounded by nothingness, of coming from nothingness, going back into nothingness, is our sense of our own contingent being. In other words, that we may or may not exist. Our natures do not require us to exist. Existence doesn't follow immediately from what we are. And all the things around us are like this.

When you understand this distinction between necessary and contingent beings, you see one thing at once—that a contingent being needs a cause of its existence at every moment of its existence. For if its existence does not follow from what it is, if its existence does not follow from its nature, then something else outside its nature must cause its existence.

In contrast, the necessary being is one which does not need a cause of its existence. For what we mean by a necessary being, let me say again, is a being the very nature of which it is to exist. Whereas a contingent being is not a being *the very nature of which it is to exist,* and so it needs a cause of its being, a cause of its existence.

Now that phrase, "cause of existence" is a very important phrase to distinguish in meaning from the phrase, "cause of the becoming of something." Would you think normally that the parents of a child are the cause of that child's existence? Normally you would. You'd say, "Yes, they cause the child to exist." No. They don't cause the child to exist; they caused the child to come into existence. And the moment after, the very moment after the child comes into existence, both parents can die and the child go on existing. That kind of cause doesn't go into the very being of the

thing. It's external. It is a cause of the changing of something. It is the cause of the coming to be or the passing away of something. A cause of existence must continue to cause existence as long as the thing exists. And so, parents are not the cause of the child's existence since the child may continue to exist long after the parents do not exist and have ceased to operate as causes.

I want you to notice that a contingent being is one which requires the cause of its existence to cause its existence at every moment of its existence. Now with these distinctions let me name three propositions for you about these two kinds of beings. The first proposition is that contingent beings do exist. You and I are contingent beings. We may or may not exist. We come into being and pass away. We exist. Cairs, tables, trees, cats, and dogs—all of these are contingent beings. They exist. So the proposition "Contingent beings exist" is true, is it not?

And the second proposition is, from the very understanding of a contingent being, that every contingent being needs a cause of its existence every moment of its existence.

The third proposition is that no contingent being can cause the existence of another. I didn't say that a contingent being, a parent, for example, could not cause the coming to be of a child. I only said that a parent, which is a contingent being, doesn't cause the existence of a child. That parent, so long as the parent exists, also needs a cause of its existence. I'm only saying now that no other contingent being can cause the existence of any other contingent being.

Now one more proposition. And that proposition is that whenever the effect exists, the cause required for the existence of the effect must also exist. Now with those propositions I can state the reasoning to show that God exists. The reasoning runs as follows. In fact, you already have it in mind. All I'm going to do now is put it in good order. Here are the propositions.

First, if the existence of an effect—listen to the "ifs"—*if* the existence of an effect implies the existence of its required cause; and *if* (second "if") contingent things exist; and *if* (third) everything contingent must have a cause of its existence at every moment of its existence; and *if* (fourth) no contingent thing can cause the existence of another contingent thing (you can't put a contingent thing here as the cause of existence of another contingent thing; you only can put a contingent thing as the cause of the becoming

or change of a contingent thing)—then, if these things are true, it follows that a necessary being exists as the cause of the existence of each contingent thing at every moment of its existence.

Let me repeat the argument again for you now. If the existence of an effect implies the existence of its required cause, and if contingent things exist, and if everything contingent must be caused to exist, and if no contingent thing can ever cause the existence of another contingent thing, then it follows that a necessary being exists as the cause of the existence of the contingent things known by us to exist.

IS THE PHILOSOPHICAL ARGUMENT FOR THEISM CONCLUSIVE?

Does this argument which I've just been expounding to you prove the existence of God conceived as the Supreme Being and therefore as a necessary being? Let me say at once that it would prove the existence of God if all the premises in the chain of reasoning could be known by us to be true. If all those "ifs" that I stated in that chain of the argument could be asserted as really true, then I think the person who asserted them as true would be entitled to say he knew God's existence as the conclusion of a rational process of proof or inference.

Philosophers and theologians differ about this. Some philosophers and theologians think that we can assert all these premises as true and therefore that we can know by our reasoning that God exists. Other philosophers and theologians very seriously doubt that we can assert the truth of these premises and therefore they think that we are in grave doubt, as far as our own natural knowledge goes, about God's existence.

My own view is neither the one nor the other of these two extremes. I think of the four premises or propositions that constitute the body of the argument, I am clear and certain about two of them. I am clear that contingent things, things like you and me or trees and stones, that such things exist. I am also clear that if the effect exists, the cause required for its existence must exist. These two things I'm clear about.

But when I come to the proposition that contingent things need a cause of their existence, I have some difficulty understand-

ing that because I'm not sure I know the difference, really under-
stand the difference, between cause of existence and cause of
becoming. And the most difficult proposition of all for me to
understand is the proposition that contingent things cannot cause
the existence of anything, they can only cause the motion or
change or becoming of things but not the existence of anything.

Now I think that some people are better able to understand
these matters than I am. And for people who can understand them
better than I, I think it is fair to say that they really understand and
know the truth about God's existence. I would go so far as to say
that even for persons like myself with a weaker understanding of
the truth of these propositions, I have some rational grounds for
asserting that God exists, even though I have to make a leap, a leap
beyond those rational grounds to a belief. My reason, being weak,
carries me just so far. My understanding doesn't carry me the
whole way yet.

My understanding and reason carry me far enough so that I'm
entitled as a rational man, as a reasonable man, to make a leap
beyond reason to the belief that God exists. And when I make this
leap, I think I make it not to a belief in the God of the philoso-
phers but I think the God I believe to exist is the God that is wor-
shipped by the religions of the West. As Pascal and other
philosophers say, "the God of Abraham, Isaac, and Jacob."

Historical Note:
How This Book Came to Be

Following the formation of the Institute for Philosophical Research in San Francisco, Mortimer Adler made his TV debut with a series of 52 weekly half-hour TV shows on philosophical subjects, *The Great Ideas*. These programs were produced by the Institute and carried as a public service by the American Broadcasting Company, presented by National Educational Television (NET), the precursor of PBS. They were broadcast in the San Francisco Bay Area in 1953 and 1954.

The TV shows, made before the invention of videotape, were recorded on film by the Institute. After the Institute moved from San Francisco to Chicago, the films were packed away in the Institute's storage room and forgotten. Later, when the building which housed the Institute was going to be demolished, the Institute moved into the headquarters of the *Encyclopaedia Britannica*. During the move, the films were rescued and transferred to both videotape and audiotape. Dr. Adler donated them to the Center for the Study of The Great Ideas, and both video and audio versions of these programs, exactly as broadcast, are now available from the Center. They reflect the TV presentation techniques of the 1950s, but the content remains timeless and highly relevant to the new millennium.

In editing the transcripts of the programs for this book, it was decided to leave the somewhat conversational and interactional flavor largely untouched, so that the chapters would read like what they are: not written articles or formal lectures, but live TV broadcasts, with improvisation and friendly interchange between Dr. Adler and his collaborator, Lloyd Luckman.

In places where the transcript was obscure or incoherent, small deletions or slight rewordings were performed. The biggest modification, however, relates to the frequent use of "charts" and other illustrations as visual aids in the TV programs. The charts just summarized the content of Dr. Adler's presentation in a few headings, but Dr. Adler would sometimes point to the chart and talk directly about what was on the chart. It was decided that in the book format these charts would be a distraction, so they were dropped and references to them were edited out of the text.

In keeping with the usage of the ancient Greeks, as well as all dialects of English prior to the 1960s, Dr. Adler frequently employed the word "men" to signify adult humans of either sex. Following more recent fashion and in the interests of avoiding unnecessary distraction, many, but not all, of these locutions have been modified, for example to refer to "human beings" or "persons."

The chronological order in which these programs were broadcast has been lost, though it could be partly reconstructed from passing references in the tapes.

These references have been deleted here, and no attempt has been made to arrive at the original order. General considerations of comprehensibility and appropriateness have determined the present order of chapters, given that some people like to read a book straight through from beginning to end. However, the chapters can be read in any order, as long as the groups of chapters dealing with a single Great Idea are read in the order given. (Within any such group, the first chapter title begins with the words "How to Think about," and subsequent chapter titles are worded differently.)

Index